The Art of Venice

From Its Origins to 1797

FILIPPO PEDROCCO

THE ART OF
VENICE
From Its Origins to 1797

SCALA/RIVERSIDE

Layout
Maria Giulia Montessori for Colophon srl, Venice

Video makeup
Pietro Grandese

Translation
Huw Evans

Editing
Marilena Vecchi

Photographs
Archivio Fotografico SCALA

Printed in Italy
Amilcare Pizzi Spa, Cinisello Balsamo (Milan)

© 2002 SCALA Group S.p.A., Florence

Published by
Riverside Book Company Inc.
250 West 57th Street
New York, N.Y. 10107
www.riversidebook.com

ISBN 1-878351-61-3

Contents

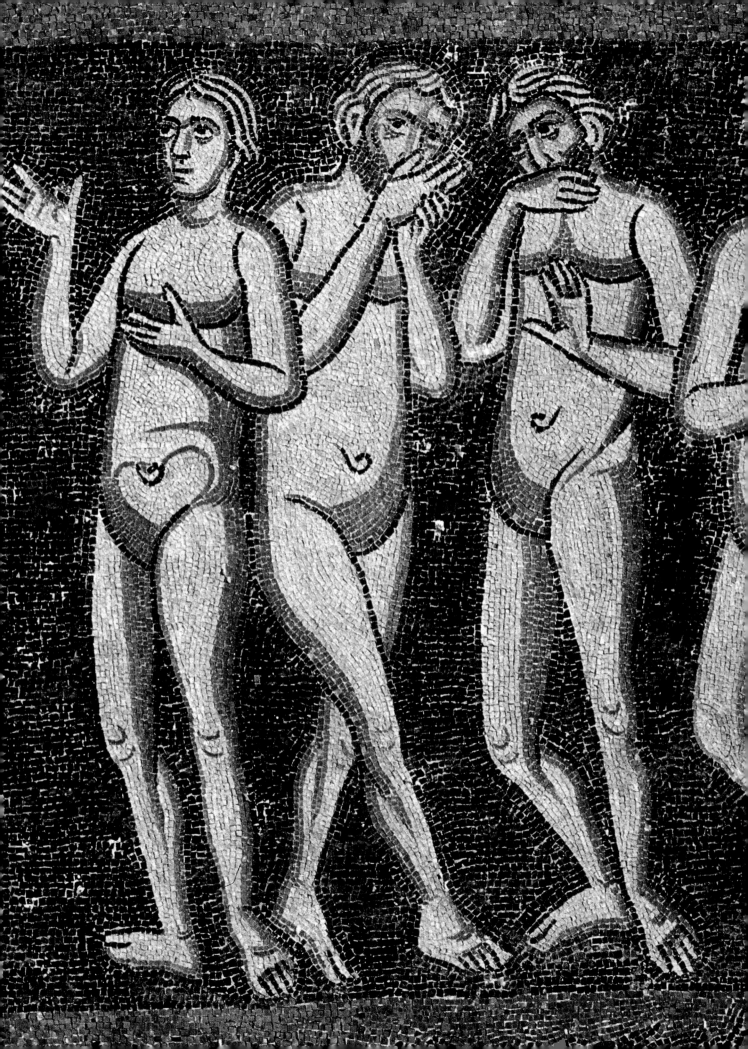

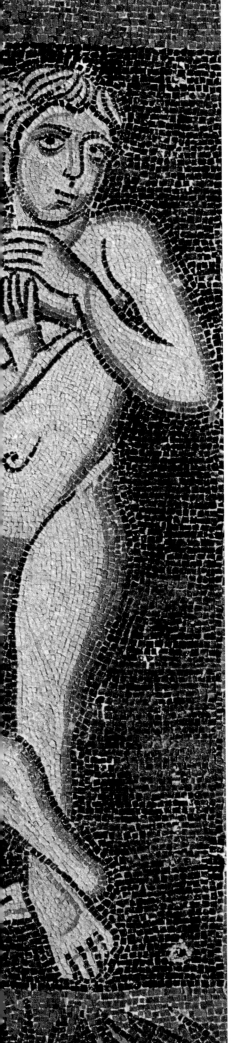

The Origins
of Venice

At the northern end of the Adriatic Sea, amidst brackish lagoons and flat islands lapped by the slow ebb and flow of the tides, stands Venice, a city whose origins are shrouded in a mystery that is only now being cleared away. No one believes any longer in that fateful date – March 25, 421 – that the Venetians themselves chose as the beginning of their city's long climb to fortune and to its tryst with destiny. It is now certain that the area ringed by lagoons on which Venice stands was once a plain traversed by rivers and was already inhabited in the Roman era. It was only later that natural events such as tidal waves and floods obliged the population to settle on those parts that had not been submerged by water. In fact, the archaeological evidence shows that the urban structure of the city is based on grids that conform to the agricultural organization of land during the Roman period, and that it did not attain a form similar to its present one until the early Middle Ages.

Last Judgment, Basilica of Santa Maria Assunta, Torcello. Detail.

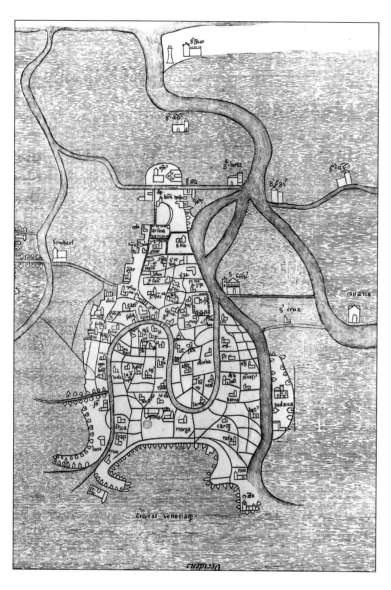

FRA PAOLINO,
Plan of Venice,
Biblioteca Marciana,
Venice.

when the city's distinctive *forma urbis* appears to have already taken shape.

Politically, Venice immediately came under the sway of the Eastern Roman Empire, as a dependency of the Exarchate of Ravenna. But very soon, probably during the reign of Orso Ipato, the third doge of Venice (726-737), it embarked on a process of emancipation, eventually achieving total independence from the Eastern Roman Empire sometime between the ninth and tenth century.

This process of shaking off the political authority of Byzantium was similar to the one that led to the formation of the Communes in Northern Italy. But there is the decisive difference that Venice did not merely achieve a limited amount of freedom while remaining subject to an acknowledged and sovereign external power, as was the case between Commune and Empire. Instead, she took the first steps toward the creation of a genuine sovereign state, perhaps the first such modern institution in the West. Of course, this was not a conscious plan, but a painful course of evolution that was often shaped by chance and lucky circumstances. Yet there is no doubt that the history of the Republic of Venice, and this includes its artistic history as well, can be seen as a journey that winds back and forth between East and West and culminates in a manifest autonomy. Moreover, from its earliest days, Venice made this role of mediation between East and West the basis of its very existence, and of the myth that it created about itself.

Architecture and mosaic were the earliest forms of Venetian artistic expression. In particular, the lagoon island of Torcello was the place where the culture of the mainland, which had been influenced by the barbarian invaders, came into contact with the Roman- and Byzantine-inspired art of Ravenna, and with fragments of the pre-existing local Latin cul-

This was the period in which the migrations caused by the Longobard invasion of Italy in 569 drove many inhabitants of neighboring cities such as Altino and Concordia to seek refuge in the more secure lagoons, resulting in a large increase in the local population. Consequently, the original fortified nucleus of which the city was made up at the time, the so-called *civitas Rivoalti*, expanded to form the *civitas Veneciarum*, spreading rapidly onto all the other pieces of land that remained above the surface of the lagoon. This is the situation recorded in the plan drawn by Fra Paolino and preserved in the Biblioteca Marciana in Venice, dating per-

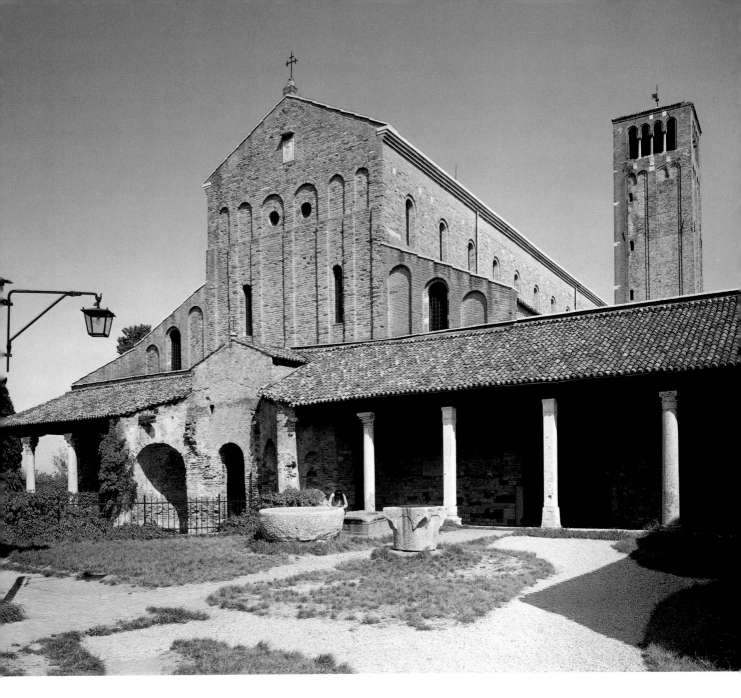

ture, and then blended with these to produce the first great art with qualities that can specifically be called Venetian. The architectural and decorative schemes of the cathedral of Santa Maria Assunta, which is the most important building on the island, founded in 639 and enlarged in 824, are clearly derived from Ravenna. And it was Ravenna that furnished the first groups of mosaicists, active initially on Torcello and then throughout the ninth century in St. Mark's and in many other churches in the city. From the Orient, again through Ravenna, came the glassmakers who made the tesserae for the mosaics and who laid the foun-

dations for the art of glass working that was soon based on another island in the lagoon, Murano.

The mosaic of the *Last Judgment* on the inside facade of Santa Maria Assunta is the most celebrated element of its decoration and was executed in the eleventh and twelfth century by craftsmen who were also working on St. Mark's. The accentuated expressionism, underlined by strong luministic effects, especially in the lower parts representing *Hell*, is of particular significance.

Facade with portico, Basilica of Santa Maria Assunta, Torcello.

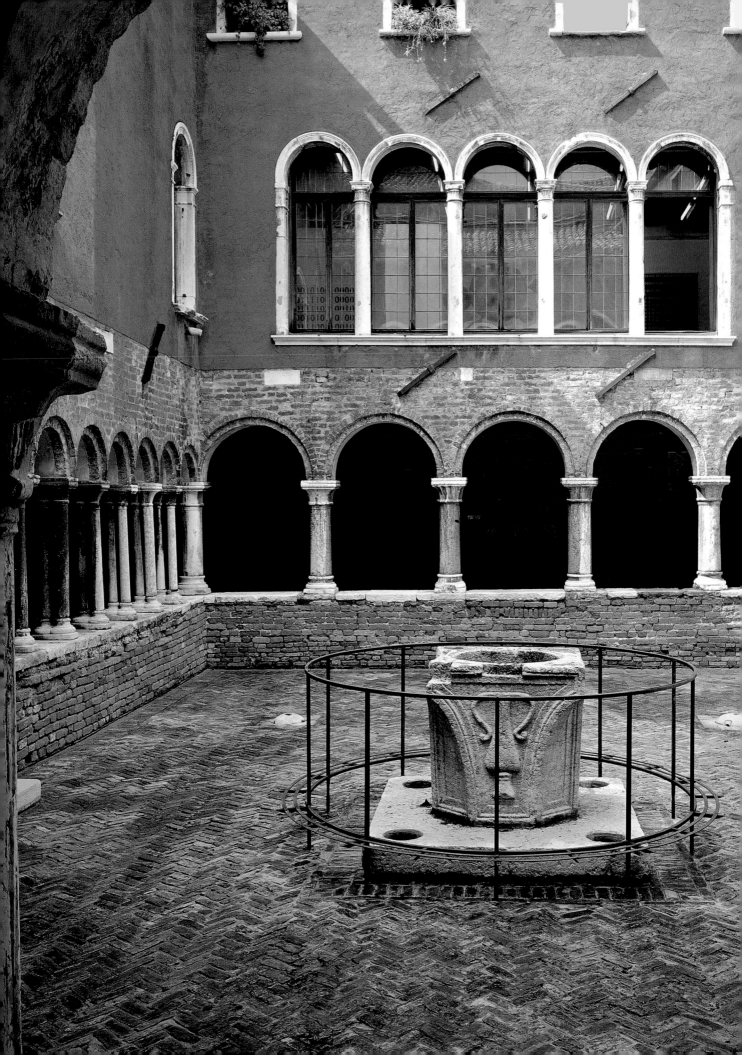

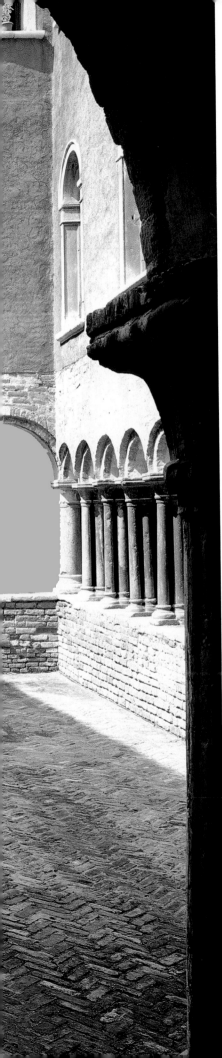

Medieval Venice

The Basilica of St. Mark. After the year 1000, Venice began to grow at an ever-increasing rate. Typical of the architecture of this period is the happy blend of Oriental and Romanesque styles that we find in such charming buildings as the cloister of Sant'Apollonia, completed in 1109, and the great Basilica of San Donato on Murano, begun in 1125. But the most important event – and not from the artistic point of view alone – to characterize the late Middle Ages in Venice was the construction of the Basilica of St. Mark, which became a mirror that reflected both the ideology of the State and its persistent desire to show itself to the world through visible signs. In fact, it served simultaneously as a chapel for the doges and a cathedral for the community, as a royal treasury housing the State's artistic heritage and as a public place of worship. In 1063 Doge Domenico Contarini began work on the reconstruction of the great building that had been founded between 828 and 832 by the family of Doge Giustiniano Partecipazio.

Cloister of Sant'Apollonia, Venice.

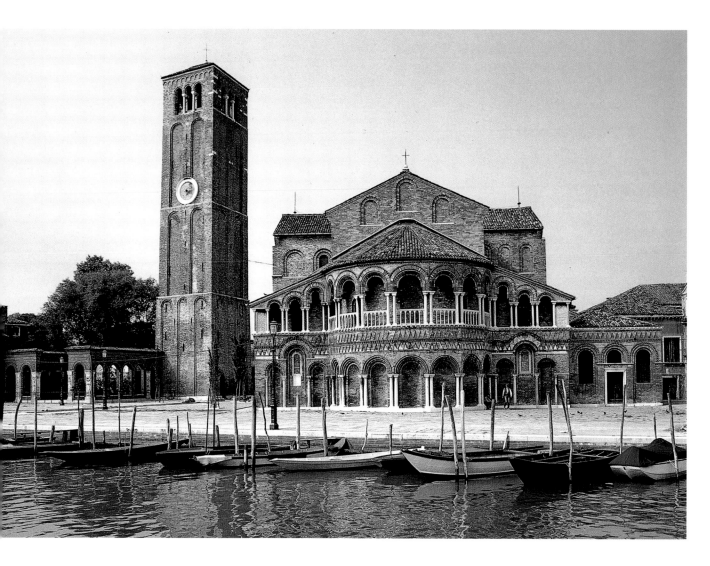

Apse, Basilica of
San Donato, Murano.

The iconographic source for the Romanesque St. Mark's was the Apostoleion, or Church of the Twelve Apostles, in Byzantium, built by Justinian in the sixth century and destroyed in the fifteenth. The masons who were summoned to erect it were probably Byzantine as well, an obvious sign of a persistent cultural debt deeply rooted in local taste and confirmed by the numerous exchanges that took place between the Repubblica Serenissima, as Venice liked to call herself, and the Exarchate of Ravenna. Yet the example of the East was not parroted in a passive way. This was due not simply to the presence in Venice of a Latin substrate that revealed itself in the way the city's patrician palaces were modeled on the late classical Roman villa, but

was also a consequence of the progressive technical and stylistic maturation of the local craftsmen, who were developing a growing sense of artistic independence. While it is true that St. Mark's has a Greek-cross plan like the Byzantine Apostoleion, and that the arrangement of the basilica's five depressed domes (they were not raised until the thirteenth century, when a wooden framework was inserted) is similar as well, the facade of exposed brick leads into a vast atrium (called an exonarthex) that has no counterpart in the ancient Oriental model. In addition, the mosaic decoration of the interior, on which work may have started toward the end of the ninth century and was to continue for centuries, with the effect of attenuating the struc-

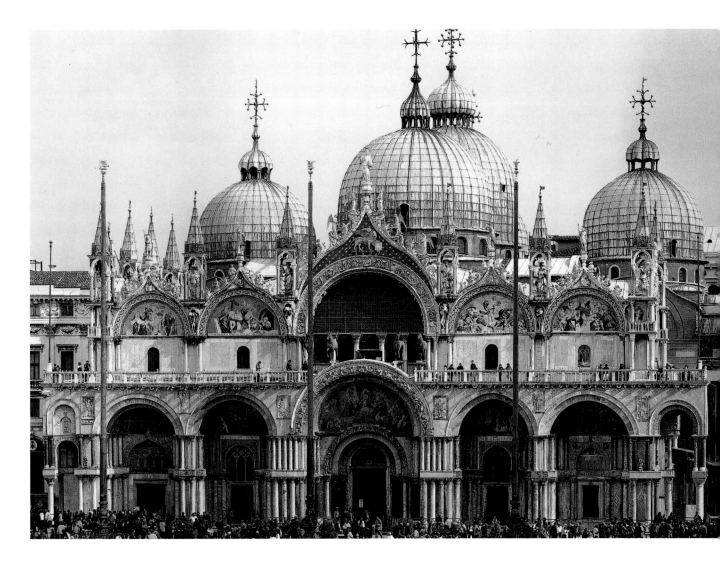

tural tension of the vaults and arches, is unquestionably the product of a pictorial sensibility and iconographic originality that are already typically Venetian.

The Mosaics of St. Mark's. Following the events of the Fourth Crusade, the Venetians took control of Constantinople for the several decades from 1204 to 1261. This allowed them to gain firsthand knowledge of the local works of art, especially the mosaics and frescoes. They were able to examine the techniques used and to study the iconography. In addition, the Venetians brought many works of art back home. These included sculptures in marble and bronze, among them the famous four horses, which were to be

placed on the basilica's facade; jewelry, some of which would be used to complete the *Pala d'oro*; precious stonework, used to decorate the basilica itself; and whole cargoes of enamels, gold and tesserae required for the execution of the mosaics. The availability of imported materials, and the impact of the examples of recent Byzantine art, which revealed the formal and iconographic shortcomings of the existing mosaic decoration in St. Mark's, were what prompted resumption of work in the basilica. This was already under way by the end of the first decade of the thirteenth century.

At this point it is necessary to take a brief look at the history of the mosaics in St. Mark's, which by themselves constitute the most impor-

Facade, Basilica of St. Mark, Venice.

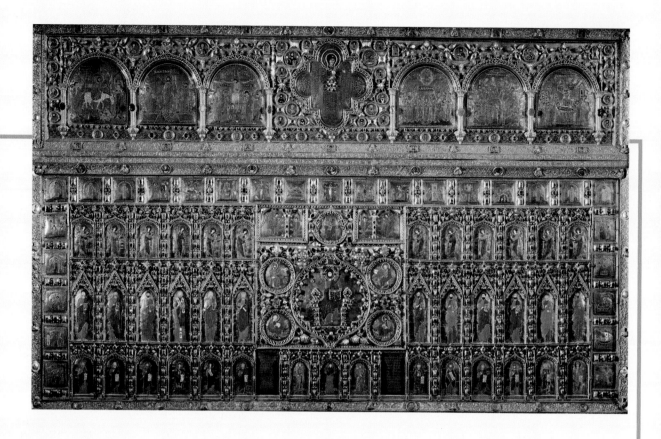

THE PALA D'ORO

The *Pala d'oro* or *Golden Altarpiece* – unquestionably the greatest masterpiece of Venetian Gothic gold work – was originally the principal ornament of the high altar of the Basilica of St. Mark. It was given its present form by the Venetian goldsmith Giovanni Paolo Boninsegna, who completed it in 1345. Two years earlier Doge Andrea Dandolo had entrusted him with the task of rearranging a precious series of Byzantine enamels dating from various periods, most of which had already been used in previous versions of the altarpiece. They were put inside a new Gothic frame of gilded silver embellished with pearls, enamels and gems. In fact we know of the existence of two earlier versions of the

Pala d'oro: the first was ordered in Constantinople in 976-978 by Doge Pietro Orseolo I; the second had been created by changing the arrangement of the enamels and adding others at the behest of Doge Ordelaffio Falier in 1105. This second one was enlarged in 1209, during the reign of Pietro Ziani, with the addition of the seven large enamels in the upper row, which were part of the booty brought back by the Venetians after the sack of Constantinople in 1204.

At the center of the altarpiece is the figure of Christ enthroned. His word is revealed to the world by the four evangelists, set around him inside round medallions, or *clipei*, and by the twelve apostles. In the

lower row of the altarpiece are twelve prophets with the image of the Virgin praying in the middle, flanked by the rulers of Venice and Byzantium. Above Christ is the heavenly throne, ready for the second coming of God on earth, worshiped by a line of cherubim, angels and archangels in the third row. The square enamels now located on the two short, vertical sides of the altarpiece represent scenes from the life of St. Mark, while the ones in the fourth horizontal row depict episodes from the life of Christ. The large frieze at the top has the archangel Michael at the center and six panels with scenes from the life of Christ at the sides.

The precious *Pala d'oro* was displayed to the faithful only on feast days. On other days it was covered by a wooden altarpiece – the *Pala feriale,* or *Weekday Altarpiece* – painted by Paolo Veneziano and his sons Luca and Giovanni between 1343 and 1345. The painting, which could be raised by means of a complex system of winches and pulleys, has been restored several times and is now kept in the Treasury of St. Mark's. It is divided into two rows: the upper one contains figures of saints, while the lower one represents – in a narrative style unusual for the Venetian world of the mid-fourteenth century – scenes from the life of St. Mark.

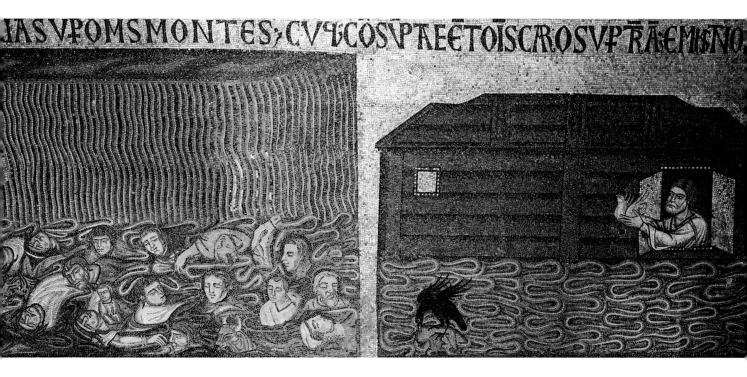

tant chapter in the Italian pictorial art of the thirteenth century. The decoration of St. Mark's with mosaic began in the reign of Doge Domenico Selvo (1071-1084), but nothing is left of this early phase except a few traces, obliterated by the marble slabs installed subsequently. The apostles in the niches of the inner portal, and the saints in the apse, works in which it is possible to discern the coexistence of an early Christian tradition derived from Ravenna with the Byzantine manner, can instead be dated to the beginning of the twelfth century. Work started on the mosaics of the domes and their arches in 1159-1160, beginning with the eastern Dome of the Emanuel, continuing with the central Dome of the Ascension and concluding with the western Dome of the Pentecost. It is likely that the iconographic program was derived from the Basilica of the Twelve Apostles in Constantinople; nevertheless, these works display a remarkable degree of stylistic autonomy with respect to their Byzantine models, especially in their dynamic accentuation of the figures.

This independence of expression is best exemplified by the mosaic representing *Palm Sunday*, with its characteristic emphasis on line, which makes the figures stand out; by the angels

of the Dome of the Pentecost, in which the vivid colors produce a Romanesque effect; and by the *Crucifixion* on the western arch of the central dome, which is the masterpiece of this phase, due to the intense drama and sense of dynamism which bring the figures to life, an effect connected to a new interest in color.

The thirteenth century, on the other hand, was a time of both stylistic and iconographic reconsideration. It is clear that the Venetian school of mosaic had run out of steam at the end of the previous century and that there was a lack of talented local craftsmen. At the same time, there was an urgent need to expand the decorative program of the basilica, with the addition, for instance, of the *Scenes from the Old Testament* and the *Christ on the Mount of Olives..* So it was only natural to make up for these shortcomings by bringing more mosaicists from the East. We even know the names of some of them, such as Theophanes, Johannes and Philippus, all originally from Byzantium.

The first mosaic executed in the thirteenth century was the panel representing the scene of *Christ on the Mount of Olives*. Here the hands of three different artists have been identified, working on the mosaic from left to right. The first was

The Flood, Dome of the Genesis, Basilica of St. Mark, Venice. Detail.

facing page
Pala d'oro, Basilica of St. Mark, Venice.

following pages
Agony in the Garden, south wall, Dome of the Pentecost, Basilica of St. Mark, Venice. Detail.

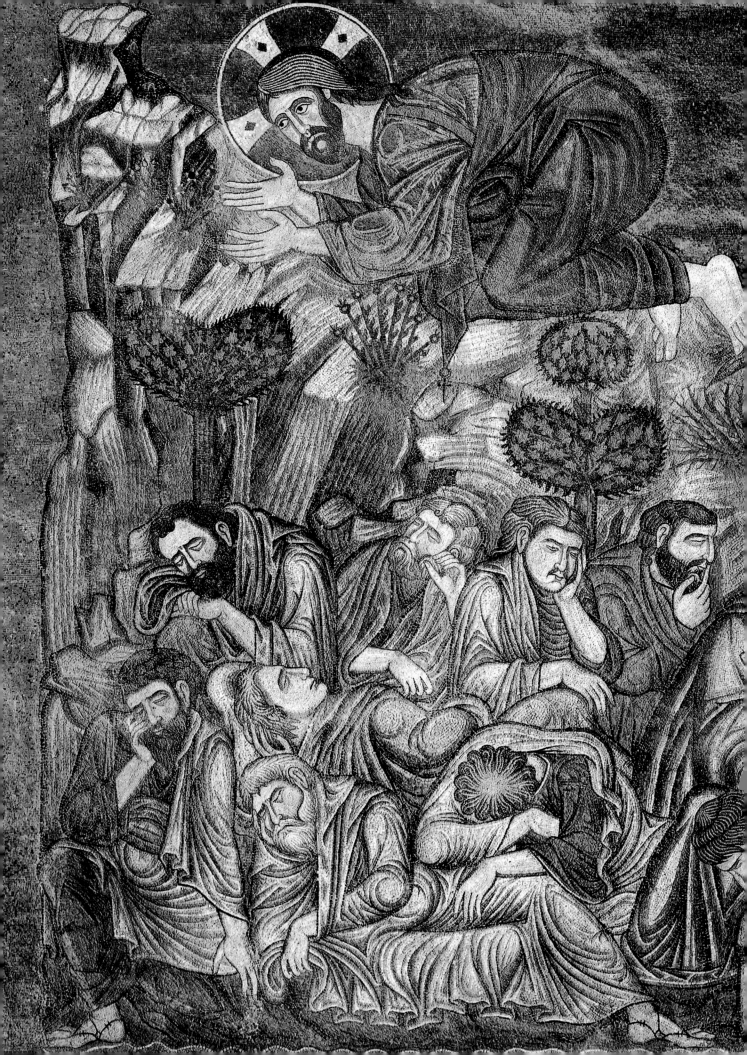

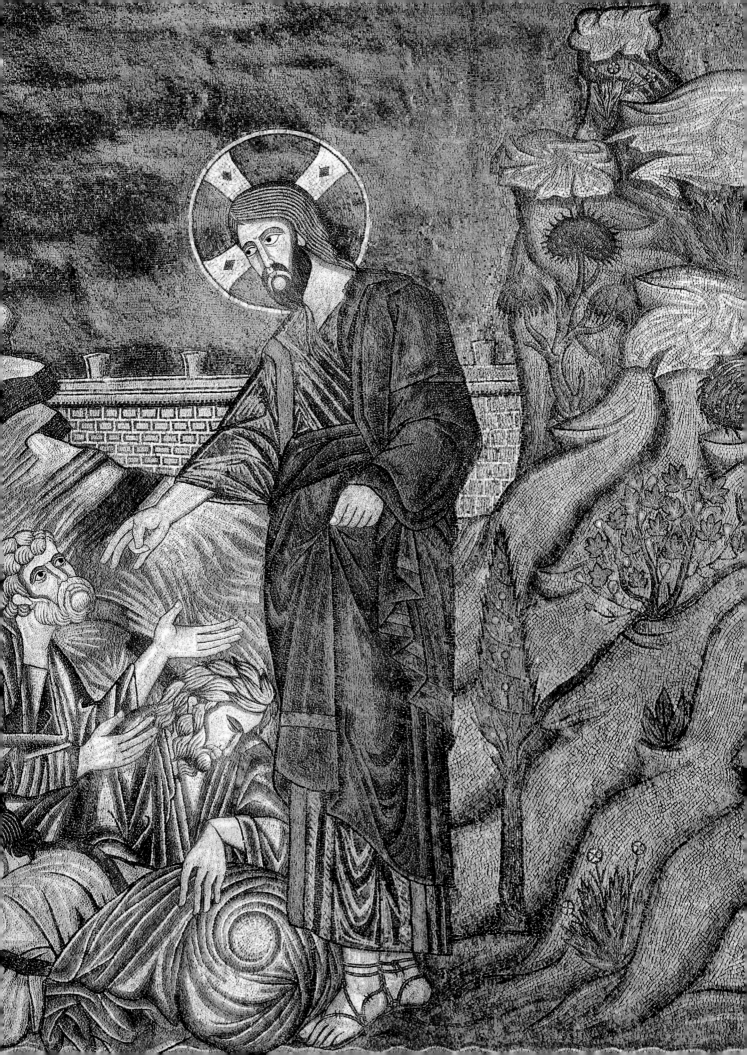

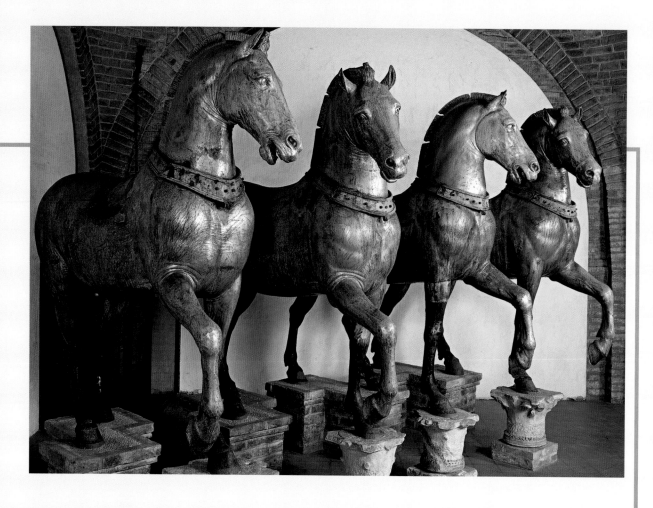

THE HORSES OF ST. MARK'S

The celebrated four horses of gilded bronze were part of the war booty the Venetians brought back from Constantinople after they captured the city in 1204 during the Fourth Crusade. At the time, the horses stood on a pedestal in the Hippodrome. Nothing is known of their history prior to their removal to Venice. None of the various hypotheses put forward by scholars with regard to their origin is supported by reliable evidence. According to some they were brought to Constantinople directly from the island of Chios, while others believe that the horses had first been taken from Greece to Rome and only transferred to Constantinople at a much later date.

Whatever the case, once in Venice, the four horses were placed on the central loggia of the Basilica of St. Mark during the reign of Doge Ranieri Zeno (1253-1268). Since that time they have been removed only once, in 1798, when the horses were taken by Napoleon's occupying army to Paris, to be set on the top of the Arc de l'Étoile. They were brought back to Venice in 1815, largely thanks to the intercession of the sculptor Antonio Canova. In the 1970's the horses underwent restoration. On that occasion the painful decision was taken, for obvious reasons of conservation, to move one of the best-known symbols of Venice to a museum inside the basilica, replacing them on the loggia with copies.

Even the studies carried out during the restoration work did not uncover any objective information that might have helped to date the sculptures with any certainty. On the basis of stylistic features they have been assigned by scholars to an extremely broad span of time, extending all the way from the fourth century BC to the fourth century AD. Nevertheless, a number of elements, such as the use of mercury in the casting of the bronze and the form of the horses' eyes, ears and manes, as well as the techniques used to repair defects prior to the gilding, suggest they were executed in the Roman era, around the time of Septimius Severus, by a school of Greco-Oriental artists who had kept alive the great tradition of Hellenistic sculpture

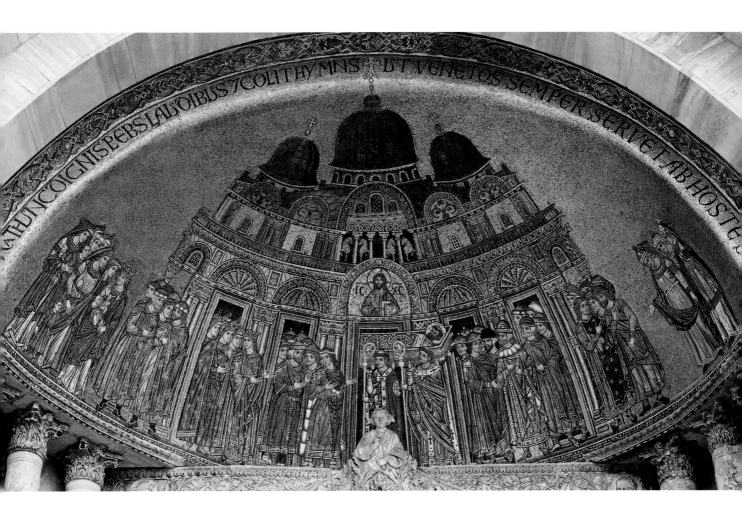

responsible for the largest part, with the eight figures of the sleeping apostles, characterized by a detailed and animated style, a marked typological differentiation of the faces, and rich and elaborate drapery. It is a "classical" style, which finds its counterpart in the Byzantine milieu in works such as the apostles in the *Last Judgment* of Vladimir (*c.* 1200).

The second hand can be recognized in the three figures on the right in the group of apostles, in the kneeling and standing figures of Christ and in the part of the background that comprises the walls. Here the forms grow more gaunt, the outlines simplified, the expressions stereotyped: all this reflects a style that emerged in Byzantium at the beginning of the thirteenth century and which is also to be found in works such as the frescoes at Mileseva in Serbia. So it can be deduced that this second mosaicist was a Byzantine artist like the first, and in touch with the latest developments in the East.

However, not even this artist was able to finish the work. A third mosaicist was called on to complete it, in a style that was different again: more fluid and picturesque, it is unmatched by anything in contemporary Eastern production. Rather it was the fruit of a combination of Byzantine and Western influences, and can in some ways be compared with the style of works already present in the basilica, dating from the second half of the previous century.

This style was destined to dominate the decoration of St. Mark's until around the middle of the thirteenth century, as seen in the first mosaics that extend along the atrium toward the front onto the square, in the large figures of *Christ*, *Mary* and the *Prophets* in the western arm and in those of the *Saints* on the lateral arches of the piers. The masterpiece of this period remains the series of episodes from the Old Testament in the basilica's portico. The decoration of the Dome of Genesis is particularly significant, with the repre-

The Body of St. Mark Carried to the Basilica in a Procession, Basilica of St. Mark, Venice.

facing page
The Horses of St. Mark's, Basilica of St. Mark, Venice.

December,
Arch of the Months,
Basilica of St. Mark,
Venice.

to the Basilica, marks a return to forms that were now outdated. Yet what they still retain from the Venetian style of the early thirteenth century is an irrepressible taste for color and a linear feeling that anticipates Gothic painting.

Sculpture and Architecture. The sculpture produced in Venice throughout the thirteenth century was noteworthy. After the sack of Byzantium, the Venetians brought back many works in relief, most of them from the centuries prior to the age of iconoclasm. These were the models that inspired a substantial part of the local production. The outstanding figure of the period was the Master of Hercules, a Venetian artist who carved five of the six reliefs executed by the middle of the century and set on the facade of St. Mark's, which had recently been modified by the slabs of marble brought as booty from the Fourth Crusade. The relief that represents *Hercules with the Hind and the Hydra* is perhaps the most significant of the group. Iconographically, the work has its origins in early Byzantine representations of the god, but from the stylistic viewpoint it denotes the emergence of a language that diverged from Eastern sculpture and adopted a manner that was linear and decorative, similar to Venetian mosaics of the first half of the century.

The same workshop must also have been responsible for the only sculptures in full relief from this period to have come down to us, the four angels located inside St. Mark's at the crossing of the arms under the main dome. These too display evident affinities with contemporary works in mosaic. It is apparent, among other things, that the *Angel Playing the Tuba* is derived directly from the Angel of the Apocalypse executed some two centuries earlier in the *Last Judgment* on Torcello.

The masterpiece of thirteenth-century sculpture in Venice is the main portal of St. Mark's, whose three arches are decorated with six carved fascias. On the lowest arch are representations of

sentation of the *Flood* providing a narrative of great freshness and vivacity, underlined by the use of a coloring rich in naturalistic effects.

For reasons unknown, the production of mosaics was interrupted around the middle of the century. When work resumed, after 1258, it brought a turnaround, that the mosaics produced between this moment and the end of the century explicitly recall the Byzantine world. It is thought that the principal reason for this return to an earlier style lay in the political rapprochement between Venice and Byzantium that occurred during the rule of the Palaeologus dynasty, and the consequent revival of cultural ties between the two cities. Certainly, the stylized composition of works like the lunette of the Door of St. Alypius (the only one of the originals on the great arches of the facade to have survived, *c.* 1270), which depicts the *Transport of the Body of St. Mark*

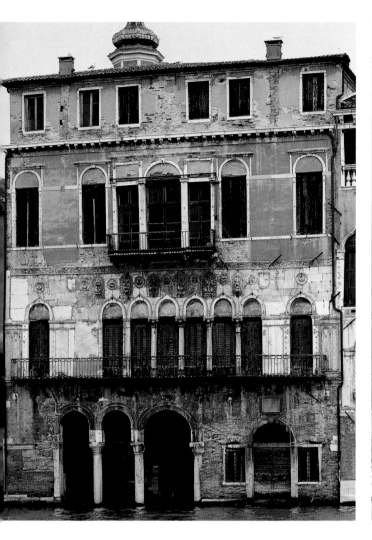

the *Earth*, the *Sea* and *Human Life*, works of a distinctly Romanesque character and influenced by Lombard sculpture that should be dated to some time before 1240. On the inner fascia of the second arch is the series of *Months* and *Seasons*, belonging to a sculptor trained in Antelami's school or even from the Île-de-France. The *Virtues* and *Beatitudes* on the outer fascia unite a still Byzantine decorative style with forms derived from French Gothic, evident in the liveliness of the figures and the handling of the clothing. Finally, the third arch is decorated with *Crafts* on the inside and *Prophets* on the outside, with *Christ Giving His Blessing* at the center. The Master of the Crafts is the most interesting of the sculptors who worked on the complex portal. In the part which he executed – dating from the eighth or ninth decade of the century – he made use of an extremely animated and fluid style,

made even more expressive by a vibrant coloring which shows signs of Pisan influences.

In addition to the large number of works carried out for the decoration of St. Mark's, which now began to assume its definitive appearance, the thirteenth century in Venice also saw the urbanistic expansion of the city. Between the end of the twelfth century and the beginning of the thirteenth, in fact, several important palaces were built on the Grand Canal, including Ca' Barzizza, Ca' Loredan, Ca' da Mosto and the present Fondaco dei Turchi, while everywhere old wooden structures were replaced by buildings in brick and stone. The new palaces, with spacious arcades set on top of ground-floor porticoes, recalled the model of the first Doge's Palace, and were already animated by that taste for the scenic and picturesque that was to be characteristic of Venetian architecture over the following centuries.

Facade on the Grand Canal, Ca' da Mosto, Venice.

Facade on the Grand Canal, Ca' Barzizza, Venice

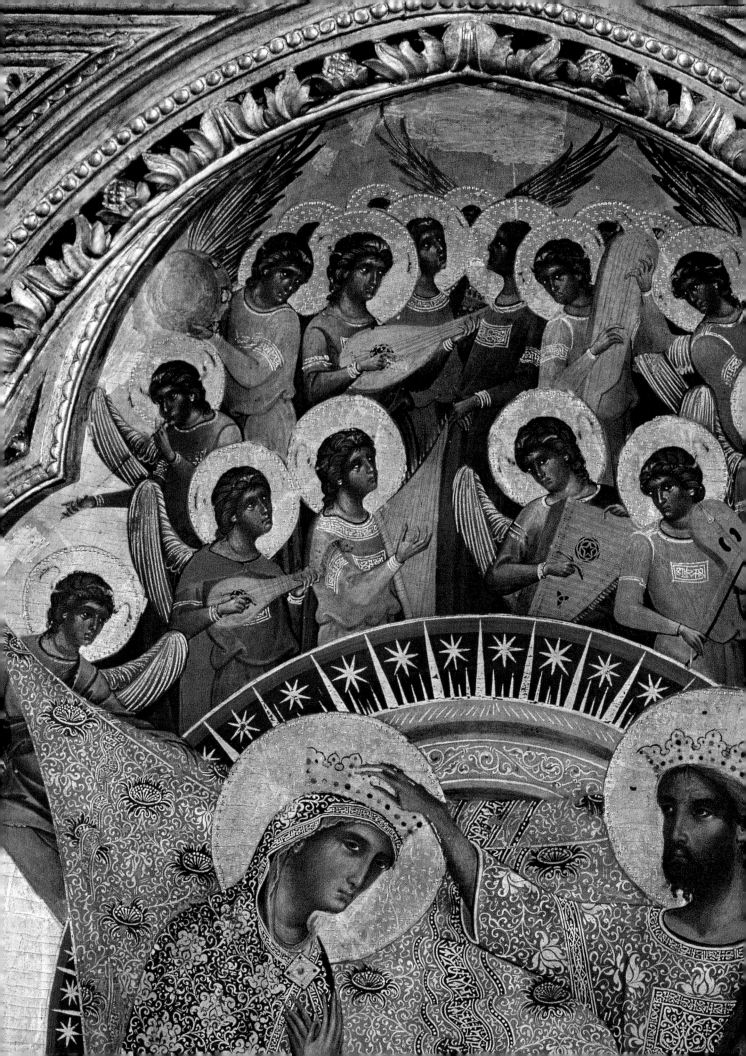

The Gothic City

Architects and Sculptors. Over the centuries, the seafaring Republic of Venice developed into a great power, but its attention was still focused chiefly on the trade routes to the East. It was not until the middle of the fourteenth century that it began to turn its attention toward the mainland. Fourteenth-century art in Venice, in short, started to move at a slow pace, while still looking backward. Or it chose, among the innovations arriving from outside, only those that were in some way in tune with its jealous isolation. The first overtures to contemporary Italian culture made by Venetian art were in the fields of architecture and sculpture. In fact the appearance of the main churches of the fourteenth century (the church of Santa Maria Gloriosa dei Frari, begun around 1330, was followed by that of Santi Giovanni e Paolo in 1333) seems dependent on their Franciscan and Dominican origins, i.e. the fact that they were built by monastic orders that had for some time been linked with the Gothic culture of Northern Europe. Typical of both churches, however, was their resistance to Gothic "verticality" and their preference for the broad naves and aisles of the basilican plan, flooded with light from lunettes, rose windows and stained glass.

PAOLO VENEZIANO, Santa Chiara Polyptych, Gallerie dell'Accademia, Venice. Detail.

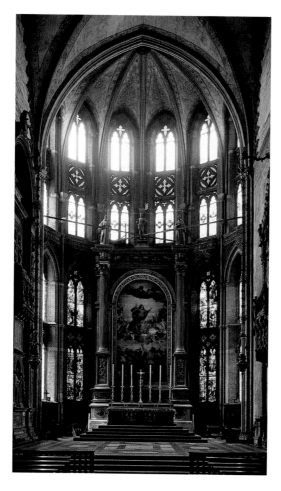

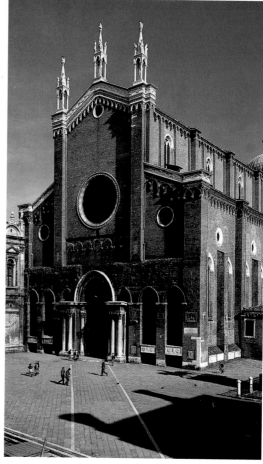

Apse, Church of the Frari, Venice.

Church of Santi Giovanni and Paolo, Venice.

As a consequence, unlike in northern Gothic works of architecture, the internal space of the Venetian Gothic churches is more dependent on optical effects than on structure. The broad and luminous naves are interrupted by the characteristic wooden tie beams that were used to link the vertical elements. The apses – especially in the Frari – act as settings for the play of light from the stained-glass windows, the work of artists from Murano. When the initiative passed from the religious orders to the state, Venetian architecture was enriched by a quite different sort of monument: the Doge's Palace. Founded as a castle at the time of the first St. Mark's, during the ninth century, it had then been modified and enlarged several times until the decision was taken in 1340 to rebuild it totally, so that it would be able to house the immense Sala del Maggior Consiglio which occupies the whole of the front onto the wharf. The new fourteenth-century palace was undoubtedly designed by a single architect, whose plans were faithfully followed by his successors. Tradition has it that this was the Filippo Calendario recorded in the chronicles in 1351. Certainly, the presence of just one creative artist is demonstrated not only by his reputation as the first great sculptor to work in the palace, but also by the formal unity and stylistic coherence of the building, whose front onto the wharf and first seven arches on the Piazzetta must have been finished before 1400.

Notwithstanding its originality, the Doge's Palace belongs to the Venetian architectural tradition, from which it stands out solely for the poetic heights it reaches. In fact, as far back as the eleventh century in Venice we find palaces with open galleries supported by the columns of the portico on the ground floor: in these the static distribution of solids and voids was inverted, so that a picturesque optical illusion was created by the complex play of light and shade. In the Doge's Palace, however, this clever idea became

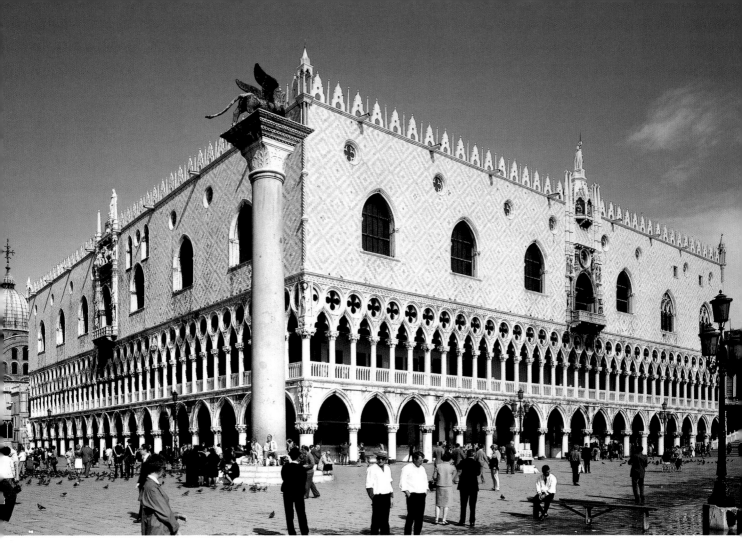

the essential figurative element, with the majestic facing of white, gray and pink panels of marble rising like a magical tapestry of color and reflecting the light, which dematerializes it into a wall barely contained by its corded edges, which in turn seem to be woven into the atmosphere.

The new Doge's Palace was also given an extraordinary sculptural decoration, the work of the same Filippo Calendario. The sculptures he carved are the ones set at the corners of the palace, principally the *Drunken Noah* and the *Adam and Eve*. They are works in which a subtle and taut graphic quality predominates and in which the realistic forms are so moving in their penetration of the human soul that it was long thought they must have been executed a century later. Yet the documentary evidence dates them to the period of Calendario's activity, and it is likely that he was also responsible for the design of the majority of the capitals of the ground-floor portico. In some, in fact – for instance the

one representing *Amorous Life* – a keen sense of everyday existence is blended with exquisite elaborations of Gothic decorative flourishes to create a model that was to give rise to the subsequent "Flamboyant" period, destined to last in Venice for another century.

The closing decades of the fourteenth century saw the arrival in Venice of two great sculptors who had received their training elsewhere, the Dalle Masegne brothers. They would carve many of the sculptural decorations of St. Mark's as well as the facades of the Doge's Palace. Pier Paolo Dalle Masegne (doc. 1383-1403) was responsible for the palace's magnificent "balcony" overlooking the wharf, finished in 1404, in which the artist showed that he was able to adapt to Venetian decorative forms, setting aside other aspects of his basically Tuscan style.

The same cannot be said of Jacobello Dalle Masegne (doc. 1383-1409), author of the *Iconostasis of St. Mark* in which a marked linear accent

Doge's Palace, Venice.

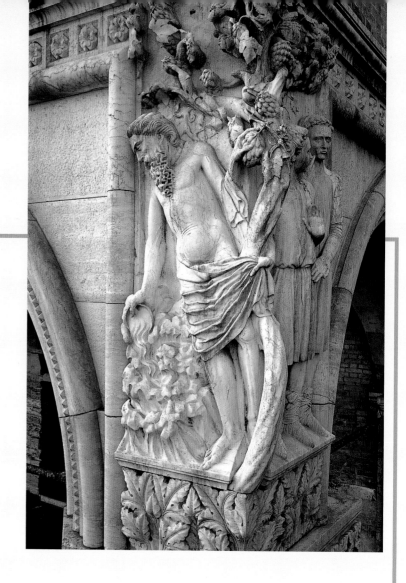

FILIPPO CALENDARIO

When, on December 29, 1340, the Signoria, headed by Doge Bartolomeo Gradenigo, took the decision to build the new Sala del Maggior Consiglio in the Doge's Palace, the planning and execution of the massive work of renovating the palace were entrusted to Filippo Calendario. He also carved the sculptures on the capitals of the arches in the portico on the ground floor underneath the hall and the remaining sculptural decoration of the facades. The work was completed around 1350.

Filippo Calendario is unquestionably the most enigmatic figure in the history of Venetian art: nothing is known of his origins and the only thing we can be certain about in his life is the way that it ended. Embroiled in the plot hatched by Doge Marin Faliero, he was beheaded between the two columns of the Piazzetta in 1355. And yet several fourteenth-century chronicles record that he was much "loved and honored" by the Signoria and that there was no master more ingenious than he, capable also of giving advice "in the matter of erecting palaces and towers and noble works".

Given the silence of the sources, it is left to his works to speak for him: the immense bulk of the Sala del Maggior Consiglio, the sculptures that decorate many of the capitals of the columns in the palace's portico, and above all the splendid marble groups on the two facades overlooking the Piazzetta and the Molo. On the southwest corner in the direction of the Molo is set the group depicting *Original Sin*. On the southeast corner is the group of the *Drunkenness of Noah*. Above the former, facing the two columns between which criminals were executed, stands the figure of the *Archangel Michael*, while the *Allegory of Venice as Justice* is set inside one of the quatrefoils on the front that faces onto the Piazzetta.

In these splendid works Filippo makes clear the breadth of his culture, which is rooted in the Veneto-Byzantine tradition but comprises elements of the more modern Gothic style. This is seen in the effort made to probe the psychology of the figures, the adherence to nature in the representation of the human body, and the attention paid to the language of gesture. All is in evident harmony with the style of the city's greatest contemporary painter, Paolo Veneziano, who executed the *Pala feriale* for the high altar of St. Mark's in 1345.

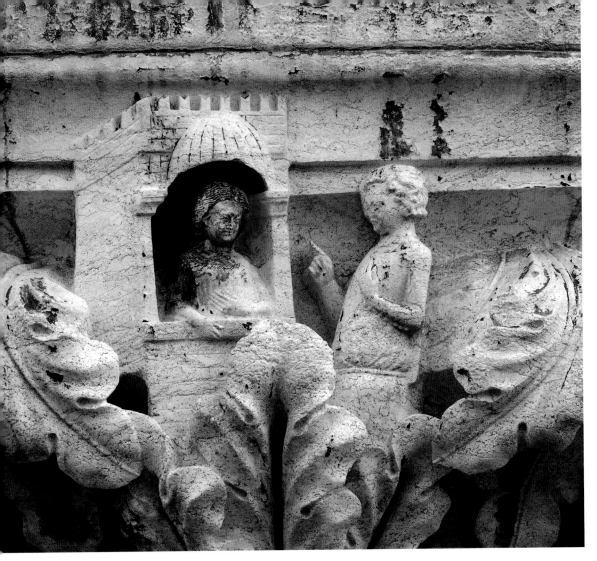

Capital of the
Amorous Life,
Doge's Palace,
Venice.

facing page
FILIPPO CALENDARIO,
Drunkenness of
Noah, Doge's Palace,
Venice.

brings out the dynamism of the forms. The vigorous and realistic typology of the apostles shows that – unlike his brother – Jacobello must have had close links with the Lombard style of sculpture that was being developed in those years through the work on Milan Cathedral.

Painters. In a period in which the sculptors and architects of Venice, either native-born or from elsewhere, began to open themselves to influences from the mainland, painters proved less willing to emerge from their isolation. Thus the unknown author of the frescoes in the church of San Zan Degolà repeated figurative schemes derived from the Byzantine world, producing effects of fixity worthy of a Coptic icon. Only the anonymous artist who painted the images that decorate the casket of the Blessed Giuliana di Collalto, now in the Museo Correr in Venice, appears to have been influenced by

developments in Bolognese painting, but with evident uncertainties and difficulties.

The painter who broke out of this isolation in the middle of the fourteenth century, clearing the way for significant innovations, was Paolo Veneziano (Venice, 1290/95-1358/62), the first outstanding personality in the history of Venetian painting. Paolo was the favorite artist of the great monastic orders, working intensely for the Franciscans in Venice and Vicenza, for the Dominicans in the Marche and at Ragusa (modern-day Dubrovnik) and for the Augustinians in Bologna. This is an important detail, since these monastic orders were the means by which Gothic art came to Venice, in the architecture of their churches. And the whole of Paolo's stylistic development turned on an effort to move away from the tired formulas of the Byzantine pictorial tradition and renew the local school of painting in a modern, i.e. Gothic,

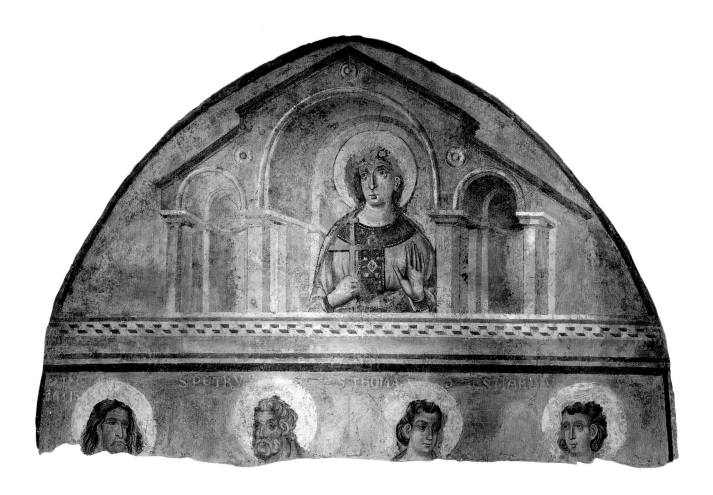

sion of Christ's body in the mandorla that appears in the central scene: with its slight movement and its location just a little off the geometric center of the picture, it succeeds in shifting the entire composition out of alignment, creating a sense of dynamism that is foreign to the Byzantine world. And so an iconographic motif that had been repeated endless times in Eastern art came to take on a breath of novelty in Paolo's work, an effect to which the interlocking of the angels' gazes, the barely suggested movement of the apostles, the minute decoration of the carpet on which the Virgin's body lies, and the absence of the customary highlights on the cloak make a notable contribution.

The *Santa Chiara Polyptych*, now in the Gallerie dell'Accademia in Venice, dates from shortly afterward. Here Paolo's attempt to break away from Oriental models is evident in the lively narrative that characterizes the scenes from the lives of Christ and St. Francis; the rich Gothic deco-

key. This is clearly apparent from the few works that can be reliably attributed to him and dated with certainty. The oldest to have come down to us is the *Dormitio Virginis* in the Museo Civico of Vicenza, executed in 1333, which already contains a number of elements that confirm the Gothicizing tendency of the painter. Though still stately, the figures of the saints at the sides display an imposing plasticism, producing a "real" sense of depth. Equally realistic is the tor-

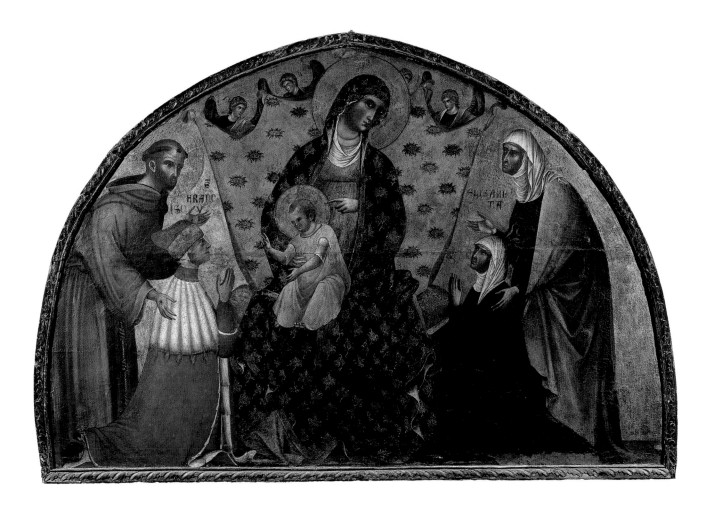

ration of the mantles of Christ and the Virgin in the central panel is splendid.

The same process can be discerned in other important works, such as the votive lunette representing *Doge Francesco Dandolo* in the church of the Frari, dating from 1339, where the realistic figures of the doge and his wife are linked to those of the saints and the Virgin in the intense dynamism of the gestures and glances. It is seen to an even greater extent in the *Pala Feriale,* or Weekday Altarpiece, of St. Mark's, painted by Paolo with the collaboration of his sons Luca and Giovanni and delivered in 1345. Here the lively narrative of the small scenes on the lower level is something totally new for the Venetian world. But even the figures of the saints and the Virgin that appear on the upper level, by their nature more closely linked to the Eastern pictorial tradition, reveal the painter's desire to break away from traditional formulas. This is evident in the attitude of the figures, no longer represented in a frontal position but almost at three-quarters and in the

act of turning toward the central figure of Christ. Their humanity is made clear by the diverse and well-characterized faces, and by the almost colloquial vitality of the gestures and the vivid color.

Paolo's last reliably attributed work – the *Coronation of the Virgin* in the Frick Collection in New York, painted in 1358 in collaboration with his son Giovanni – is a manifesto of the new Venetian Gothic painting. It is exceptional for the vividness of the forms, the realism of the figures and the miniaturistic depiction of the elements of the throne and decorations.

Subsequent Venetian painters proceeded down the road marked out by Paolo. Among them were Stefano Veneziano (doc. 1369-1381), whose delicate *Madonna and Child* in the Museo Correr is an elegant continuation of Paolo's manner, and above all Lorenzo Veneziano (Venice, doc. 1356-1379), who was able to further refine Paolo's precious coloring, giving it a more delicate luster set against a gold ground. In his early works – such as the *Lion Polyptych,*

PAOLO VENEZIANO, Votive Lunette of Doge Francesco Dandolo, Church of the Frari, Venice.

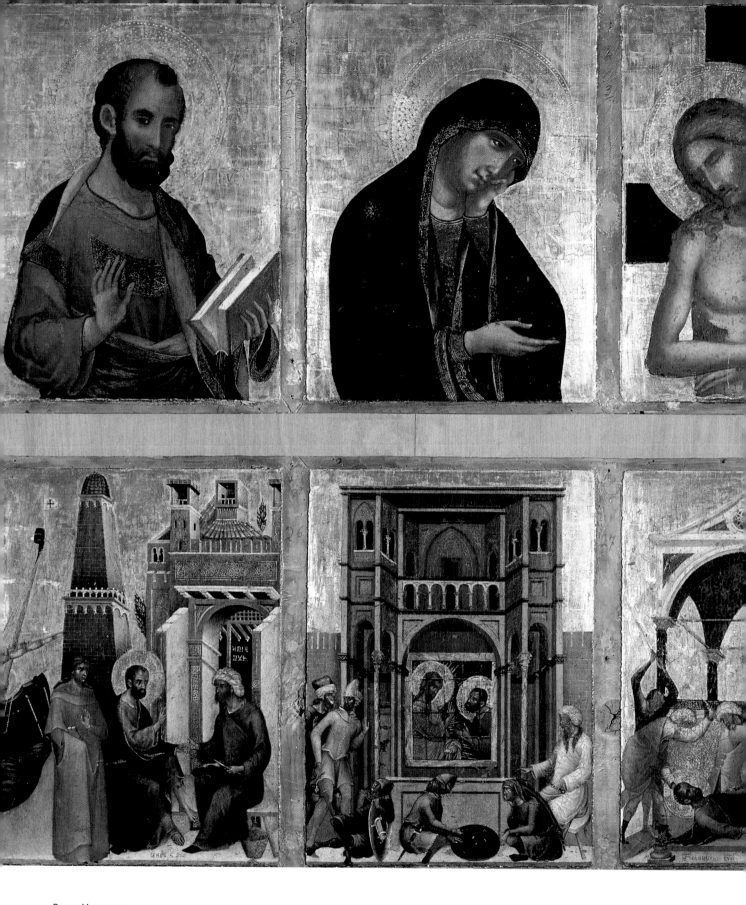

PAOLO VENEZIANO,
Pala Feriale, Basilica
of St. Mark, Venice.

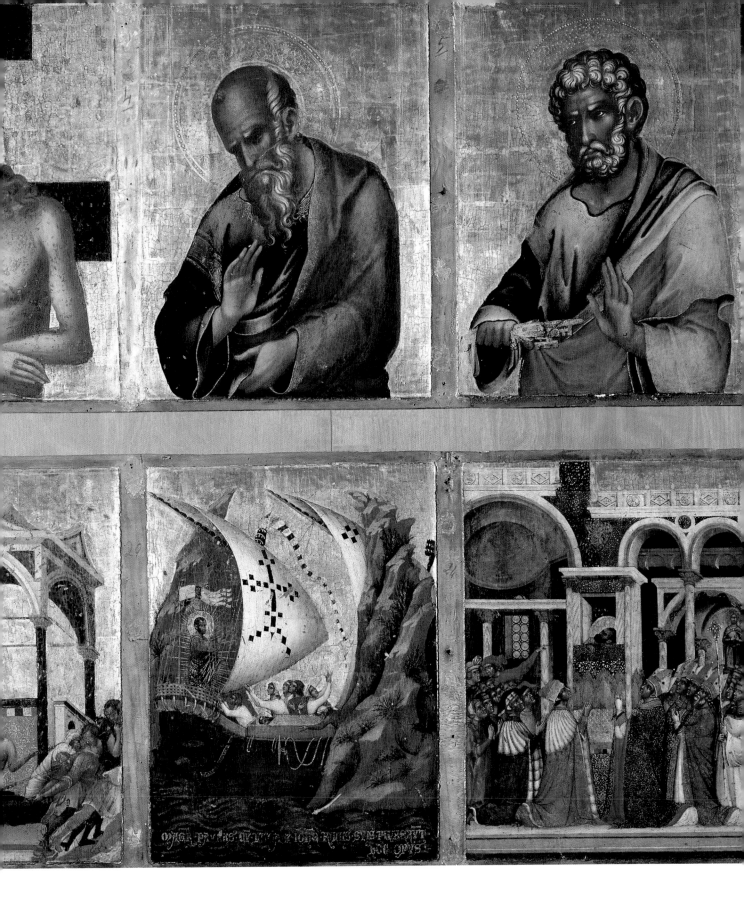

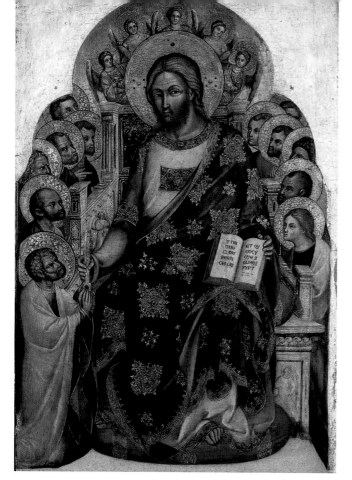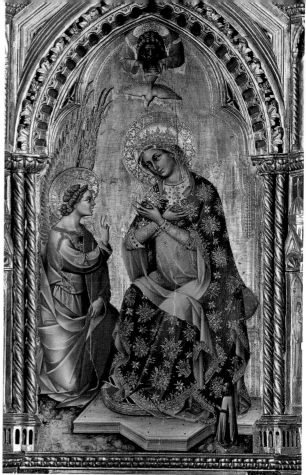

above left
LORENZO VENEZIANO,
Jesus Handing Over
the Keys to St. Peter,
Museo Correr,
Venice.

above right
LORENZO VENEZIANO,
Lion Polyptych,
Gallerie
dell'Accademia,
Venice. Detail.

facing page
STEFANO VENEZIANO,
Madonna and Child,
Museo Correr,
Venice.

following pages
LORENZO VENEZIANO,
Annunciation with
Saints, Gallerie
dell'Accademia,
Venice.

painted between 1357 and 1358 and now in the Gallerie dell'Accademia – Lorenzo already appears to take a more realistic approach than Paolo. Over time the spirituality of his figures – as is apparent, for example, in the polyptych in the Museo Correr whose central panel represents *Jesus Handing Over the Keys to St. Peter* (1369) – grew more delicate and human, probably thanks to his familiarity with the works of Tommaso da Modena, active in nearby Treviso.

This heralded a singular "cosmopolitan" evolution in the late works of Lorenzo, who may have come into contact not only with the style of painting in Bologna (he worked there in 1368 and the effect of this is clearly evident in the *Annunciation* in the Gallerie dell'Accademia, dating from 1371), but also with the Gothic culture of Northern Europe. The sources were probably Bohemian or Rhenish, the same as can be found in the work of other artists who are still mostly unknown, such as Niccolò di Pietro (doc. 1394-1430), whose signed *Madonna* of 1394, in the Gallerie dell'Accademia, recalls the Bohemian style.

It is certain that these artists performed an important function in Venetian culture toward the end of the century, in particular Niccolò, who combined elements of the Northern European style with the unaffected mode of expression of the Bolognese. Thus we find, in late fourteenth-century Venice, a vein of greater vitality that liberated the vocabulary of painters from the glittering stylizations of the Byzantine manner, in parallel with the flowering of Gothic sculpture.

Also active in Venice in those years was the most famous Paduan painter of the time, Guariento (first recorded 1338 - died before 1370). Between 1366 and 1368 he was at work on the imposing fresco of the *Coronation of the Virgin* in the Sala del Maggior Consiglio in the Doge's Palace. Guariento was a remarkable artist, with close ties to the Gothic world of Northern Italy, and the great fresco – badly damaged in the fire of 1577, its surviving parts have only recently been restored – is rendered astoundingly decorative by the gold and silver ornamentation of the clothing of its many figures, its vivid chromatic effects and the animation that extends to the whole of the picture.

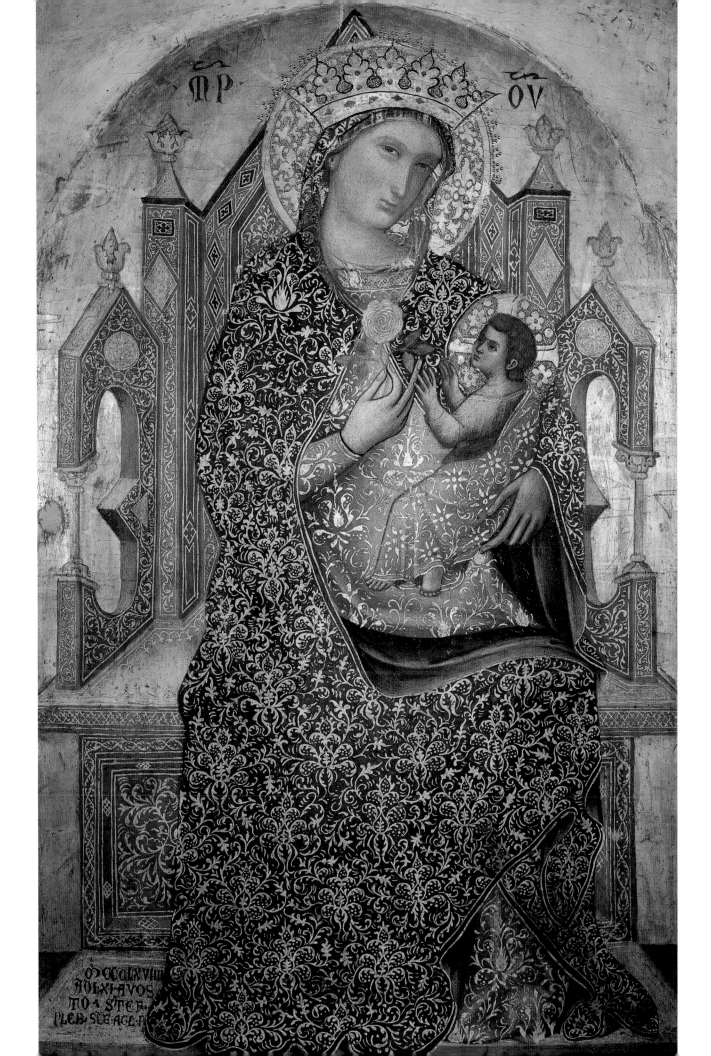

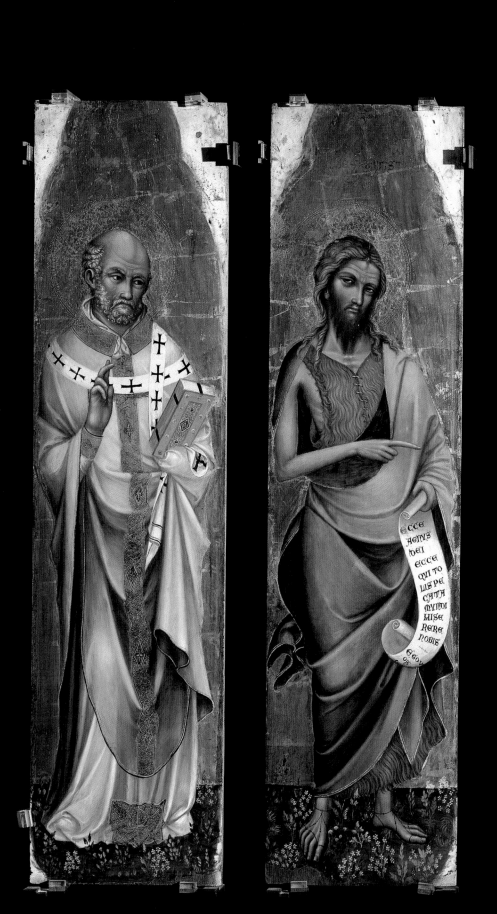
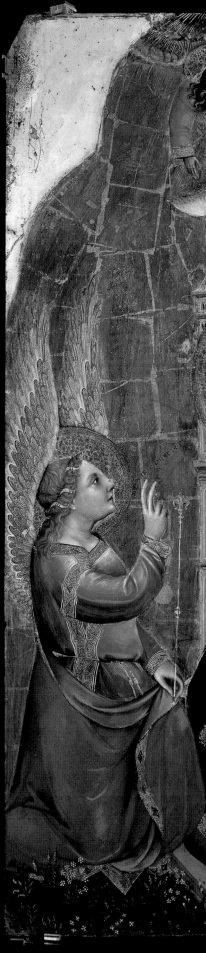

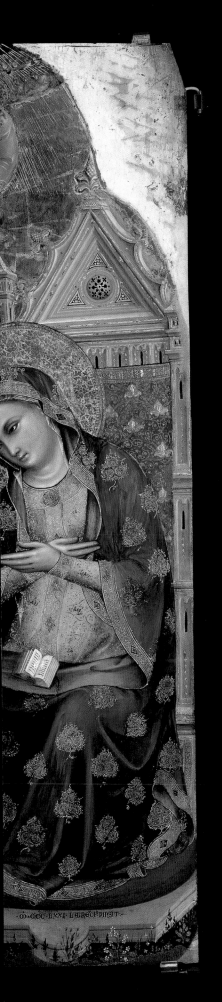
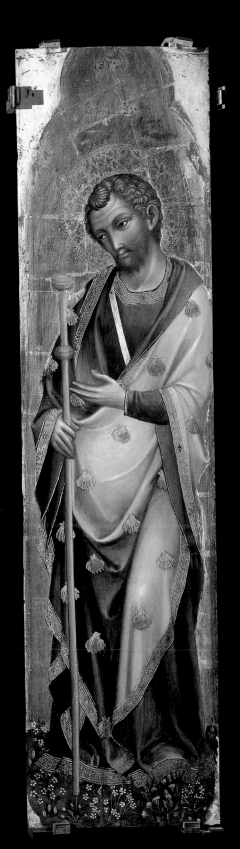
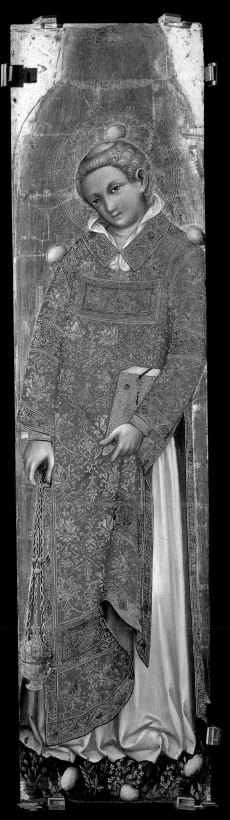

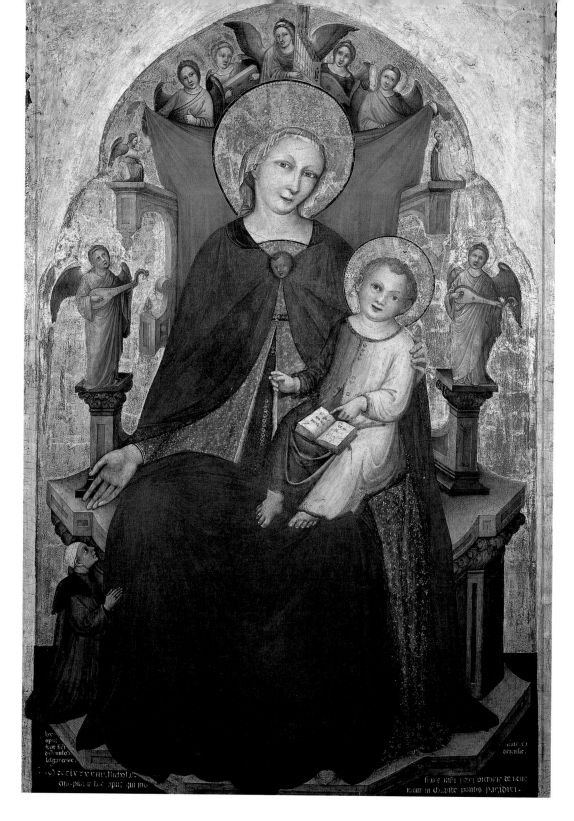

NICCOLÒ DI PIETRO,
Madonna and Child,
Gallerie
dell'Accademia,
Venice.

facing page
JACOBELLO DEL FIORE,
Justice (St. Michael),
Gallerie
dell'Accademia,
Venice. Detail.

The Flamboyant Gothic in Venice.

The course taken by Venetian art in the first half of the fifteenth century should be connected with the language of International Gothic, taken to its most advanced stage by Gentile da Fabriano and Pisanello in the first few decades with the works they executed in the Doge's Palace, which were subsequently lost. The term "Flamboyant" is particularly well suited to the Venetian architecture and sculpture of this period, underlining the decorative tendency that found expression in the sophisticated linearity of late Gothic. The major artistic undertakings of this time were still in St. Mark's and the Doge's Palace, whose external decoration was completed by several workshops of stonecutters.

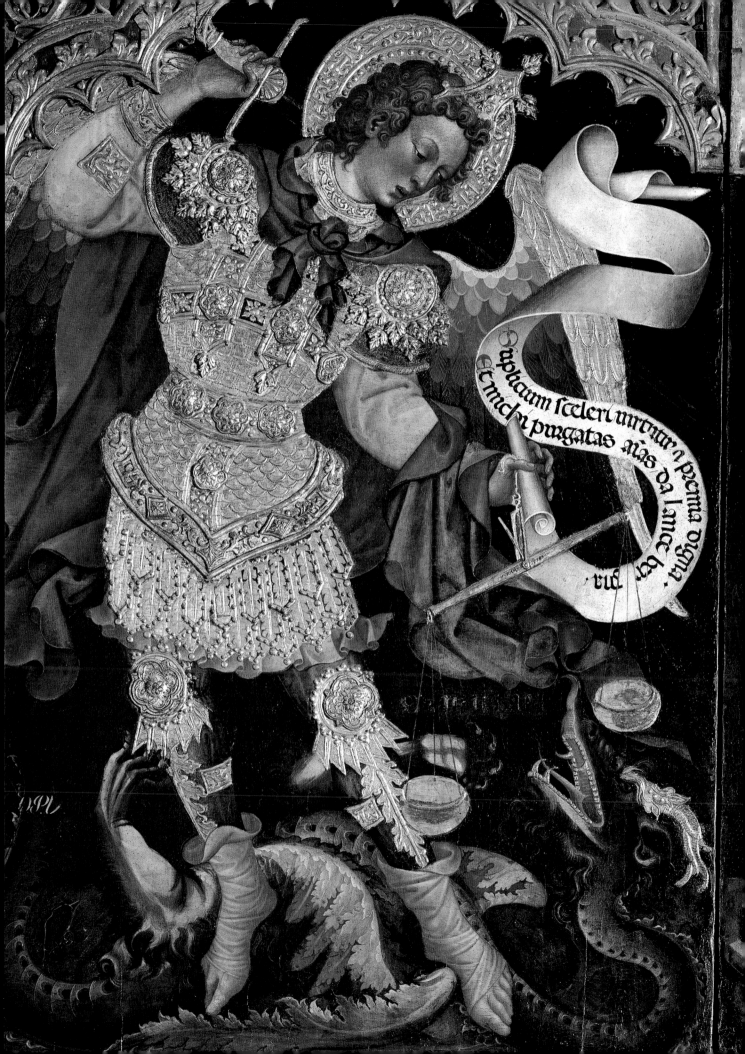

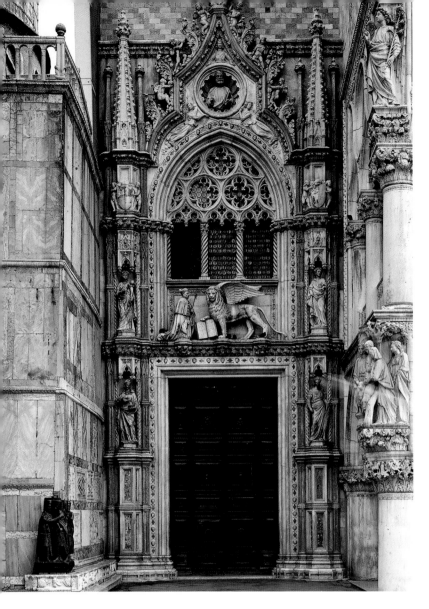

BARTOLOMEO BON,
Porta della Carta,
Doge's Palace,
Venice.

facing page
Ca' d'Oro, Venice.

Most of the sculptors at work in St. Mark's were Tuscan, engaged on the decoration of the upper coping with rampant foliage alternating with figures of saints in the moldings of the arches. The group was headed by Nicolò Lamberti (died in 1451), active chiefly on the north facade, and his son Pietro, who carved many of the sculptures.

Once they had arrived in Venice, however, these artists seemed to succumb to the charms of a tradition poised between the Byzantine and the Gothic in which the taste for elegant exteriors prevailed over any concern for volume. This tendency, clearly an aspect of Flamboyant Gothic, was also followed by the dominant Venetian figure in the field of architecture and sculpture, Bartolomeo Bon (active 1441-1464). Modern research has assigned to him, in addition to the

Porta della Carta of the Doge's Palace (1441), the plan of another masterpiece of the Flamboyant Gothic, the Ca' d'Oro, which faces like an embroidered curtain onto the waters of the Grand Canal. Bon was probably also responsible for the capital representing the *Judgment of Solomon* in the Doge's Palace, regarded as another masterpiece for its sensitive expression of feelings, though couched in flowing and musical rhythms.

Unfortunately a great deal of early fifteenth-century painting in Venice was lost in the fire of 1577 that destroyed the frescoes of Gentile da Fabriano and Pisanello in the Doge's Palace, along with canvases added by Bellini and the masters of the early sixteenth century. But the example set by these great "international" artists was followed by some notable local painters. In fact the lesson of Gentile was essential to Jacobello del Fiore (Venice *c.* 1370-1439), the best known of the Flamboyant Gothic painters. Perhaps his finest work is the *Scenes from the Life of St. Lucy* at Fermo (*c.* 1410), executed in an exquisite courtly style. His late works, such as the *Justice* painted in 1421 for the Doge's Palace and the *Madonna della Misericordia* of 1436 in the Gallerie dell'Accademia, show a regression, in which he wavers between echoes of Byzantine traditionalism and the forms of the late Gothic. Michele Giambono, active between 1420 and 1462, was a much more lively personality. His style reached the peak of its refinement in the *St. Chrysogonus* in the church of San Trovaso and the *Coronation of the Virgin* in the Gallerie dell'Accademia, where a color that already offered a presentiment of naturalism was imbued with a gilded preciosity.

With the work of these painters, now seriously out of step with developments in Tuscan art, the Flamboyant period of the Venetian art of the fifteenth century must be considered at a close. A wind of innovation was blowing from Florence, where the ferments of the artistic culture of the Renaissance had already been at work for some time.

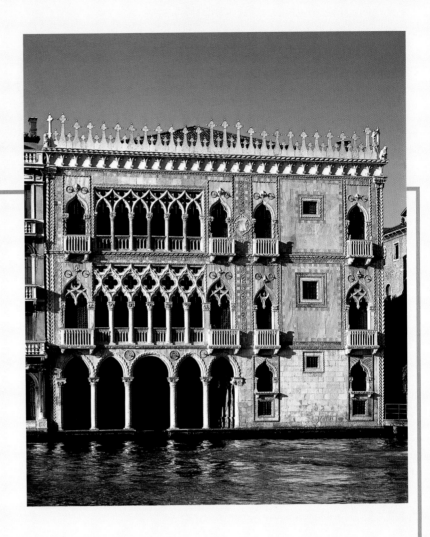

THE CA' D'ORO

Far from having been the residence of a mysterious family called Doro, as was claimed by a nineteenth-century historian, this splendid building – certainly the finest example of the Venetian Gothic in the field of private civil architecture – owes its name, the "House of Gold", to the fact that the parts in relief on its facade were gilded in 1431 by the French painter Jean Charlier, called Zuane de Franza by the Venetians.

The palace was built between 1421-1422 and 1437-1440 for the procurator of St. Mark, Marino Contarini. Two groups of masons of different origin and culture were employed on its construction: at the outset the workshop of the Lombard Matteo Raverti, who received his training at the cathedral in Milan; and then, from 1425, the workshop of the Venetians Giovanni and Bartolomeo Bon. Yet it is perfectly unitary and homogeneous in its appearance. This is probably due to the vigilance of the client, who personally supervised the work of the two groups. The account book kept by Contarini, which has been preserved, makes it possible for us to assign the individual elements to each of the workshops with certainty. Raverti executed the sumptuous portal on the *calle*, the windows above the portico of the internal courtyard and the brightly-lit arcade on the first *piano nobile* of the facade, which echoes that of the Doge's Palace. The Bon were responsible for the four-light window inside the portico that provides access to the palace from the Grand Canal, the decoration of the single-light windows, the distribution of the spaces inside the building – compromised over the course of the heavy-handed restoration to which the building was subjected by Giambattista Meduna in the nineteenth century – and the wonderful well curb in red Verona marble that is in the courtyard, carved by Bartolomeo himself between 1427 and 1428. The splendid six-light window on the second *piano nobile* is the fruit of a collaboration between the two workshops, where it seems that Raverti only executed the extremely refined sculptural decoration of the capitals.

At the end of the nineteenth century the palace was acquired by Baron Giorgio Franchetti, an enthusiastic collector who used it to house his many works of art, leaving them to the State on his death in 1922. The new museum, named after the generous donor, was opened to the public in 1927.

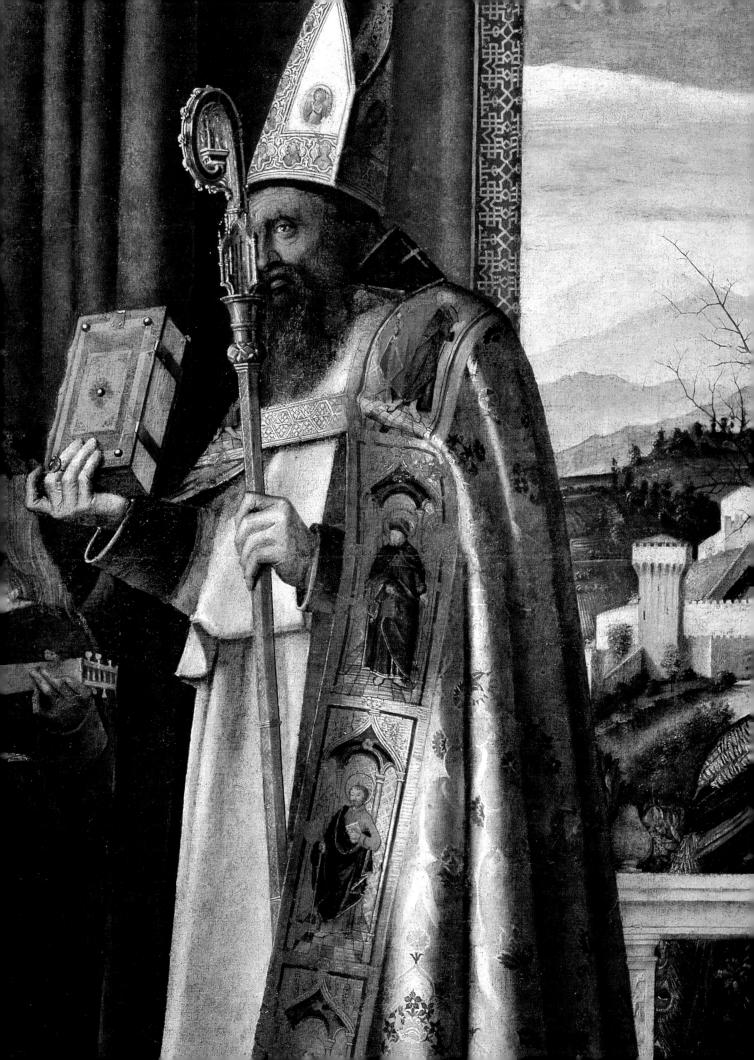

The Early Renaissance

Between Tradition and Innovation. The Renaissance got off to a slow start in the Veneto region, partly as a consequence of the persistence of the Flamboyant Gothic figurative culture following the visits to Venice of Gentile da Fabriano and Pisanello. In that highly conservative climate new forms struggled to take root, though signs of innovation began to emerge in a timid naturalism that was based on the delicate handling of color. Renaissance motifs did in fact penetrate the Veneto. This was not so much a result of the fleeting passage of Florentine "meteors" as it was due to a slow assimilation of these motifs by artists whose background lay in the dying currents of Gothic art and who had difficulty in showing their awareness of the cultural process that was laying the foundations of a new language in Tuscany.

GIOVANNI BELLINI, Altar Frontal of Doge Barbarigo, Church of San Pietro Martire, Murano. Detail.

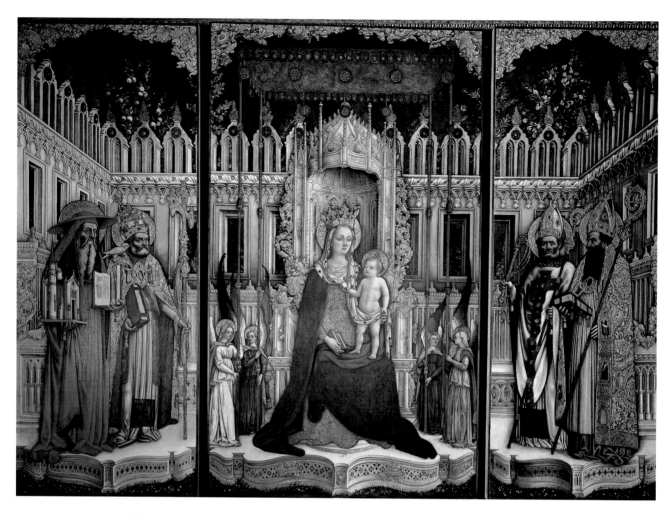

ANTONIO VIVARINI
and GIOVANNI
D'ALEMAGNA,
Madonna Enthroned,
Gallerie
dell'Accademia,
Venice.

ANDREA DEL
CASTAGNO, St. Mark
and St. Luke, chapel
of San Tarasio,
Church of San
Zaccaria, Venice.

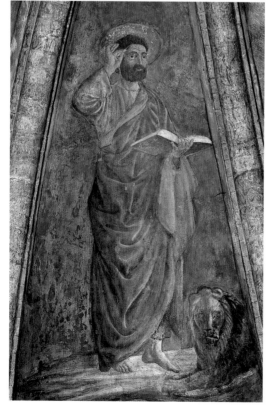

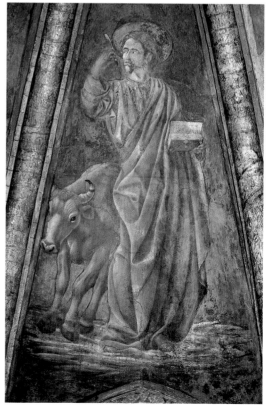

Proof of this can be found in the work of one of the most gifted of these artists, Jacopo Bellini (Venice, 1396?-1470?). A typical figure of transition, the father of Gentile and Giovanni was already active around 1430. His first experience was certainly within the sphere of International Gothic. Indeed, having probably followed Gentile da Fabriano back to Florence, he displayed a Renaissance vision in his famous *Books of Drawings* in the Louvre and the British Museum. These two collections composed between 1430 and 1450 can be taken as an example of Jacopo's transition from Gothic culture to that of the Renaissance. In them, the study of perspective is always subordinate to a still symbolic conception of nature, reminiscent of certain conventions assimilated from Gentile and Pisanello. So we doubt that Jacopo's real position was only that of an intermediary who introduced Renaissance forms to Venice. As many of his paintings have been lost, our picture of his work is much reduced, confined largely to numerous *Madonnas* that reveal a subtly lyrical vein, a somewhat anemic coloring and an old-fashioned preciosity, at times reminiscent of Byzantine frontal patterns. After 1450, however, the *Descent of Christ into Limbo* in the Museo Civico of Padua shows an effort to update his style, under the influence of the new art which had now arrived from Tuscany and of which his son-in-law Mantegna and son Giovanni were to be the main exponents in the Veneto.

Antonio Vivarini (Venice, *c.* 1415 to 1476/84), founder of the flourishing Murano workshop, found himself in much the same situation around 1440. Even more than Jacopo, he represented the spearhead of Venetian art in the transition from the first to the second half of the fifteenth century. Characteristic of his early period are certain Madonnas such as that of the Oratorians in Padua (*c.* 1440 to 1450). These are rosy in color and veiled with a human lyricism that achieves a delicate compromise between Tuscanizing forms in

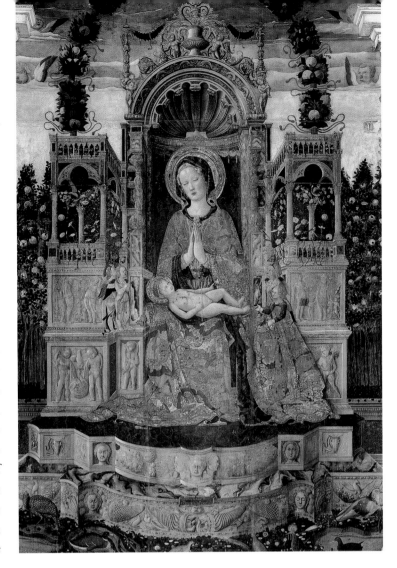

the manner of Domenico Veneziano and the Flamboyant decoration of Gothic thrones and gardens in the courtly tradition. Later, when his brother-in-law Giovanni d'Alemagna began to collaborate on the architectural parts, Antonio withdrew into a coloring that resembled glass paste, while his line stiffened in an effort to create plastic effects, as in the large *Madonna Enthroned* in the Gallerie dell'Accademia and in the *San Tarasio Altarpiece* in San Zaccaria. This was the result of a certain modernizing tendency, now oriented toward Andrea del Castagno, who was present in Venice starting from 1442, when he frescoed the bays and archivolt of that same chapel of San Tarasio and completed the mosaic decoration of the ceiling of the chapel of the Mascoli in St. Mark's, begun by Giambono.

An exceptional role in the process of disengagement from Gothic culture was played by Antonio da Negroponte, author of the splendid

ANTONIO DA NEGROPONTE, Madonna, Church of San Francesco della Vigna, Venice.

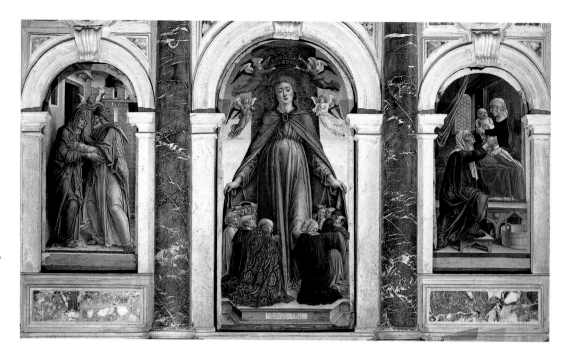

BARTOLOMEO VIVARINI, Santa Maria Formosa Polyptych, Church of Santa Maria Formosa, Venice, and, facing page, detail.

DONATELLO, St. John the Baptist, Church of the Frari, Venice.

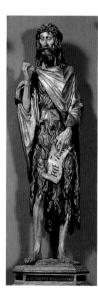

Madonna in the church of San Francesco della Vigna in the second half of the fifteenth century. This work is still Gothic in its decorative repertoire but avowedly modern in the gently humanized features of the figures.

Padua, the Tuscans and Francesco Squarcione.

It was not Venice but nearby Padua that came to assume the role, before the middle of the fifteenth century, of an outpost of the Tuscan Renaissance in the Veneto.

In 1424 Lorenzo Ghiberti passed through Padua. The year after that, Paolo Uccello stopped in the city on his way to Venice. Then it was the turn of Filippo Lippi, who between 1432 and 1437 painted the lost frescoes in the chapel of the Podestà and the Basilica of Il Santo. In 1444 Donatello arrived in the city, where he would remain for ten years. In 1438 he had sent a wooden sculpture of *St. John the Baptist* to Venice, destined for the altar of the chapel of the Florentine merchants in the Frari. This work was to prove of exceptional importance in the subsequent development of Venetian art. The bearded and shaggy saint is dressed in a short tunic of skins that accentuates the gauntness of his figure; the piercing gaze of the eyes in his tormented face is unforgettable. The expressive force of this

work, harrowing in its realism, made a great impression on the generation of Venetian artists active around the middle of the century. The Paduan movement of "renewal" centering on the Tuscans – and Donatello in particular – attracted the attention of the principal local artists. Among them, Francesco Squarcione (Padua, 1397-1468) was certainly the most important representative of an early humanism in the field of the figurative arts: craftsman, dealer in prints, entrepreneur of pictorial decorations, teacher of painters and a painter in his own right (the *De Lazara Polyptych* in the Museo Civico of Padua), he was in fact at the heart of the main artistic undertakings in Padua at the time. The most important artists of the next generation were trained in his workshop: Cosmè Tura, Carlo and Vittore Crivelli, Andrea Mantegna, Giovanni and Gentile Bellini.

Andrea Mantegna frequented Venice at an early age. It was there that he married the daughter of Jacopo Bellini, perhaps in 1454, returning to the city the following year. There are valid reasons to suppose that he spent a great deal of time in Venice in those years, and it is only natural that he should have exercised a decisive influence on local artists, just as he had in Padua. This was particularly true of the painters of the Murano school who, owing to

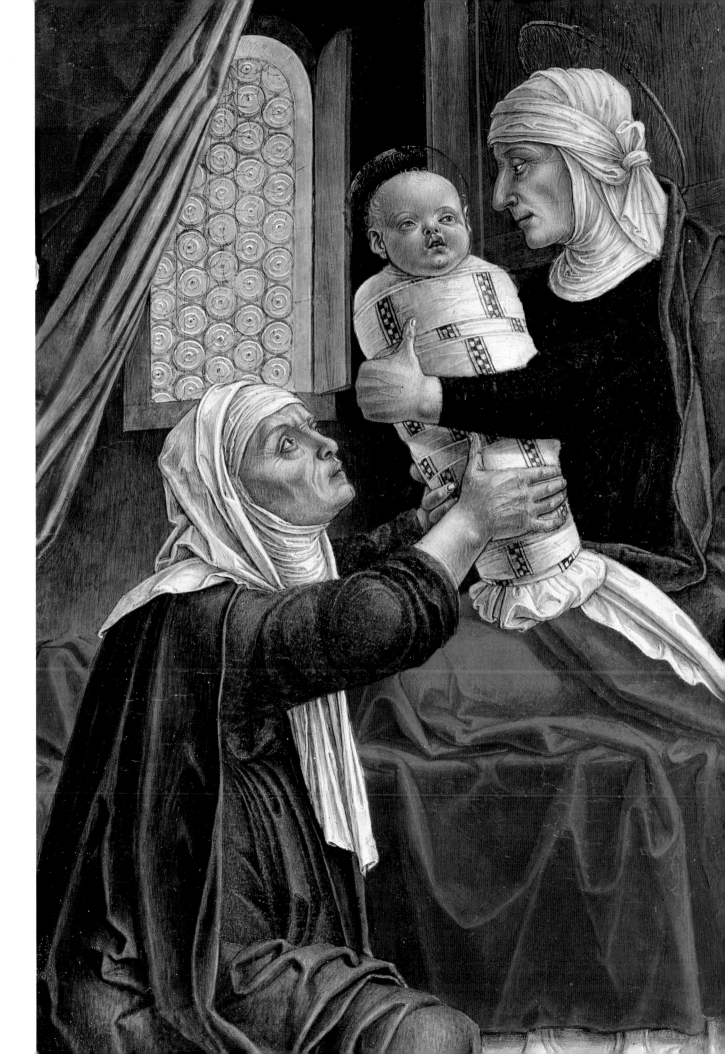

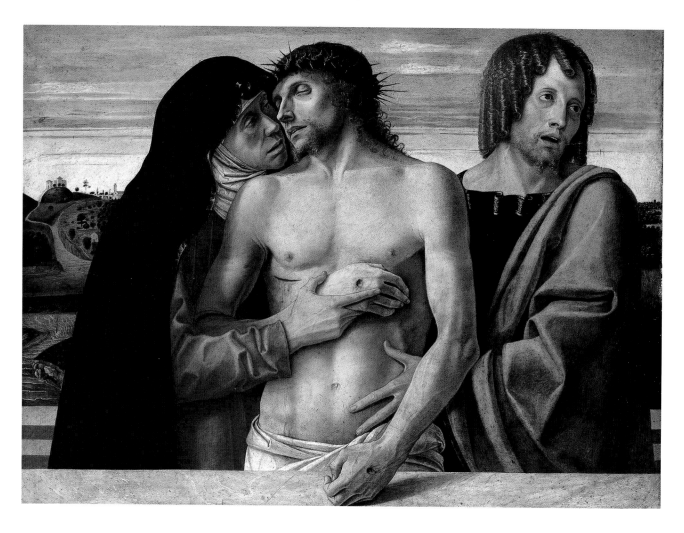

their contacts with followers of Squarcione, were able to understand him better than could the last followers of the "backward-looking" trends. Among them, Antonio Vivarini's brother Bartolomeo (Venice, 1430-1499) was the one who came closest to him around 1460, in works such as the *Madonnas* in the Galleria Nazionale di Capodimonte in Naples and the Museo Correr in Venice, in which the brilliant red tints gleam against a traditional gold ground. But in the following decade, with the *Santa Maria Formosa Polyptych*, and then in his prolific subsequent output, Bartolomeo fell back on an ever more mechanical repetition of vitrified forms, ostentatiously reflecting light from their multi-faceted structures.

Giovanni Bellini.

The great merit of Giovanni Bellini (Venice, *c.* 1430-1516) is that he went beyond the confines of the Venetian milieu, which was still steeped in the last flowering of the Flamboyant Gothic style, and turned to Padua. It was here that he began to shape a style of his own, one that, in spite of being renewed several times over sixty-five years of activity, always remained coherent and rich in poetry.

For a Venetian who had grown up amidst the mosaics of St. Mark's and his father Jacopo's timid transpositions of the Tuscan school, the great figures of Donatello and Mantegna whom he encountered in Padua must have appeared almost superhuman. Learning from them was a real revolution, which implied a rejection of the forms to which he was accustomed. So Giovanni, even though he had the eager temperament of an experimenter, had to make considerable efforts to bring about a gradual renewal of his style. At the outset, it would not be easy to distinguish one of his Madonnas from those produced by the painters of the Murano school,

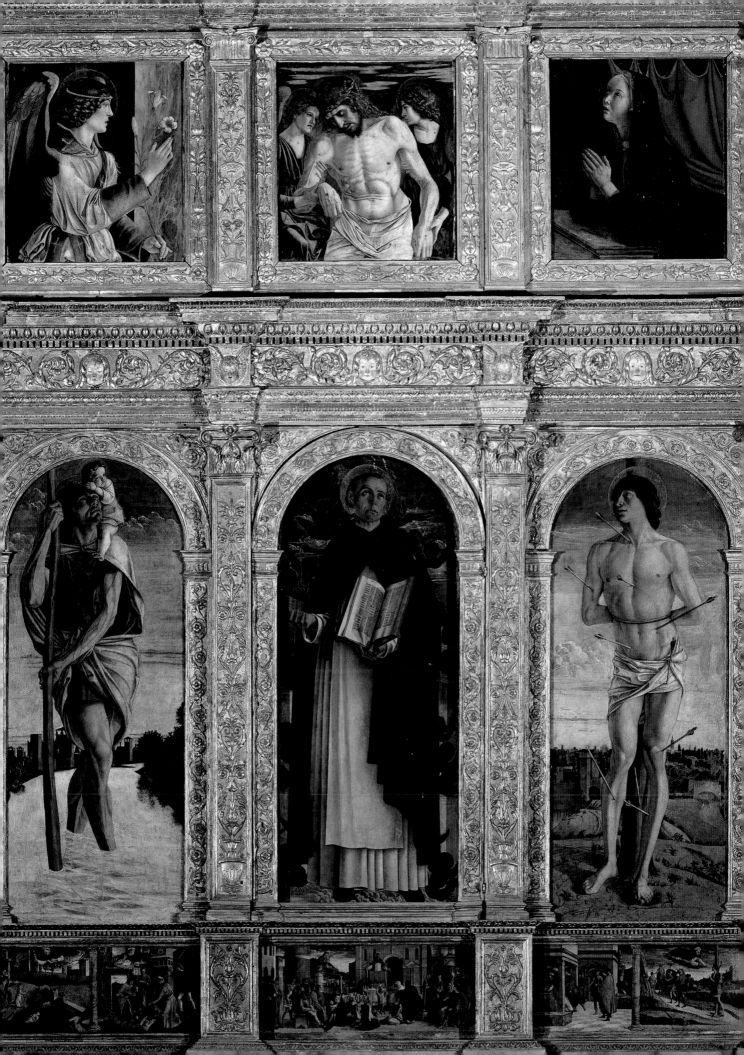

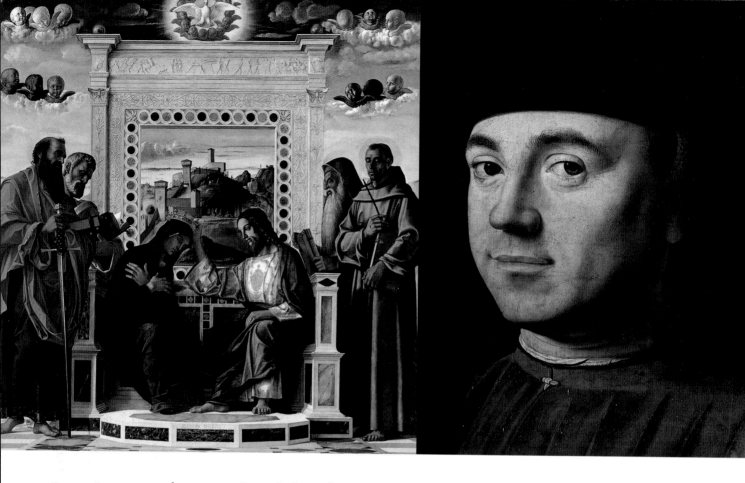

who were serving a similar Paduan apprenticeship at the same time. Yet the contribution of Mantegna was immediately refashioned, almost overpowered by the growing lyricism of an emphasis on color that would soon become the distinctive and confident voice of the young artist. So while Mantegna's influence on Giovanni was decisive, he was inclined to go beyond it right from the start, adopting it as just one of the elements of Paduan culture and not in its specific stylistic meaning. In fact, Mantegna's rational and erudite fascination with archeology remained worlds apart from the lyrical and sentimental sphere in which Giovanni moved from the outset, with an innate feeling for the expressive possibilities of color that if anything came to him from his contact with the works of his father and other painters of transition such as Antonio Vivarini (the *Madonna and Child* in Milan; the *Crucifixion* in the Museo Correr).

The *Pietà* in the Brera, a masterpiece that demonstrates the perfect equilibrium of Bellini's poetics, with its measured juxtaposition of shades of violet, brown and deep blue set against the more subdued tones of the heavenly vault,

should probably be dated to around 1460. Clearly we are coming to the end of the early Paduan period: in fact the freer distribution of the areas of color in a spacious composition seems to be an attempt to achieve picturesque results. This is confirmed by the evolution in his drawing, which continued to underscore the outlines in the manner of Mantegna but broadened out to create larger spreads of planes with new effects of plasticity, over which he would soon begin to lay a denser veil of color.

And so we come, around 1464, to the imposing *St. Vincent Ferrer Polyptych* in Santi Giovanni e Paolo, seething with color that is laid on in broad expanses. Even the emphasis given to light reveals the artist's intention of going beyond the idea of perspective to create a spatial and atmospheric effect rather than the geometric one sought by Mantegna. This was a decisive step on the part of Bellini, and should be linked not only to his constant search for a means of expression based on color, but also to the influence of Piero della Francesca, which may have come to him through Ferrara and Rimini, opening the way to an ever more integral vision of space in color.

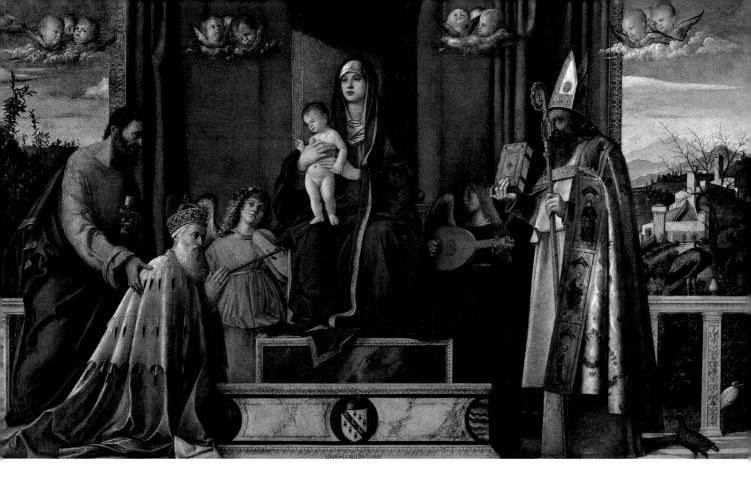

The linchpin of this fundamental moment in Bellini's development was the *Pesaro Altarpiece* with the *Coronation of the Virgin*, painted in oil around 1475 for San Francesco in Pesaro. Here the warm and amber intonation of the color, laid on with gradual transitions from dark shades to pale, assumes a true autonomy. In the central panel, the planes are arranged on the basis of a perspective that is no longer merely geometric, but profoundly linked to the chromatic value of the forms. At the center the landscape recedes into the distance in a vision that is no longer based on patterns outside the real world, but that is natural in the atmospheric scale of its colors.

So it is easy to understand how the contact with Antonello da Messina, who came to Venice for a brief stay in 1475, with his coloring made up of denser pigments crystalline in character (as the technique of painting in oil may well have appeared), proved of great value to Bellini, enriching a style that was already pointed in that direction. But we should not overestimate the influence that works by Antonello, such as the *San Cassiano Altarpiece*, fragments of which can now be seen in Vienna, or the *Vianello Portrait* in the Gal-

leria Borghese in Rome, may have had on Bellini, given that Giovanni himself passed on to the artist from Messina ideas about the use of color to create spatial effects that served to revive his memories of the early works of Piero della Francesca. In fact, if we examine the pictures Bellini painted in the years immediately following his encounter with Antonello, we find a great independence of expression. An example of this is the *Lochis Madonna* in Bergamo, embellished with a thread of gold woven into the deep-blue mantle. Even in the portrait, Bellini had found his own solutions before meeting Antonello, for instance in the lyrically pensive effect of the blacks and browns on the deep-blue ground of the *Portrait of Jörg Fugger* in the Contini-Bonacossi collection (1474). Another theme of Antonello's, that of the *Pietà*, is the subject of Bellini's panel in Rimini, painted in shades of pale ivory, green and rosy violet with iridescent reflections on a black ground that almost have the transparence of a stained-glass window. But the highly unusual effect, which brings out the values of the color, and the sentimentalism expressed through linear rhythms, almost modeled in the manner of Donatello, make this work a

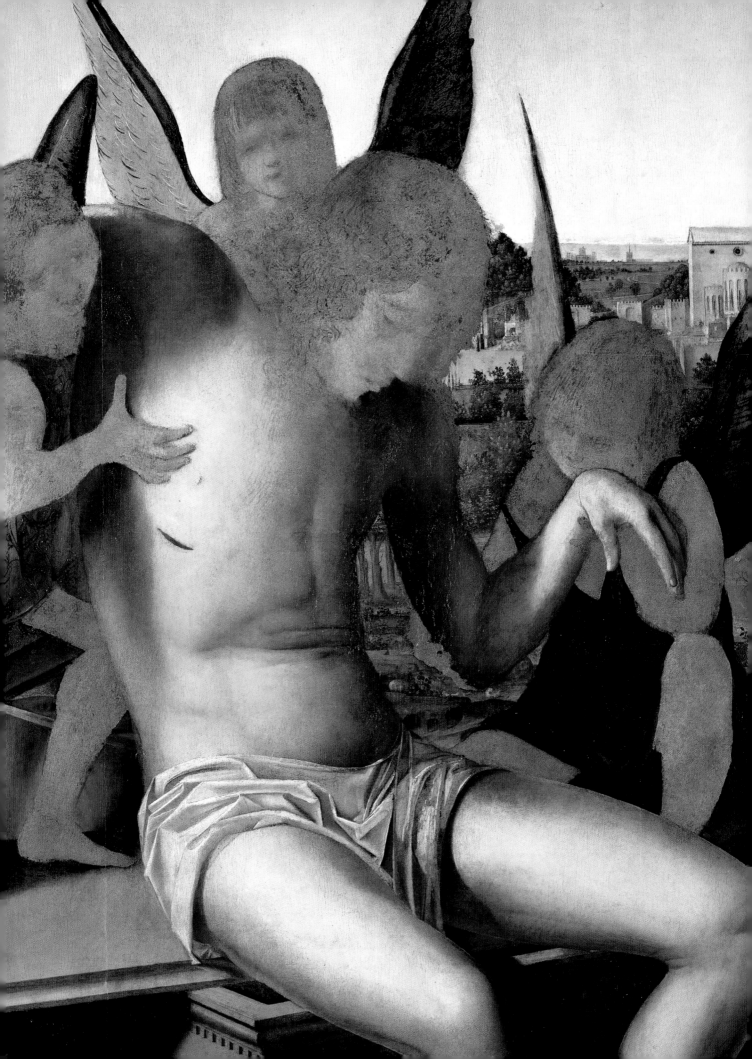

masterpiece as well as attesting to his figurative independence. It is possible that Antonello's *Pietà* – now in Venice's Museo Correr – served as a distant model, but it remains in a completely different world, where geometric form still dominates the expression of sentiment in nature.

And so we come to the 1480's abounding in major works that confirm the success attained by Bellini, now the undisputed leader of the Venetian school. The *Transfiguration* in Naples, the *Frari Altarpiece* and the *San Pietro Martire Altarpiece* in Murano, dating from 1488, and the *San Giobbe Altarpiece* are masterpieces in which Bellini succeeds in conveying his vision of a world that is at once divine and human, represented with heartfelt warmth in a lyrical atmosphere of color. A gilded hollow space, in which light is reflected by the mosaic decoration, or is subdued by its absorption into the varied colors of the figures (now handled in plastic planes, free from the torment of drawings that show contours and carvings), forms the setting of these *sacre conversazioni*, permeated by a solemn classicism but filled with life and humanity. In the suggestive *Ecstasy of St. Francis* in the Frick Collection, perhaps painted in the 1490's, the sacred theme is given a broad, naturalistic setting, a mark of that particular climate of Venetian humanism which was to prove such a fertile terrain for Giorgione's poetics. The elegiac unity of these landscapes of Bellini's is particularly significant, with their balanced relationship between space and color, now so carefully weighed that it finds expression in the lyrical and dreamy language of distances.

These were Bellini's last works of the fifteenth century, but his activity was to extend another fifteen years into the new century. Soon we shall see what kind of revolution was to take place in Venice at the beginning of the sixteenth century, when Carpaccio was halfway through his career and Giorgione only starting out on his. Just as he had been the master of the entire generation of fifteenth-century artists, the aging Bellini also

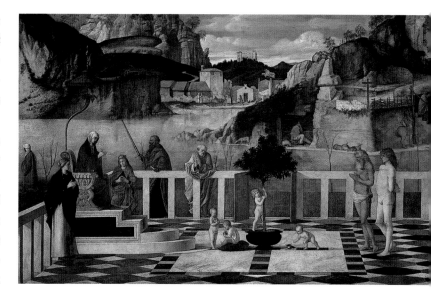

exercised a fundamental influence on the artists who were now commencing their activity, above all Giorgione, Lotto and Titian. He offered them a supple and varied vocabulary, in which color had already acquired an independence of expression, together with a world as concrete and human as it was spiritual and filled with purified forms. It is not easy to tell what the old master received in exchange and it is preferable to skim rapidly through the principal stages in the final part of Bellini's life, underlining his capacity to learn from the achievements of others while remaining independent and faithful to a vision of the world that now appeared, in contrast to the naturalism of his younger colleagues, noble and courtly, classical in its love of measured form and almost preciously archaic in its vision of things: as if they still corresponded to an idealized representation rather than to an image of reality.

In the *San Zaccaria Altarpiece* of 1505, the traditional chapel opens onto an airy portico. The light enters at a steep angle and fills the area of shadow under the mosaic with vibrant dust. The red, yellow and deep-blue clothing of the saints forms a backdrop to the light, suffusing color into the atmosphere and producing an effect of noble harmony that is echoed in the masterly topography of the figures, arranged in such a way

GIOVANNI BELLINI, Allegory, Galleria degli Uffizi, Florence.

facing page
ANTONELLO DA MESSINA, Pietà, Museo Correr, Venice.

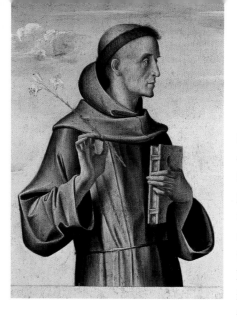

that they form an architectural setting of great spatial lucidity.

Giorgione's experiments with landscape also spurred Bellini to try out a new approach: in the *Madonna del Prato* (*Madonna of the Meadow*) in London he replaced his usual composite scenery with a rural view of shepherds, roads and castles. Only the insertion of the green meadow to separate the two planes on which the Virgin and the village are set still distinguishes Bellini's vision from the unitary approach taken by Giorgione. No direction had been left unexplored by the artist, certainly one of the greatest in fifteenth-century Italy, at the time of his death in 1516, when, as the contemporary diarist Marin Sanudo recorded, "old as he was, he still painted with perfection".

The Influence of Bellini and Antonello.

All the painters who worked alongside Bellini were strongly influenced by his powerful personality. It must be pointed out, however, that apart from the minor artists who belonged to his workshop and did little more than reproduce their master's designs, the ones that maintained a degree of independence were drawn instead to the antithetical approach, i.e. to the style of Antonello. Thus we find in Venice, alongside the close followers of Bellini, the generation of Alvise Vivarini and Cima da Conegliano, whose work was characterized by a greater commitment to plasticism that found expression in more highly structured forms and in a use of color to create not so much atmospheric tones as solid and crystalline blocks.

Bartolomeo Vivarini's nephew Alvise (Venice, *c.* 1445 - *c.* 1505) was the leader of this group, if for no other reason than age and the tradition of the workshop. His best works were produced around 1480, strongly influenced by Antonello. A good example is the *St. Anthony* in the Museo Correr, in which the dense and precise color is used to build up plastic forms. The sharp-edged drawing overcomes the limits of Bartolomeo's linear outlines and offers instead extensive support for the patches of color, producing an effect of vivid luminism. In later works, such as the *Crucifixion* in the Museo Civico of Pesaro and the *Montefiorentino Polyptych* now in Urbino, Alvise adopted a more markedly monumental style.

Giambattista Cima (Conegliano 1459?-1518?) was without doubt the finest exponent of Antonello's style. He started out in 1489 with the *San Bartolomeo Altarpiece* in Vicenza, in the manner of Mantegna. But he soon went beyond this in his masterpiece of 1493, the *Conegliano Altarpiece* with its limpid and well-turned forms. Moving to Venice in 1492 and going into partnership with Alvise, he came into contact with the work of Bellini and Antonello, although his reaction to it, as is clear from his altarpiece for the church of San Giovanni in Bragora representing *The Baptism of Christ*, was an idiosyncratic one, in which he remained jealous of his autonomy. The figure of St. John the Baptist stands out sharply against the sky, in a landscape illuminated, like the saint himself, by warm sunlight. Often he would make nature the protagonist of his pictures, in an intense and lyrical evocation that already bears comparison, in such early sixteenth century works as the *Altarpiece of the Madonna dell'Orto*, with Giorgione.

Gentile Bellini and Carpaccio.

Giovanni Bellini's younger brother Gentile (Venice, 1429-1507) occupies a quite different position in Venetian painting. Taking over from his father as head of the workshop, he enjoyed a high rep-

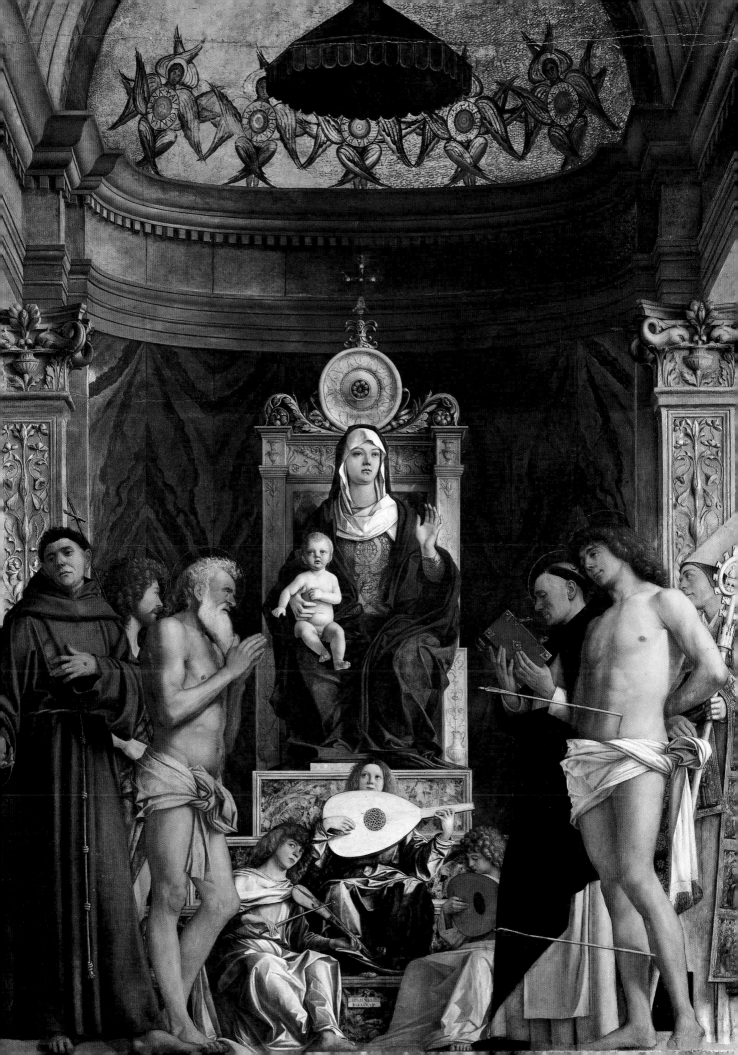

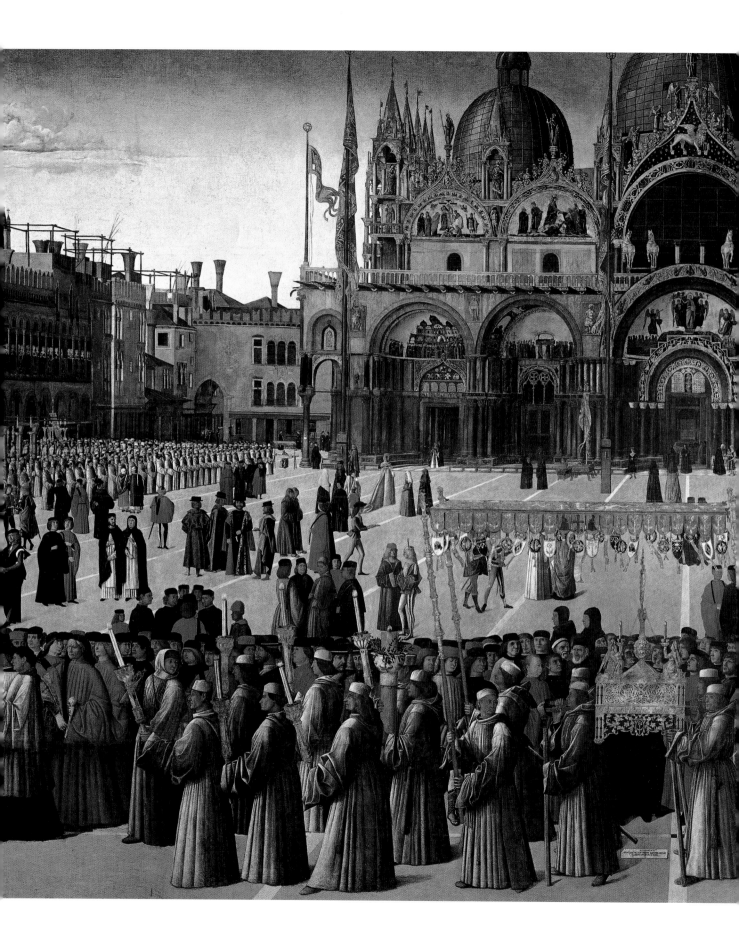

GENTILE BELLINI, Procession in Piazza San Marco, Gallerie dell'Accademia, Venice.

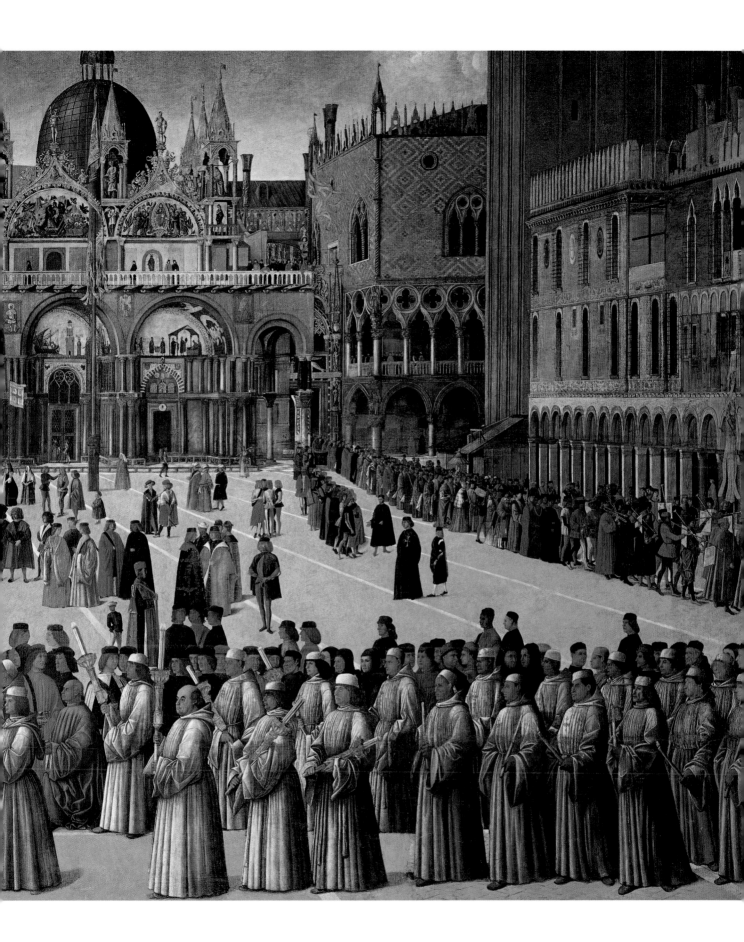

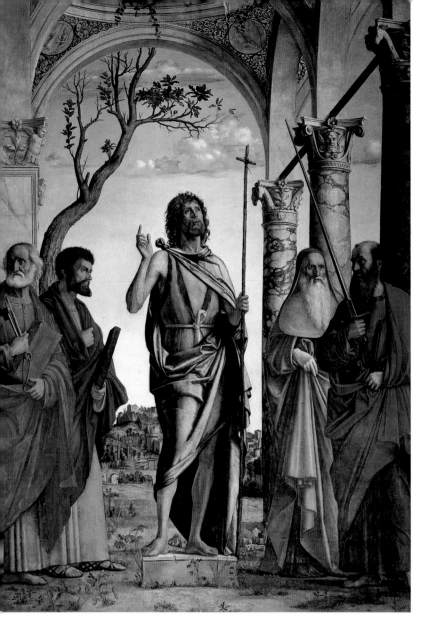

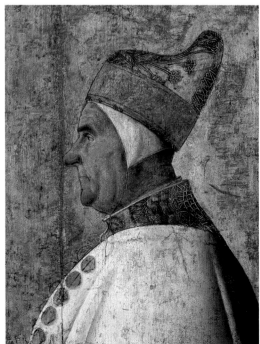

above
GIAMBATTISTA CIMA
DA CONEGLIANO,
Madonna dell'Orto
Altarpiece, Church
of the Madonna
dell'Orto, Venice.

right
GENTILE BELLINI,
Giovanni Mocenigo,
Museo Correr,
Venice.

facing page
GIAMBATTISTA CIMA
DA CONEGLIANO,
The Baptism of
Christ, Church
of San Giovanni
in Bragora, Venice.

utation in the city, where he was official portraitist to the doges and was even sent by the republic to the court of Mahomet II, where he stayed from 1479 to 1480. Temperamentally averse to artistic experimentation, Gentile clung for a long time to Jacopo's timid version of perspective, though he did learn from Mantegna, as is apparent in the organ doors of St. Mark's, executed prior to 1465. Within the linear limits of a style almost that of a medalist, he painted in heavily veiled tempera, using a palette of pale pinks, delicate tints of gray, soft blues and whites. Thus he was naturally inclined to the portrait, painting on panels effigies of the doges that resembled cameos set against solid backdrops of space that have no depth (*Giovanni Mocenigo* in the Museo Correr). In his later years, he produced more varied and crowded "portraits" of Venice, depicting its bridges and palaces, its rooftop loggias and chimneys and the banks of its canals with analytical precision.

This was the time at which the *scuole*, the trade guilds that doubled as religious confraternities, were renovating their headquarters and commissions for large decorative paintings came thick and fast. Gentile was the principal impresario in these undertakings, from the Scuola Grande di San Marco to the Scuola di San Giovanni Evangelista, making these huge canvases with many figures almost a specialty. If we look at the works Gentile produced for one of these commissions, such as the *Procession in Piazza San Marco*, an episode in the series related to a relic of the Holy Cross that he painted for San Giovanni Evangelista toward the end of the century, we find a wholly descriptive vision of Venice, a lucid literary prose in which each phrase is set in the right place and expressed in a beautiful form. In the Fondamenta di San Lio that provides the setting for the *Miracle of the Reliquary of the Cross*, recovered after it had fallen into the water (1496), the space remains motionless, without echoes, from facade to facade of the red-plastered, Gothic

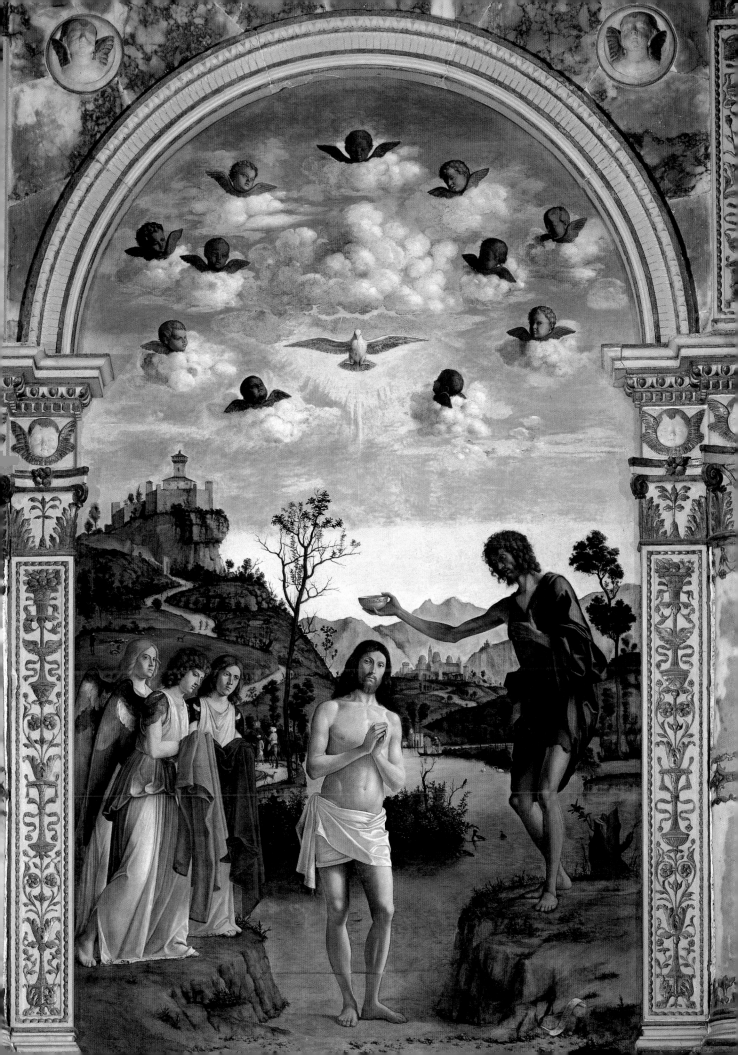

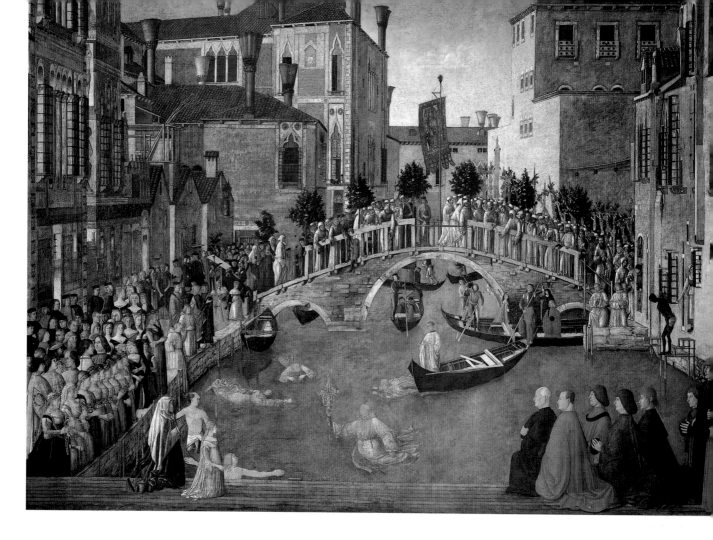

palaces. The light has an unreal quality and everything is subordinated instead to his determination to paint the ranks of Caterina Cornaro's maids of honor and portraits of the members of the confraternity. A style of the highest graphic quality signals at once the grandeur and the limitations of this last vestige of a world ordered according to formal hierarchies, a world that had in reality already been swept away.

It suffices, in fact, to compare Gentile's images with the ones that Vittore Carpaccio (Venice, *c.* 1465 - Koper, 1526) was painting at the same time and in the same place. The *Miracle of the Reliquary of the Cross* (Gallerie dell'Accademia) was painted by Carpaccio at the age of thirty, at about the same time as Gentile's picture. There is a substantial difference between each artist's view of Venice: in Carpaccio's everything is in movement, a play of colors in an architectural spacing that distributes and measures the forms, creating an atmosphere that brings the scene to life. The most untrammeled fantasy has taken the place of

Gentile's documentary intent, and the color is organized into scaled planes of light, resulting in a magical accord between perspective abstraction and representation of reality.

The ten canvases of *Scenes from the Life of St. Ursula*, painted for the Scuola di Sant'Orsola between 1490 and 1500, are the most important work of Carpaccio's youth and present an organic vision in which the tale of Ursula is set against a figurative backdrop of measured spatiality, culminating in that language of "plausible fantasy" that is the highest achievement of Carpaccio's art. In that form he was able to bring about a magical blend of Oriental fable and the reality of Venetian skies and waters, transcending the narrative episode or literary description and often expressing his poetics on an almost abstract and always symbolic plane.

So we should not naively class Carpaccio among the narrators and still less the painters of folklore, even where the charm of his subjects might tempt us to do so. It is enough to look at

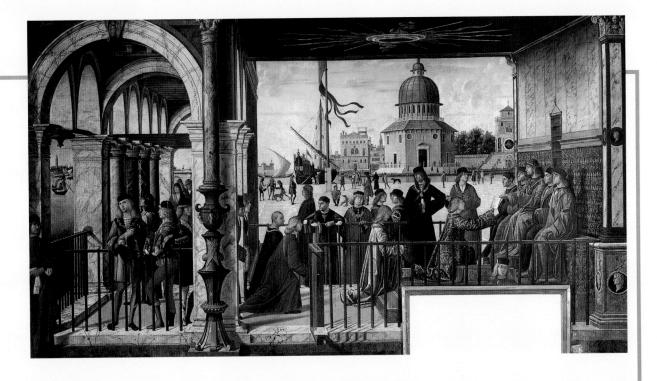

THE "TELERI" OF THE SCUOLA DI SANT'ORSOLA

In comparison with the magnificent buildings that housed the six Scuole Grandi, such as those of San Rocco and San Marco, the seat of the Scuola di Sant'Orsola at Santi Giovanni e Paolo is certainly nothing special. Indeed, so insignificant is it from an architectural point of view that for a long time it was even thought to have been demolished. It is only relatively recently that the modest building was "rediscovered" and incorporated into the rectory of the friars of the nearby church of Santi Giovanni e Paolo, which had been enlarged during the nineteenth century.

And yet this small fourteenth-century building used to hold one of the greatest treasures in the whole history of Venetian art: the series of nine *teleri* or "large canvases" narrating the legend of St. Ursula, to whom the Scuola was dedicated, that were painted between 1490 and 1500 by Vittore Carpaccio. These were later transferred to the Gallerie dell'Accademia in 1808.

They are works that mark a genuine revolution in the world of Venetian painting, going well beyond the tradition of the hagiographic or historical narrative that was in vogue in late fifteenth-century Venice and that was represented principally by Gentile Bellini, who held uncontested sway over pictorial work in the Doge's Palace and the Scuole Grandi. At the Scuola di Sant'Orsola, a popular legend about the Breton saint, who converted to Christianity and was massacred along with the pope, her betrothed and her companions by the Huns at Cologne, became the occasion for a narrative that, setting aside the exoticism of the places and characters, directly recalls traditional and much-loved ways of life and customs that were easily recognizable and comprehensible to any observer. Carpaccio's genius is revealed above all in the particular tone assumed by the stage setting: as if in a great popular theater, the events of the saint's betrothal, voyage, miraculous dream and martyrdom are couched in the visual modes of a means of expression that is naturally attractive and communicative. Also surprisingly new and highly original is the way the scenes are set in a rational perspective that was unprecedented in Venice, amidst works of architecture in the style of Codussi and Lombardo based on the real buildings that were being constructed in the city in those very years. The effect of the colors is also wholly new, appearing to dissolve into a harmonious vibration of light, transparent even in the meticulously depicted shadows, and vivid and scintillating in the details drawn with patience worthy of a Flemish artist.

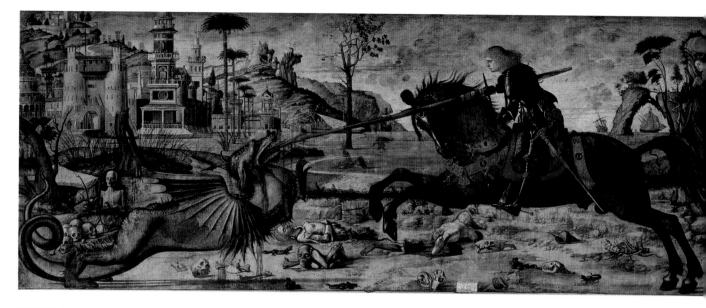

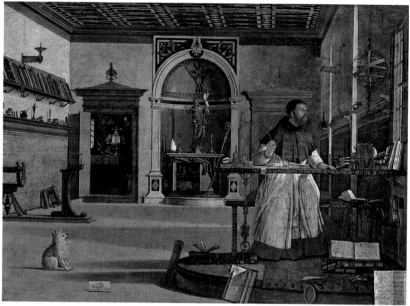

the best of the *Scenes from the Life of St. Ursula* to grasp the real essence of that sublime voice: from the parade of the bishops in the *Arrival in Rome*, where the grazing light strips the forms of all weight so that they look like inlays in the green meadow, over which they seem to slide as if drawn by an invisible thread, to the *Departure of the Betrothed*, in which the touching scene in the foreground is steeped in the vibrant luminosity of the water and sky. A sense of space is created by the distant view of the towers and sails, in a perfect calculation that suggests not the reality of nature but a motionless and enduring abstraction. Once again, then, the artist has chosen to

rely on the infallible power of perspective. But Carpaccio's "architectural" style unquestionably reaches its peak in the three canvases of the *Ambassadors*, representing the request for Ursula's hand in marriage and her response. They were painted around 1500, at the time when the painter's infatuation with the new architectural forms introduced into Venice by Codussi was at its height. Note the portico in the *Arrival of the Ambassadors* (which resembles the arch of the Clock Tower in Piazza San Marco), or the palace in the background of the *Return*, which recalls the trefoil windows in Codussi's palaces on the Grand Canal. During his most successful period

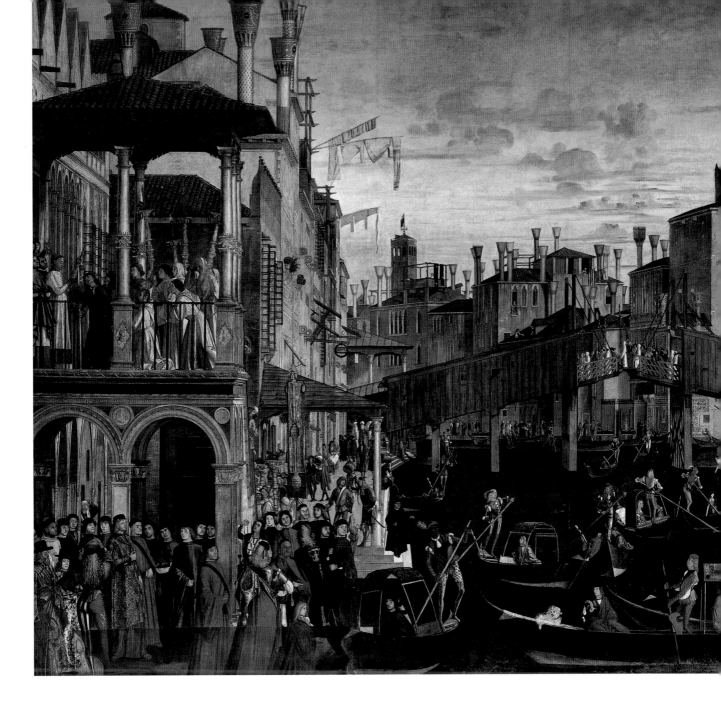

Carpaccio's style underwent no substantial variations. It was only with the *Scenes from the Life of St. George* painted for the Scuola di San Giorgio degli Schiavoni between 1502 and 1507 that his awareness of the autonomy of color grew, leading him to play with counterpoints of light and shade, blurring them in local tones with exceptional freedom. The objects often take on a symbolic and absolute life of their own, frozen by the image just beyond the limit of the real. This is particularly true of certain books, a chair and the broad patches of light in the *Study of St. Augustine*, of the juxtaposition of colors in *St. George Killing the Dragon*, and of certain Turkish turbans and some very perfect drawings of costumes and animals.

After the Schiavoni, something broke down in Carpaccio's miraculous equilibrium and he showed little sensitivity to the revolution brought about by Giorgione. He left Venice for Istria, where he painted in an old-fashioned and nostalgic manner, making a vain attempt to update his style by adopting the brilliantly-colored plasticism of Cima's late works.

Sculptors and Architects. New forms were slower to make their way into Venetian architecture and sculpture. A Lombard-Venetian

VITTORE CARPACCIO, Miracle of the Reliquary of the Cross, Gallerie dell'Accademia, Venice.

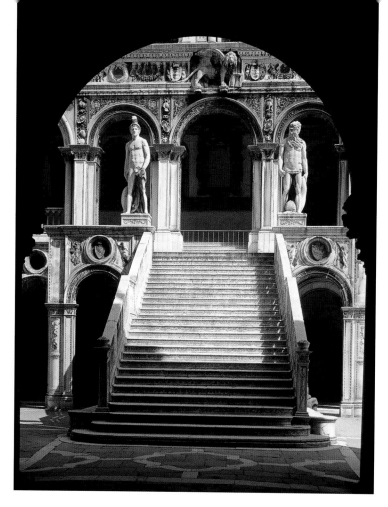

ANTONIO RIZZO,
Scala dei Giganti
("Giants' Staircase"),
Doge's Palace,
Venice.

facing page
PIETRO LOMBARDO,
Ca' Dario, Venice.
Facade on the Grand
Canal.

group of stonecutters was active in the Doge's Palace. It was headed by Antonio Bregno, who was responsible for the design of the Arco Foscari (*c.* 1440), the long Gothic portico concluding in a triumphal arch that links the Porta della Carta with the interior of the palace. Antonio Rizzo (Verona, *c.* 1430 - Foligno, 1499) worked alongside him and was later to complete the construction. Rizzo's artistic background is uncertain, but was certainly linked to the world of Flamboyant Gothic. Yet his style rapidly evolved in the direction of a marked naturalistic tendency, apparent in the sculptures of the sepulchral monument of Doge Tron in the Frari (1477-1479), as well as in the marble statues of *Adam and Eve* in the Arco Foscari, masterpieces in which the realistic forms are given an unexpected conclusion in their perfectly oval faces, which the light molds into an integral and explicitly idealized mass. Antonio Rizzo also worked as an architect inside the Doge's Palace, where he designed the staircase known as the Scala dei Giganti. In line with the portico of the

Arco Foscari, it completes the monumental entrance to the Doge's Palace with a complex of extraordinary richness. Given a broad and majestic effect by the risers of the steps decorated with niello and by the carved banisters, it seems, with the vast facade behind it, more like a precious work of sculpture than of architecture.

Expelled from Venice in 1498 for embezzlement in the work on the palace, Antonio Rizzo left the field to his rivals, the Lombardo family. Pietro Lombardo (Carona, 1435 - Venice, 1515) was the head of a large workshop of stonecutters that was dominant in Venice for many decades at the turn of the century. In contrast to the brilliance of Rizzo, he represents the more academic aspect of the new style, using Renaissance models in a manner that placed an emphasis on color but which was not always able to create an original plastic language. Trained in Padua (1464-1467), where he worked in a milieu heavily influenced by Donatello, on his arrival in Venice he was incapable of going beyond the fragmentary Gothic approach to decoration in sculpture, squandering his energies – although with great refinement – on innumerable folds and articulations. In his works of architecture he sought to create patterns of light and shade on the surface, picturesque in their effect but remote from any true capacity for construction.

This tendency to treat architecture as decoration triumphed in his later works, such as the Palazzo Dario on the Grand Canal (*c.* 1490). It is clear that Lombardo's interest was focused on the facade, which he reduced to a screen that covered the structure without any real relationship to the space inside. He spurned the very essence of architecture for a picturesque effect that was unable to rise above the level of graceful decoration. Linear moldings on the facade, bands of color marking the stories, and multicolored oculi of rare marble embellish these facings, in a display that soon turned into mere virtuosity. Even this was almost always sustained solely by the

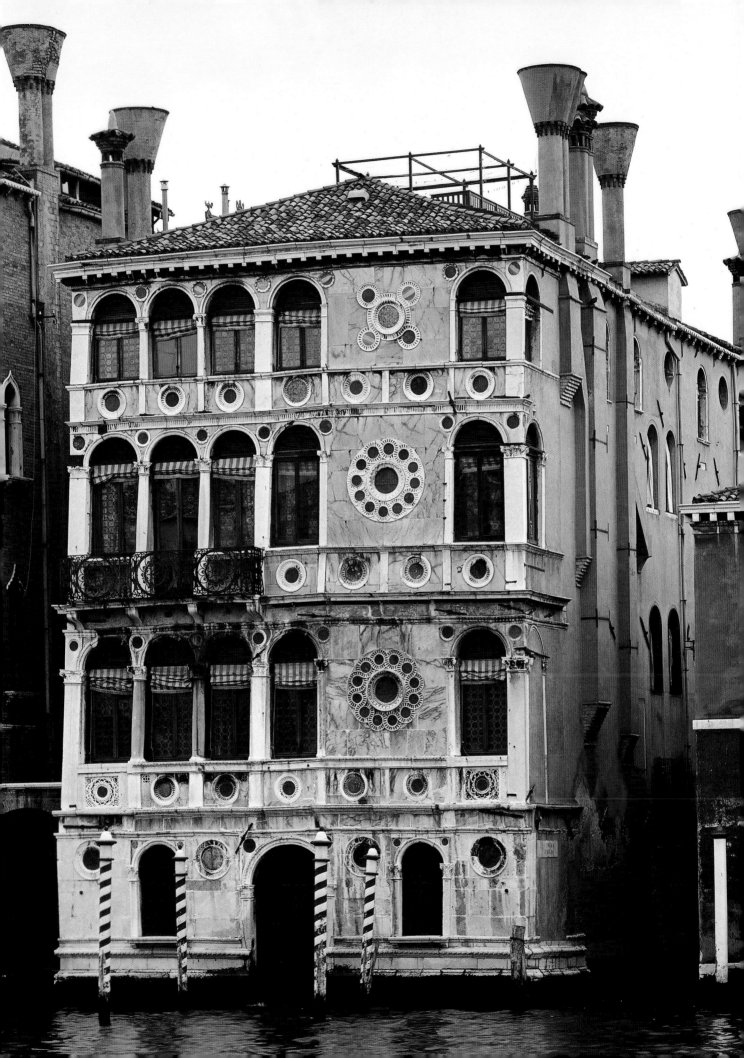

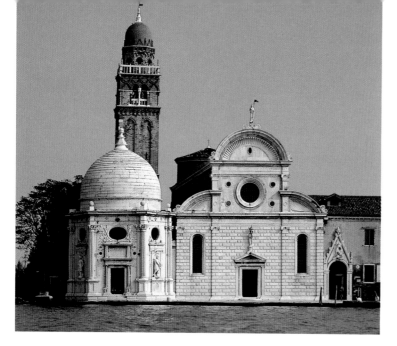

refinement of the carving. A similar decorative style characterizes the facade of the church of Santa Maria dei Miracoli, perhaps begun – at least as far as its structure is concerned – by Codussi a decade earlier.

When, in 1490, the Scuola Grande di San Marco in Venice found itself in difficulty with the Lombardo workshop, which had got no further than the first story in its construction of the new facade, and decided to have the work appraised, it called on Rizzo and the architect Mauro Codussi (Lenna, *c.* 1440 - Venice, 1504). Codussi, a native of Bergamo, had been working in Venice for twenty years, and his work stood in complete contrast to that of Pietro Lombardo. Where Lombardo, in fact, represented a form of Renaissance architecture still subordinate to a decorative vision, concerned with linear rhythms and surface chromatic values, Codussi's language was a reaffirmation of Tuscan plastic and spatial ideas, resulting in an organically vital architecture.

We still do not know where Codussi received his training, but already in his first work in Venice, the church of San Michele in Isola (1478), it is possible to discern the signs of a singularly concrete vision of space, in the Tuscan manner. From the limpid facade that hints at the internal division into a nave and two aisles, to the lucid series of arches and the square presbytery where the dome is set on a beautifully designed cornice, it appears that Codussi was drawn to

solutions in the style of Brunelleschi or Alberti, such as Michelozzo had adopted in Florence and perhaps in Venice too, in the destroyed Libreria di San Giorgio. This Tuscan influence, which in Codussi signified the plastic construction of spaces within a luminous and simple framework of walls, is most evident in his more mature works, such as the reconstruction of San Zaccaria (1483) and above all the interior of Santa Maria Formosa (from 1492 onward).

Combining a vigorous spatial structure with an ever more exquisite design, Codussi carried out many more works in the last decade of the century, including the monumental staircase of the Scuola di San Giovanni Evangelista and the church of San Giovanni Crisostomo (1497).

Among the last of his creations, around 1500, were several palaces. The one that stands out most is the Palazzo Corner-Spinelli (*c.* 1490), with a front on the Grand Canal framed by a cornice and pillars at the corners, highly restrained yet with a rigor that does not limit the fanciful invention of the windows and the trefoil balconies. It was at this time that he started on the restructuring of Piazza San Marco, including the construction of the clock tower and the design of the Procuratie. Here, once again, Tuscan moderation is united with a pictorial Venetian elegance. The same can be said of his final creation, the Palazzo Vendramin-Calergi (1502-1504), where the prototype of Palazzo Corner-Spinelli is given a more monumental treatment, in which mullioned windows alternate with columns along the plastic cornices. This solution was to set a trend, fixing the model for Venetian facades that look out onto the water in a picturesque play of light and shade. A model that established itself, with a majestic but measured effect of classicism, in the age in which Venice was dominated by the art of Giovanni Bellini, to whose solemn grandeur Codussi's architecture can be compared.

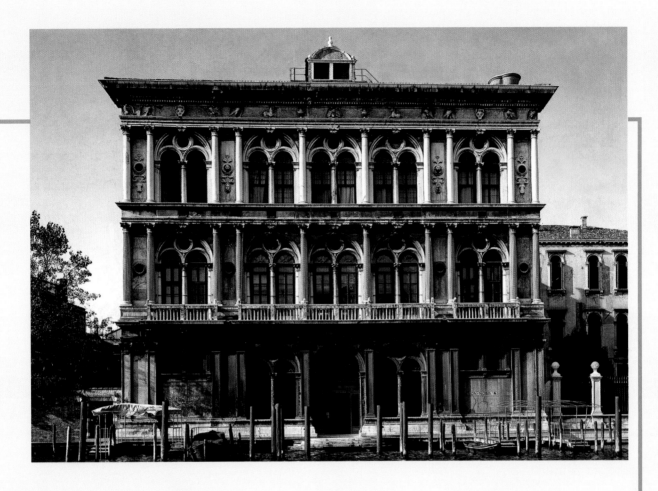

CA' VENDRAMIN CALERGI

There can be no doubt that the palace now universally known as Ca' Vendramin Calergi constitutes the finest example of Renaissance civil architecture in Venice. It was designed by the architect Mauro Codussi for the nobleman Andrea Loredan, perhaps as early as the end of the 1480's. For reasons linked to relations with its neighbors, construction did not start until much later, in 1502, and when Codussi died two years afterward it was completed, with total respect for the original plans, by Mauro's son Domenico, in or before 1509.

Built entirely of Istrian stone, the main facade on the Grand Canal is divided, according to Venetian architectural tradition, into three parts. This tripartition is underlined by the presence of the close-set columns on the two *piani nobili*, but at the same time it is partially masked by the almost unbroken succession of Codussi's characteristic two-light windows – crowned by an arch enclosing an oculus – that runs right along the facade. And it is the insistent repetition of this motif that gives the building an airy lightness totally new for Venetian architecture.

The rich sculptural decoration of the front, in particular the high cornice under the roof, where the allegorical symbols of the unicorn and the eagle are insistently repeated, is also of notable quality.

Codussi's client – Andrea Loredan – was certainly a man of considerable culture, well acquainted with the new ideas of the Renaissance. It is no accident, in fact, that he turned for the decoration of the new palace to the three main Venetian exponents of the new direction in painting after Giovanni Bellini: Giorgione, who painted the frescoes in the atrium on the ground floor of the building, now lost but known to us through Zanetti's eighteenth-century engravings; Sebastiano del Piombo, who painted the palace's magnificent *Judgment of Solomon*, the most important work of the artist's Venetian period; and the very young Titian, who painted for Loredan the *Flight into Egypt* now in the Hermitage in St. Petersburg.

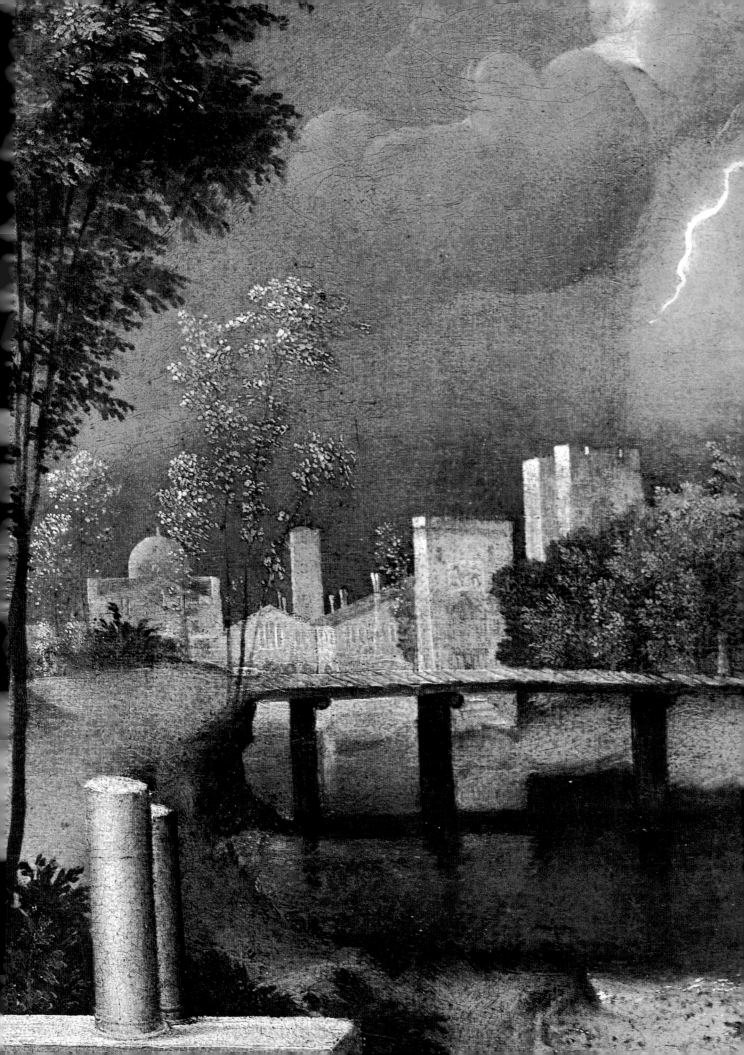

The Sixteenth Century

Giorgione. Master Zorzi da Castelfranco, called Giorgione (Castelfranco, 1477? - Venice, 1510) was at the head of the first generation of sixteenth-century Venetian painters. His career was a very short one, not extending beyond the decade from 1500 to 1510, and we know little about his life. Even the catalogue of his works is uncertain and only the references in a contemporary diary kept by the patrician Marcantonio Michiel allow us to identify three of his paintings without doubt: The Tempest, the Three Philosophers and the Sleeping Venus. Documents also identify him as the painter of the Young Nude, a surviving fragment of the frescoes he painted for the Fondaco dei Tedeschi. Around this nucleus are grouped only a few other works that have been unanimously accepted as his work by the critics. In spite of this, Giorgione's art stands out strongly, for he was able to create a language in which nature was approached with full spiritual independence, allowing him to attain an autonomous form of expression centering on the atmospheric values of color.

GIORGIONE, The Tempest, Gallerie dell'Accademia, Venice. Detail.

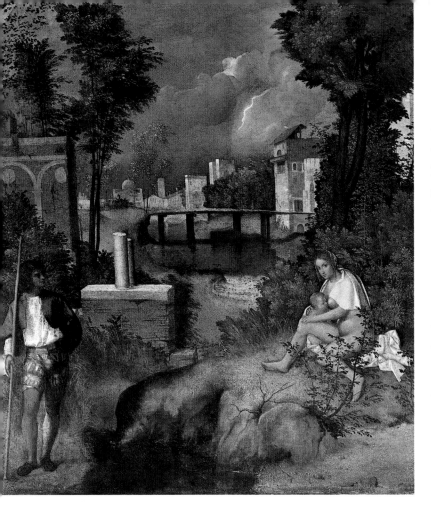

GIORGIONE,
The Tempest,
Gallerie
dell'Accademia,
Venice.

facing page
GIORGIONE,
Castelfranco
Altarpiece,
Cathedral,
Castelfranco.

Giorgione was originally a pupil of Bellini. The influence of the old master is evident in the *Castelfranco Madonna*, which must be ascribed to the beginning of his career given the ingenuous and even experimental character of its language. Faced with the problem of composing a picture to be placed on the altar of the chapel that was to be used as a burial place for the young warrior Matteo Costanzo, who died in 1504, Giorgione dithered between the tradition of Bellini and a new and explicitly naturalistic vision, evident in the landscape, which was now given so much importance that the image of the Madonna is drawn into its luminosity.

The *Judith* in the Hermitage in St. Petersburg, datable to the same years, also displays a few contradictions, but is still fascinating for the gentleness of the woman's face and of the landscape, contrasting with drapery that still shows the influence of Dürer. The first signs of maturity can instead be seen in the *Allendale Adoration of the Shepherds*, in the National Gallery of Art in Washington, from around 1505, where the con-

tradiction between the naturalistic intention of the artist and the traditional vision appears to have been partly overcome. The figures are smaller now, while more emphasis is placed on the landscape, depicted in the sort of minute detail to be found in Northern European engravings.

These characteristics probably derive from his firsthand contact with the works of German and Flemish artists, and in particular Albrecht Dürer (Nuremberg, 1471-1528), who visited Venice on two separate occasions (in 1494 and in 1505-1506). And it is obvious that Giorgione, like the other painters of his generation, could not have remained unaffected by works such as the *Feast of the Rosary*, painted by Dürer for the church of San Bartolomeo in 1506 and now in Prague. It is splendid in its painstaking representation of the landscape, in the intensity of its portraits and in the dynamism of the figures, displaying that exceptional linear tension and sense of reality that characterize Dürer's vigorous style.

But in his works Giorgione also displayed a precise interest in color, something that may have had its source in Carpaccio. By this time Carpaccio had completed most of his work in the Scuola di San Giorgio degli Schiavoni, while the *Scenes from the Life of St. Ursula* had been on view to the Venetians for ten years. And these canvases must have made it clear to Giorgione that it was possible to paint "without drawing", with color alone, a discovery that led him to develop a new style that was all his own.

Starting first with Bellini, therefore, Giorgione then drew on the painters of Northern Europe and on Carpaccio while establishing spiritual ties to the circle of Venetian philosophers who were his friends. Out of this he developed a more lyrical fusion of the human element with nature, instinctively creating a more flexible language capable of expressing his poetics through the free use of color. And so the *Castelfranco Madonna* was followed by a group of works of

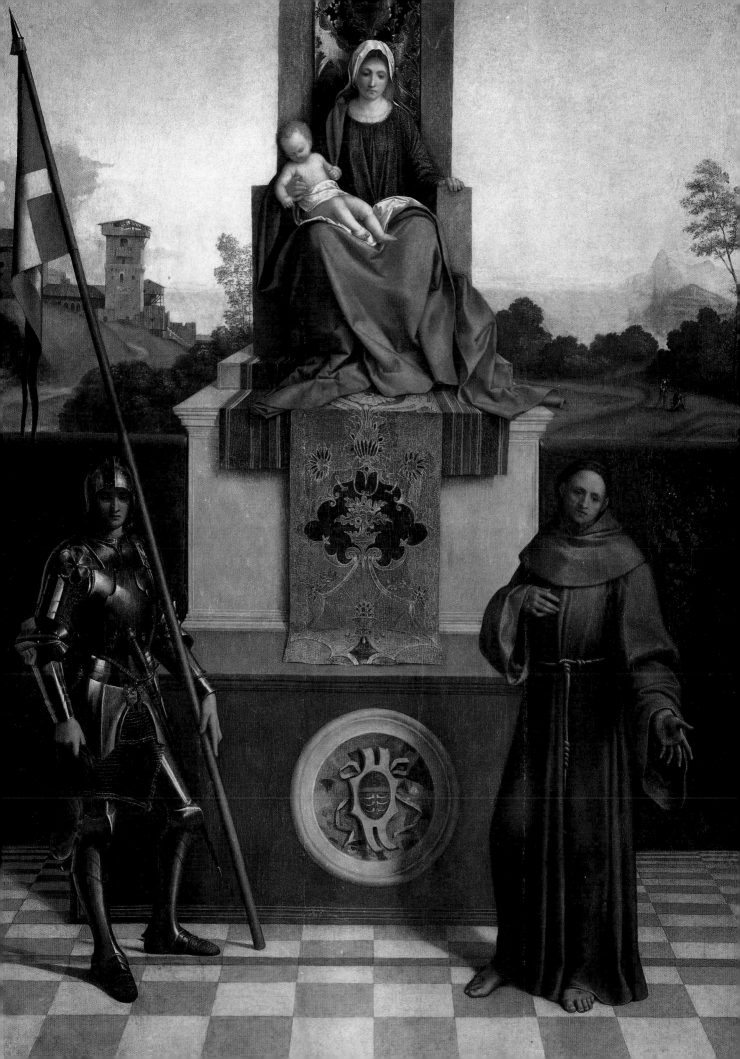

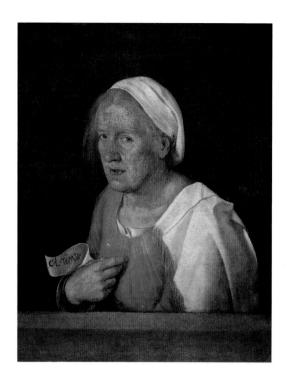

GIORGIONE,
The Old Woman,
Gallerie
dell'Accademia,
Venice.

facing page
ALBRECHT DÜRER,
The Feast of the
Rosary, Hradcany,
Prague.

The harmonic fusion of humanity with nature is so penetrating that even the emotions are caught up in the play of forms. Thus there is no longer any barrier separating humanity from the world of phenomena. The language of color, now a decisive element of the poetic image, makes possible an intense and revelatory focus on nature in the Flemish manner. But at the same time it suggests a vibrant emotional unity, an outpouring of sentiment, a liberty of representation that is "open", i.e. outside the patterns of a Platonically predestined world.

The key to a critical interpretation of the *Three Philosophers* in Vienna appears very similar. Here the natural setting so fully embraces the three figures dressed in yellow, red, and white and green respectively that they seem almost to be elements of its structure.

In 1508 Giorgione finished the frescoes on the facade of the Fondaco dei Tedeschi that looks onto the Grand Canal. All that remains of them is the fragment of the *Young Nude.*. In eighteenth-century accounts their chromatic values are described as fairly "artificial" compared with the realism of the ones painted by Titian on the same building. But what is interesting about the *Young Nude* is not so much the quality of the painting as the fact that it is an element of the same problem that renders so obscure the later activity of Giorgione, when he was working alongside Titian. In fact his younger colleague painted the facade of the Fondaco that overlooks the *calle*, with such success that a number of contemporaries attributed those frescoes to Giorgione as well. This confusion, which can be explained by the fact that at the outset Titian took his master as a model, extends to many other paintings. These include *The Old Woman*, the *Christ Carrying the Cross* and the *Sleeping Venus*, which are actually the work of Giorgione; and *The Adulteress Brought Before Christ* in the Art Gallery and Museum of Glasgow and the *Concert Champêtre* in the Louvre in Paris, which were

such poetic force that they clearly indicate the direction in which his personality was developing. Prominent among these are the portraits, such as the *Laura* in Vienna and the *Giustiniani* in Berlin. These works opened up a wholly new vision, one that had no precedent in the Venetian tradition. Here Giorgione reveals his special feeling for natural forms, a sensibility that allows him to approach the representation of the human figure with the same lyrical attitude as the landscape. Also evident is the influence of the works of Leonardo, who passed through Venice at the beginning of the century and was equally interested in the investigation of nature through the use of subdued colors and gradations of shade. There is no breach in Giorgione's style, whether he is painting figures or landscapes: both are elements, in his poetics, of the lyrical quality of nature, as is demonstrated by the other works of this period, *The Tempest* and the *Three Philosophers*.

None of Giorgione's paintings reflects his personality better than *The Tempest* in the Gallerie dell'Accademia di Venezia. The air of mystery that cloaks the subjects of almost all his pictures here reaches the level of a true enigma. Suffice it to say that no one has ever been able to discover just what the painting is about.

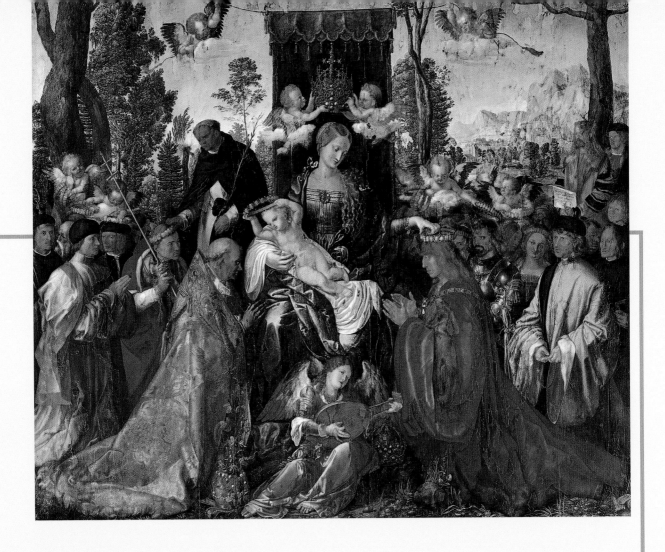

ALBRECHT DÜRER IN VENICE

Albrecht Dürer first came to Venice in 1494, from his native city of Nuremberg. Still very young – he was born in 1471 – he brought with him a limited stock of experience, largely gathered on his previous artistic pilgrimage to the north of Germany, where he had shown a particular interest in the works of the Flemish painters. Yet the brief period he spent in the circles of the Vivarini and the Bellini, and in contact with Mantegna as well, did not leave much of a mark on his subsequent activity, which remained basically tied to the realistic manner of the Germans and Flemish. Nor can it be said that this first visit to the lagoon city had any

significant influence on Venetian painters.

Things proved quite different on his second stay, which began in 1505 when the artist returned to Venice to paint *The Feast of the Rose Garlands* for the church of San Bartolomeo, delivered in 1506 and now in Prague Castle. This painting was commissioned by the German community, which had its center at the Fondaco dei Tedeschi in Rialto. It was his highest achievement thus far in painting, and marked a fundamental turning point for Venetian art as well, both for the meticulous representation of the landscape and for the suggestive portraits of Pope

Julius II and Emperor Maximilian, along with those of the clients, the German bankers Fugger and Burckhardt, and the artist himself. The inspiration for the painting's composition clearly came from the works of Giovanni Bellini, with the pyramid formed by the throne and the kneeling figures. But the dynamism of the figures displays above all that singular linear tension and sense of reality that renders Dürer's vigorous style so unmistakable. Nor does the color, still gleaming and uniform, seem to have absorbed the atmospheric values discovered by Bellini and, by this date, Giorgione as well. Even the later portraits painted in Venice

do nothing but confirm the very high quality of Dürer's observation and his growing lack of interest in Venetian tonalism.

Local artists, however, did show a great interest in the works of the German painter, even seeking to wheedle drawings and ideas out of him, as he told his friend Pirkheimer in a letter, adding that of all the many Venetian artists it was the aging Bellini he liked best. And there is no doubt that the breath of realism brought to Venice by Dürer had a decisive influence on the artists of the generation after Bellini, from Giorgione to Titian and from Lotto to Savoldo.

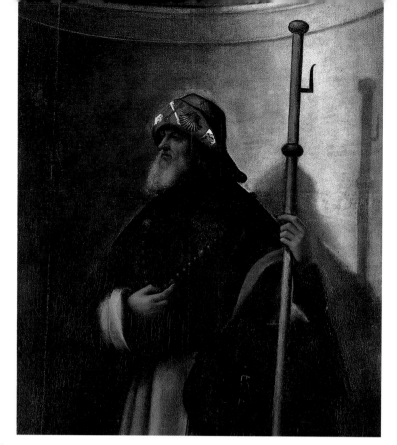

SEBASTIANO DEL
PIOMBO,
St. Sinibaldus,
Gallerie
dell'Accademia,
Venice. Detail.

facing page
SEBASTIANO DEL
PIOMBO, San Giovanni
Crisostomo
Altarpiece, Church
of San Giovanni
Crisostomo, Venice.

painted by Titian. Of all these pictures, the only one that Michiel states to be the work of Giorgione is the *Venus* in Dresden, and it should certainly be attributed to him, even though Titian may have finished the landscape, adding a cupid and perhaps retouching the lower part. But Titian's addition could not mar the ineffable purity of Giorgione's nude set against a distant landscape, in which the profiles of the hills and woods echo the undulating line that encloses the figure, resulting in a measured and perfect image.

Dying at the age of only thirty-three, Giorgione undoubtedly never completed his stylistic development, a process that – through his contact with Titian – was taking him in a quite different direction, especially in the last year of his life, compared to the central phase of his career, when he was still under the sway of Bellini and the Northern Europeans. It was at this point, in fact, that he painted works such as *The Old Woman* in the Gallerie dell'Accademia, the *Christ Carrying the Cross* in the church of San Rocco and the *Goldmann Portrait* in the National Gallery of Art in Washington, all of which display a more marked note of naturalism, reflecting his laborious struggle with the new pictorial ideas pro-

posed by Titian. Yet they still show the softness that results from nuanced gradations of color laid on patiently, layer by layer, and which constitutes the chief difference between Giorgione's style and the dense and dramatic brushwork of Titian in works executed around the same time.

After Giorgione. However brief, Giorgione's activity had a powerful influence on the course of Venetian painting. Immediately after his death, art lovers began to fight over his works. Those of his pictures left incomplete were retouched by some of the best Venetian artists, described in the sources as his followers. His distinctive style served as a model for lesser artists, who made it something stilted and artificial in which the emphasis was placed on the qualities of sentimentality and mystery that were its most external aspect.

But Giorgione's most authentic message, i.e. his new vision of color, was taken up principally by Titian, who immediately used it to give substance to his heroic humanism. Before moving on to Giorgione's greatest "disciple", however, it is worth taking a look at two artists who, making their debut in that first decade of the century so rich in decisive developments, were in close contact with him at the beginning, and later distanced themselves, in a position made more independent by their departure from Venice and frequent visits to the Rome of Raphael and Michelangelo. These two artists, Sebastiano del Piombo and Pordenone, were roughly the same age as Giorgione, but we can regard them as being closer chronologically to Titian, because of what they came to represent, especially Pordenone, in opposition to the main current of Venetian art, which was characterized by the triumph of illusionistic and sensual coloring. To this Sebastiano and Pordenone appear to have contrasted the more "rational" values of plastic form and movement, derived from Rome, becoming one of the channels through which the anticlassical

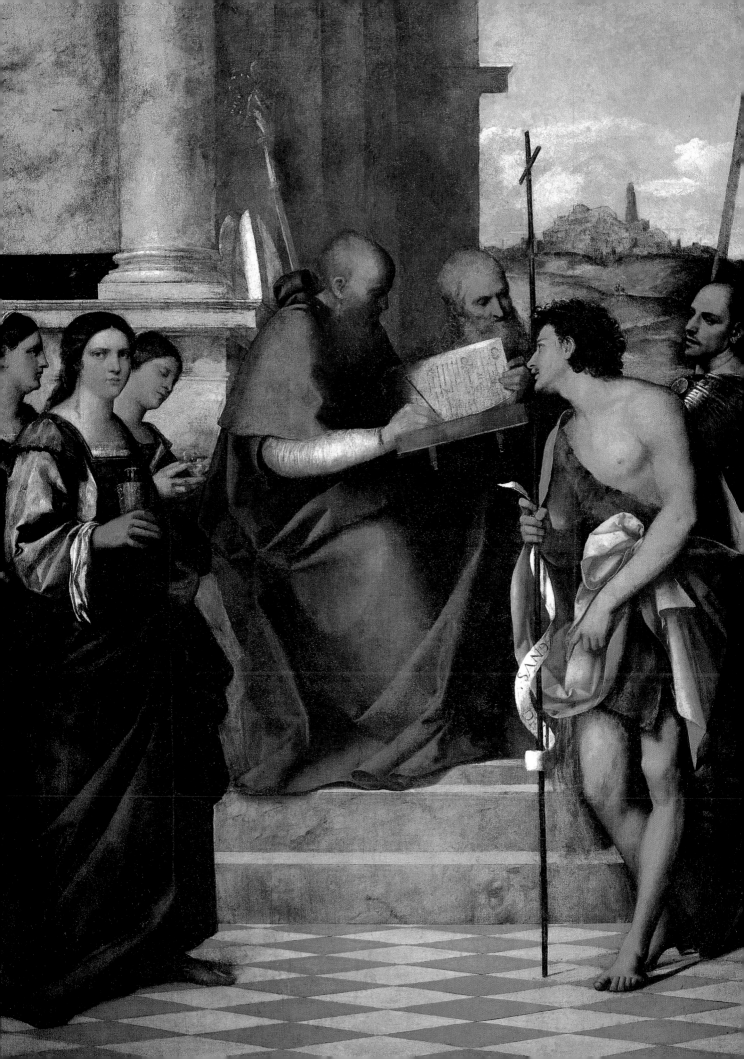

PORDENONE,
The Blessed Lorenzo
Giustiniani and
Saints, Gallerie
dell'Accademia,
Venice, and, *facing
page*, detail.

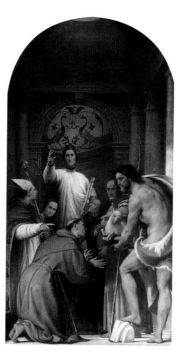

movement of Mannerism that had emerged in Florence and Rome made its way into the classical and luminous painting of Venice, a process whose effects were to become clear only around the middle of the century, when they created the premises for the art of Tintoretto.

Sebastiano Luciani, who in Rome acquired the nickname of Sebastiano del Piombo (Venice, c. 1485 - Rome, 1546), started out as a follower of Bellini, but his first important works were the ones that stemmed from his frequent contact with Giorgione. While it is not easy to distinguish what part he played in the completion of the *Three Philosophers*, his emerging style is certainly discernable in the *Judgment of Solomon* at Kingston Lacy in Dorset: this is a monumental scene with large figures, similar to those on the Fondaco, showing a marked preference for sculptural forms set in spaces framed by architectural perspectives. Sebastiano's version of Giorgione's approach to color is apparent in the elegant and harmonious *San Giovanni Crisostomo Altarpiece*, and above all in the two organ doors of San Bartolomeo which are decorated with *St. Bartholomew* and *St. Sebastian* on the outside and *St. Louis* and *St. Sinibaldus* on the inside (1508-1510). Here the figures, set in niches filled with an atmosphere rendered almost tactile by glittering motes of dust, bring the color to a height of tension thanks to the blurring of the shadows and the stippling of the surfaces with light, displaying an exuberant sensibility. But a precise formal structure is immediately apparent beneath the flood of color: in short, even in his early works, Sebastiano reinforced the tonal lessons of his master through a strict squaring of forms, with an architectural moderation that was classical in character.

In 1511 Sebastiano left for Rome, where he had been summoned by Agostino Chigi to fresco the Sala dei Pianeti in the Farnesina. And it was in Rome that he was to pursue the rest of his career, under the influence of Raphael and Michelangelo.

Like Sebastiano, Giovanni Antonio de' Sacchis, called Pordenone (Pordenone, 1483/1484 - Ferrara, 1539), fell under the sway of Giorgione's painting in his early years. And yet, though he resembled Sebastiano in the propensity for travel that brought him into contact with the most diverse currents of sixteenth-century Italian art, Pordenone could not be described as a true "follower of Giorgione", even at the outset. This was not so much the result of his innate temperament as of the course taken by his training. In fact, he started out in the backward-looking milieu of Tolmezzo. It was only subsequently, after a journey to Padua that brought him into contact with Titian and his dynamic compositions charged with realism, and after visiting Urbino and Rome where he was exposed to the complex influences of Raphael and Michelangelo, that his painting took on a decisively new timbre in the frescoes of Cremona Cathedral, executed between 1520 and 1521. These made him the first artist in Northern Italy to shatter the equilibrium of the Renaissance. In fact, the *Scenes of the Passion of Christ* offers a bold theatrical show of movement with violent foreshortenings and tensions, and relies on vivid colors sustained by a handling of light that was to become an example for the Mannerism of the following decades.

Pordenone's dynamism was unprecedented, and certainly surprised his contemporaries: a tonal dialogue of color and light that in Venice

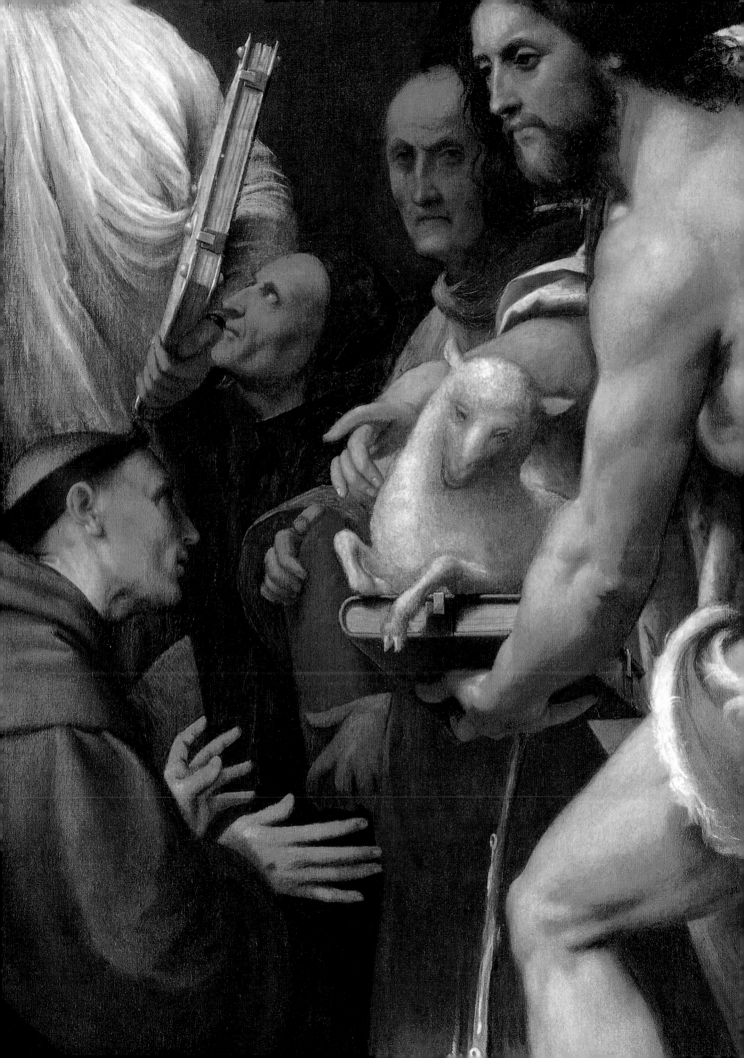

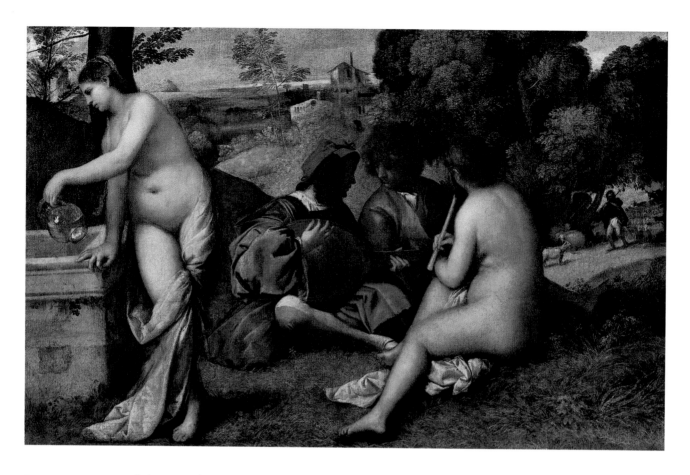

(where Pordenone returned around 1526) had the significance of a sensational assault on the calm and polyphonic coloring of Titian.. Not that Titian was wholly deaf in those years to the echoes of a more plastic style that were arriving from Rome. But the tone of his painting was still founded on a sensual quest for coloristic effects, whereas Pordenone sought and created bolder effects of movement and used more daring foreshortening, in a style of drawing that openly evoked, in its brilliant luminism, the chiaroscuro of Michelangelo. An example from this time is the altarpiece with *The Blessed Lorenzo Giustiniani and Saints* in the Gallerie dell'Accademia, painted in 1532 and characterized by the great plastic relief of the figures, the dramatic force of the composition and the remarkable quality of the color and light.

Titian.

Arriving in Venice as an adolescent, Titian (Pieve di Cadore, *c.* 1488 - Venice, 1576) at once established ties with the finest painter then active in the city, Giorgione. This must, in fact, be the significance of the choice to work alongside him (although not as an assistant) on the decoration of the Fondaco dei Tedeschi, finished by Giorgione in 1508. Titian, as Dolce recorded in 1557, "was not quite twenty years old at the time". There can be no doubt that, in this phase, the younger artist drew on the elder's style to develop his own, which tended to shake off the traditional graphic chiaroscuro of Giovanni Bellini, under whom he had studied. In short, Titian at once began to move in the direction of that "modern manner" based on the autonomous values of color. Yet the idyllic vision and lyricism of Giorgione were soon transformed into a much more robust and dramatic image of humanity: thus out of the "naturalism" of Giorgione was born the "realism" of Titian.

Such a direct derivation was bound to lead to confusion between the works that the two artists painted side by side, at least until Titian began to develop a characteristic style of his own. We know in fact that there were doubts over the attribution of the *Christ Carrying the Cross* in San

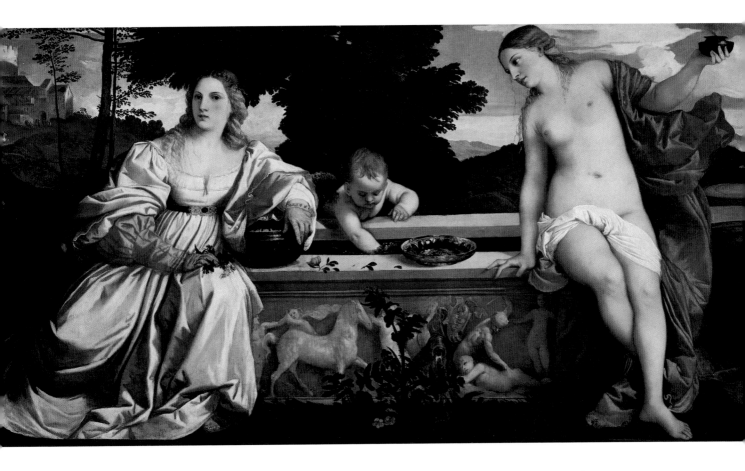

Rocco, which was assigned by Vasari to first one and then the other painter in the 1550 and 1568 editions of his *Lives*. The same problem arises over other works, including the *Concert* in the Palazzo Pitti in Florence and the *Concert Champêtre* in the Louvre in Paris. Notwithstanding the diversity of opinion among the critics, these works can be safely assigned to Titian, in a moment of nostalgia for Giorgione's style, almost a deliberate homage to his master. The fact is that we can find in them, although held in check by the pastoral subject, all those stylistic elements that characterize the early Titian, from the articulated structure of the composition to the predominance of the dialectic between color and light. And it suffices to note the way the two nudes are used to frame the foreground of the *Concert Champêtre*, while the chromatic effect is softened in the dense reddish-brown tones of the musicians; and how a blade of light emphasizes the receding of the landscape, vanishing in the almost corporeal density of the copse of oaks only to reappear in the pale green of the grass.

The whole picture turns on this liveliness of composition, taking on an extraordinary intensity in the figures of the musicians and the two nudes, where it is expressed through the sensuality of the color, glowing in the light.

The three frescoes in the Scuola del Santo at Padua, painted in 1511 just after Giorgione's death, confirm the degree to which Titian's personality had matured. The monumental structure of the *Miracle of the Newborn Child*, where the figures are arranged in the foreground to form a procession of classical tone, the dense vibration of the color, laid on in broad areas over which the light plays, brightening up the tints, and the dramatic intensity of the representation of emotions, even more evident in the scene of the *Miracle of the Jealous Husband*, present us with the figure of an artist who has deliberately broken his ties with the figuration of the past, whether this be the fifteenth-century emphasis on drawing of the Bellini school or the atmospheric lyricism of Giorgione. It is a new humanism of heroic character that now typifies Titian's work and brings to

TITIAN, Sacred and Profane Love, Galleria Borghese, Rome.

page 78
TITIAN, Assumption, Church of the Frari, Venice.

page 79
TITIAN, Pesaro Altarpiece, Church of the Frari, Venice. Detail.

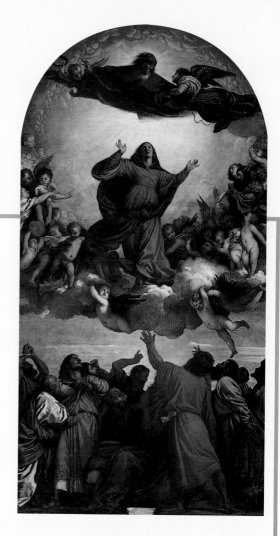

TITIAN'S "ASSUMPTION" AT THE FRARI

The large painting (270 x 140 inches) that constitutes the splendid ornament of the high altar of the church of the Frari was commissioned from Titian in 1516 by the custodian of the monastery of the Friars Minor, Germano da Casale. The painting was installed on May 19, 1518. It is made up of twenty-one panels each with a thickness of one and a quarter inches, fixed together with dovetailed wedges.

The sixteenth- and seventeenth-century sources are agreed in asserting that the altarpiece did not meet with the immediate approval of those who saw it at the time of its creation: the client and the friars often went to "bother" Titian

while he was working on the painting in a studio set up inside the monastery, complaining about the excessive size of the figures of the apostles. The painter responded to these criticisms by saying that they were proportionate to the scale of the church. It also seems that the client – who was evidently still too attached to the style of the late fifteenth-century works of the Vivarini and Bellini families, also present in his church – was initially inclined to reject Titian's painting and only decided to accept it when the imperial ambassador offered to buy it instead.

But the lack of comprehension on the part of the friars soon gave way

to unanimous admiration for this magnificent masterpiece, which was appreciated in particular for the monumentality of its conception, the daring positioning of the huge figures and the fiery quality of the colors. These elements permitted the painting to overcome – to use the words of an eighteenth-century historian – "the contrary light" coming from the windows of the apse, and become the animating point, beyond the marble screen and the imposing wooden choir of the friars, for the immense space of the Gothic church. It is helped in this by the presence of the monumental marble frame that isolates the altarpiece from the light

entering through the windows. It is likely that Titian, who was particularly concerned about the visibility of the painting, played a part in its design (the frame was probably executed by Lorenzo Bregno).

The altarpiece is structured on three different levels, each with a different perspective. In the lower one appear the agitated figures of the apostles; in the middle one the Virgin, accompanied on her ascent to heaven by a flight of angelic putti; in the upper, arched part, the Eternal Father. And yet the altarpiece is made to look absolutely harmonious by the unifying effect of the brilliant coloring.

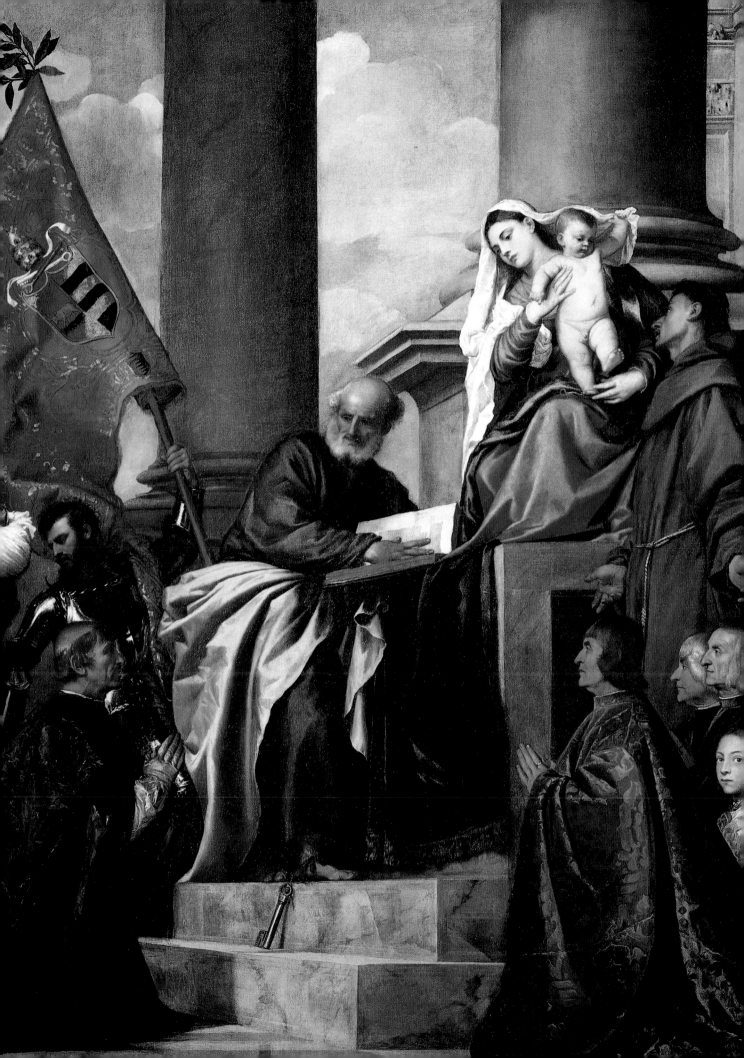

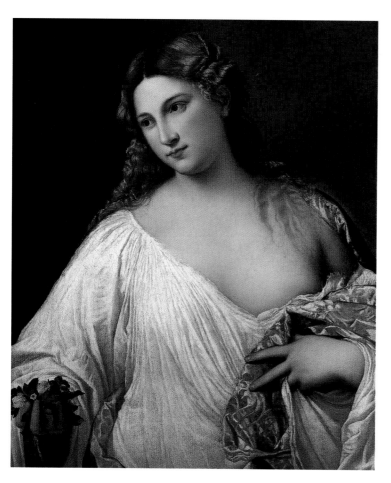

TITIAN, Flora, Galleria degli Uffizi, Florence.

son with the *Sleeping Venus* in Dresden, so balanced in its undulating relationship between the planes in the foreground and the background, immediately reveals the imposing nature of Titian's humanistic mythology. The two splendid female figures display a robust beauty that is also to be found in many of the other paintings of this period (*Flora* in the Uffizi in Florence, *c.* 1515).

Titian set to work on the *Assumption* in 1516, finishing it two years later. With unprecedented violence, he brings the agitated movement of all the figures into the foreground. All given different orientations, their brilliantly colored clothing illuminated by various sources of light, the apostles form the base from which the composition develops. All the rest – Madonna and cherubim, angels and the Eternal Father – rotate in flight, against a sky of burning gold, in a polyphonic crescendo of majestic and yet restrained effect. It is no wonder that Titian's contemporaries celebrated the unveiling of the work with exceptional solemnity. With the *Assumption* – wrote a chronicler with an element of truth – Venice had found "its Raphael and its Michelangelo". Putting hyperbole aside, it is certain that Titian had created a form of expression capable of bringing out his stately and dramatic temperament and at the same time making an important contribution to the scenography of the church, in its formal as well as social aspects.

In the decade between 1520 and 1530 Titian was at the peak of his creativity. The *Assumption* was followed by commissions from the Estensi (*Festival of Venus* and *Festival on the Island of Andros* in the Prado in Madrid, 1519-1520, *Bacchus and Ariadne* in the National Gallery of London, 1523) and from the papal legate Averoldi (*Resurrection Altarpiece* in Brescia). He reached a similar formal level in the portraits of this second decade, in which what was to become their unmistakable characteristic was already apparent: the progressive shift from psychological investigation to poetic idealization, almost the creation

a conclusion the process of naturalistic renewal initiated by Giorgione. A few years later he was to come up with a new model for the mythological idyll in the *Sacred and Profane Love* in the Galleria Borghese in Rome, a new type of altarpiece in the *Assumption* in the Frari, and a new kind of *Sacra Conversazione* in the painting in the Magnani-Rocca Collection, along with some unforgettable portraits in the *Pesaro Madonna*. Of course we are not talking about compositional inventions here, but of a more profound emotional understanding of the human character, a renewal of plastic forms imbued with monumental significance and a dynamic conception of space which certainly drew inspiration from his knowledge of Dürer's work.

His wonderful painting entitled *Sacred and Profane Love* (*c.* 1515) marks the distance he had come from the world of Giorgione. A compari-

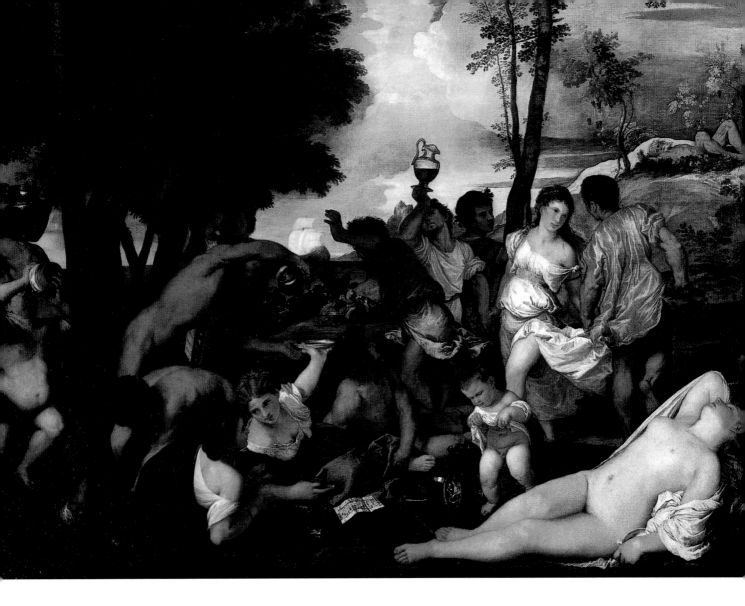

of a "type", at once characterized yet absolute. This is the impression produced by the *Portrait of Vincenzo Mosti* in Florence's Palazzo Pitti, with its subtle vibrations of white and gray, and by the *Man with a Glove* in the Louvre in Paris, faintly reminiscent of Giorgionesque "melancholy" but already remote from that lyrical world in its marked accentuation of the effects of light. An entire gallery of portraits is also to be found in the *Pesaro Madonna* painted for the altar of the family of that name in the Frari between 1519 and 1526. Seeking an epic grandeur, Titian sets the saints and clients on the steps of a colonnaded portico; at the sides, the glowing garments of the senators form a base. The composition, dominated by the figure of Mary Immaculate, is balanced by the flag with its intense shade of red.

Spurred on by his success, Titian devoted the greater part of the fourth decade to satisfying requests from the courts of Mantua, Urbino and the emperor, Charles V. His painting grew increasingly joyful and radiant. The forms were balanced in gilded harmonies, the colors became less aggressive, in an amber-tinted palette.

For Duke Guidobaldo of Urbino he painted *La Bella* in the Palazzo Pitti (1536) and the *Venus* in the Uffizi (1538). Apparently he had not forgotten the design of Giorgione's reclining nude. But what intensity there is in the warm atmosphere of this room; what sense of real humanity in the languid figure of the woman, while the intimacy of the scene is accentuated by the silent activity of the maids, busy choosing clothes from a chest in the background.

Around 1540, the artist reached a crucial turning point. The Mannerist style had made its way from Rome, Tuscany and Emilia to Venice as well. Not that Titian had not already had intima-

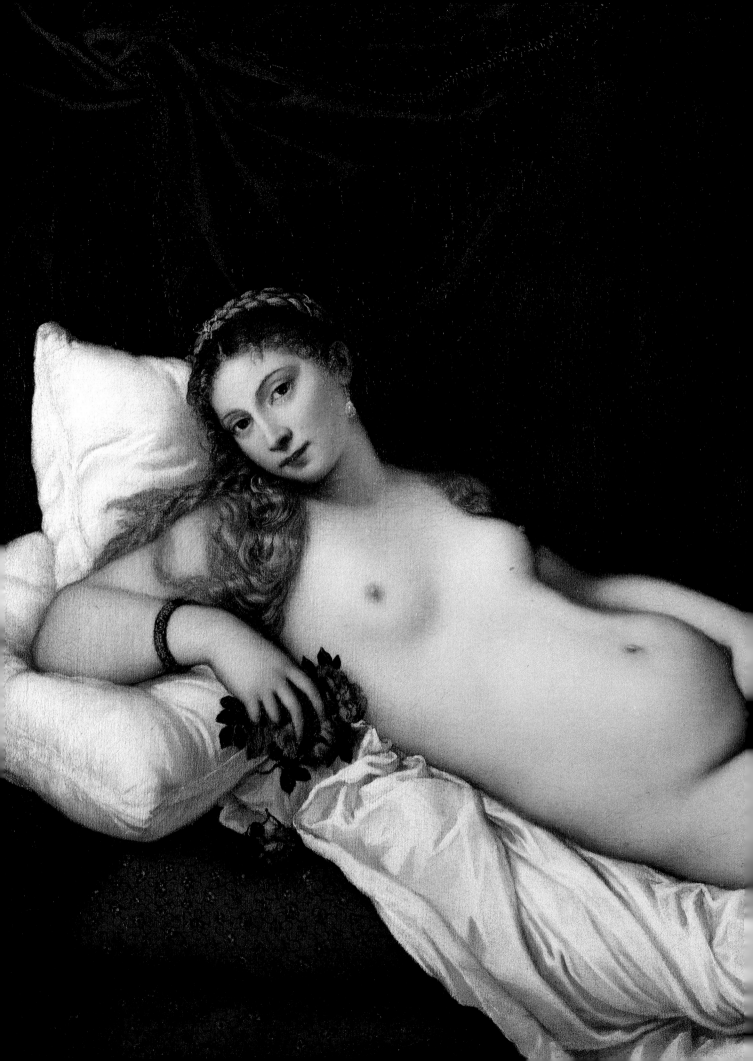

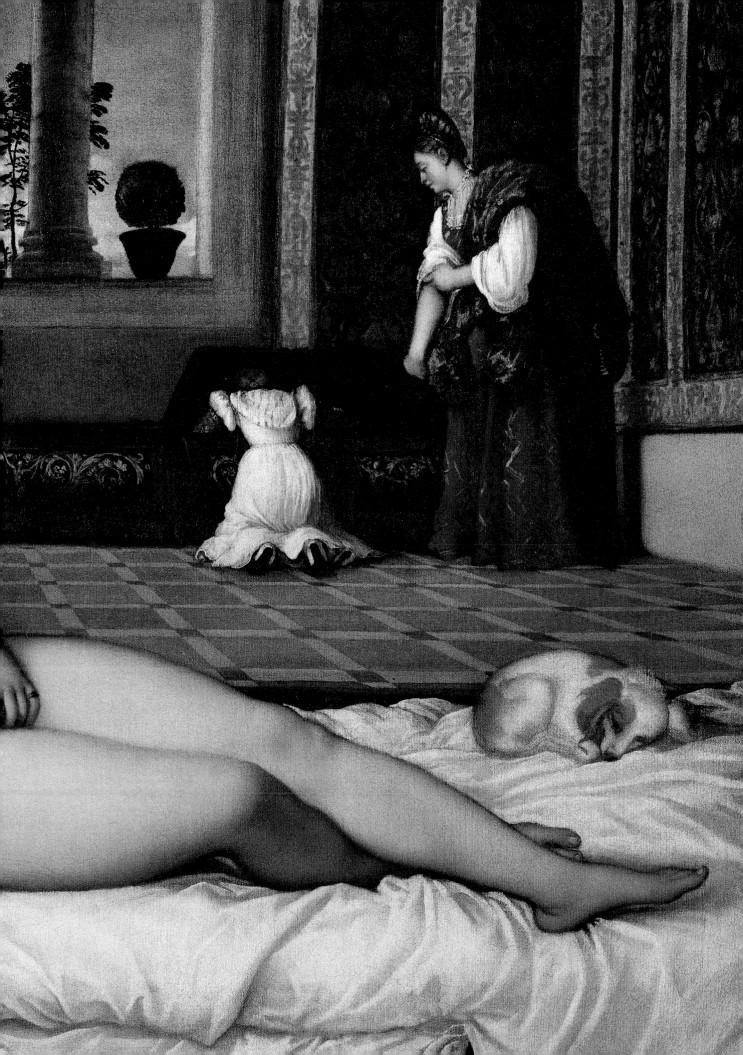

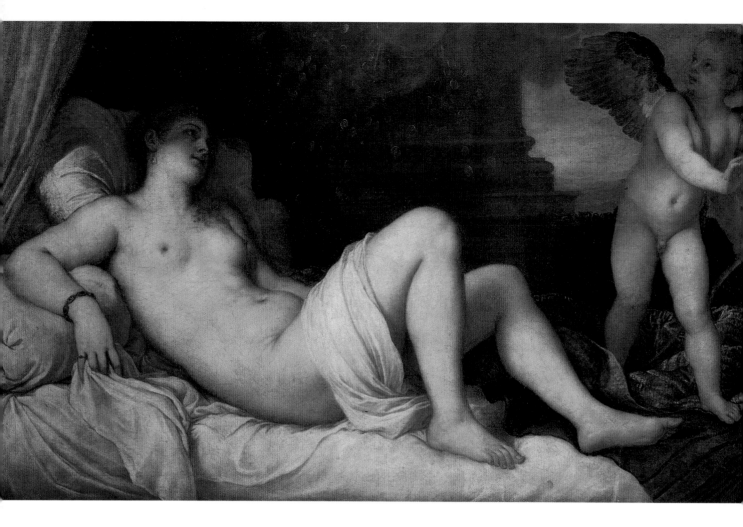

TITIAN, Danaë,
Museo di
Capodimonte,
Naples.

facing page
TITIAN, St. John
the Baptist, Gallerie
dell'Accademia,
Venice.

tions of that figurative culture, but now those ferments, at first ignored, had gained ground and caught the artist at what may have been a moment of low ebb in his creativity. Thus between 1540 and 1545 Titian deliberately moved away from color and sought to make use of a design that placed greater emphasis on chiaroscuro and was more complex in its composition in order to attain a more plastic effect, something which did not always produce poetic results worthy of the effort. We can point, for example, to the imposing *St. John the Baptist* in the Gallerie dell'Accademia, or the *Christ Crowned with Thorns* in the Louvre in Paris (1543), in which the borrowings from classicism in the central figure or the echoes of Giulio Romano only serve to curb the drama of the scenes.

That champion of Tusco-Roman Mannerist painting Giorgio Vasari was also in Venice in 1541 and accepted a commission for three *Scenes from the Bible* for the church of Santo Spirito. In the end, however, they were painted by Titian and are his most avowedly Mannerist pictures (they can now be seen in the sacristy of Santa Maria della Salute in Venice). Vasari's comment that Titian "executed them very beautifully and with wonderful artistry foreshortened his figures from below upwards" comes as no surprise. In fact the foreshortening, melodramatic movement, decorative drapery and monumental anatomies make them striking pictures, although too closely connected – like the *Christ Crowned with Thorns* in the Louvre in Paris before them – to a program with which the artist was not entirely in agreement, attached as he was to the course of his own development.

By now a trip to Rome had become a necessity for Titian as well and the artist went there in the winter of 1545-1546. And yet, painting in a studio in the Belvedere, he seems to make an

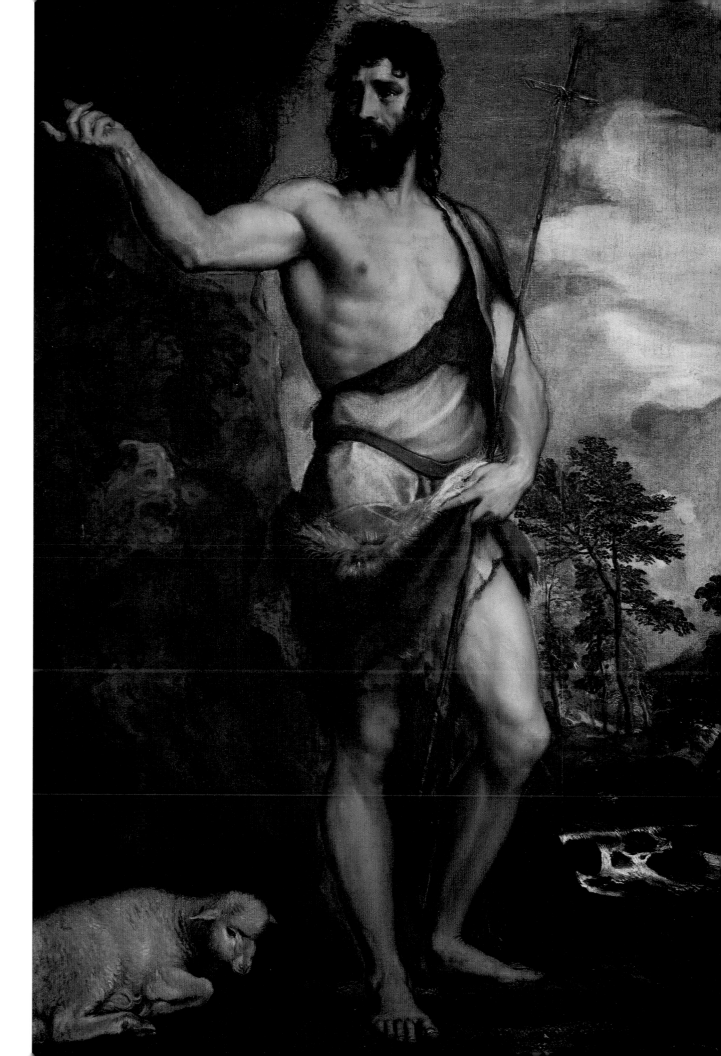

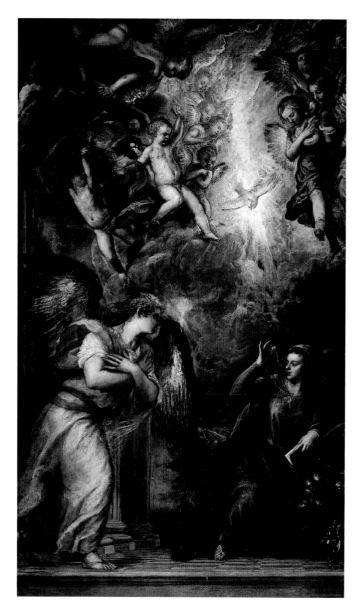

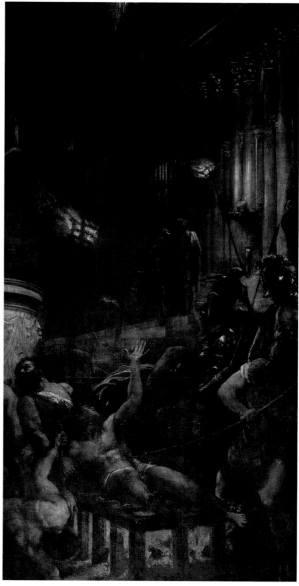

almost polemic return to the independence of his wholly Venetian emphasis on color. This is evident in the *Danaë* in Naples (which he later replicated, some time before 1553, for the emperor, a version that is now in the Prado in Madrid), of which Michelangelo appears to have said that "his coloring and his style pleased him very much but that it was a shame that in Venice they did not learn to draw well from the beginning". In any case, from this time on Titian's compositions grew more dynamic: set in open spaces, they were painted in an increasingly uneven range of colors, sensitive to the effects of the light.

Around 1550 Titian reached the age of sixty. Younger artists like Tintoretto, Bassano and Veronese had begun to contend with him for primacy in Venice, where the style of painting was beginning to change. From this moment on he devoted his attention largely to the requests he received from the court in Madrid, from Emperor Charles V and his heir, Philip II. Between 1548 and 1551 he went repeatedly to the imperial court at Augsburg, where he spent most of his time painting the emperor and members of his court. The following period saw Titian in the service of the new king of Spain, Philip II, who mostly commissioned mythological paintings that were known as "poems": thus the chambers of the melancholy ruler were embellished with *Venus and Adonis, Danaë, Europa* and *Androm-*

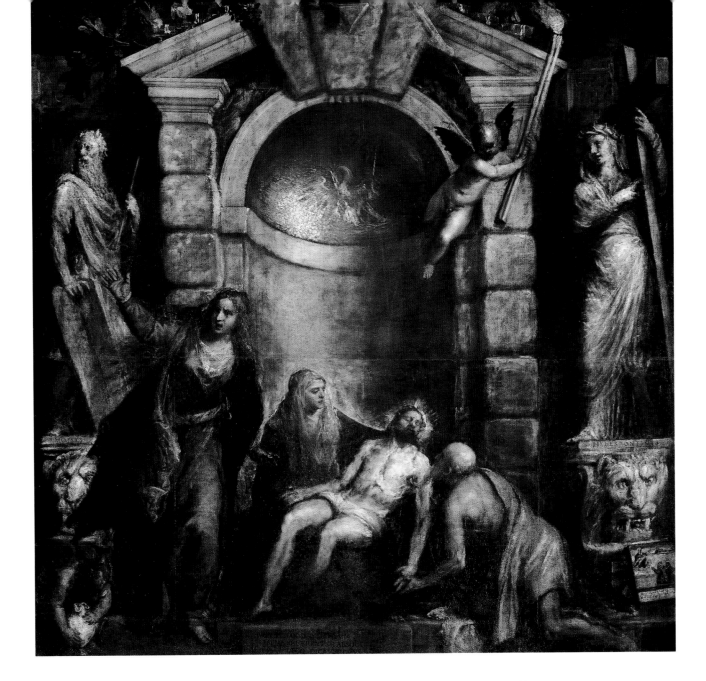

TITIAN, Pietà, Gallerie dell'Accademia, Venice.

eda. Brought back to the subjects of his youth, Titian returned to a denser and more tremulous coloring, enriching his palette with a glittering range of tones. The landscape dominates the scenes, raising its evocative power to new heights. In his late works, the painter showed an ever-growing propensity to seize on the dominant chromatic note, resorting to a luminism that neglected the definition of plastic forms and concentrated on the expressive values of color. From the *Martyrdom of St. Lawrence* in the church of the Gesuiti to the *Annunciation* for the church of San Salvador, and from the *Entombment* in the Prado in Madrid to the *Flaying of Marsyas* in the Umeleckohistorické Muzeum, Kroměríž, Titian increasingly tended to reduce the variable emotion of the color to a dominant tint, and the plastic forms to a vibrant and ghostly image, painted in impasto with agonizing and blurred brushstrokes. After blocking out the figures and building up their forms with successive layers of paint, Titian added the final touch by smudging the borders between brighter and darker tones with his fingertips and placing lumps of black, white lead or red at particular points, in order to bring the surface to life.

One of his last paintings, the *Christ Crowned with Thorns* in the Alte Pinakothek of Munich (*c.* 1570), is a replica of the one in the Louvre, painted almost thirty years earlier. Losing all their

weight and solidity, the figures take on an almost spectral existence; the spent atmosphere absorbs them, rendering the outlines smoky and frayed; vibrant serpentines run over the surfaces with magical effects. And yet, amidst this preponderance of light, the value of Titian's poetry remains rooted in the color, and is sufficient to justify a comparison with the contemporary painting of Tintoretto, closer now on the cultural plane though infinitely far away in its figurative qualities. While Tintoretto was approaching maturity in a vision that anticipated the baroque, Titian's last works, such as the *Pietà* in the Gallerie dell'Accademia, testify, in their realism laden with human pathos, to the master's undiminished capacity for expression which had led him to take a freer approach to the handling of color.

Lorenzo Lotto. The artistic career of Lorenzo Lotto (Venice?, *c.* 1480 - Loreto, 1556) was a highly unusual one, given his independence from the contemporary currents in Venetian painting. In contrast to Titian, who assumed the function of a guide in the first half of the century, Lorenzo Lotto remained a loner, devoted to the jealous intimism of his own style. A restless man, he followed the wandering star that led him from one provincial town to another, from Treviso to the Marches, from Bergamo to Loreto.

The early period of Lotto's activity took place in the first decade of the century, and was already surprising in the way that he showed no interest in Giorgione's tonal revolution, choosing instead to draw on fifteenth-century models or the realism of Northern European painting, introduced into Venice by Dürer himself. In the *Sacra Conversazione (Madonna and St. Peter Martyr)* in the Museo di Capodimonte in Naples, dated 1503, he appears to be a follower of Giovanni Bellini, imitating his composition while enlivening it with effective touches of naturalism in the landscape, painted from life, and in the

gruff and rustic figure of St. Peter Martyr. From 1503 to 1507 he moved between Treviso and Venice. A *Portrait of Bishop Bernardo de' Rossi* (1505) earned him a reputation in Treviso. It is a remarkable work of lucid design, in which the colors are as shrill as those of a flag, and one that is strongly characterized, reflecting the imperious psychology of the sitter. It is not easy to find anything among the portraits by contemporary Venetian painters that matches this stylistically. The crystalline quality of the color could be compared with the figures of Antonello da Messina, but it is most reminiscent, in its incisive representation of reality, of Dürer and his prints, with which Lotto was certainly familiar.

The influence of Antonello and Bellini can also be seen in the *Santa Cristina Altarpiece* in a church near Treviso, painted between 1507 and 1508. However, Lotto's picture differs from Antonello's altarpiece for San Cassiano or Bellini's for San Zaccaria in the shallowness of its visual field, which brings the figures into a more immediate dialogue with the observer. Further evidence of this "directness" can be seen in the swift and burning glance of the figure of St. Liberal, which looks as if it were a real portrait.

In the same period Lotto painted the various panels of the *Recanati Polyptych with the Madonna and Saints,* finished in 1508. This is the most advanced work of his early period, summing up the experiences of fifteen years' activity in Treviso and the Marches. The secret of the poetic charm of this painting may lie in the intense and close-knit orchestration of the discourse. A medium of realistic light sets and binds together the whole of the scene, entering from the side and marking out the shadows and then picking out, with the reflection from the polished flooring, the dimly lit faces of Mary and the saints. Thus light becomes the protagonist of the picture and reveals the tiniest details, recreating a sense of spatial unity beyond the limits of the now archaic form of the polyptych by the sur-

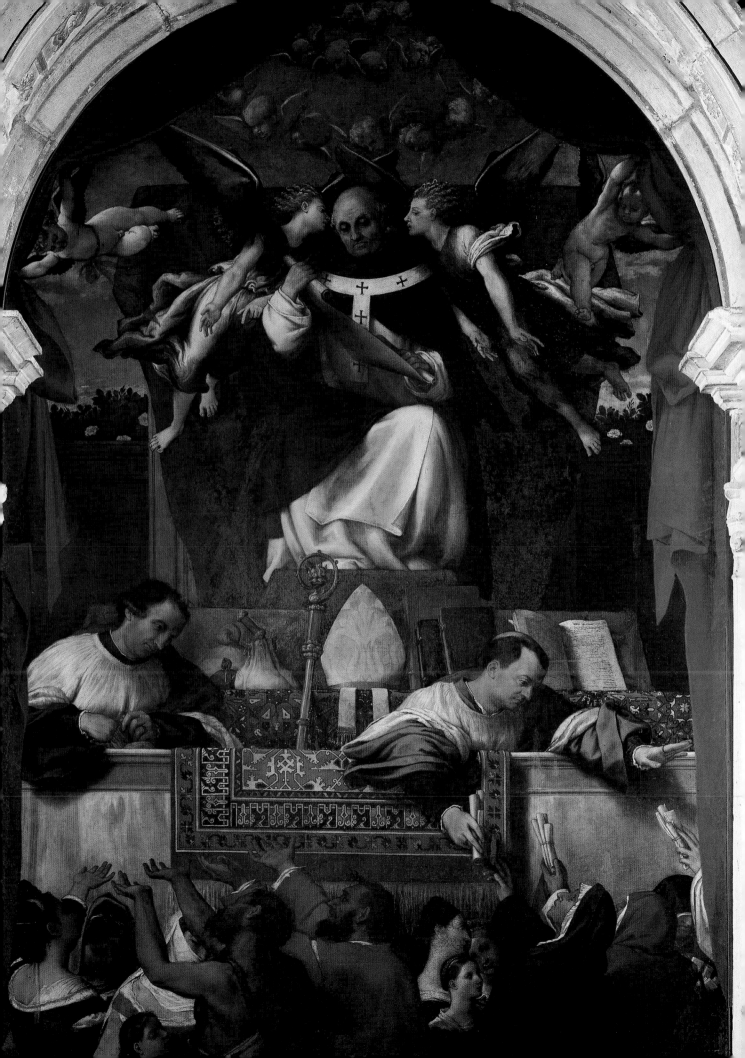

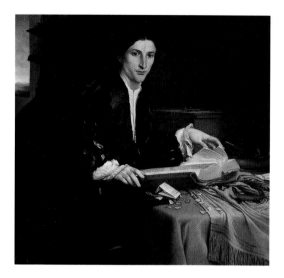

prising device of the receding shadows on the ground, which delineate elongated and slender cones.

This brings to an end the early period of Lorenzo Lotto's career, linked to fifteenth-century models although already moving toward a full independence of invention, built on the foundations of his narrative realism. The opportunity to shake off any archaism was provided by a visit to Rome, probably made between 1509 and 1512. Nothing has survived of Lotto's work in the Stanze of the Vatican, even though the documents show that he was working there at around the same time as Sodoma and Peruzzi. It can be argued that the richness of Lotto's coloring had some influence on Raphael, but Lorenzo must have taken a great deal more from Raphael's painting, completely renewing his own figurative vocabulary. It suffices in fact to look at the first work he executed after his return from Rome, the *Deposition* at Jesi (1512), to gauge the importance of the lesson he had learned there, destined to take his painting in a new direction. The composition is now framed in a wholly natural spatiality, setting aside all the scenographic conventions of the fifteenth century. The attitudes are supple and unconstrained, the malleable figures immersed in the diffuse luminosity of the landscape. The color is lighter

and more expansive, fading out musically into the distance. This time his stay in the Marches did not last long and by 1513 he was already in Bergamo working on the large *San Bartolomeo Altarpiece*, finished in 1516. The atmosphere of Lombardy was providential as it brought him into contact with the pictorial tradition of Foppa and Leonardo and their special interest in the truthful representation of nature, something that agreed perfectly with the whole course of his development. Thus he returned to the narrative vein in which he had started out so successfully in his youth. In a way the altarpieces in Bergamo can be regarded as embodying Lotto's "grand manner". Alongside them, however, the artist produced a no less fortunate series of portraits and small compositions. Initially influenced by Dürer, Lotto's portraiture then came under the sway of Raphael and he went on to define a style of his own in a blend of the two currents. Always penetrating in his ability to capture the natural truth of the sitter, he took a freer approach to form, was more open and varied in his use of color and displayed a special feeling for the interior in which the portraits were set, describing them with great attention to realistic detail, the light well calibrated and the whole enlivened by a quiet and amicable intimacy.

Examples of this are the portraits of the *Della Torre* family in London (1515), and of *Lucina Brembati* in Bergamo (around 1520) and the *Young Man in His Study* in the Gallerie dell'Accademia: masterpieces of a now mature art that brought an attitude of serene independence to the representation of the human figure, remote from any abstract ideal and concerned solely with rendering the secret history and hidden meaning of each subject's soul.

After a brief stay at Trescore Balneario, where he painted the *Scenes from the Lives of St. Barbara, St. Clare and St. Brigid* (1524), and at Jesi in 1525, where he received the commission for the *San Francesco al Monte Altarpiece*, Lorenzo went back

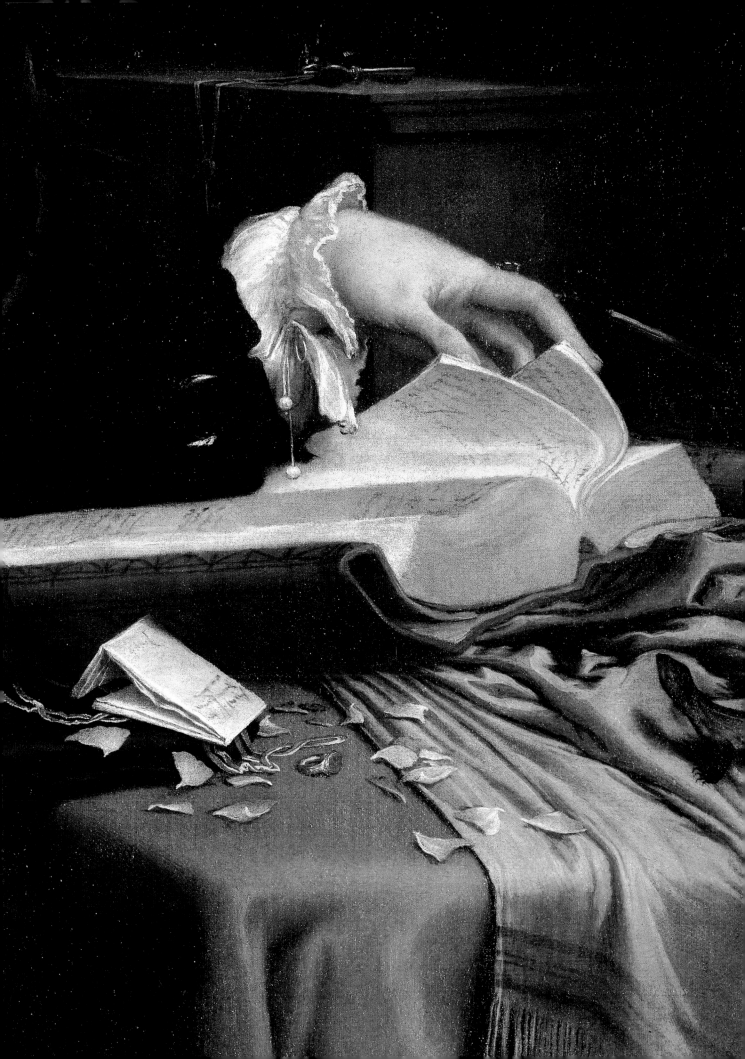

to Venice, setting up his own studio in the monastery of Santi Giovanni e Paolo. In 1529 he obtained his first public commission, for the *Carmini Altarpiece*. It is evident that the artist put a great deal of effort into this work, which he hoped would mark a triumphant return to the city. However, it was – from that point of view – a failure, if we are to accept the judgment of Dolce (1557), who called the picture an "example of bad tints", referring to the evocative but perhaps excessively Northern European landscape, where storm clouds darken the sky above the walls of an old castle, while ships flee across the turbulent sea for shelter in a harbor filled with limpid water. Above, the symmetrical and monumental group of saints is deliberately Titianesque, but for this very reason is unable to escape an academic subservience.

Over the course of time, however, the Venetians would take a less dismissive attitude toward his work and Lotto stayed on in the capital. In the fifth decade he produced a remarkable series of portraits. These include the *Ailing Gentleman* in the Galleria Doria Pamphilj in Rome, a masterpiece couched in pale and bloodless hues; the *Portrait of the Surgeon Stuer* in Philadelphia (1544), strongly characterized by chiaroscuro; the portraits of *Laura da Pola* and *Febo da Brescia* in the Brera (1544); and the *Old Man with a Red Beard* in the same gallery, one of the most suggestive portraits of the Italian Cinquecento. Yet it would not be correct to speak of him moving closer to Titian, even though the broadening of the areas of color is evident and their fusion into a tonal unity made up of highly controlled shades is almost complete.

But apart from a superficial adoption of the language of Venetian art, Lorenzo Lotto maintained his individuality. The *St. Antonino* in Santi Giovanni e Paolo (1542) also dates from these years of compromise with Venetian art. In fact, the upper part of the scene is framed by sumptuous drapes held open by Titianesque cherubs,

while a ring of winged angels is conventionally set around the saint's venerable head. But when we look at the throng of postulants below, and the chorus of waving hands and heads thrust forward that rises out of the shadows and blends the various colors, the painting attains a level of spirituality and pathos that is unique to Lotto.

As his *Libro di spese diverse* or "Book of Sundry Expenses" – an extraordinary artistic and human record kept from 1538 to 1556 – demonstrates, his solitary position meant that his last years were embittered by poverty and disappointment: auctions of his pictures were a failure and paintings commissioned from him were rejected. On August 5, 1554, the elderly painter retired to the monastery of Loreto: "So as not to have to wander around any longer in my old age, I have decided to live a quiet life in this holy place". Only three years later this unbending artist, certainly the most individual to have been active in Italy at the height of the Renaissance, ended his life in retreat and silence.

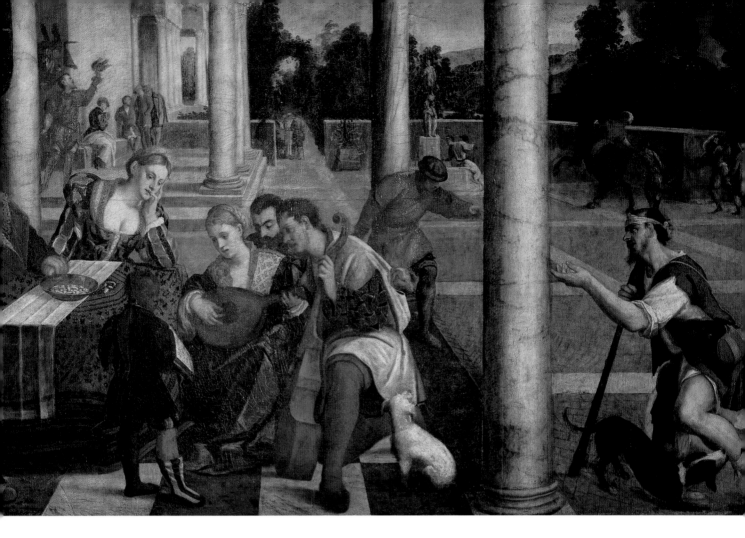

Toward Mannerism. From the third decade of the sixteenth century onward early Mannerist ideas began to make their way into Venice in a sporadic manner, through the experiences of individual artists. Fairly marginal was the adoption of Mannerist forms by Bonifacio de' Pitati (Verona?, 1487 - Venice, 1553), who, after painting various *Sacre Conversazioni* in light and brilliant colors, renewed his approach to composition under the influence of Roman works, and those of Raphael in particular. From this moment on Bonifacio's coloring was subordinate to a more coherently integrated figurative discourse, often resulting in a narrative of great effect and a frank representation of human events that was to make an impression on the young Tintoretto and on Bassano.

Paris Bordone (Treviso, 1500 - Venice, 1571), on the other hand, was more strongly influenced by Titian. An instinctive colorist, he was drawn to effects of iridescence which he created by letting light play along the edges of his elegant and sinuous forms, as in the portrait in London or in the sumptuous portraits of women in Munich and Vienna, which were painted around the end of the third decade. Later, a stay in Lombardy (1524-1527) brought him into contact with Lotto's realism and, on a subsequent visit in the 1540's, with the cold tints of Moretto. Later still, he would come under the influence of Giulio Romano (*Jupiter and Io* in Göteborg, *c.* 1559).

More interesting is the figure of Andrea Meldolla, called Schiavone (Zara, *c.* 1510/15 - Venice, 1563). It is obvious that he started out in the ambit of the rich Titianesque coloring of the decade 1530-1540, but he soon added to this the new element of an enthusiastic adherence to the refined and elegant forms of Parmigianino. Once again it was the distribution of prints that served as the vehicle for the transmission of a style that led to the development of a particular Mannerist language. And Schiavone can be said to have been the most deeply affected of all Venetian painters by the crisis in form, which only had a transitional effect on the others.

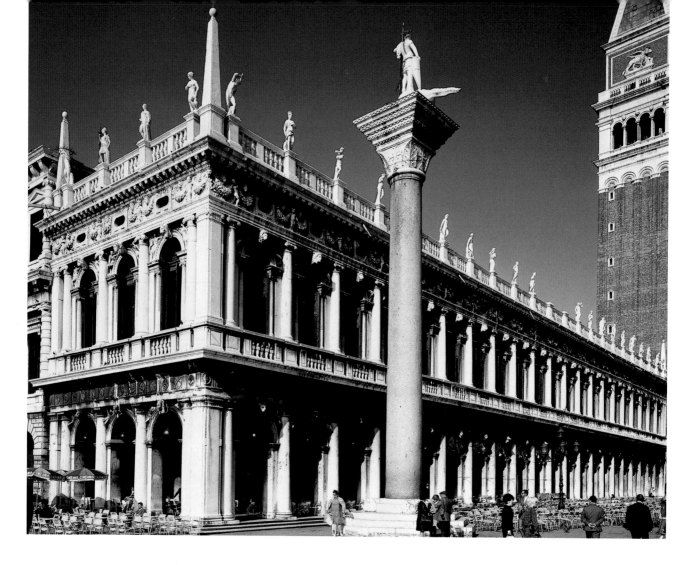

JACOPO SANSOVINO,
Library of St. Mark,
Venice

In the meantime other important developments were taking place in Venice. Francesco Salviati had arrived from Rome in 1539 with his pupil Giuseppe Porta (also called Salviati), and with them one feels the genuine spirit of Raphael. In 1541 the Tuscan Giorgio Vasari (destined to earn greater renown as a historian of Italian art, with his *Lives of the Most Excellent Architects, Sculptors and Painters*, of which the first edition was published in 1550 and the second in 1568) also came to Venice. In the same year Vasari decorated a ceiling in Palazzo Corner Spinelli with panels painted in a revolutionary *sottoinsù* perspective (literally "from below upward"), arousing great interest among the younger artists and impressing even Titian.

But it was the younger generation – i.e. that of Bassano, Tintoretto and Veronese – that was most affected by the challenge made to the principles of the Renaissance and of Venetian painting by the painters of *buon disegno*, i.e. in

the "manner" derived from the study of sculpture and the works of the great Tuscan and Roman masters. Further on we shall examine the consequences of this.

Architects and Sculptors. Even in fields outside painting, important figures were connected with the arrival of Mannerism in Venice, coincident with an event of great historical significance: the sack of Rome by the imperial troops of Charles V in 1527. As a result, a number of leading artists fled from Rome to Venice, including the writer Pietro Aretino and the architect Jacopo Sansovino, giving new impetus to the diffusion of Mannerist aesthetics.

Like many of his contemporaries, Jacopo Tatti, called Sansovino (Florence, 1486 - Venice, 1570), practiced both sculpture and architecture. He received his training as a sculptor in post-Michelangelo Florence. However, his limpidly classical style was softened by picturesque refine-

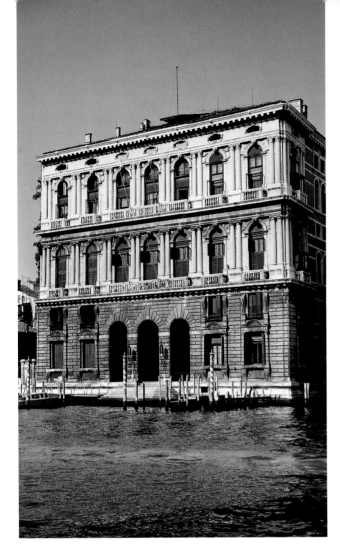

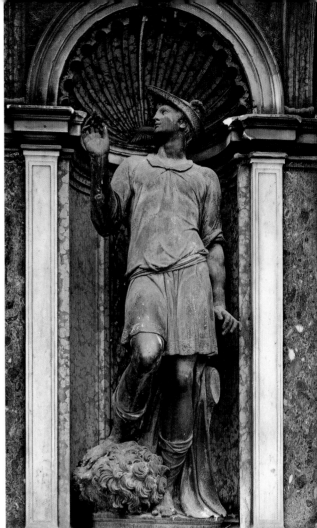

ments derived from Andrea del Sarto, as can be seen in the *Bacchus* in the Museo del Bargello (*c.* 1514). His formation as an architect, on the other hand, took place in Rome, where he worked with the followers of Bramante. In 1527 he joined the circles of Titian and Aretino in Venice and became one of the most influential figures in the city's art world. Appointed proto of St. Mark's in 1529, he took charge of the ambitious operation of urban planning carried out at the behest of Doge Andrea Gritti, which set out to give a new and triumphal face to Piazza San Marco and the Piazzetta, the nerve centers of the republic.

Work on what is now known as the *Libreria Sansoviniana* began in 1537. It is also known as the Library of St. Mark, and includes the National Library, the Old Library (the *Libreria Marciana*) and the Archaeological Museum. In it, Sansovino succeeded in marrying his classical culture, filtered through the Mannerist architecture of Rome, with the traditional play of light

and shade of Venetian architecture, displaying an extraordinary feeling for scenographic effect. The shadows grow deeper in the portico, laid out with solemn majesty along the piazzetta, and then pass, with successive shading, from the gray band of the cornice to the rhythmic luminosity of the columns of the second order and the terrace, which is adorned with statues. It is therefore an architectural facade whose monumental elements are subordinate to the delicate vibration of a pictorial sensibility that is typical of Venetian Mannerism. The library also performs an important urbanistic function, giving a solemn appearance to the piazzetta in front of the Doge's Palace and clearing the area around the campanile, previously filled with medieval structures.

Sansovino went on to design numerous works of architecture, commissioned by the nobility and the government, starting with Palazzo Dolfin-Manin on the Rialto (1538) and

left
JACOPO SANSOVINO, Ca' Corner della Ca' Grande, Venice.

right
JACOPO SANSOVINO, Mercury, Loggetta of the Campanile, Venice.

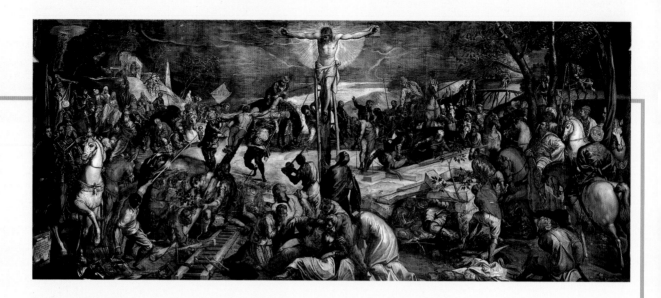

JACOPO TINTORETTO IN THE SCUOLA DI SAN ROCCO

The Scuola Grande di San Rocco was founded in 1478. Its seat stands in the *campo* named after St. Roch of Montpellier, the saint, along with Sebastian, to whom the Venetians were most prone to turn in times of danger. It was built, following the recurrent outbreaks of plague that devastated the city in the fourteenth and fifteenth centuries, from 1516 onward to a design by Bartolomeo Bon. Work on the construction of the grand building dragged on for a long time, in part as a result of disputes with the architect, who was dismissed in 1524. His place was taken first by Sante Lombardo and then by Scarpagnino. The building appears to have been completed, at least as far as its essential structures were concerned, in 1548, the year preceding Scarpagnino's death. The finishing touches were added by Giangiacomo dei Grigi, who brought his work on the Scuola to a conclusion in

1560. At this point the problem of the pictorial decoration of the building arose. Titian had already offered to paint a picture for the Sala dell'Albergo in 1553. However, in 1564 the members of the confraternity decided to hold a public competition, and Paolo Veronese, Giuseppe Salviati and Federico Zuccari took part. But, as the sources tell us, Tintoretto preempted his colleagues by donating to the Scuola a canvas representing *The Glorification of St. Roch* and thus laying the foundations for a privileged relationship with the institution. The competition was canceled and Jacopo was entrusted with the task of decorating the second floor of the building, which he carried out in the space of just three years, from 1565 to 1567.

The complex decoration of the ground floor includes the ceiling – with the aforementioned *Glorification*

of *St. Roch* at the center, surrounded by numerous canvases with allegorical representations of the seasons, the other Venetian Scuole Grandi and *Virtues* set inside large wooden frames – and the walls, where *Scenes of the Passion* are depicted. Here the figure of Christ inevitably dominates, not as a victim but triumphant: at the top, dressed in white clothing that stands out against the shadows, before Pilate; invincible in his own faith; seated as a triumphant king in the *Crowning with Thorns*; a heroic figure in the *Road to Calvary*; reaching out to embrace the pain of all humanity in the *Crucifixion*.

The same feeling of tense expressiveness characterizes the canvases painted by Tintoretto for the ceiling of the Sala Grande on the second floor from 1576 onward. Scenes such as *Manna*, the *Brazen Serpent* and *Moses Finding Water in the Desert* exude that sense

of popular mysticism that was already present in the Sala dell'Albergo. Cascades of light emphasize the events, skies rent by lightning accompany the celestial apparitions. Even more extraordinary are the ten pictures on the walls, painted between 1577 and 1581, which again depict, continuing the theme of the decoration of the Sala dell'Albergo, *Scenes from the Life of Christ*. Jacopo's last work was in the lower hall, for which he painted, between 1581 and 1588, eight large canvases with *Scenes from the Childhood of Jesus*, the *Assumption*, *St. Mary of Egypt* and *St. Mary Magdalene*.

In celebration of this great pictorial undertaking, the Scuola di San Rocco has been described as "Tintoretto's Sistine Chapel". What is certain is that the painter's work in the Scuola represents one of the highest achievements in the Venetian art of any age.

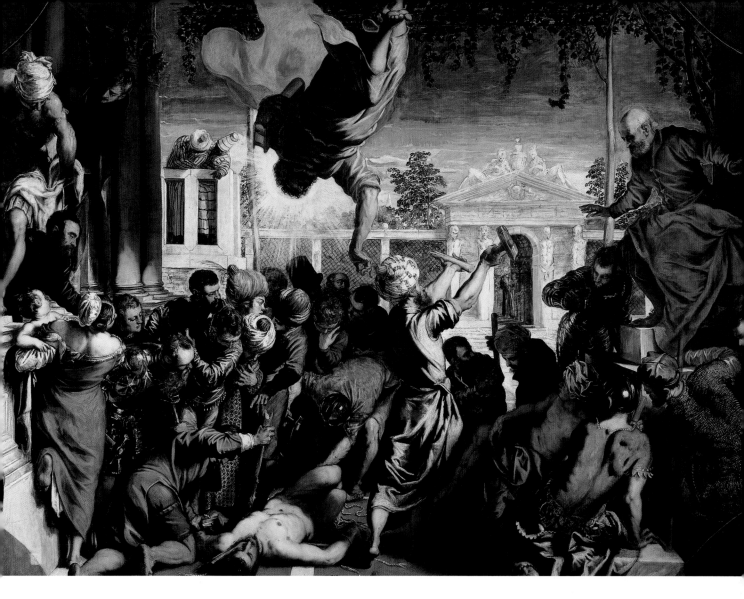

culminating in the palace built for the Corner family on the Grand Canal in 1545, a masterpiece of Mannerist scenography.

The works of sculpture produced by Sansovino in Venice spoke the same language. The statues set on the delicate loggetta of the campanile (between 1538 and 1545) are all subordinated to the effect of the light, which models them in the chiaroscuro of their niches. An ever more marked quest for picturesque effects led him to limit the use of marble, preferring more ductile materials like terracotta or bronze. In fact his sculptural masterpiece is the door of the sacristy of St. Mark's, cast in 1562-1563. In the *Deposition*, the echoes of Donatello's *rilievo schiacciato*, or flattened relief, are fused into a dynamic vision of the forms, with broken and agitated reflections of light that can be compared to the contemporary figurative vision of Jacopo Tintoretto.

Tintoretto. The traditional claim that Jacopo Robusti, called Tintoretto (Venice, 1514-1594), entered Titian's workshop at a very early age and was then expelled from it due to either lack of understanding or professional jealousy is probably true. Whatever the case, we have to look for Tintoretto's first masters among the artists opposed to the style of Titian, that is to say among the exponents of Mannerism. In fact his earliest works, dating from 1540 onward, such as the *Sacra Conversazione* in the Wildenstein Collection, New York, display clear references to the plasticism of Michelangelo rather than to Titian.

After this moment, in which Tintoretto took what he needed from the artists most committed to a plastic representation of forms, the influence of Schiavone brought a new vivacity to his color and at the same time induced him to place more emphasis on narrative, rendering his style increas-

JACOPO TINTORETTO, Miracle of the Slave, Gallerie dell'Accademia, Venice.

facing page
JACOPO TINTORETTO, Crucifixion, Scuola di San Rocco, Venice.

following pages
JACOPO TINTORETTO, Crucifixion, Scuola di San Rocco, Venice. Detail.

ingly dramatic. In the *Scenes from the Bible* on the wedding chests in the Kunsthistorisches Museum in Vienna (1543-1544), his gift for narrative took a more and more articulate turn, in which the fluid and concise line and the lively and expressive brushwork came to take the place, with luministic accents, of Titian's customary language. Light, hitherto treated as an atmospheric medium for molding the color, gradually turned into an autonomous means of expression, valid in itself as the basic element of his figurative language.

Thus Tintoretto came to the execution of the canvas representing the *Miracle of the Slave*, commissioned by the Scuola di San Marco in 1548: a work that almost seems to recapitulate the stages of his development. The chronicles of the time record the mixed reactions to the picture which, in the Venice of Titian, sounded a violent and aggressive note. Nothing could be further from the mark, however, than the seventeenth-century critic Ridolfi's claim to find in it "the design of Michelangelo and the coloring of Titian". Where the former is concerned, we know the extent to which his style had been filtered by Mannerism; and then the color is wholly subordinate to the language of luminism, which was already an unmistakable characteristic of Tintoretto's style. So light is the true protagonist of the *Miracle*: a fantastic light that, entering from above and the side, creates a scenic effect, canceling out the actual illumination of the setting. Poised on the ray of light, the massive and foreshortened figure of the saint floats along a symmetrical diagonal that intersects, in the space, with the one along which the body of the martyred slave is aligned. This was the first hint of a technique of "composition by contrast" that Tintoretto had derived from Michelangelo but that was to become typical of his art, in which it took on a profound and dramatic significance.

The *Miracle of the Slave* closed the first decade of the artist's activity. Subsequently, the luministic tension of Tintoretto's language diminished,

transforming itself into an ever more molten and denser handling of the paint, in which the aspiration to Mannerist preciosity seemed to resurface. In the pictures for the Scuola della Santissima Trinità (1550-1553), including the *Adam and Eve* in the Gallerie dell'Accademia, the landscape is painted with such sensitivity to the emotional values of light and shade as to almost eclipse its natural state. An analogous effect, with the landscape subordinated to the dramatic unity of the vision, can be found in the agitated *St. George* in London, where the composition swirls upward to a sky riven by lightning, in an atmosphere rendered tumultuous by the passage of the light.

By now Tintoretto had reduced nature to a luministic and phosphorescent commentary on his figurative vision. This is at once apparent from a comparison between the *Susanna and the Elders* in Vienna and Titian's several paintings of Venus, where Tintoretto is as abstract as Titian throbs with sensuality. Even the countryside turns into pure arabesque in the *Susanna*: the hedge of roses, contrasted with the nude, is hardly more than a broad tapestry used to enhance the luminosity. Even the vibration of the light does not tend, as it did in earlier works, to accentuate the plasticism of the form, but spills over it in an artificial transparency of color. This marks an important stage in the development of Tintoretto's style, now moving toward a totally unrestrained fantasy.

So if we want to define his attitude toward nature, we have to conclude that he tended to transfigure it to meet the needs of his luministic dynamics. Thus the landscape is in turn incandescent or serene, stormy or decorative. Even the human figure is subjected to a handling of form that verges on expressionism.

The 1560's saw Tintoretto at the height of his creative powers. For the Scuola di San Marco, he painted three *Scenes from the Life of St. Mark* (now in the Gallerie dell'Accademia and the Brera in Milan) in a forceful style that returns to the freer

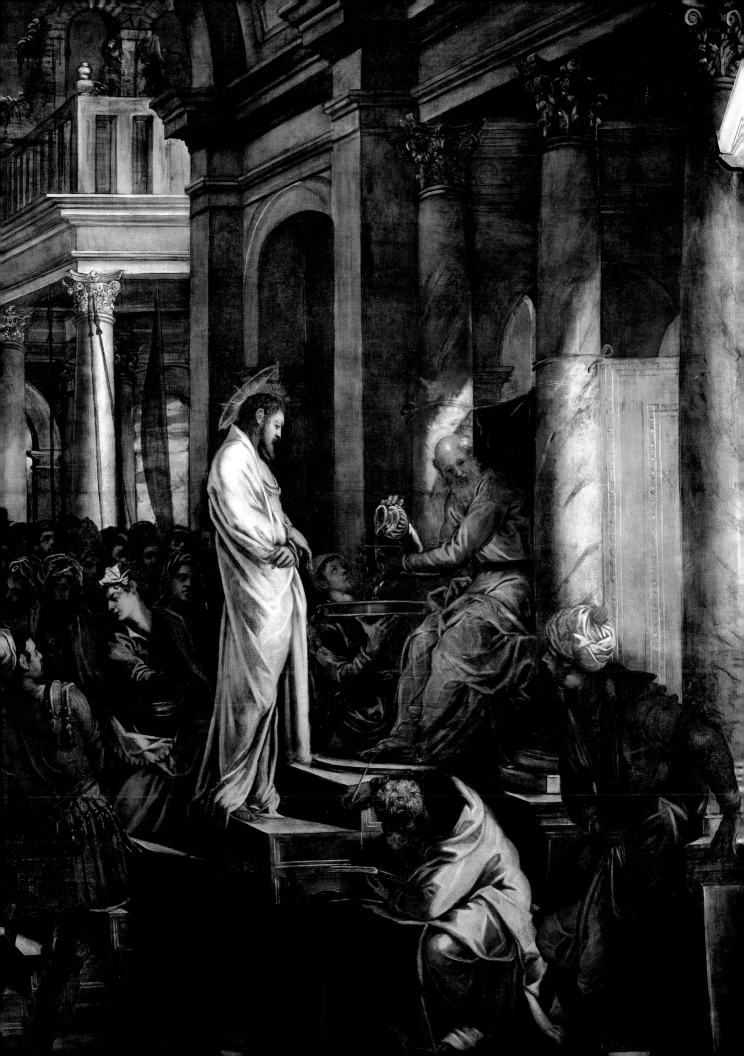

forms of Mannerism. For the Madonna dell'Orto he created the enormous canvases of the *Last Judgment* and the *Golden Calf*, with a search for effect that sometimes descends into theatricality, but attains an incredible vitality of representation. And so we come to the decoration of the Scuola di San Rocco, in 1564, a commission that he obtained through a competition in which he adroitly outmaneuvered his rivals Salviati, Veronese and Zuccari.

The Scuola Grande, with its immense walls to be covered in their entirety with canvases, was to be the adventure of his life and keep him occupied until 1587. The *Scenes from the Old and the New Testament* comprise, in fact, many of the finest examples of Tintoretto's choral sensibility and deep religiosity, almost always kept on a very high level of spiritual tension. The decoration of San Rocco was certainly his most private and intimate challenge, on which he worked alone, with hardly any assistance from his now flourishing studio. The greatest masterpiece of all in San Rocco is the *Crucifixion* in the Sala dell'Albergo (1565), a majestic and harmonious composition in which his complex vision of space is taken to dizzy heights in the pyramidal groups that occupy the scene. The color is subdued and vibrant under the flashes of light, expressionistically pathetic in its tone.

In the canvases of the upper hall (1575-1581), Tintoretto took his sense of dynamics to even greater lengths, producing one of his finest works in the *Christ before Pilate.*. The canvases in the hall on the ground floor, painted between 1583 and 1587, see the painter's language stripped down to a phantasmagoric flow of light, culminating in a fantastic nocturnal effect in the *St. Mary of Egypt.* Here we encounter the artist's most contemplative picture. The saint is looking up from her reading to gaze at the horizon, lit up by sulfurous gleams. The foliage and the water, the distant mountains and the profiles of the houses, seem to catch fire and swell up. Tin-

toretto's luministic coloring has now become something basic and spare, approaching a monochrome of dull brownish tones.

This painting was probably the last in the "San Rocco" cycle. Here Tintoretto already seems to be on the threshold of the baroque: in the use of light for the expression of movement; in the choral, popular subjects, often rendered with the freedom of a genre painting; and in the multiple and interconnected spatiality.

These characteristics of his style are now so strong that they even appear in paintings

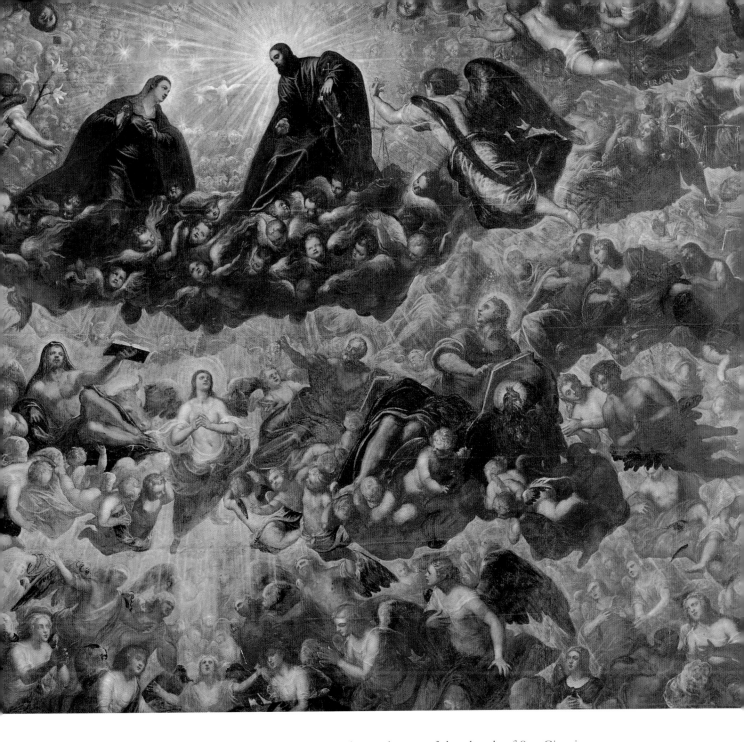

intended for a public with a more "formal" taste than that of the amenable members of the confraternity of San Rocco: in particular in the Doge's Palace, where he painted *Battles* and *Profane Scenes* between the 1570's and 1580's, playing a significant part in the redecoration following the fires of 1574 and 1577. In the Salone del Maggior Consiglio he also painted the huge canvas of *Paradise*, in collaboration with his son Domenico and his large studio (1588-1592).

Tintoretto's final masterpiece was the *Last Supper* that hangs, along with the *Fall of Manna*, in the presbytery of the church of San Giorgio Maggiore: a phantasmagoric vision, where light and shade are used to construct angelic forms out of the vapors that rise in the dimly lit room that houses Christ and the apostles.

Bassano. Compared with the dominating personality of Titian and the "heroism" of his painting, Tintoretto, as we have seen, appears to have been the painter of the middle class, as represented by the confraternities of Venice. Rather than being addressed to a world of supermen, his

JACOPO TINTORETTO, Last Supper, Church of San Giorgio Maggiore, Venice.

painting aimed for a religious spirituality of a popular flavor. Jacopo Bassano, similar to Tintoretto in age and in his solitary stand with respect to the great Venetian tradition headed by Titian, chose instead to turn to nature, understood in its everyday reality.

Jacopo da Ponte, called Bassano (Bassano del Grappa, *c.* 1510-1592), spent almost the whole of his long life in the town of his birth and managed to hang onto the freshness and purity that stemmed from this provincial isolation, while showing an awareness of cultural developments in the capital..The son of a painter of modest talents, he was a follower of Bonifacio de' Pitati in his youth and imitated him in the academic compositions of his early works. The *Madonna of the Podestà Soranzo*, in the Bassano Museum, datable to 1536-1537, already displays a degree of independence in the freedom of the color, in certain details that are reminiscent of Lotto and in the forceful plasticism of the figures, which calls Moretto to mind. So Bassano looked not so much to Titian as to other artists from the provinces, who already represented the vanguard of "reality painting" in contrast to the triumphant emphasis on color of the Venetians.

Around the year 1540, Bassano also changed direction and took up Mannerism with enthusiasm. His interest was distinctly intellectual in nature, but sustained by a remarkable independence of poetics that allowed him to adopt certain decorative features without being dragged into the stylistic anonymity of the minor painters. Above all, it encouraged him to persist in his refusal to adopt Titian's tonalism. But when looking at one of the masterpieces he painted around 1543, the *Martyrdom of St. Catherine* in the Bassano Museum, one cannot help noticing the polemical character of the composition. It is based on a close interlocking of forms in a measured equilibrium of movements and spaces that recalls – although with a more rustic but imperious tone – the elegance of Parmigianino. Arranged in a space of

varying depth, this intellectual distribution of mass allows him to regulate the chromatic values with care, producing an effect that is like a brilliant intarsia and that will soon be transformed into a vivid and plastic luminism.

Jacopo overcame the intellectual limitations of Mannerist canons by turning to nature. In the *Rest on the Flight into Egypt* in the Pinacoteca Ambrosiana he produced a touching example of bucolic poetry, in a glittering triumph of color that was intended to produce a new understanding of the vivifying presence of light, which it renders limpid and precious. There are flows of silvery white in the swaddling clothes of the

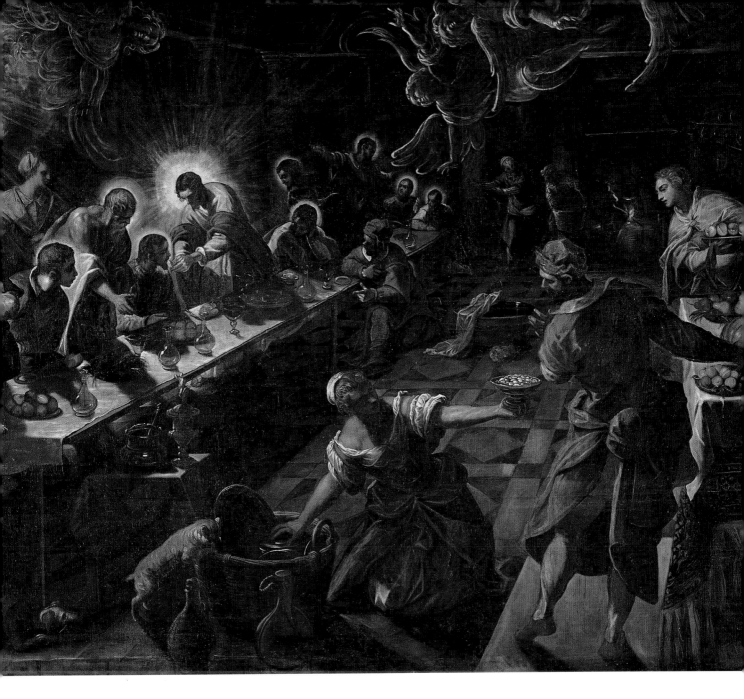

Child and in Mary's veils, along with gleaming emeralds in the pattern of foliage against the sky and warm impastos in the ruddy faces of the shepherds and the soft and shiny fleece of the animals. In 1562-1563, the *Crucifixion* for San Teonisto, now in the Treviso Museum, provided confirmation of this fundamental change in Bassano's style. The brushwork, emphasized in his earlier work, is now quite different from Titian's impastos. It has grown autonomous and independent, and is used to create an exceptional plastic effect with a range of cold tones that give it a sharp luminosity. This marks the onset of Bassano's mature style, free of any Mannerist formulation and reflecting a realistic vision of nature, where the life of a rustic humanity takes on a coherent sense of poetry in a twilit landscape.

In tranquil isolation, Jacopo produced a series of masterpieces. In 1568 he painted the *Adoration of the Shepherds* in Bassano Museum. It is set in a nocturnal atmosphere that dims the lively shades of yellow and blue, wine-red, gold and silver into precious iridescences. Bassano's handling of light is, in short, based on color rather than on chiaroscuro as in Tintoretto's painting. Thus he underlines his independence of his famous colleague and rival, an independence that did not of course exclude contacts between the two artists,

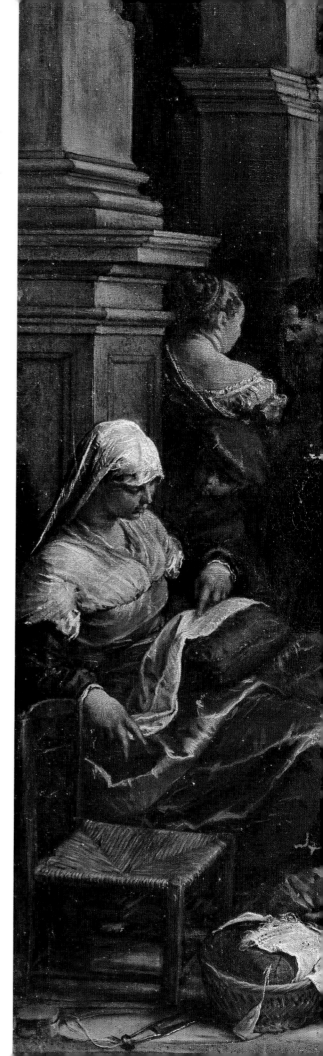

an exchange in which the balance of indebtedness was often in favor of Bassano.

Almost all the paintings executed around 1560 depict agricultural scenes, for which he now showed a decided preference. These include the *St. John the Baptist* in Bassano, where the human figure has become part of the surrounding nature, and the *Country Scenes* in the Thyssen Collection in Lugano (*c.* 1565), without doubt his finest landscape and capable of rivaling those of the Dutch painters who passed through Venice. From that naturalistically represented world he draws accents of extreme formal refinement and profound humanity.

After 1581, partly as a consequence of fading eyesight, Jacopo Bassano's output diminished, but among the rare paintings of the last decade of his life, the *Baptism of St. Lucilla* in the Bassano Museum is of outstanding quality, with its silvery gleams in a velvety nocturnal atmosphere that is barely illuminated by the shower of light that falls onto things, almost liquefying their surfaces. The glitter of the saint's clothing; the dew that glistens on the copper pots heaped on the ground; the straw basket and chair; the landscape with its mysterious shadows: these are a series of "still lifes" painted in the most daring brushwork that make Bassano's luminism a true anticipation of seventeenth-century painting.

Andrea Palladio and Paolo Veronese.

The ideological conception that emerged in the Venetian art of the mid-sixteenth century, and that was most visible in the works of Tintoretto and Bassano, proposed a vision of the world quite different from the Renaissance tradition, i.e. from the heroic exaltation of man as the center of the perceptible universe. In fact, Tintoretto, with his dynamism of form, opened the way to baroque spatiality, while Bassano discovered completely new and hidden qualities of reality, creating the premises for landscape painting, the still life and the popular genre scene.

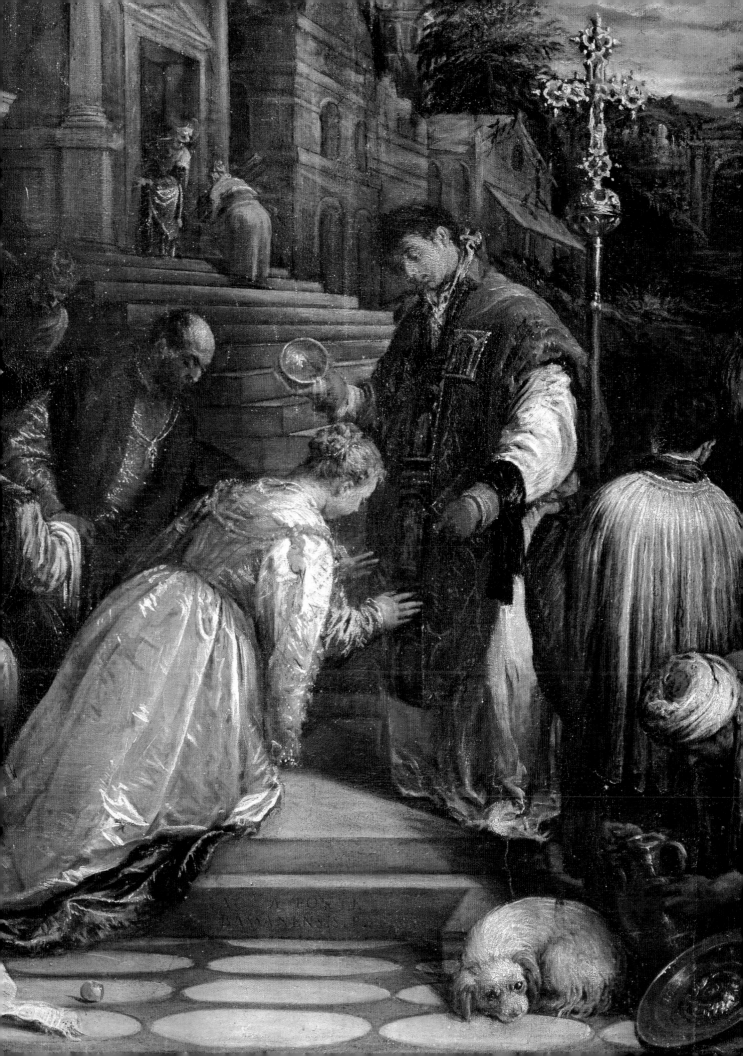

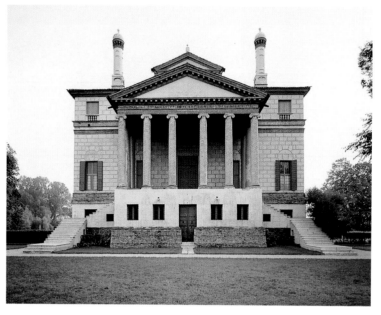

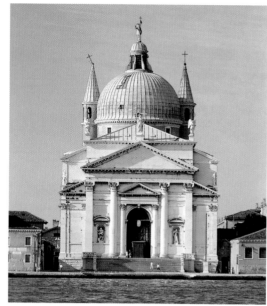

Yet the second half of the century saw the emergence, alongside these precursory tendencies, of a new and distinctive approach that, in the way that it harked back to a magnificent vision of the ancient world, and in its serene and radiant handling of color, seemed to want to reestablish the flagging dominion of classicism. This was the world of Andrea Palladio and Paolo Veronese.

The real significance that should be attributed to the "classicism" of these two artists is certainly not that of the artists in Rome, from Bramante to Raphael, who had interpreted antiquity in terms of a typically Tuscan plasticism, i.e. subjecting it to rational laws of design and perspective. Palladio's architecture, like Veronese's painting, while using a classical vocabulary, moved onto a different terrain and drew distinctive ideas from the Venetian milieu. It was always more deeply rooted in an illusionistic vision than in a rational one, a vision founded on laws of chromatic rather than geometric perspective and therefore more responsive to the aesthetics of Mannerism. To speak of the classicism of Palladio and Veronese, therefore, is only legitimate in a special sense: to the extent, that is, that the term can be understood in an ahistorical way. In fact, they give to the forms of antiquity a value of their own, separate from their plastic qualities and their justification through perspective, representing a beauty that is absolute and not dependent on a relationship of forms.

Andrea Palladio (Padua, 1508 - Venice, 1580), appears for the first time working as an apprentice on the villa at Cricoli that Giangiorgio Trissino was having rebuilt in 1537. The friendship that he forged with the famous humanist and the generous aid that he received from him allowed the young architect to establish an independent position and to execute his first work, the villa at Lonedo. He went to Rome with Trissino in 1541, returning with a stock of studies and drawings of ancient buildings and works of art that were to remain the basis of his figurative vocabulary.

His first major work, the Palazzo della Ragione in Vicenza, known as the "Basilica" and begun in 1549, shows that Palladio tended to interpret Roman antiquities in a personal way, bringing to them all the warm sensibility of a native of the Veneto. Hence the essentially chromatic design of the Basilica's grand facades, where a portico and an arcade in the Roman manner are used as fronts for the fourteenth-century hall, should be traced back to his early training in Padua. It is evident that in this imposing work Palladio was thinking of the rhythm of solids and voids in the Colosseum rather than of Sansovino's library in nearby Venice. But where

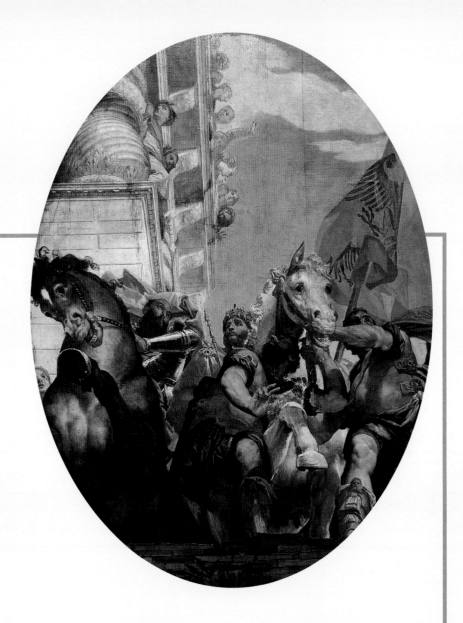

SAN SEBASTIANO:
A CHURCH FOR PAOLO VERONESE

San Sebastiano is a small church, and not even particularly significant from an architectural point of view, standing in a very isolated part of the city that was once inhabited chiefly by fishermen and sailors. But the modest building designed by Antonio Abbondi at the beginning of the sixteenth century is in reality the container of a precious collection of paintings by one of the greatest representatives of sixteenth-century Venetian art: Paolo Veronese.

Paolo began to work on the decoration of San Sebastiano shortly after his arrival in Venice, painting the canvases on the ceiling of the sacristy in 1555. Immediately afterward, he executed the three large scenes set on the ceiling of the church's nave, representing *Scenes from the Story of Esther*, an extraordinary triumph of his lively narrative vein and exceptional feeling for color.

From then on Paolo worked for the church almost uninterruptedly for nearly two decades, producing an impressive series of masterpieces on canvas or in fresco that completely cover the walls of the building. Perhaps the most striking of all the works in the church are the frescoes in the nave, where Paolo reaches heights never before attained in the liquidity of the colors and in the iridescent vibrations. But even more in these works he shows himself capable of adapting his extraordinary inventiveness to the limitations imposed on him by the fairly cramped space of the nave. A good example of this is the scene of the *Martyrdom of St. Sebastian*, with the archer painted on the left-hand wall shooting his arrows right across the nave to strike the saint on the opposite wall. An equally powerful illusion is created by the mock door at which a monk and a Negro boy appear, symmetrical with the real door through which the friars made their entrance into the choir of the church: a splendid anticipation of the *trompe-l'oeil* that Paolo was to paint a few years later in Palladio's Villa Barbaro at Maser.

his style reveals its full autonomy is in the exaltation of the pictorial quality of the members, treated in isolation as a value in its own right, against the chromatic modulation of the areas of shadow. So the Basilica's classicism already has a distinctive tone. It does not set out to create a block with a monumental effect based on planes of perspective vision, but seems rather to want to play a scenographic part in its surroundings. In this way Palladio's architecture appears to be the fruit of an empirical conception, and one that is more than ever designed to meet the demands of the society of an individualistic character in which he was operating. In fact there was no other architect of his time who always worked on a human scale in the way that Palladio did. We have proof of this in the numerous villas to which he devoted much of his activity.

It was in the early period of his career that he built the Villa Barbaro at Maser. Finished in 1559, it is set on the slope of a hill, with a central block in a classicizing style and two wings with highly functional and picturesque turrets. It would be decorated with frescoes by Paolo Veronese. The Villa Foscari (known as La Malcontenta) was almost complete by 1561. It is located picturesquely on a bend in the river, in a gently rolling landscape in which the almost perfect cube of the construction sits lightly thanks to the tactile chromatic quality of the surfaces. Even La Rotonda (Villa Almerico-Capra) at Vicenza, begun in 1567 and the masterpiece of his maturity, despite the apparent classicism of a central plan with four arms ending in colonnades, stems from a sincere feeling for the picturesque.

Although he always lived and worked in the territory of the Repubblica Serenissima, Palladio

spent only the last decade of his life in Venice itself. As early as 1560, however, he had begun work on the renovation of the complex of San Giorgio Maggiore, starting with the imposing refectory and then, in 1565, the new church. In 1577 he started on the church of Il Redentore, one of his masterpieces. Set at the water's edge on the island of Giudecca, where it is often in direct sunlight, the gigantic building seems to hover just above the surface of the water, while the dazzling mirror of the lagoon reflects a haze of light onto the flat and linear facade. On it, the various triangular profiles of the tympana and the gable ends of the roofs intersect in a close-knit pattern that rises upward to conclude in the vast dome. Inside, a long rectangle contains the nave, around which are arranged the semicircular chapels, alternating with coupled columns, in an evident but delicate reference to Roman forms. This rectangle is closed at the bottom by a flight of three steps and at the top by a massive cornice, making it look like a large, freestanding and luminous hall. An ellipsoidal transept leads into a more secluded zone, culminating in the presbytery enclosed by a screen of four columns, behind which the choir is visible. The space is filled with a white and diffuse light, canceling out the shadows: a harmonious interplay of arches, circular moldings, vaults, niches and domes creates a polyphonic ensemble, couched in a silvery, triumphal range of tones. And yet this architecture of bewitching eloquence and joyful creativity is assembled out of the most modest materials. The columns are built of plastered brick and even the fanciful capitals are made of painted wood. Palladio's last work, the Teatro Olimpico in Vicenza, begun in 1580

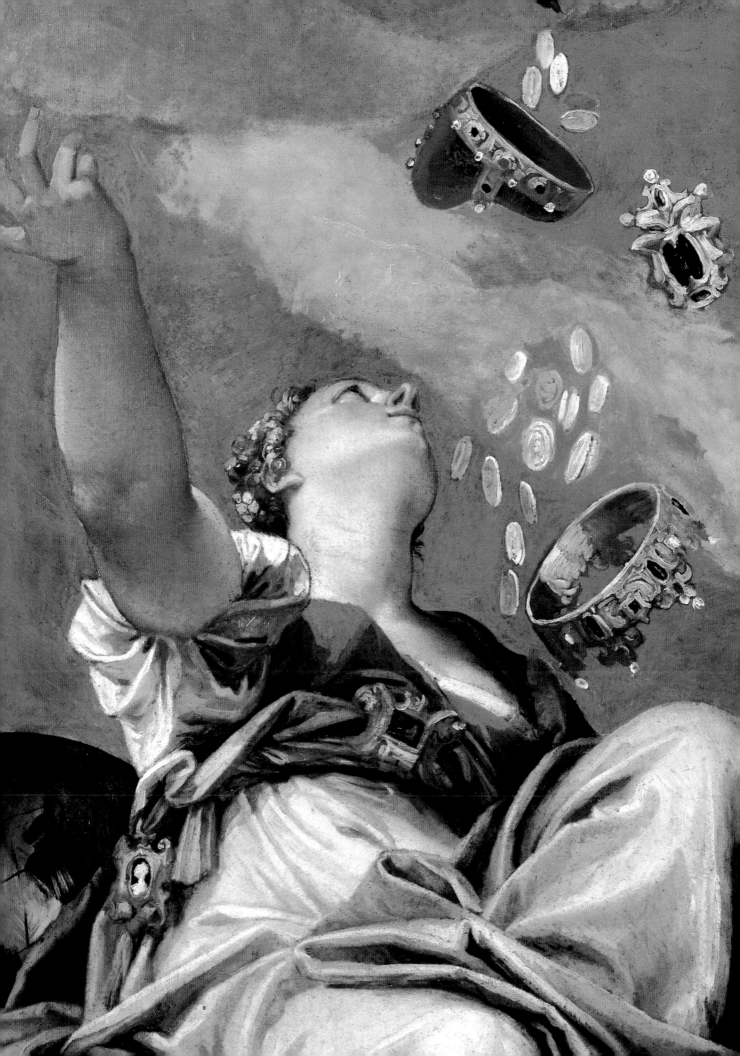

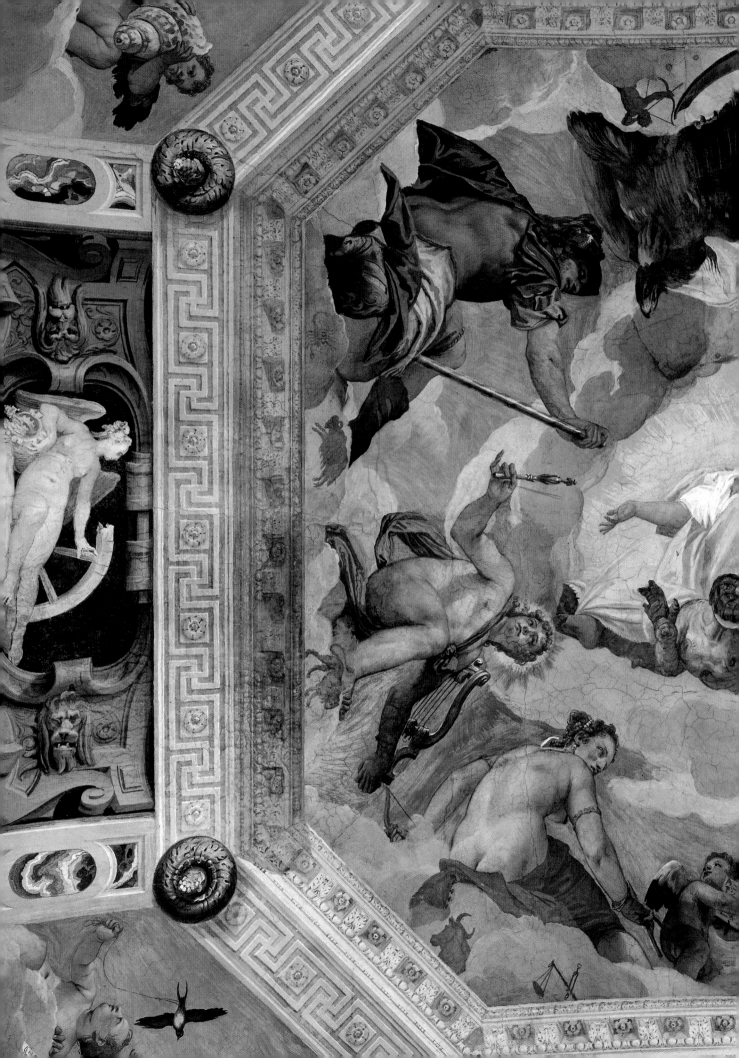

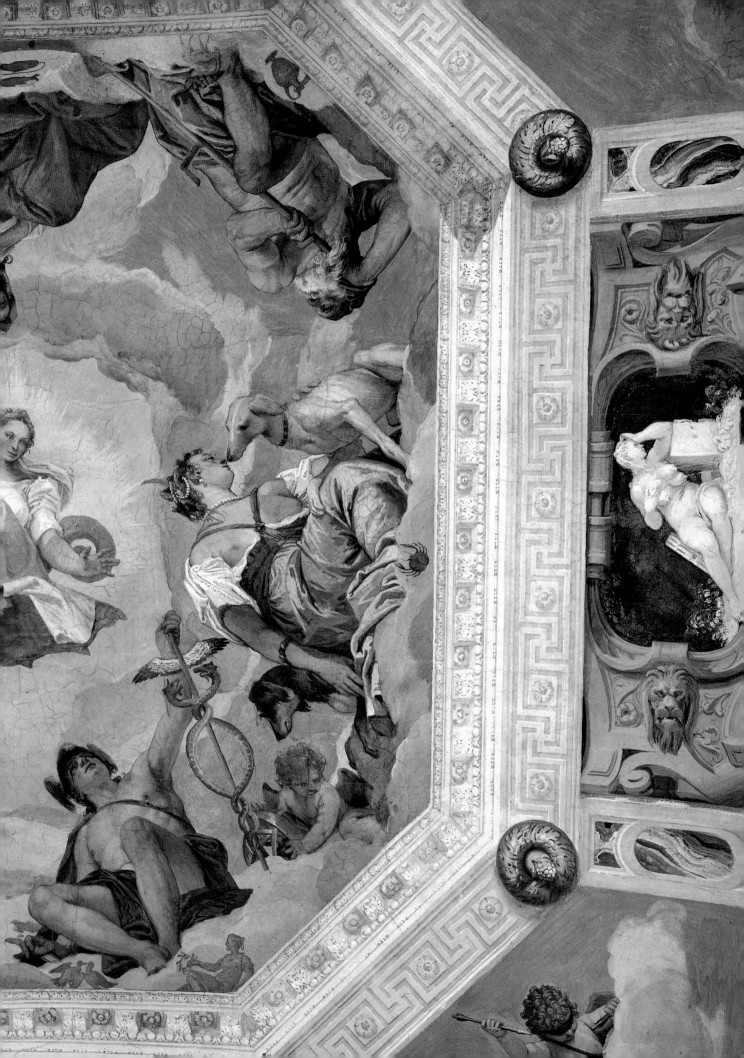

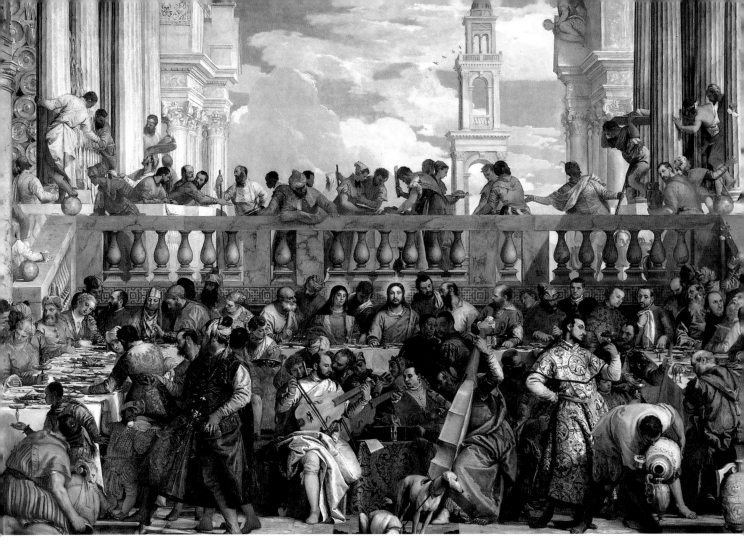

but left unfinished at his death, is also built largely out of wood. The auditorium is occupied by a semi-elliptical tier of seating surmounted by a gallery crowned with statues, and by the stage in the form of a monumental facade, pierced by five openings behind which are set backdrops painted in perspective by Vincenzo Scamozzi.

Paolo Caliari, called Veronese (Verona, 1528 - Venice, 1588), was the other representative of the current that we have defined as "classicist" in the Venetian art of the late sixteenth century. Less obviously linked to the actual forms of antiquity than Palladio, he can still be classified alongside him for the tendency to create an analogous spatiality in his images, one that went beyond both the tonalism of Titian and the chiaroscuro of Tintoretto.

His figurative language is based on a world of almost abstract chromatic values, in so far as they are detached from the problems of the description of reality, as well as from the representation of a dynamic space. His palette of colors is serene and steeped in a bright and cheerful light. The shadows are imbued with hidden vibrations. His pictures, painted with joyful bliss on canvases and on the walls of aristocratic villas and the Doge's Palace, take on a musical quality, almost an elated comment on the good fortune of being alive in sixteenth-century Venice.

At the outset Paolo, like his contemporaries, was influenced by Mannerism. But this influence was at once more direct and of less effect: more direct, because he received his early training in Verona, where he had firsthand experience of the Emilian and Roman schools through the works he saw in nearby Parma and Mantua; of less effect, because it acted on an artist whose vision was clearly empty of any naturalistic intent, as well as of any intellectualistic pathos. In short, Veronese set out to create an unconstrained and festive language of color. This attitude was in its own way profoundly classical, not in a "historical" sense, but

in that of an Olympian faith in his own poetic universe.

On this level, one could almost accuse the detached melody of grays, pinks and greens in the early *Bevilacqua-Lazise Altarpiece* in the Museo di Castelvecchio at Verona (*c.* 1548) of frigidity. But it suffices to observe the transparency of the colored shadows that emerge at the top, in the angels under the

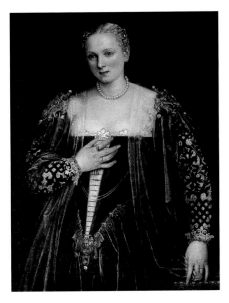

drape, to realize at once the new character of Veronese's approach to color. The beginning of the 1550's saw Paolo free himself from all his previous influences, from the Mannerism of Parmigianino to the rich tonalism of Titian. Arriving in the capital around 1551, he made a name for himself with the *Giustiniani Altarpiece* in San Francesco della Vigna, where, while borrowing from the composition of Titian's *Pesaro Madonna*, he displayed a clarity of timbre and a graphic skill in the lively juxtaposition of pure and luminous tints. Much the same can be said of the mythological canvases in the rooms used by the Council of Ten in the Doge's Palace (1553-1556), such as the picture of *Juno Showering Gifts on Venice*, in which a propensity for Mannerist foreshortening is already enriched by a sumptuous and variegated palette, shot through with gleams of gold and silver, hinting at what was soon to come.

By the time he started on the decoration of the church of San Sebastiano (where he worked on several different occasions from 1555 onward), Paolo's style had found a stable formulation, and one to which he was to remain essentially faithful. The objective of his painting was not the dramatic or idyllic representation of reality, as in the work of Titian or Bassano, nor its hallucinatory transfiguration, as in Tintoretto's. Paolo did not belong to the category of the dramatists, but to that of the contemplatives: in fact his figures adopt Olympian and serene poses and give off a radiant energy, invading even the most hidden corners of the soul and exalting it in the contemplation of so much beauty.

To be convinced of this, it is enough to look at the ceiling of San Sebastiano, painted in 1556, where we can find all the decorative joy of Veronese's world. To depict the young *Esther*, climbing a colonnaded staircase that recalls Palladio's La Rotonda, or the *Triumph of Mordecai*, Veronese used the most festive coloring that had ever been seen in Venice, in a range of pale tints that is the unmistakable mark of his style. The matching of shades, the transparency of the shadows and the scintillating brushwork create an unforgettable effect of luminous, musical painting. A great contribution to this is made by his technique, which surpasses Titian's tonalism (i.e. the harmonious fusion of tints) as well as the luminism of Tintoretto and Bassano (which can be roughly described as an exaltation of the chromatic values of light in contrast with darkness). Paolo, anticipating modern theories of the composition of light, instinctively discovered the increase in luminosity that stemmed from the contraposition of two complementary colors (i.e. the ones that, mixed together, make up white, the brightest of all tints). His reds and blues, his yellows and violets come together to create a myriad of multifaceted planes of light, with an unreal effect of extraordinary intensity. The local tints take on the reflections of those set alongside them. Black is abolished and even the shadows are tinged with color, so that the luminosity of the picture is greater than that of reality itself. From this effect comes the illusion of an exaltation of life, rendering it more brilliant, more effervescent and more joyful.

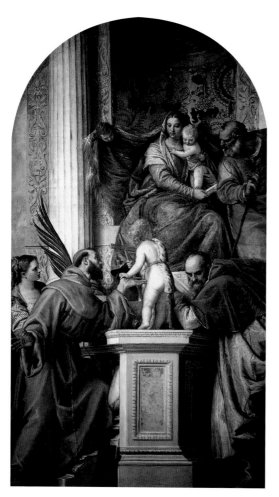

PAOLO VERONESE,
San Zaccaria
Altarpiece, Gallerie
dell'Accademia,
Venice.

facing page, above
PAOLO VERONESE,
Mystic Marriage
of St. Catherine,
Gallerie
dell'Accademia,
Venice.

facing page, below
PAOLO VERONESE,
Baptism of Christ,
Pinacoteca di Brera,
Milan.

This language, which is of the highest decorative poetry, found its most exuberant application in the frescoes of Venetian villas and palaces. The most famous of Paolo's decorations is that of the Villa Barbaro at Maser (*c.* 1560). The landscapes he painted in its rooms open up the walls illusionistically and emit a calm and relaxed luminosity, spilling over into the color of the setting, which grows soft and intimate. Above, in lunettes and ceilings adorned with architectural perspectives, easily understood mythological figures and allegories create a whole Olympian world, one that transcends in the diaphanous clarity of its tints the persistent reference to the plastic forms of Michelangelo and the Mannerism that he inspired. But even where the mythological spell is broken by the unexpected appearance of a down-to-earth figure (a servant, a gentleman in modern dress, the mistress of the house with a wet nurse on a loggia), the extraordinary

transparency of the colors keeps the image on a plane of luminous abstraction that is highly decorative in its effect. This brilliant weaving of colors lends a particular tone to Paolo's portraiture as well, as is evident in the *Countess Nani* (*La Belle*) in the Louvre, vibrating with a harmonious symphony of blues and pinks.

Yet there is no doubt that a formal abstraction prevails in all his secular subjects, in which Paolo was able to take a more direct approach to the representation of reality. We allude not just to his portraits but also to the pictures of the various feasts and celebrations inspired by contemporary life. This was one of the artist's favorite subjects, certainly not for reasons of deeply felt religiosity, but for the opportunity provided to present a multicolored crowd of figures and a spectacular scene: the result was a series of decorative and festive images that grew increasingly rich in color.

That these scenes were "pretexts for color" is made clear by Paolo himself. For example, in the *Marriage at Cana* (1562-1563) in the Louvre, he sets in the foreground a "concert" performed by his principal colleagues (Titian, Tintoretto, Bassano and himself). And, in the *Feast in the House of Levi* in the Gallerie dell'Accademia (1573) – which was originally commissioned as a *Last Supper* – he places his own self-portrait among the German soldiers and buffoons in the entourage of Jesus. Called on to justify these liberties before the Inquisition, his response was almost ironic: "I received the commission to decorate the picture as I saw fit. It is large and, it seemed to me, it could hold many figures". Earlier he had said: "We painters take the same license that poets and madmen take".

One of the principal undertakings of his later period was the decoration of the Sala del Collegio in the Doge's Palace (1575-1577). The three main panels are set along the central axis of the ceiling, surrounded by a series of *Virtues* and *Allegories of Venice*. It is as if the brilliant light of the sun were rising above the gilded screen of

the moldings. Yellows and blues, ruddy and sil-
very tints, shades of white and pink: the colored
surfaces reflect the dazzling light, cold and sharp
in its tone, while the drawing, hitherto always
well defined, tends to crumble at the edges into
iridescent streaks of color. In the Sala del Colle-
gio, Paolo created a mythology of luminous
images that seem, along with the contemporary
Allegories he painted for Emperor Rudolph II
(1576-1584), to bring to a close the golden age
of art and life in Venice. With these paintings he
reached the height of his powers: it is in fact a
resonant musicality, along with a refined quest
for ideal forms, that gives these works their fun-
damental character. It is worth while to single
out the *San Zaccaria Altarpiece* and the extremely
festive *Mystic Marriage of St. Catherine* in the Gal-
lerie dell'Accademia, the secular pictures of *Her-
cules and Wisdom* and the *Poet between Vice and
Virtue* in the Frick Collection in New York, the
Mars and Venus in the Metropolitan Museum and
the *Venus and Adonis* in the Prado in Madrid, for
their dense and seething chromatic sensuality.
These are all paintings in which the most refined
preciosity of tone is combined with a grand and
more classically harmonious rhythm of form,
derived from an extremely fine balancing of fig-
ures and groups. The works of the last decade of
his life, on the other hand, are characterized by a
vein of sentimentality and a softening of the bril-
liant and forceful coloring of the previous
period. It almost seems as if, under the influence
of Bassano's "lighting", Paolo was attempting to
move toward a more naturalistic type of repre-
sentation. He often used a twilit or nocturnal
illumination, with a softer, more molten tone, as
in the anguished sulfurous-green atmosphere of
the *Baptism of Christ* in Milan. Or he let slip a
more openly pathetic intention, as in the phos-
phorescent *Miracle of St. Pantaleone*. But the figu-
rative language retained its vivid characterization
of form through the free and ground-breaking
handling of color. In fact the entire stylistic line

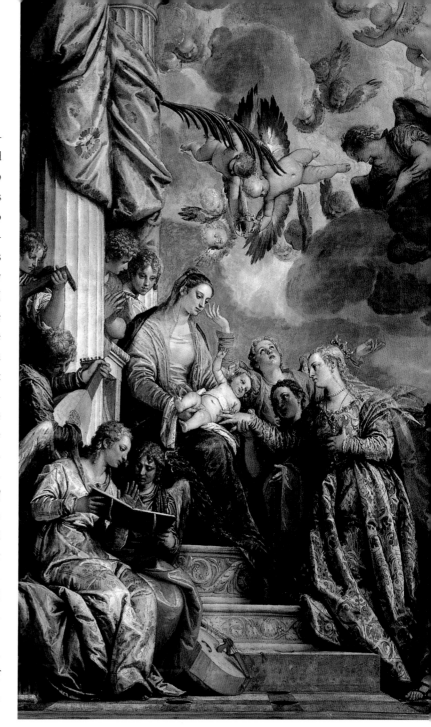

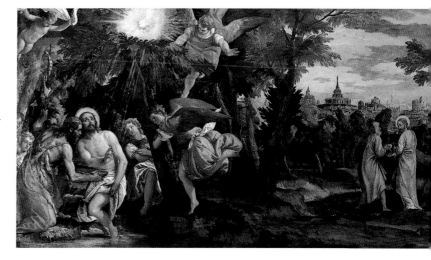

that was to run from Annibale Carracci to Pietro da Cortona, and from Luca Giordano to the antecedents of rococo, would find the true matrix of its inspiration in the work of Veronese.

El Greco. It is with a "foreign" painter that we bring the story of sixteenth-century Venetian painting to a close. In fact, Domenikos Theotokópoulos, called El Greco (Iraklion, 1541 – Toledo, 1614), first made a name for himself in Venice, where he may have stayed uninterruptedly from 1566 to 1570, before going on to attain fame and fortune in Spain. His contact with the art of Titian and Tintoretto gave a new awareness of his powers to the talented painter, who was initially bound by the iconographic canons of Byzantine art. This is demonstrated by a number of works recently uncovered among the products of the anonymous Greco-Venetian *madonneri,* or painters of Madonnas, who operated in Venice in those years. Theotokópoulos reached the climax of his Venetian period with the polyptych in the Galleria Estense, *c.* 1569-1570. It is the masterpiece of a now fully formed personality that introduced the visionary mysticism of the East into the refined but sterile culture of Mannerism.

In 1570 El Greco went to Rome, where his presence is documented until 1572 and where he was undoubtedly electrified by Michelangelo. Returning to Venice, he moved closer to Tintoretto (*Crucifixion* in a private collection in Zurich). He left for Spain in 1576, probably summoned to work in the Escorial in Madrid, but settled in Toledo. His *Assumption* (1577), now in the Chicago Art Institute, marks the new course of his painting in Spain, but still clearly shows his Venetian inspiration. These were the premises from which, finding an ideal environment in Catholic Spain, El Greco was to develop his expressionistic language, one of the most important episodes in seventeenth-century European art.

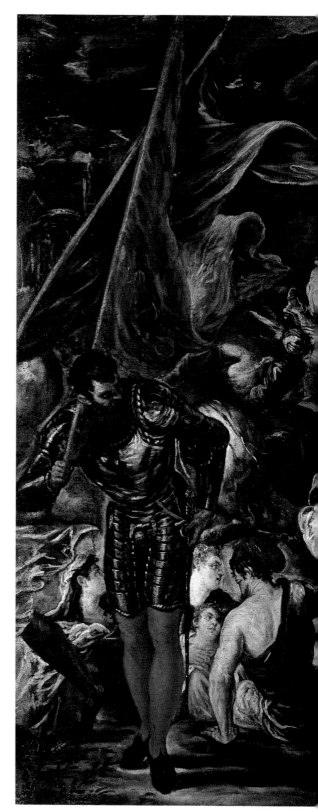

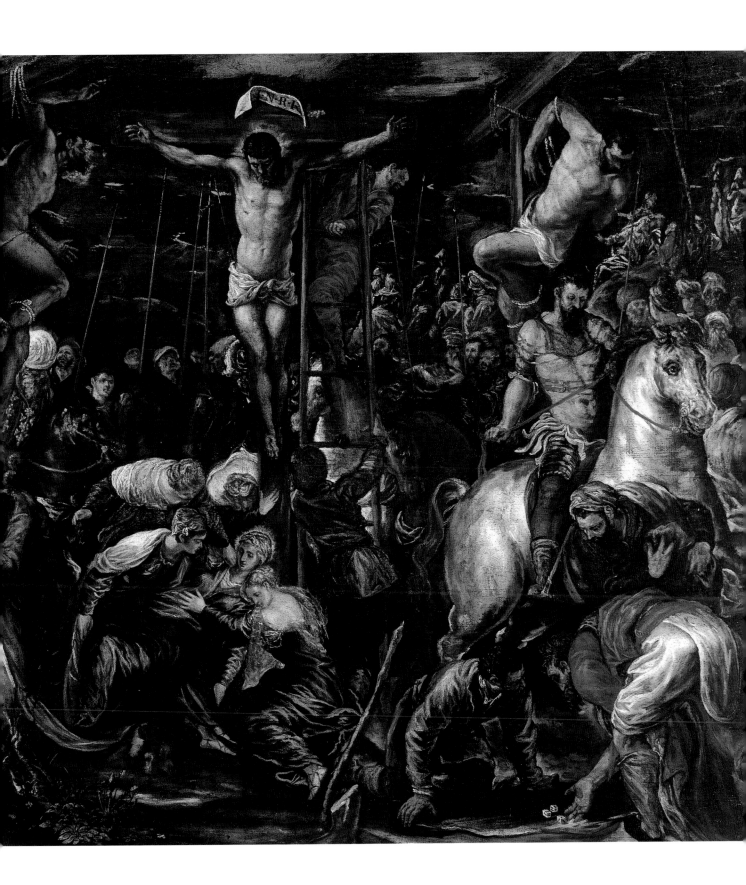

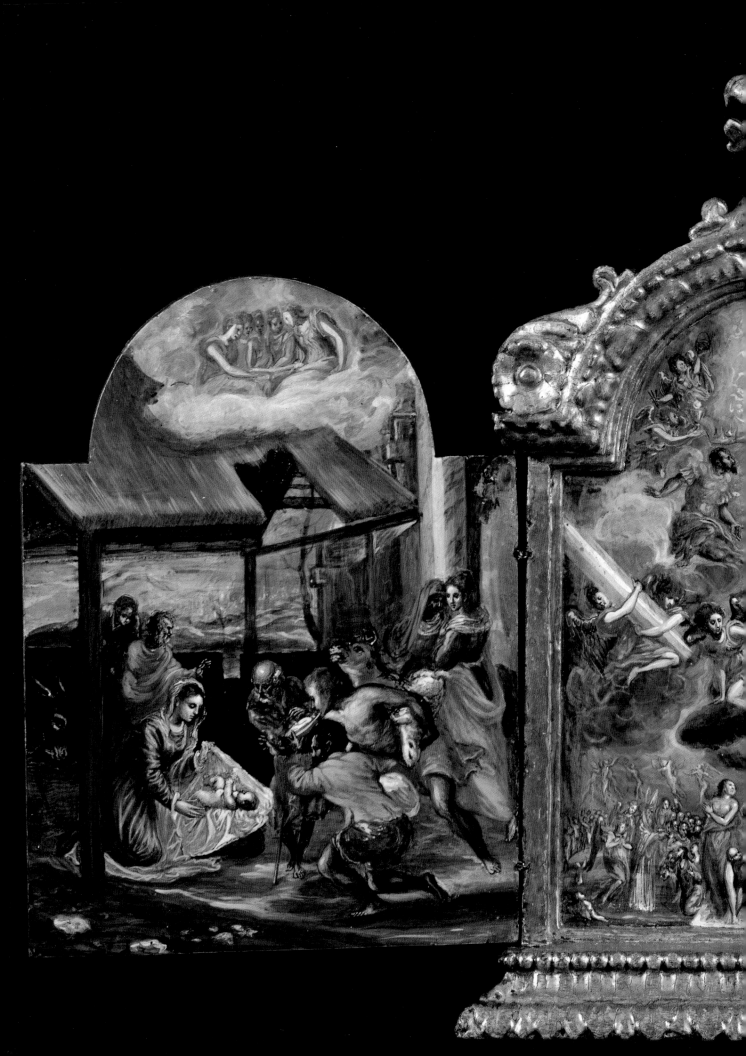

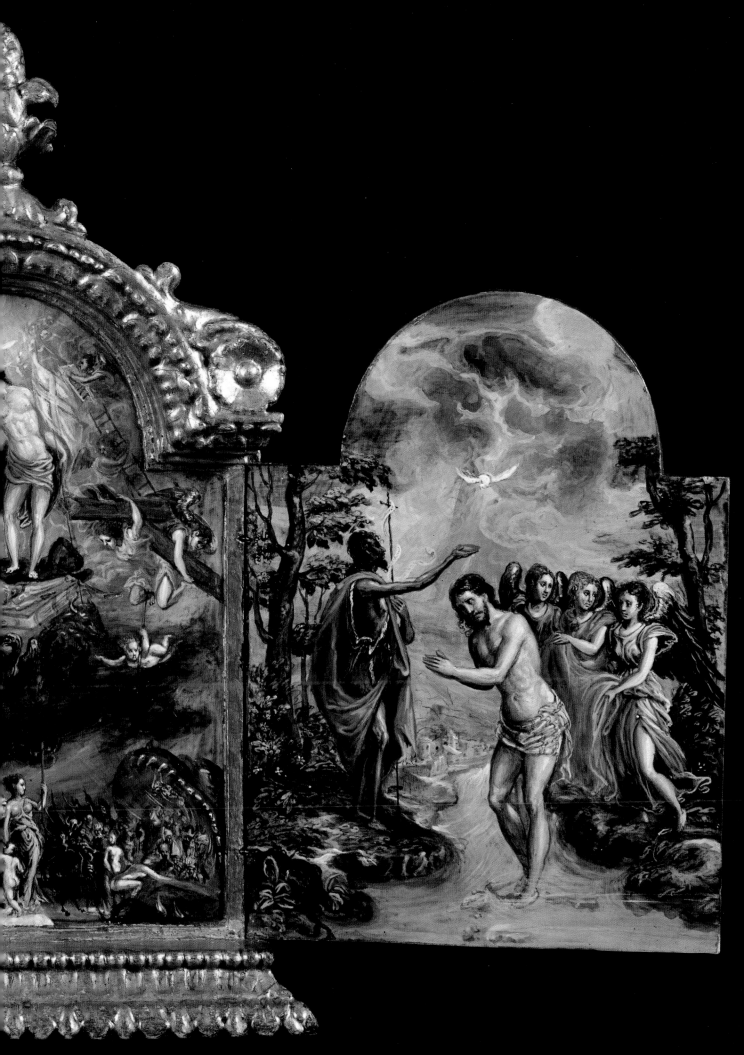

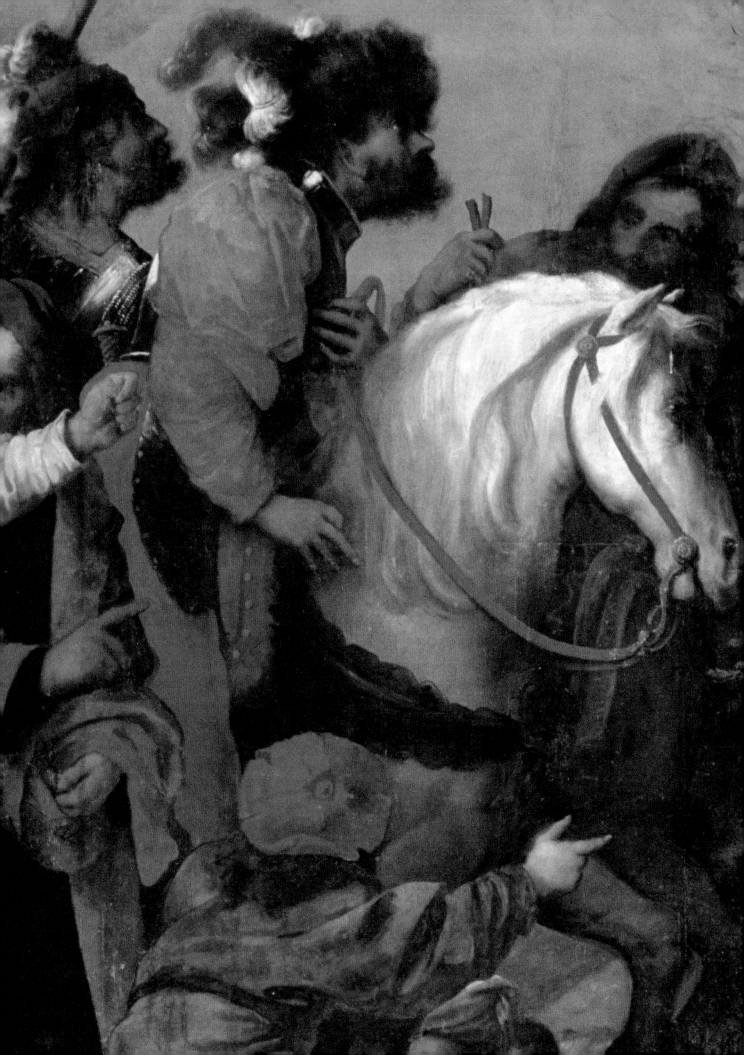

The Seventeenth Century

The Mannerist Regression. The course taken by Venetian painting in the first twenty years of the seventeenth century cannot be understood without taking into account two important factors – one of a historico-political character, the other more properly artistic – that came into play between the end of the sixteenth century and the early years of the seventeenth. The first was Pope Paul V's interdict of 1606, which severed relations between Rome and Venice. This led to a regression in the late Mannerist style of the Venetian painters and meant that the innovations of Caravaggio's naturalism and the classicism of the Carracci could not make their way to Venice from Rome. The second was that after the death of the great protagonists of the sixteenth-century (Titian in 1576, Veronese in 1588, Bassano in 1592, and Tintoretto in 1594), Venetian art was dominated by a large group of collaborators and imitators who clung to the more easily reproducible elements of the painters' individual styles.

Pietro della Vecchia, Crucifixion, Fondazione Cini, Venice. Detail.

below
PALMA IL GIOVANE,
Madonna and Saints
with the Parish Priest
Giovanni Maria da
Ponte, Church of
San Giacomo
dell'Orio, Venice.

Among them it is worth singling out the artists of Veronese's studio, who for a long time went on repeating the patterns of composition developed by their master, sometimes signing their works with the collective name *Haeredes Pauli* ("Heirs of Paolo"). Also Tintoretto's son Domenico (Venice, 1560-1635), his main assistant in the execution of the large canvases for the Doge's Palace. Among the members of Bassano's studio, following the tragic death of Francesco in 1592, it was chiefly Leandro (Bas-

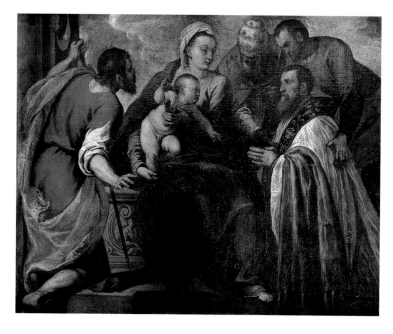

sano del Grappa, 1557-1622) who kept his father's tradition alive in the seventeenth century, producing numerous altarpieces whose composition was derived from Jacopo's models but which were characterized by a facile narrative style that tended to simplify understanding of the iconography in deference to the injunctions of the Council of Trent.

At the turn of the sixteenth century, therefore, Venetian painting suffered primarily from a lack of creative originality, for the activity of these artists – some of whom were engaged in the redecoration of the Doge's Palace after the disastrous fire of 1577 – was linked to a nostalgic and inevitably academic revival. This was the

facing page
CARLO SARACENI and
JEAN LE CLERC,
Doge Enrico
Dandolo's Address
to the Crusaders,
Doge's Palace,
Venice.

period which has been aptly described as the "crisis in Mannerism".

No real innovation came even from the best of those artists that the critic Marco Boschini, in the brief "Instruzione" that served as an introduction to his *Ricche Miniere della Pittura veneziana* (1674), defined as "painters of the seven styles", listing them in order of merit: Palma il Giovane, Leonardo Corona, Andrea Vicentino, Sante Peranda, Antonio Aliense, Pietro Malombra and Girolamo Pilotto.. In fact, the limitation of each of these painters was precisely what Boschini saw as their chief merit, that of having maintained the pictorial characteristics of the sixteenth-century tradition in a historical and cultural situation that was now completely different.

Not even Jacopo Palma il Giovane (Venice, 1548-1628), the most gifted of the seven, was able to break away from the late-Mannerist standpoint and the eclectic academism of the studios which carried out the pictorial decoration of the Doge's Palace, replicating the themes of the Cinquecento. The early works, such as the series of canvases for the sacristy in the church of San Giacomo dell'Orio and the ones for the oratory of the Ospedaletto dei Crociferi (1586-1587), are his best, as they are not yet touched by the magniloquent rhetoric that was to characterize his later production. In any case Palma's work was still deeply connected to Mannerist culture, both in the subjects that he tackled, which adhered unconditionally to the rules of the Counter Reformation, and in his prolific output (he left behind some 600 paintings and around a thousand drawings).

Between Classicism, Caravaggism and Tradition. Very different – with respect to that of the "painters of the seven styles" – was the approach to painting taken by Alessandro Varotari, called Padovanino (Padua, 1588 – Venice, 1648), who adopted the classicism of the

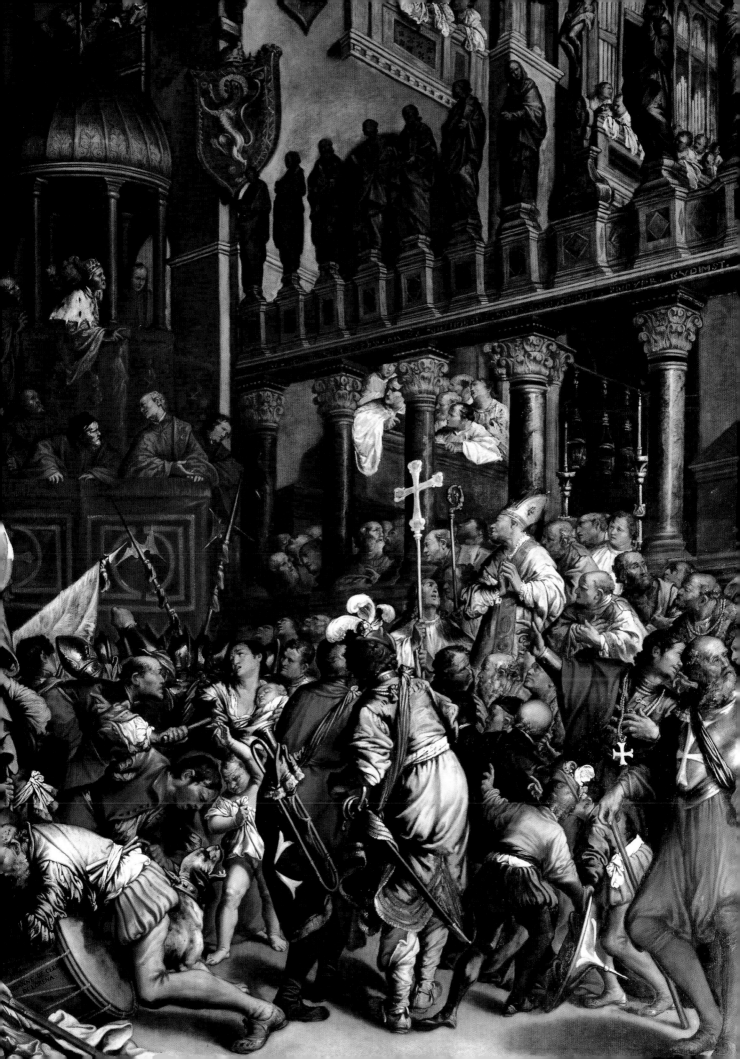

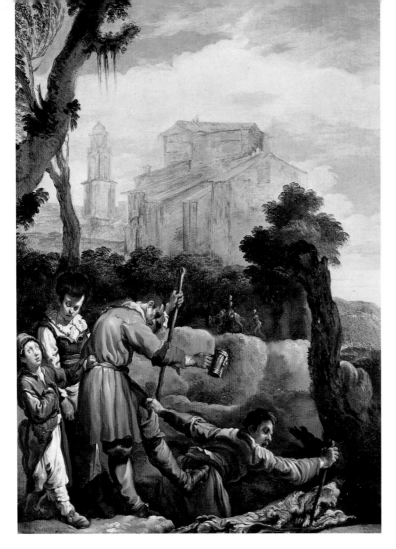

DOMENICO FETTI,
Parable of the Blind,
Institute of Fine Arts,
Birmingham.

Venetian Cinquecento without passing through late Mannerism. In one of his earliest works, the *Incredulity of St. Thomas* in the church of the Eremitani at Padua, dating from 1610, we can already find all the characteristics of his subsequent production, including a classicism in the Titianesque mold and above all a complete detachment from the late Mannerism of Palma. On a visit to Rome made in all probability between 1614 and 1616, he was able to see the *Bacchanals* that Titian had painted for the Duke of Ferrara, Alfonso d'Este. At the same time he developed an idealized classicist vision from his contact with the works of Domenichino, Albani and the Carracci.

Following his return to Venice, the programmatic directions pursued by Padovanino were to exercise an important influence, especially on the artists who were active there around the middle of the century. What the painter strove for was to combine a coloristic approach that he took from

the early Titian with a structural layout of great refinement. These elements were already present in the works he executed in the years immediately after his return to Venice, especially those with secular subjects such as the sensual representation of the *Graces and Cupids* in the Hermitage in St. Petersburg, painted at the beginning of the 1630's.

The presence of Carlo Saraceni in Venice in the last year of his life was also to prove highly significant. Venetian by birth, but active in Rome for around twenty years, Saraceni (Venice, 1579-1620) was profoundly fascinated by Caravaggio's art, which led him to take his own style in a naturalistic direction. Invited by the Venetian Republic to finish the cycle of paintings for the Sala del Maggior Consiglio in the Doge's Palace, the artist died of the plague before he could complete the task. During his brief stay in Venice he was a guest of the procurator Pietro Contarini, who was known to be an admirer of Caravaggio and certainly appreciated the large canvas depicting *Doge Enrico Dandolo's Address to the Crusaders* – finished later by Saraceni's French pupil, Jean Le Clerc – in which the narrative approach and the use of color denote a now decidedly baroque sensibility.

Another suggestive painting that could easily have been seen by his contemporaries was the *St. Francis in Ecstasy* commissioned by the friars of Il Redentore and hung in the church's sacristy. The painter adds a notably luminous atmosphere to the substantiality of the design and the strong chiaroscuro inspired by Caravaggio, a result of his early Venetian training.

The Foreign Painters of Transition. But the impulse for a renewal of expressive formulas in Venetian painting came largely from a group of foreign artists, including Fetti, Liss and Strozzi, who came to Venice to study the painters of the sixteenth century and ended up staying there, making a decisive contribution to the cre-

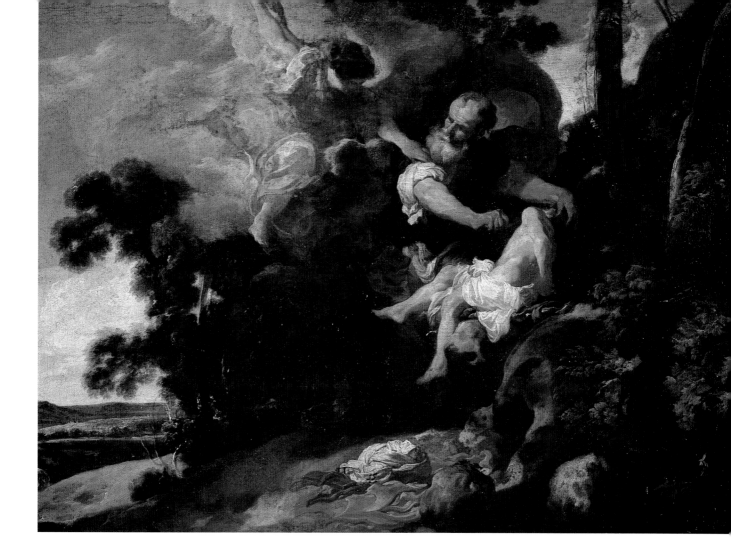

ation of a new pictorial sensibility. In fact they succeeded in grafting the tonal coloring of the local tradition onto the neo-Caravaggesque style. Thus what interested these painters was not the style derived from Tintoretto, which had now sunk into a late-Mannerist academism, but the reinterpretation of Veronese's coloring in a modern key. And this assimilation of the world of Veronese was to give rise to the great decorative painting of the following century.

Domenico Fetti (Rome, 1588/90 - Venice, 1623) was active in the city of his birth in the first decade of the century, where he was introduced to Caravaggism by Orazio Borgianni, who was probably his teacher. He was undoubtedly influenced by painters such as Elsheimer, Saraceni and Rubens, who was also present in Rome in those years. Fetti enjoyed the protection of Cardinal Ferdinando Gonzaga and in 1613 went to join him in Mantua, where the prelate had succeeded his brother Francesco IV

as ruler of the duchy. During his stay in Mantua (1613-1621), he had the opportunity to familiarize himself with the Venetian painting of the Cinquecento through the works of Bassano, Tintoretto and Veronese, of which there were many in the court collections. In this period he favored the theme of parables from the Gospels, painting small pictures that allowed him to create scenes of an intimate character, using a palette characterized by a skillful handling of light (*Parable of the Lost Coin*, Palazzo Pitti, Florence). Thus the stylistic heritage on which Fetti was able to draw on his arrival in Venice in 1621 consisted of an atmospheric coloring united with a realistic solidity of design (*Parable of the Blind* in Birmingham).

Johann Liss (Oldenburg, 1595/97-1631) was also in Venice prior to 1625. German by birth, he was trained first in the Netherlands and Paris and then in Rome, where he went after a first brief visit to Venice in 1621. The Roman milieu with

JOHANN LISS, Sacrifice of Isaac, Gallerie dell'Accademia, Venice.

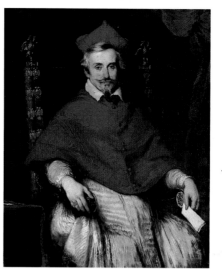

which he came into contact was that of the Dutch community and the neo-Caravaggisti, such as Manfredi, who had softened the poetics of their master through the use of a color closer to that of sixteenth-century Venetian painting. So it was natural that when Liss went back to Venice he was drawn to the style of Fetti, as is evident in the *Game of Morra* in the Gemäldegalerie, Kassel, which is almost a secular transliteration of the Roman painter's Gospel parables. Liss's subsequent works show him drawing progressively nearer to Veronese's world, as can be seen in the *Sacrifice of Isaac* in the Gallerie dell'Accademia and the *Venus in the Mirror* in the Uffizi, Florence, in which his palette has grown more filmy and exuberant.

Even more significant for Venetian pictorial culture was the arrival of the Capuchin friar Bernardo Strozzi (Genoa, 1581 - Venice, 1644) in 1633. During his long period of activity in Genoa, he had developed a complex style that blended the lessons of Flemish painters such as Rubens and van Dyck with elements of Tuscan and Lombard Mannerism and the naturalism of the Caravaggisti. Strozzi was given an enthusiastic welcome in Venice and received numerous commissions for both secular buildings and places of worship. These include the *Allegory of Sculpture* in the Sala d'Oro of the Libreria Marciana, the ceiling for the church of the Ospedale degli Incurabili (destroyed in 1821), and canvases for the churches of San Nicolò dei Tolentini and San Beneto. Around 1640 he painted the *St. Lawrence Distributing Money to the Poor* and *St. Sebastian Tended by the Three Marys*, in which he showed a typically baroque propensity for dense brushwork, with colors based on impastos rather than on pure tints, united with a solid design. It

was these great technical skills, combined with a marked capacity for the physical and psychological characterization of his subjects, that earned the painter considerable fame as a portraitist. The most significant examples of this genre are provided by the *Portrait of Bishop Grimani* in the National Gallery of Art in Washington and the *Portrait of Patriarch Federico Corner* in Ca' Rezzonico. Nor, finally, should it be forgotten that the length of Strozzi's stay in Venice allowed him to make an important contribution to the future development of the local school of painting in the direction of the more original and suggestive forms of the baroque.

And so, if we take account of the fact that all three of these painters were familiar with and appreciated the great tradition of the Venetian Cinquecento even before their arrival in Venice, and indeed that they had founded the most innovative part of their own style on it, we come to the paradoxical conclusion that it took artists from outside to teach the Venetians to make the most of the pictorial heritage bequeathed to them by the previous century.

Between Tradition and Baroque. However, the efforts made by Fetti, Liss and Strozzi did not produce immediate effects on contemporary Venetian artists. In fact, the training of the group of painters active after the outbreak of plague in 1630 and for the following fifty years – whose common characteristic was that most of them came from the Venetian provinces, especially Padua and Vicenza – took place chiefly in the classicist milieu of Padovanino, and was therefore influenced by the style of the early Titian.

These were the circles in which Pietro della Vecchia (Venice, 1603-1678) moved. His most

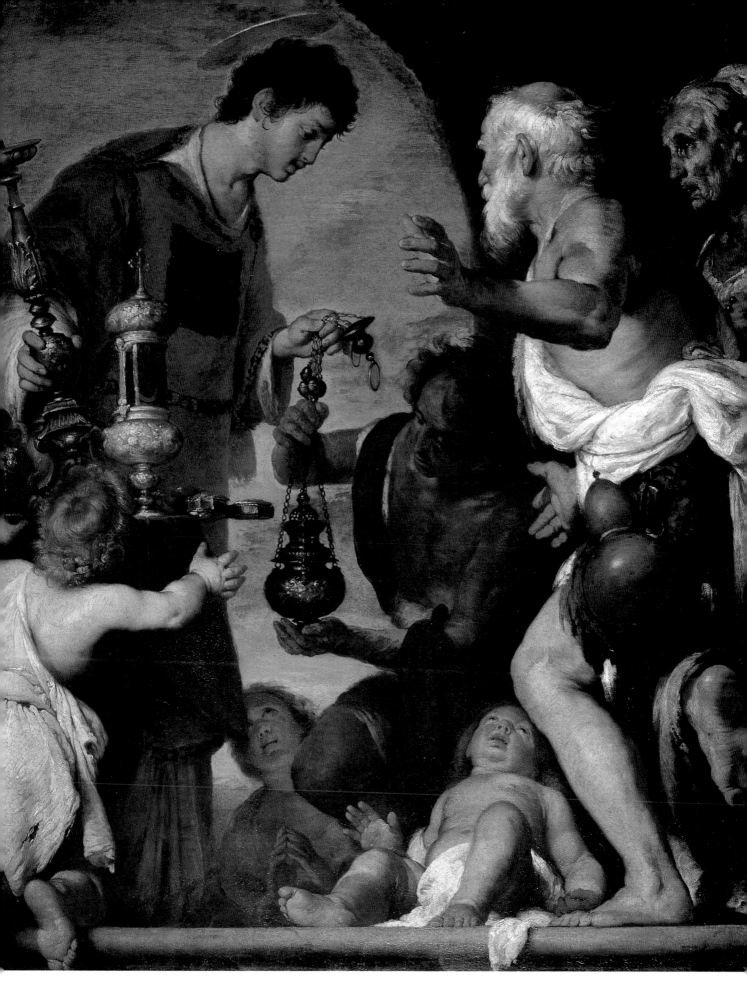

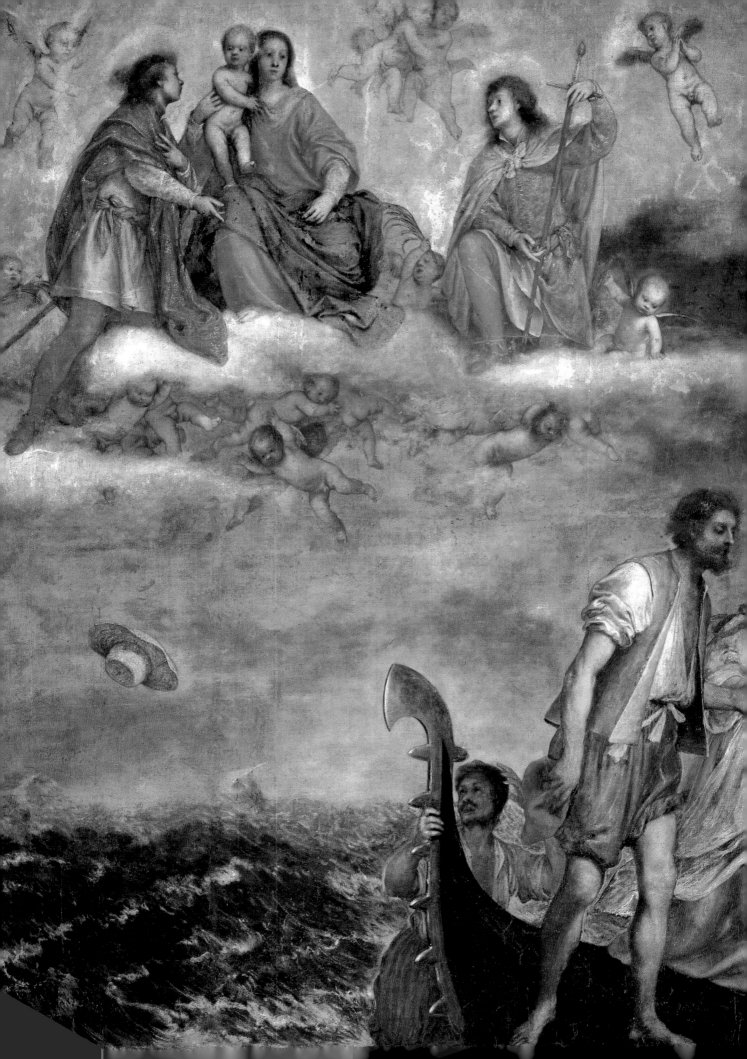

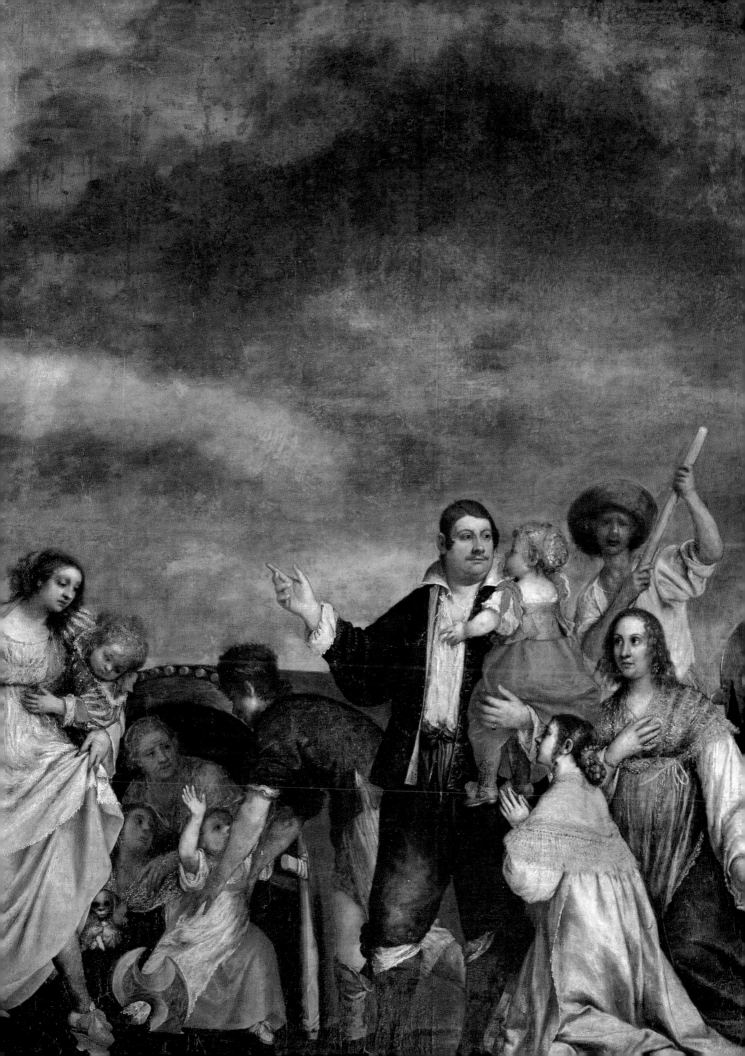

PIETRO DELLA
VECCHIA, Crucifixion,
Fondazione Cini,
Venice.

facing page
FRANCESCO MAFFEI,
Guardian Angel,
Church of the Santi
Apostoli, Venice.

original ideas found expression in large canvases of a religious character, for instance the *Crucifixion* for the church of Ognissanti in Venice (painted in 1637, now in the Fondazione Giorgio Cini). The scene resembles a stage set and allows the artist to demonstrate his ability to reinterpret the sixteenth-century tradition in a baroque key, placing isolated episodes that look as if they have been lifted from a genre painting in the foreground, such as the group of knights in shining armor on the left, or the animated dispute of the soldiers dividing up Christ's clothing. But Vecchia's reputation was undoubtedly inflated by contemporary critics, who appreciated his incredible ability to imitate the work of the masters of the sixteenth century, especially Giorgione, in genre scenes that look almost like forgeries. On close examination, however, this endless series of plumed warriors, heads of bravos and Davids with the head of Goliath reveals a pictorial exuberance that is unmistakably baroque.

Another pupil of Padovanino, Gerolamo Forabosco (Padua, 1604/5-1679), owed his fame to his skills as a portraitist, painting pictures in which his attachment to baroque sensibilities is manifested in the soft and hazy brushwork used to emphasize the sumptuous and glittering clothing worn by his subjects. The large canvas representing *The Miraculous Rescue of a Gondola* painted as an ex-voto in 1646 for the parish church of Malamocco, perhaps his highest

achievement, can also be considered a splendid group portrait.

Yet another of Padovanino's pupils was Pietro Liberi (Padua, 1605 - Venice, 1687), one of the most significant figures in Venetian culture at the time. Liberi moved permanently to Venice after 1643, after a long period spent wandering in distant lands (Tunisia, Malta, Spain, and Sicily) and a stay of three years in Rome, where he came into contact with the circles of the Carracci and Pietro da Cortona. He quickly made a name for himself in Venice through numerous public commissions for paintings of a devotional character, such as the altarpiece with *Mary Magdalene at the Foot of the Cross* in Santi Giovanni e Paolo, executed in just thirteen days in 1650. These pictures testify to the affirmation of a baroque dynamism in their composition clearly derived from the style of Pietro da Cortona, something quite new for Venice, accompanied by a notable lightening of color that harked back to Veronese.

Making a forceful entry into the Venetian cultural milieu, Liberi was much appreciated by local and foreign collectors for his paintings of erotic and mythological subjects, such as the *Diana and Callisto* now in St. Petersburg, which is characterized by an ebullient sensuality that derives in part from the use of soft impastos of color in the manner of Titian.

Francesco Maffei (Vicenza, 1605 - Padua, 1660), perhaps the most original painter in the Veneto in the mid-seventeenth century, also had a provincial background. Trained in the late Mannerist circles of Vicenza, Maffei reworked the lessons of the sixteenth-century painting of Bassano, Tintoretto and Veronese in a personal and independent way. Even before his brief stay in Venice in 1638, however, he gradually shook off the last vestiges of Mannerism as well as the influences of Padovanino's classicism. Thus the *Adoration of the Shepherds* in Modena, executed at the beginning of the 1650's, already shows signs of his attachment to the baroque style, a ten-

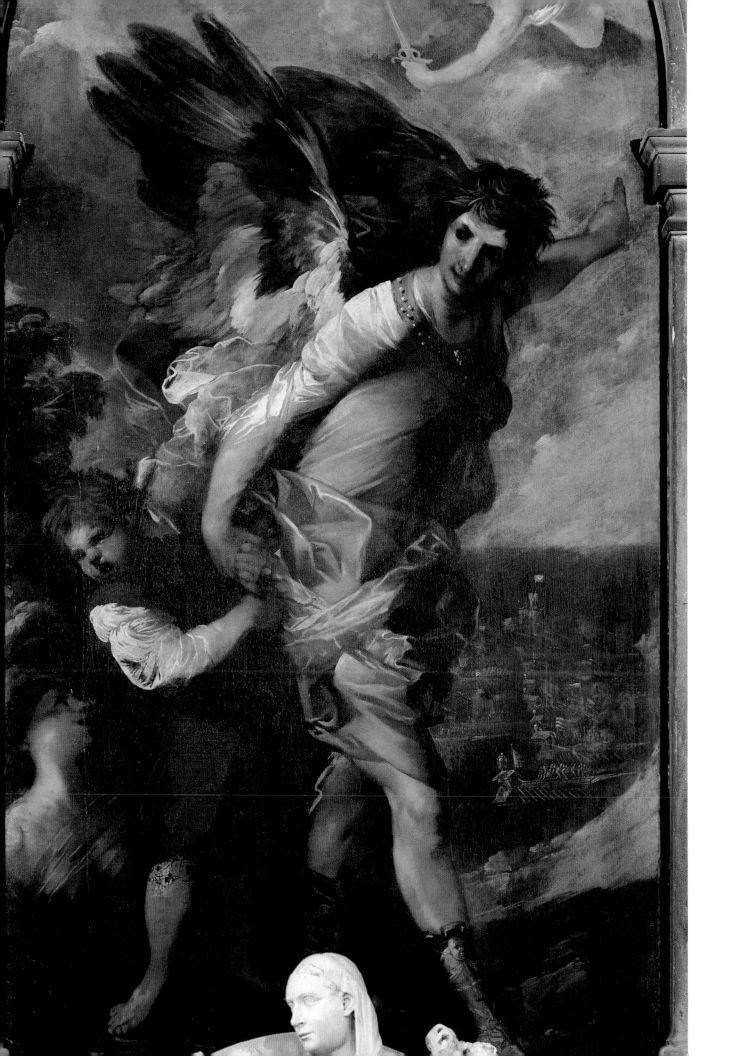

dency that was to grow stronger in Venice through his contact with the works of "foreign" painters, Bernardo Strozzi in particular. While the legacy of the great Venetian tradition of the sixteenth century is still clearly visible in the ceiling he decorated with the *Paradise* in the church of the Ospedale degli Incurabili, the palette used in the *Guardian Angel* in the church of the Santi Apostoli reveals a fanciful composite structure that is by now decidedly baroque.

Sebastiano Mazzoni (Florence, 1611 - Venice, 1678) followed a similar line of development, but his style was in marked contrast to the vivacious and effervescent character of Maffei's works. His background lay in the Counter-Reformation world of his native Tuscany, where he was a pupil of Allori and Furini. Arriving in Venice around 1640, Mazzoni painted the canvases with *Scenes from the Life of St. Benedict* for the church of San Beneto in 1648-1649. While these showed that he had assimilated certain elements typical of Strozzi's style, such as a propensity for portraits and the use of varied colors, they also revealed great originality in the way the figures are dilated, rendering them almost evanescent. Even in later works, such as the *Dream of Honorius III* in the church of the Carmini dating from around 1670, Mazzoni adopted a highly individual technique, based on frothy and at the same time incisive brushwork and on variations in the play of light that to some extent anticipate the paintings of Sebastiano Ricci.

The "Tenebrosi". Yet the painting of the second half of the seventeenth century did not proceed along the baroque lines indicated by Maffei and Mazzoni. At the beginning of the 1650's, in fact, Luca Giordano made his first appearance in Venice, followed at the end of the

same decade by a painter who was Genoese by birth but Roman by training, Giambattista Langetti. In different ways, both had fallen under the sway of the grisly themes of which Jusepe de Ribera was so fond and introduced them into the world of Venetian painting. An entire generation of artists born in Venice or active in the city for a long time grew up on this iconography, and above all on the forbidding style and heavy chiaroscuro in which it was represented. This led to the formation of a genuine and cohesive style whose exponents, because of the dark and dramatic character of their language, came to be known as the *tenebrosi*, from the Italian word for "murky" or "obscure".

Luca Giordano (Naples, 1634-1705), who had probably been a student of Ribera in his native city, was present in Venice on at least four different occasions over the span of twenty years. His first stay, in 1652-1653, was perhaps the most significant, owing to the influence that the altarpieces he painted at the time exercised on the local painters. In fact there can be no doubt that his heartrending *Deposition from the Cross* for the church of Santa Maria del Pianto (now in the Gallerie dell'Accademia) served as the model for numerous similar works painted by the Venetian *tenebrosi*.

But the real leader of this school was the Genoese artist Giambattista Langetti (Genoa, 1635 - Venice, 1676). After an initial training in the city of his birth, Langetti went to Rome at a very early age, where he frequented the studio of Pietro da Cortona and above all came into contact with the works of Ribera, of which many could be seen in the local collections. Moving to Venice around 1655, he achieved immediate success. His works, much sought after by local collectors, mostly represented his-

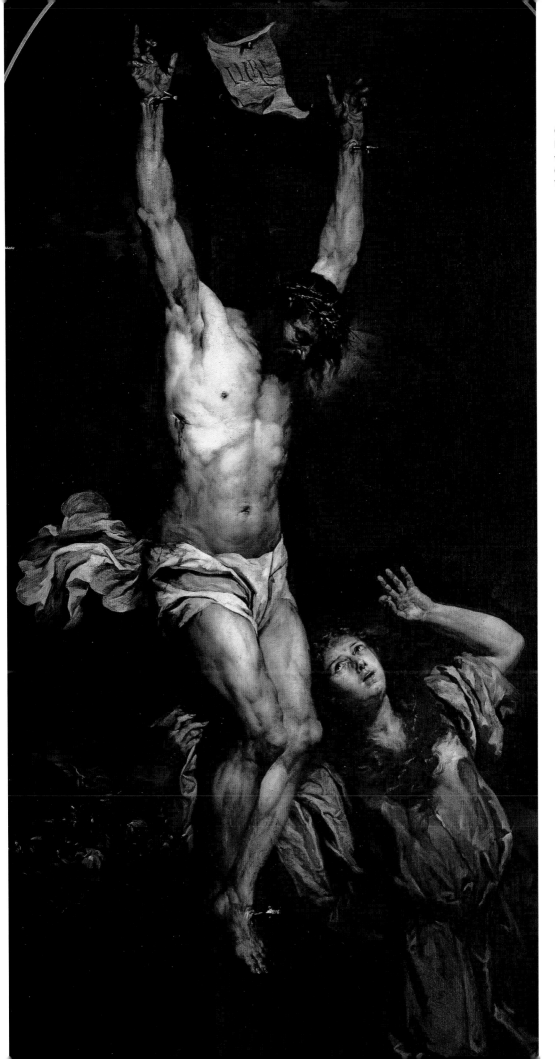

GIAMBATTISTA
LANGETTI, Crucifixion
with Mary Magdalen,
Ca' Rezzonico,
Venice.

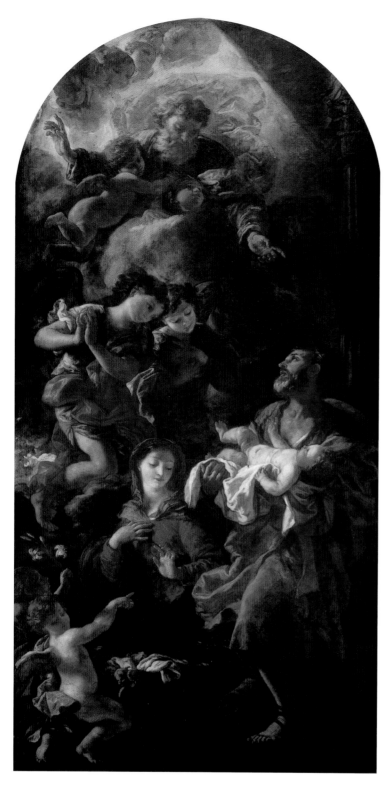

JOHANN CARL LOTH,
Holy Family,
Church of San
Silvestro, Venice.

the Terese, where the "atrocity" of Ribera's style went hand in hand with precious chromatic effects. But of great importance to forthcoming developments in Venetian art were the numerous works he painted for private collectors, including the *Ixion* in the Puerto Rico Museum of Art and the *Death of Cato* in Palazzo Rosso at Genoa, where the painter's attention centers on the figure of the protagonist, depicted with analytical precision at the moment of greatest physical agony.

His work was to influence a whole generation of painters in Venice, some of whom remained active well into the next century. Among them were Pietro Negri, Antonio Carneo, Giovanni Carboncino and Francesco Pittoni, but the most prominent figure was certainly Antonio Zanchi (Este, 1631 – Venice, 1722). Settling in Venice around 1650, he painted many works (e.g. *The Plague in Venice* in the Scuola Grande di San Rocco, from 1666) characterized by swirling compositions and the nightmarish tones he had inherited from Langetti, but which also show some awareness of Tintoretto's models. It was not until much later, after the death of Langetti which marked the beginning of the breakup of the *tenebrosi*, that Zanchi to some extent turned his back on his past, lightening his coloring and adopting an almost Veronesian luminosity, in homage to the new *chiarista* taste that was emerging (*Beheading of St. Julian* in the Venetian church of San Giuliano).

Another important contribution was made by the Bavarian artist Johann Carl Loth (Munich, 1632 – Venice, 1698), present in Venice around 1655. He was a prolific author of mythological and religious scenes, painted in a somber style that favored dark tones and deep shadows (*Death of Seneca* in Munich). His debt to Langetti is discernible not just in his choice of subjects, but also in his use of violent chiaroscuro and dramatic lighting to model his figures. In the latter part of his career, however, even Loth lightened

torical subjects or scenes from the Old Testament and tended to focus on dramatic events at their moment of greatest violence or highest tension, painted in a dense palette rich in chromatic effects but rendered ever more dramatic by a skillful use of light.

His masterpiece is without doubt the altarpiece depicting the *Crucifixion with Mary Magdalen*, executed around 1663 for the church of

his style, adopting a livelier tone and more fluid, almost histrionic poses (*Holy Family* in the church of San Silvestro, 1681).

Antonio Molinari (Venice, 1655-1704) was a pupil of Zanchi and throughout his career remained faithful to the world of the *tenebrosi*, something that was most evident in the vigorous structures of his pictures and his use of a marked chiaroscuro. On this uncompromising base, he turned, in the later phase of his activity, to more elegant forms, dropping the more dramatic aspects of tenebrist poetics from his style and giving more importance instead to the naturalistic side (*Madonna and Child with St. Maurus* in the church of the Madonna dell'Orto, 1696). This attitude was to play a fundamental part in the training of the numerous pupils who attended his school, including Pellegrini and Giambattista Piazzetta.

Architects and Sculptors. Just as painting at the beginning of the seventeenth century was dominated by the academism of the "painters of the seven styles", after the death of Palladio in 1580 clients and architects were bent on transforming his great legacy into a series of rigid precepts and superficial imitations, setting off a process of "mummification" that had little or nothing to do with the inimitable inventiveness of the Paduan architect. Those who continued to work in Palladio's style included Vincenzo Scamozzi (Vicenza, 1553 - Venice, 1616) and Antonio da Ponte (Venice, 1512-1597), who designed the Rialto Bridge in stone that was erected between 1588 and 1591 to replace the wooden footbridge that had previously spanned the Grand Canal at its narrowest point.

In this dreary panorama the figure of Baldassare Longhena (Brescia or Venice, 1597 - Venice, 1682) appeared almost from nowhere. His first work, the church of Santa Maria della Salute, is unquestionably the greatest masterpiece of the baroque architecture of the Veneto.

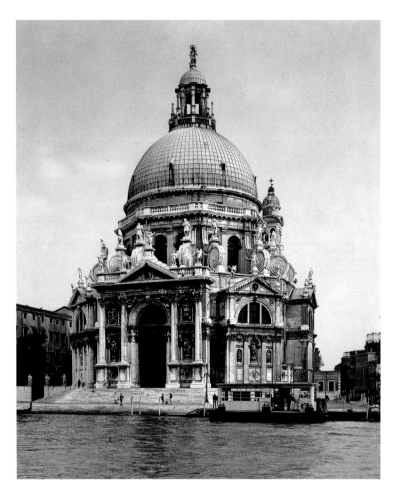

The site of the great votive church – built in thanksgiving for the end of the plague in 1630 – was officially chosen by the Venetian State and it is a true hub in the plan of the city, at which a multitude of natural and artificial elements come together: the Grand Canal and the Giudecca Canal; the immense expanse of water of the Bacino di San Marco, which is lined with the architecture of Sansovino; and the religious axis of the Giudecca and San Giorgio Maggiore, consecrated by the churches of Palladio. Longhena showed a perfect understanding of this complexity of physical surroundings and of its power of suggestion. Putting his clients' self-celebratory intentions somewhat under strain, he proposed a building on a central plan that was virtually unprecedented and revolutionary for Venice, where, by established tradition, all the churches had longitudinal plans. It was only this new typology, in fact, that allowed the church to fit perfectly into its surroundings – in the physi-

BALDASSARE LONGHENA, Church of Santa Maria della Salute, Venice.

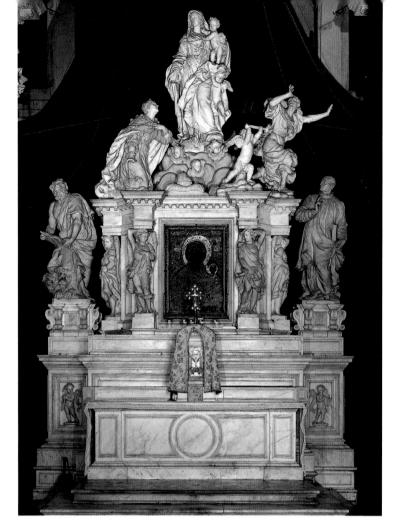

JUSTE LE COURT,
High Altar, Church
of Santa Maria della
Salute, Venice.

the bombast of Roman architecture and a severity that already seems to anticipate some of the rationalist designs of the following century.

In the field of sculpture, on the other hand, there was no one in Venice to rival the brilliance of Longhena and the creations of the city's sculptors had exclusively decorative functions, subordinate to the work of architects. The main artist active in this field in Venice over the course of the century was Juste Le Court (Ypres, 1627 - Venice, 1679), present in the city from 1655 and Longhena's faithful collaborator. His masterpiece is the high altar in the church of La Salute, a very fine piece of carving in which the ebullience of Bernini, whose work the artist had encountered during a stay in Rome in his youth, is contained within the limits of a far more moderate taste.

The Turn of the Century. If the naturalism of the Caravaggisti, of which the *tenebrosi* can be considered a peripheral offshoot, reached Venice considerably later than the rest of Europe, the same can be said of the decorative baroque of Pietro da Cortona. It was not introduced into the city in a systematic fashion until the 1660's, by two artists born in Lucca, Giovanni Coli and Filippo Gherardi, who decorated the magnificent library of San Giorgio Maggiore with large canvases based on the theme of Divine Wisdom, in or before 1671. As a result the library, designed by Baldassare Longhena along with the magnificent bookcases carved by the German Franz Pauc, became the most extraordinary example of the baroque in Venice. It was the model from which local artists were often to draw their inspiration, as is apparent in the great decorative undertaking carried out between 1684 and 1704 in the church of San Pantalon by a Venetian painter who had spent time in Emilia in his youth, Giovan Antonio Fumiani (Venice, 1650-1710). He decorated the enormous surface of the ceiling in the church that had just been renovated by Antonio Comin

cal and ambient sense as well as the historical and architectural – and to become the pivot around which everything turned.

The architect also based the structure of the church on this same principle of a dynamic rationalization of spaces, turning it into something like a mechanism in movement: from the powerful and sweeping play of light and shadow created by the eight sides of the base to the giddy swirl of the coiled elements on which a whole forest of statues pirouette, and to the evanescent volume of the dome which blends into the sky and seems almost on the point of turning slowly and solemnly on itself.

The reputation he acquired with La Salute put Longhena in a position to win the principal public and private commissions of the mid-seventeenth century. From these came such splendid private buildings as Ca' Rezzonico and Ca' Pesaro, extraordinary examples of Longhena's supreme ability to impart rhythm to the baroque style, maintaining a perfect equilibrium between

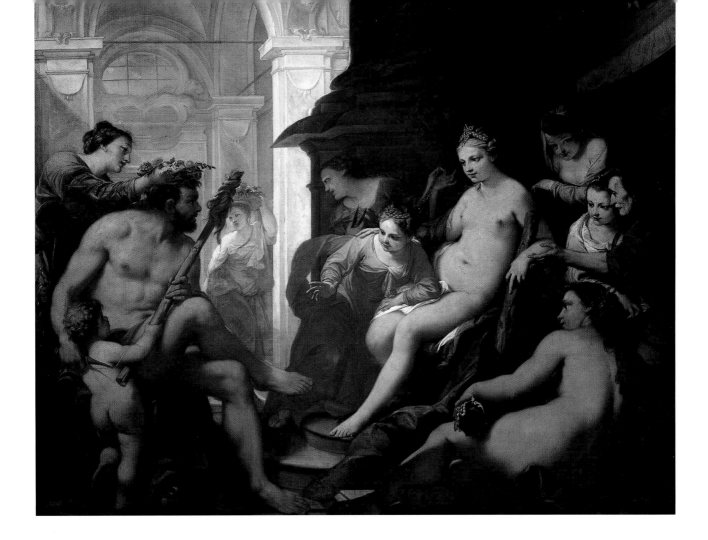

with forty panels of canvas mounted on wood (representing the *Martyrdom and Glorification of St. Pantaleone*), creating the first truly monumental example of baroque scenography in Venice. In this enterprise Fumiani made use for the first time in Venice of those architectural elements painted in perspective (*quadrature*) that were typical of the tradition of the great baroque decorators of Emilia, showing the way that would be followed by numerous Venetian artists in the eighteenth century, above all Giambattista Tiepolo.

With these works the scenographic element burst forcefully into the field of decorative painting. It was a complete novelty for Venice, where up until that moment painters had relied chiefly on the effect produced by figures foreshortened from below and set in flamboyant carved and gilded moldings, in accordance with a decorative scheme whose principal model was the work carried out by Paolo Veronese in the Doge's Palace and San Sebastiano.

There were many Venetian painters who took up the new type of decoration, often reviving the fresco technique, which had been in vogue during the Cinquecento and then fallen out of favor, partly because the climate was ill-suited to the preservation of plastered walls. Above all, however, the painters active in the last quarter of the century reacted to the dominance of the *tenebrosi* by adopting the new style that was defined, by contrast, as *chiarista*..This reaction was founded, as has been pointed out, on the new interest in the wellsprings of the Roman baroque, from the Carracci to Pietro da Cortona, but certainly had its focal point in the rediscovery and reassessment by local artists of the work of Veronese. From this moment on, Veronese was to become the most frequent and significant source of inspiration for Venetian painters.

The new *chiarista* style was adopted by a painter who had initially been one of the *tenebrosi*, Andrea Celesti (Venice, 1637 - Toscolano, Brescia, 1711). The two large lunettes he painted

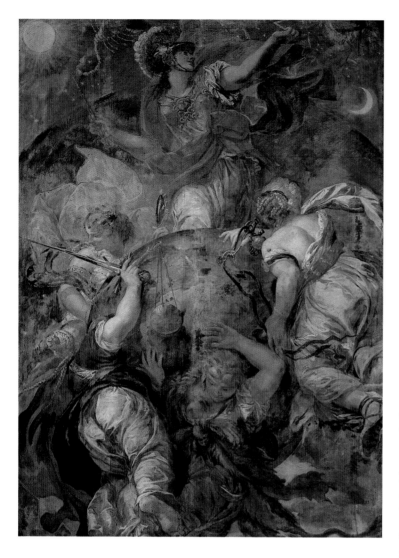

GIOVANNI COLI and FILIPPO GHERARDI, Minerva and the Cardinal Virtues, Library of San Giorgio Maggiore, Venice.

facing page
GIOVANNI ANTONIO FUMIANI, Martyrdom and Apotheosis of St. Pantaleone, Church of San Pantalon, Venice.

between 1684 and 1688 for the church of San Zaccaria, representing *Benedict III Visiting the Church* and *The Arrival in Venice of the Body of St. Zacharias*, and the canvas with *Moses Destroying the Golden Calf* painted shortly before for the Doge's Palace, all indicate, in the decorative preciosity with which the clothing of the figures is rendered, and in the lightening of the color, his desire to draw on Veronesian models.

Another figure of considerable importance was Gregorio Lazzarini (Venice, 1655 - Villabona Veronese, 1730), who, after working in the studio of Francesco Rosa, a follower of Langetti, came under the influence of Forabosco, deriving from him a taste for a soft and elegant coloring. At the beginning of the 1690's Lazzarini began an intense activity as a painter of religious and historico-mythological pictures, soon acquiring

a preeminent role in the Venetian art world of the time, working both in the Doge's Palace and in the cathedral church of San Pietro di Castello (*San Lorenzo Giustiniani Begging*, 1691).

Lazzarini's smooth, elegant and easily comprehensible style had a powerful influence on many Venetian artists active between the end of the seventeenth century and the first few decades of the eighteenth. One of them was Antonio Bellucci (Venice, 1654 - Pieve di Soligo, 1726), who also worked in Austria, Germany and England, developing an extremely elegant manner of painting that looked back to Veronese. His brilliant coloring, particularly evident in the refined mythological pictures (*Hercules and Omphale* in Ca' Rezzonico) which gave him an opportunity to portray female nudes in sensual scenes, marks the point of transition between the baroque and the rococo.

Nicolò Bambini (Venice, 1651-1736) was a pupil of Sebastiano Mazzoni. Right from his earliest works (the *Allegories* in Ca' Pesaro, Venice, 1682), he revealed a familiarity with the art of central Italy, perhaps acquired on a journey he made to Rome in his youth, but more probably through the example of Luca Giordano, who paid his third visit to Venice in 1672-1673. Bambini was an artist capable of complex and spectacular scenes, as is clear from the series of canvases with *Episodes from the Life of St. Teresa* that he painted sometime before 1710 for the church of the Scalzi. These works are characterized by the sculptural grandeur of their figures and a rich and luminous palette.

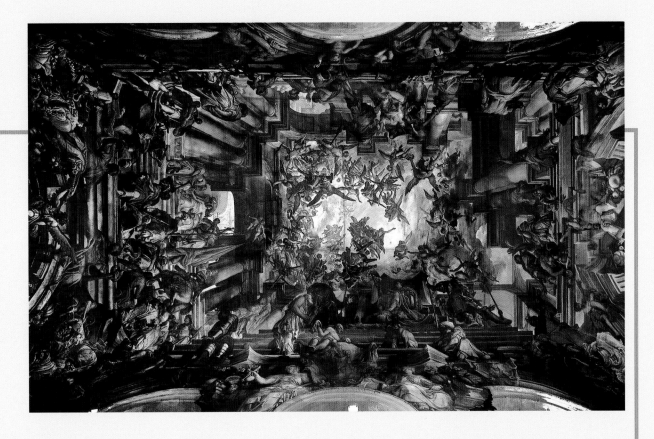

THE LARGEST CANVAS DECORATION OF A CEILING IN THE WORLD: SAN PANTALON

Between 1684 and 1704 Giovanni Antonio Fumiani painted the forty canvases that, assembled and mounted on panels, make up one of the most astonishing and largest decorations in Venice. It has been claimed that its dimensions – around 443 square meters or nearly 4800 square feet – make it the largest painting on canvas ever to have existed. These paintings of the *Martyrdom* and *Apotheosis of St. Pantaleone* can still be seen in the church dedicated to that saint.

The ancient church of San Pantalon, originally founded in the eleventh century, was completely rebuilt at the end of the seventeenth century to a design by Antonio Comin. Fumiani's decoration covers the whole of the ceiling and the upper part of the building's walls and constitutes the first monument of baroque scenography in Venice. In fact the painter made use of the architectural elements painted in perspective (*quadrature*) typical of the great baroque decorators of Emilia, indicating a road that would be followed by numerous other Venetian artists over the course of the eighteenth century, including Giambattista Tiepolo.

In his youth Fumiani spent time in Bologna, working in the studio of the *quadraturista* Domenico degli Ambrogi and, back in Venice, tried to make a career for himself as a theatrical scene painter. At San Pantalon he drew on these experiences to create an illusionistic space and to bind the figures and the architectural scenery into a splendidly unified whole that appears to rise directly out of the real structure of the church.

Most of the numerous and grandiose figures that throng the scene are huddled at the edges of the architecture painted on the walls, represented in extreme foreshortening with typically baroque bombast. At the center, against a sky resplendent with light, a host of angels with large wings perform spectacular and reckless aerial acrobatics.

To realize the extraordinary novelty of this work by Fumiani we must remember that up until that time Venetian painters, in deference to a tradition dating back to the mid-sixteenth century, had relied chiefly on the effect produced by figures foreshortened from below and set inside flamboyant carved and gilded frames. This followed a scheme of decoration whose principal model was the work carried out by Paolo Veronese in the Doge's Palace and in the sacristy of San Sebastiano. At San Pantalon this approach was superseded and baroque scenography made a thunderous entry into the world of Venetian decoration.

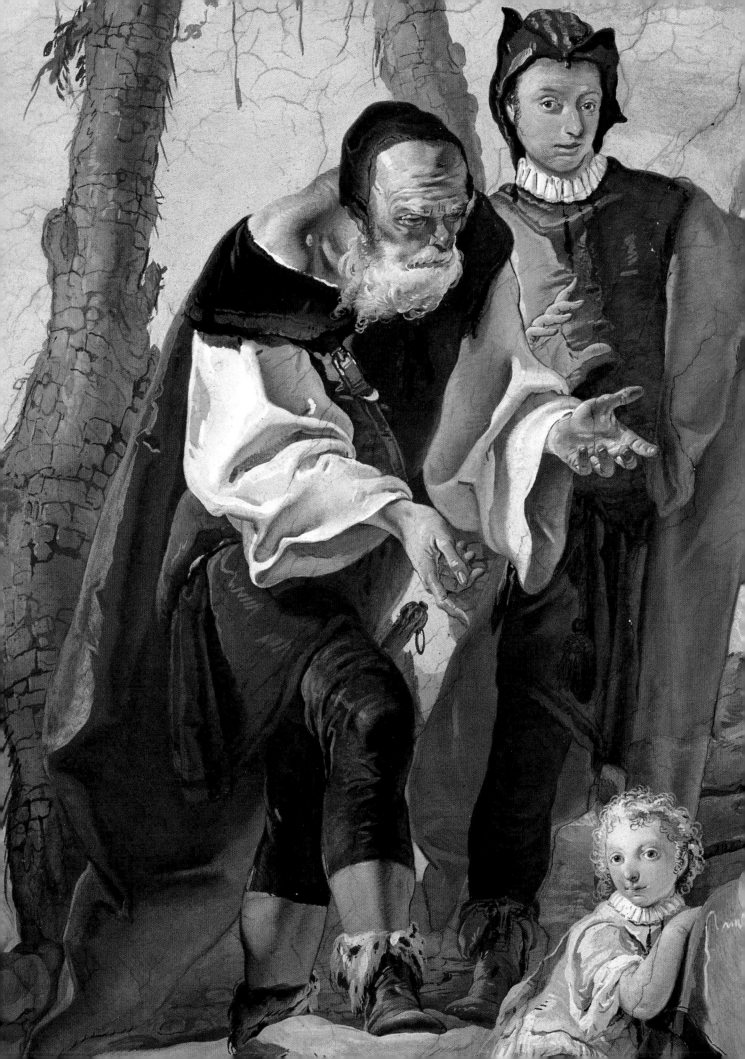

The Eighteenth Century

The Rococo. The origins of Rococo lie in the rocaille, a style that developed in France from the decoration of the Palace of Versailles, but there can be no doubt that in Italy it attained its finest flowering in Venice, in the field of painting. By the end of the seventeenth century, in fact, the chiarista movement had already emerged from the ashes of the late baroque, rediscovering the luminous timbres of a coloring that made the most of a free interplay of picturesque effects, a fresh and inventive approach to composition, graceful subjects and a refined elegance. The preferred technique was a "spontaneous" one, based on light touches of the brush and a fluid and rapid design. The sources of this revival were numerous, but an important part was played by the example of Luca Giordano, which had a powerful influence on Sebastiano Ricci (Belluno, 1659 - Venice, 1734). He, in turn, passed on the lesson to the painters of the next generation, in particular Pellegrini, Rosalba Carriera and Antonio Guardi.

GIAMBATTISTA TIEPOLO, Rachel Hiding the Idols, Palazzo Arcivescovile, Udine. Detail.

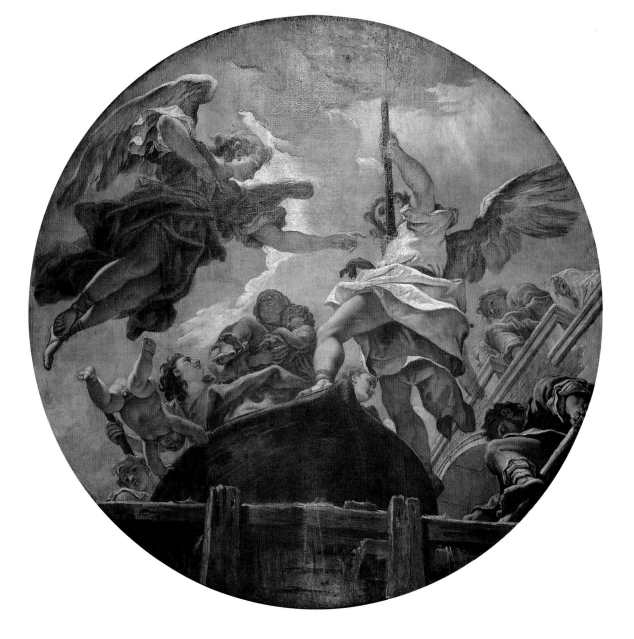

Sebastiano Ricci can be considered the initiator of eighteenth-century Venetian painting, and he often journeyed far from his adopted city in search of new inspiration, even as late as the turn of the century. In fact his first experiences, after an apprenticeship with Federico Cervelli, were in Bologna and Parma. The oratory of the Madonna del Serraglio, at San Secondo near Parma, preserves the earliest examples (1685-1687) of what might be called Ricci's Carracci- and even Correggio-inspired beginnings. A journey to Rome (1691-1694) then brought him into contact with the great baroque decorators, from Baciccia to Pietro da Cortona, and the artist's rhetorical vein was enriched with extravagant compositional and chromatic sonorities.

The start of the new century saw Ricci in Vienna, where he frescoed the ceiling of the Blaue Stiege in Schönbrunn Castle in 1702. The following year he went to Belluno, where he worked on the decoration of a number of rooms in Palazzo Bertoldi in a limpidly airy style that is not without echoes of Luca Giordano's late manner. By the time of his return to Venice, Ricci's personality appears to have settled into a stable maturity: onto his solid cultural base in the baroque were now grafted the luminous colors of Paolo Veronese, perhaps following the example of his younger and talented rival, Gian Antonio Pellegrini. Ricci lightened his tints in the ceiling of San Marziale, a work that was a harbinger of a festive emphasis on decoration, couched in a range of very pale, liquid and silvery tones, and free from the heavy plasticism

and murkiness of the seventeenth century. During a brief stay in Florence he painted the frescoes and canvases in Palazzo Marucelli (1706-1708), followed immediately afterward by the wonderful room in Palazzo Pitti. These works set the seal on the artist's development and are a manifesto of the new painting: a flow of open lines in space, filled in with luminescent tints that often verge on transparency. The subjects are given an animated treatment, with incisive figurations of joyful and musical charm. They are, in short, the fundamental elements of the decorative style that was emerging in parallel in France, using other means but attaining similar results: the Rococo.

From the time of his affirmation of this new approach to painting, Ricci never departed substantially from its principal and now established line. A long stay in England (1712-1716) brought him into contact with the work of Flemish artists, including Rubens and van Dyck. But more striking than the large fresco in the Chelsea Hospital are the exquisitely elegant forms of the canvases he painted for the staircase of Burlington House in Piccadilly (now the seat of the Royal Academy) and the ones that are now in Lord Burlington's villa at Chiswick. In 1716 Ricci returned to Venice and two years later was in Belluno, where he had been summoned to decorate the villa of Belvedere with frescoes: paintings on a "grand" scale that returned to the models of Veronese, as is clearly visible in the contemporary series of canvases painted for Palazzo Gabrielli, later Taverna, in Rome.

From 1724 to 1733 Sebastiano was in touch with the Savoy court at Turin, for which he painted *Solomon Worshiping the Idols* and *The Repudiation of Hagar*, works that permitted him to take one last step in the process of refinement of tone and his search for precious hues. The scheme of composition is still based on Veronese, with theatrical backdrops and illu-

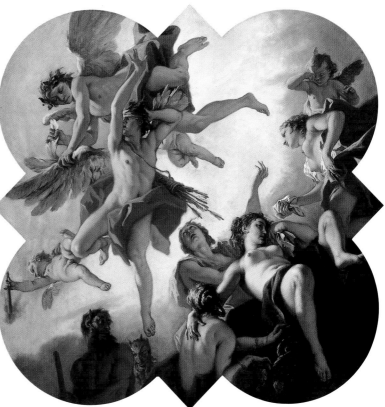

SEBASTIANO RICCI, Allegory, Palazzo Marucelli, Florence.

sionistic wings framing broad terraces set against luminous skies. But the gracious and persuasive attitudes of the figures and the incisive and animated design show that the Rococo style has reached its full maturity. From the beginning of the 1720's onward Sebastiano worked, often in collaboration with his nephew Marco, on various canvases for the English merchant Joseph Smith that were later acquired by the British Crown and are now at Hampton Court (*Adoration of the Magi*, 1726). This was a very important commission that confirmed Ricci's central role in the Venetian art world.

In parallel to the development of Ricci's style, it is worth mentioning the perhaps less eye-catching but equally innovative activity of Gian Antonio Pellegrini (Venice, 1675-1741). Like Ricci, he traveled a great deal, at first with his teacher, the Lombard Paolo Pagani, and then by himself, making direct contact with all the great masters of baroque painting. From his earliest works, in fact, Pellegrini showed the influence of the picturesque and expansive style of the later Luca Giordano: the colors already assume a liquid

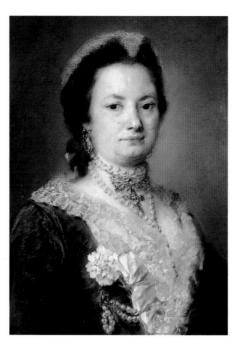

transparency, the forms crumble into an airy lightness, the tone is sonorously musical and sets out to create effects of joyful luminosity. Less closely linked to the Venetian tradition of the Seicento than Ricci and certainly more imaginative, Pellegrini devised an even more communicative and scintillating language that made him one of the finest exponents of the new Rococo manner in Europe.

In 1708, summoned to England by Lord Manchester, Pellegrini enriched his style through study of the works of the great Flemish masters of the seventeenth century and executed with airy lightness a series of brilliant decorations at Castle Howard, Norford Hall and Kimbolton Castle. His paintings also embellished the London homes of his patrons with elegant images, in a characteristically secular interpretation of the biblical subjects, full of verve, that would not escape the notice of the great exponents of French Rococo, and Boucher in particular. Pellegrini went on to work in Germany and the Netherlands, before going back to England for a short time (1719) and then to Paris (1720), where he triumphed with the ceiling of the Banque Royale, which was destroyed not long afterward. Returning to Venice, he alternated stays in the city, where he painted works such as the *Martyrdom of St. Andrew* for the church of San Stae, with collaborations on various decorative undertakings abroad. The importance of his influence is particularly apparent in the style of Rosalba Carriera, his sister-in-law, and of Antonio Guardi.

Ricci and Pellegrini meanwhile influenced the religious works, and above all the "mythologies" of Arcadian freshness and effusive sensual-

ity, of Jacopo Amigoni (Venice, *c.* 1682 - Madrid, 1752). Without yielding completely to the forms of the new Rococo style, Amigoni adopted its themes and in general its clear and festive palette, with a distinctive delicate and cloying flavor. He carried out several grand fresco decorations in Germany, for the castles of Nymphenburg (1718) and Schleissheim (1720-1723), which are among the most significant monuments of Bavarian Rococo. After returning to Venice for a short time, Amigoni went to England, where he also painted portraits in which his style underwent a characteristic reversion to classicism and his color took on a much colder tone, growing ever more brilliant and translucent. Following one last stay in Venice, during which he probably painted the altarpiece of the *Visitation* in the church of Santa Maria della Fava and the fresco with the *Judgment of Paris* in the Villa Pisani at Stra, he ended his days in Madrid, devoting himself principally to portraiture (*Portrait of the Castrato Farinelli with His Friends* in the National Gallery of Victoria, Melbourne, 1750).

However, the outstanding portrait painter in the cosmopolitan world of early eighteenth-century Venice was a woman, Rosalba Carriera (Venice, 1675-1757). Rosalba was the great interpreter of the aristocracy of this carefree period: her pastel portraits, famous all over Europe, constitute one of the fundamental elements of Rococo figurative culture. Without being limited in any way by the unusual technique – the only one, along with that of the miniature painted in tempera on ivory, with which she was really familiar – Rosalba went well beyond the immediate pictorial desires of

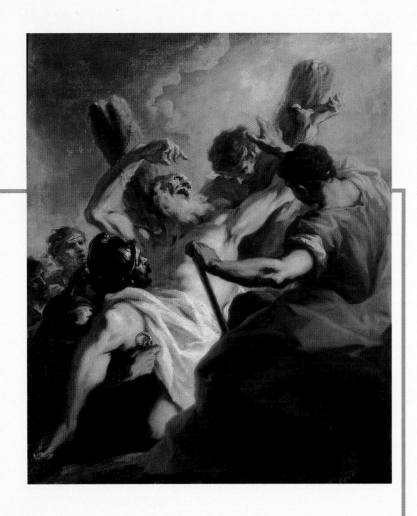

THE STATE OF THE ART IN 1722:
THE "APOSTLES" IN THE CHURCH OF SAN STAE

Venice boasts a large number of public and private museums, along with many other buildings – especially seats of confraternities and churches – that contain splendid works of art. Among these "containers" there is one that stands out for the extremely complete and exhaustive panorama that it offers of Venetian painting in a specific year, 1722: the church of San Stae. The reason is a simple one. In a codicil to his last will and testament, drawn up on April 10, 1722, the patrician Andrea Stazio, who was to die shortly afterward, on May 5 of the same year, left a large sum of money for the execution of twelve canvases representing scenes from the lives of the apostles to be hung on the plinths of the engaged columns that frame the limpid and luminous space of the nave of the church of San Stae, of which he was a parishioner. A few years after they were painted, however, the canvases were moved to the walls of the presbytery, where they were surrounded by a rich set of stuccoes made for that purpose.

Each of the pictures was entrusted by the nobleman's executors to a different artist: the artists were Piazzetta, Giambattista Tiepolo, Pellegrini, Sebastiano Ricci, Balestra, Lazzarini, Uberti, Bambini, Pittoni, Manaigo, Mariotti and Angelo Trevisani. The only well-known painters active in Venice at the time who were not included were Gaspare Diziani and Brusaferro.

The list of artists is revealing in itself. It is evident in fact that the executors of Stazio's will had not "taken sides" with regard to the different styles of painting in vogue in Venice at the time. Among those chosen were aging academic artists such as Gregorio Lazzarini and Balestra; heirs to the tradition of seventeenth-century *tenebrosi* such as Giambattista Piazzetta; and the main representatives of the more modern Rococo style of the *chiaristi*, Giannantonio Pellegrini and Sebastiano Ricci. Nor, of course, could it fail to include the youngest and most promising of all the artists operating in the city in those days, the twenty-six-year-old Giambattista Tiepolo. So it is not an entirely wild speculation to suggest that it really was Stazio's desire to leave in San Stae, through the series of paintings he commissioned, the most complete panorama possible of the world of Venetian painting that he obviously found particularly fascinating.

ANTONIO GUARDI,
Marriage of Tobias
(Tobias and Sara at
Prayer), Church of
the Angelo Raffaele,
Venice. Detail.

her subjects to achieve unmistakable characterizations through subdued and mellow colors and through figures rich with a lovely refinement of gesture. Right from the start of her career, around 1700, her production was distinguished by a range of pale tones, still sustained by a considerable solidity of drawing, as is evident in the *Portrait of Anton Maria Zanetti the Elder* in the National Museum of Stockholm (1700). But Rosalba soon turned even more decisively toward the world of Rococo, certainly influenced in this by the example of her brother-in-law Gian Antonio Pellegrini. Her portraits were progressively enriched by a greater refinement of color, in which the elegant and diffuse luminosity is prominent, and by extremely delicate moiré effects in her depiction of clothing (*Portrait of a Lady* in the Treviso Museum).

In her later period Rosalba's style tended to a greater plasticism, as can be seen in the tragic *Self-Portrait* in the Gallerie dell'Accademia. Her visits to Paris (1720-1721) and Vienna (1730-1732) had a decisive influence on the local painters of pastels, who adopted and diffused her fascinating technique, absorbing much of her style in the process.

In the extraordinarily varied panorama of Rococo painting, Antonio Guardi (Vienna, 1699 - Venice, 1760) occupies a special place. The Guardi family was originally from the Trent region, and its head, Domenico, also a painter, had settled in Vienna at the end of the seventeenth century. So it is not unlikely that his eldest son received his training in Austria and began his career there, working for a long time as a copyist, first in the service of the Giovanelli family and then, until around 1747, of Marshal Schulenburg.

The reconstruction of the figure of Antonio Guardi is the fruit of modern research and is dogged by uncertainty. Yet it seems possible to assemble, around his few documented paintings and the odd drawing of which we can be

absolutely certain, a body of work that reflects an outstanding personality, molded by the influence of the great decorative painters and with close links to the tradition of Ricci and, above all, Pellegrini. His progressive lightening of forms allowed him to produce toward the end of his career some of the masterpieces of late Rococo, characterized by sketchy brushwork and paleness of color. It is a manner that cannot be confused

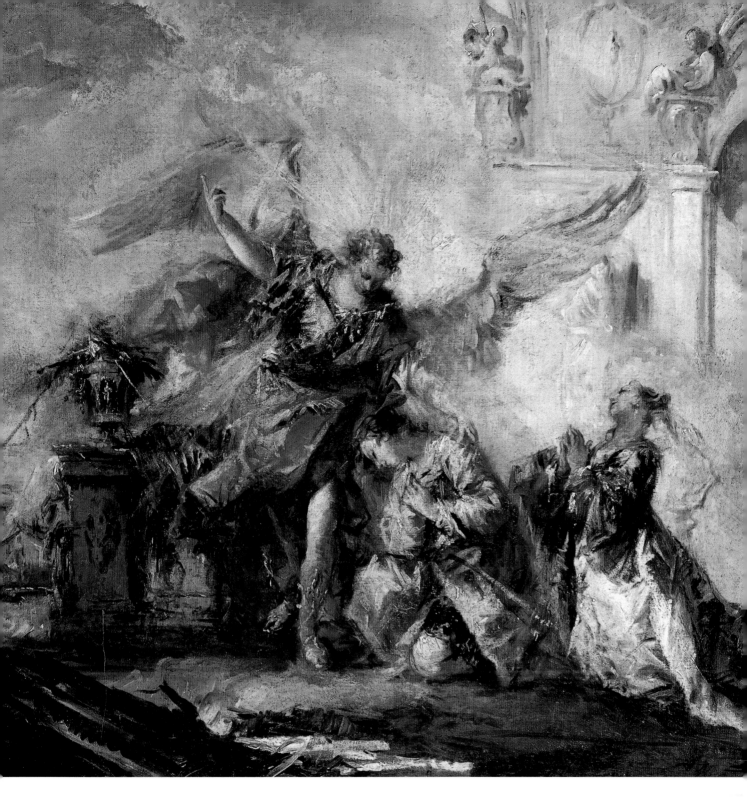

with the highly individual and solitary approach to painting taken by his younger brother, Francesco Guardi, who worked within the tradition of *vedutismo* and tended to produce melodramatic pictures whose origin lay in the work of Magnasco whenever he tackled figure painting, especially in his youth.

At the beginning of the 1750's Antonio decorated the organ loft of San Raffaele with scenes from *The Story of Tobit*, a work that represents one of the finest achievements of Rococo painting. In it, the artist achieves a rhythmic sense of exhilaration, breaking up the forms and dissolving them into a sparkling luminosity. With these canvases, Venetian Rococo painting reached its limit in the chromatic dematerialization of what had been baroque form. As is immediately apparent, it was a stylistic process analogous to

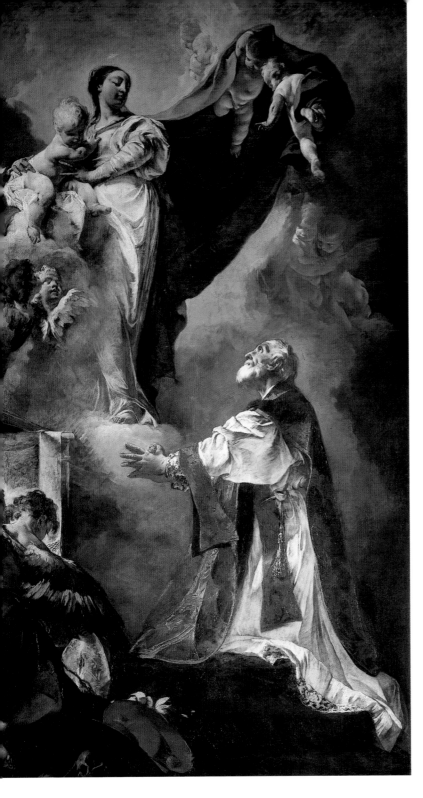

GIAMBATTISTA PIAZZETTA, The Virgin Appearing to St. Philip Neri, Church of Santa Maria della Fava, Venice.

other important artistic figures emerged over the course of the century, responding above all to the endless requests that came from the Church and the nobility. There were two main currents: the first, which principally followed Piazzetta in its religious themes, developed what has been called the "pathetic Rococo"; the second, of a more openly decorative nature, had its undisputed leader in Tiepolo. There can be no doubt that, owing to the success it achieved in ecclesiastical circles, the first current was of great importance even where it diverged markedly from the forms and spirit of the other. One of the cultural elements that distinguished the pathetic current from the decorative one is in fact the more evident reference to Emilian art, which had gone through a golden age in the seventeenth century. At the turn of the century that school of painting had a special attraction for the more traditional Venetian artists, who chose to go there for their training. At Bologna in particular, the Accademia Clementina and the studios of Cignani and Canuti handed down the figurative rules of a late baroque that perhaps was not yet ready to assimilate the new ideas of the Settecento. The studio of Giuseppe Maria Crespi exercised a particular attraction, to a certain extent making up for the absence of a true academy of art in Venice, one being officially founded only in 1756 under the direction of Tiepolo.

The Bolognese painter, heir to the late-baroque emphasis on colors and images through Cignani and Burrini, interested the Venetians not only for his proficiency in academic drawing, but also for an innate liveliness of touch and richness of color, which he himself had consolidated in Venice during two visits he had paid to the city around 1700 to study the great masters of the Cinquecento. Returning to Bologna, he took on a number of young Venetians such as Bencovich and Piazzetta as his pupils, the first of a whole series who felt the need to go to him for the teachings that were not available to them in late

the one that was taking place in other arts, especially music, which reached its highest poetic level in the mid-eighteenth century in works that were performed at Venice's numerous concert halls and opera houses.

The Pathetic Rococo. Alongside the great exponents of Venetian Rococo – Ricci, Pellegrini, Rosalba Carriera and Antonio Guardi –

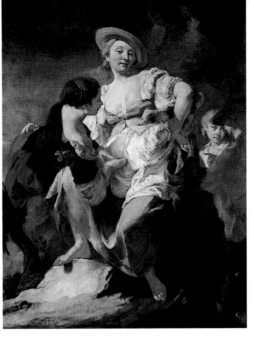

GIAMBATTISTA PIAZZETTA, Fortune Teller, Gallerie dell'Accademia, Venice.

seventeenth-century Venice, given that the creators of the Rococo such as Ricci and Pellegrini were still absent, engaged on their work abroad.

Probably the first person to introduce Crespi's violent chiaroscuro effects into the Venetian milieu was the gifted Federico Bencovich (Venice, 1667 - Gorizia, 1756), as is already discernible in his early *Bergantino Altarpiece* of 1710. Around that year Bencovich moved back to Venice, where he worked for private clients and stayed until 1716, before going to Vienna, remaining there for at least a decade. Returning to Venice, Bencovich painted just a few pictures, such as the *Altarpiece of the Blessed Pietro Gambacorti* in the church of San Sebastiano (*c.* 1725-1730), but his work was to have a considerable influence on the very young Tiepolo and on Piazzetta. However, Bencovich spent the most interesting part of his career in the German-speaking countries: in fact he made a fundamental contribution to the birth of Austrian Rococo, which took from him the peculiar agitated and dramatic tone that often characterized the production of the local painters. But in this ambit the really great personality was without doubt Giambattista Piazzetta (Venice, 1683-1754). Moving to Bologna at around the age of twenty, he acquired there an innovative impetus that would permit him to break free of the residues of the seventeenth-century that had come down to him through the *tenebrosi* painters such as Molinari, who was his first teacher, or Langetti, Loth and Zanchi. With the aid of Crespi, Piazzetta was able to move away from the somewhat gloomy chiaroscuro of those artists and toward a vivid transparency of tints, introducing more warmth to his palette. This change is clearly apparent in the *St. James Led to Martyrdom* in the Venetian church of San Stae (1722), a painting that has strong contrasts of light and is violently disjointed in the construction of the figures. It is a powerful expression of the new and passionate sense of devotion that was to remain at the root of the painter's sincere inspiration.

Piazzetta produced the masterpiece of his decorative painting with the *Glory of St. Dominic* for the church of Santi Giovanni e Paolo, delivered in 1727. The foreshortened images at the edge of the oval *quadratura* and the vigorously ascending spiral in the sky, which glows with a very bright light, seem to have been inspired by Crespi's frescoes in Palazzo Pepoli. But the ecstatic animation of the figures and the symphonic harmony of the colors are typical of Piazzetta and speak a language that is now decidedly Venetian.

Over the following decades Piazzetta would also turn his attention to popular themes: heads of characters, scenes of peasant life and imaginary portraits. The painter's interest in naturalism often went no further than a generic "typification", but his setting of the images in a strong chiaroscuro that makes the colors vibrate intensely is particularly effective.

The altarpiece he painted for the church of Santa Maria della Fava in 1725, representing *The Virgin Appearing to St. Philip Neri*, marked the beginning of the next phase in Piazzetta's style, now imbued with a radiant and luminous coloring that was to reach its climax in the *Assumption* in the Louvre in Paris, executed for the elector of Cologne, Clement August, in 1735. A number of fine works depicting secular subjects

also belong to this particularly propitious period in Piazzetta's production, including the so-called *Fortune Teller* in the Gallerie dell'Accademia (1740) and the *Idylls* in Cologne and Chicago, both painted for Marshal Schulenburg in 1740 and 1745 respectively, in which Piazzetta refines the hedonistic beauty of his color and adapts it to the elusive and frivolous spirituality of the Settecento.

In the final period of his career Piazzetta surrounded himself with a large number of assistants and carried out teaching activities in a school that was soon to be transformed into the Academy of Painting and Sculpture.

In the meantime, a group of painters torn between the example of Ricci and that of Tiepolo remained active up until the middle of the century. While devoting themselves to the same themes as the pathetic current, they often diverged from it in their use of a lighter and agreeably festive coloring that to some extent harked back to the early Rococo.

The most interesting of these artists was Giovan Battista Pittoni (Venice, 1687-1767), a pupil in his youth of his uncle Francesco, a mediocre *tenebroso*, but mindful of the innovations proposed by Ricci as well as of the Venetian works of Luca Giordano and Solimena. By this means, Pittoni came to define a style characterized by an extremely vivid coloring and sustained by a great suppleness of drawing. He specialized in paintings of historical and mythological subjects, in which he succeeded in giving free rein to his own creative fantasy (*Diana and Nymphs* in the Museo Civico of Vicenza, 1725; *Sacrifice of Polyxena* in the J. Paul Getty Museum at Malibu, 1733), but also produced a number of religious pictures of a more conventional character. And then there were the small-scale works of a very high quality – such as *The Adoration of the Child* in Rovigo – in which it is easy to discern the more cheerful and effervescent vein of the Rococo.

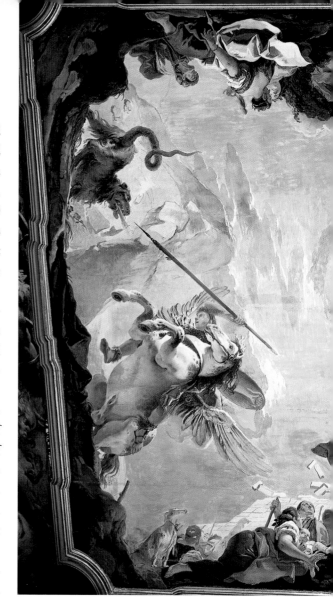

Decoration on a Grand Scale. In the complex picture of eighteenth-century Venetian painting, the school of painters of large-scale decorations, carried out on behalf of ecclesiastic as well as aristocratic clients, is undoubtedly worthy of separate discussion. The technique they most frequently adopted was that of fresco, while their style drew directly on the principal sources of the Rococo, from which it derived a grandeur of composition that had its roots in the Cinquecento and a light and sparkling palette.

In this ambit operated several fresco painters of considerable talent, such as Mattia Bortoloni (San Bellino, 1696 - Milan, 1750) and above all Giambattista Crosato (Venice, *c.* 1685-1758), who was influenced by Ricci and Amigoni, enriching their style with a vein of animated Emilian solidity. After painting frescoes of brilliant color and

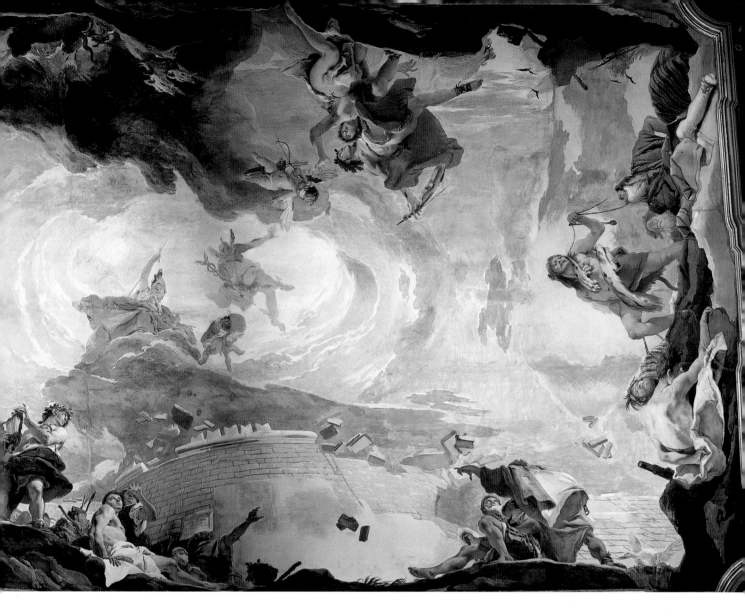

fluent design in the royal hunting lodge at Stupinigi (1732) and the royal palace in Turin (*c.* 1740), he returned to Venice, where he left his masterpiece in the ballroom of Ca' Rezzonico, a *Triumph of Apollo* (*c.* 1753) that rivals the great Tiepolo in the radiant clarity of its palette.

The work of Gaspare Diziani (Belluno, 1689 - Venice, 1767), who did not stray far from the narrow confines of his compatriot and teacher Sebastiano Ricci, is facile and academic, with glassy colors laid on in fluid brushstrokes. And yet his over-elaborate canvases and fresco decorations are often effective, and this is even more true of his numerous drawings. Among his best works are the lunettes depicting the *Flight into Egypt* in the sacristy of Santo Stefano (*c.* 1732), the frescoes in the Palazzi Rezzonico, Widmann and Contarini, executed in the 1750's, the lumi-

nous canvases in the church of the Carmini and those on the ceilings of the Scuola di San Giovanni Evangelista (1760-1762), as well as several elegant paintings of small format, in which the direct derivation of his style from Ricci's airy models is most apparent.

One of the last exponents of Ricci's school was Francesco Fontebasso (Venice, 1709-1769), active largely as a fresco painter in numerous Venetian buildings, including the church of the Gesuiti, where he decorated the ceiling around 1734, the Palazzo Contarini at San Luca (*c.* 1750), the Spezieria on the Fondamenta dei Vetrai on Murano (*c.* 1759-1760) and finally the chapel in the church of San Pietro where, amidst stuccoes and sculptures in perfect Rococo style, he depicted the *Miracles of St. Peter of Alcántara*. His flowing style and bright colors earned him a

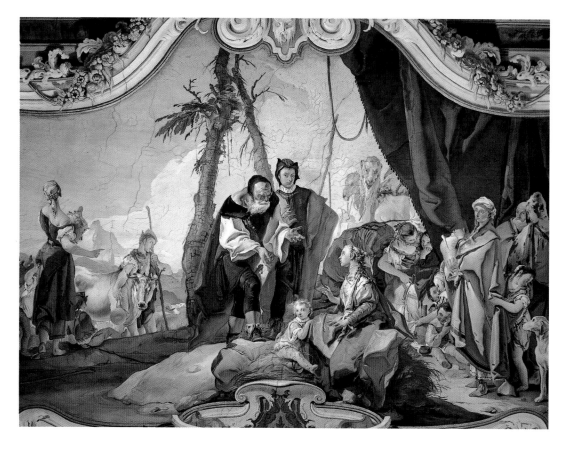

GIAMBATTISTA
TIEPOLO, Rachel
Hiding the Idols,
Palazzo
Arcivescovile, Udine.

facing page
GIAMBATTISTA
TIEPOLO, Institution
of the Rosary,
Church of the
Gesuati, Venice.

reputation outside the borders of the republic as well, so that Fontebasso went to work in Trent on two occasions, in 1736 and 1756, and subsequently to St. Petersburg, where he was summoned in the spring of 1761 to decorate several rooms in the Winter Palace with canvases and frescoes. In addition to large-scale decorations, Fontebasso also devoted himself to the production of easel paintings, amongst which a number of small pictures of realistic subjects and refined coloring (*Little Girl Eating Gruel* in the National Museum of Stockholm, *c.* 1760) stand out for the spontaneity and vivacity of their brushwork, as do some delightful votive canvases, characterized by an exceptional luminosity.

Giambattista Tiepolo. Born into a family of merchants, Giambattista Tiepolo (Venice, 1696 - Madrid, 1770) made an authoritative entry onto the Venetian art scene before the age of twenty. Even though so many great painters were

already at work there, his truly extraordinary personality and genius had a great impact. For over fifty years he was to be the dominant figure in eighteenth-century Venetian painting and his fame would spread throughout Europe. In fact Tiepolo epitomizes decorative painting on a grand scale, becoming almost a symbol of his age in its most dazzling aspects: the theater, *la vie galante*, the frivolous and superficial culture of Arcadia, and a certain mannered and melancholic nostalgia for the good old days of the classical sixteenth century. The great Tiepolo was to some extent all of these things: spiritually more akin to the dramas of Metastasio than to the comedies of Goldoni, to the music of Marcello and Galuppi than to that of Vivaldi. Thus he became almost a figurative embodiment of the showy and grandiose side of the century. Only fleetingly, chiefly in his mature period, did he touch on the other side, the one represented by the irony of Baretti, sensistic philosophy and the

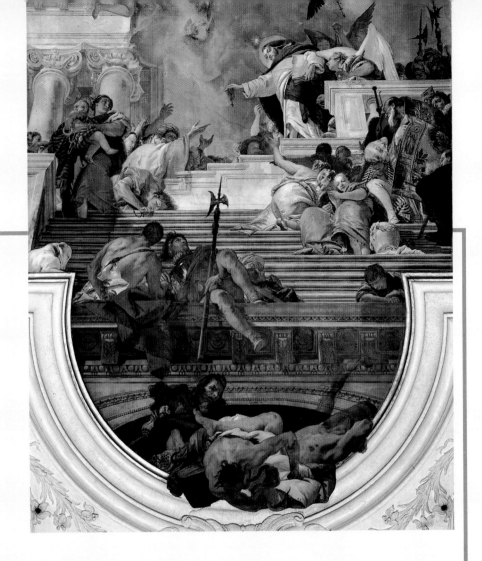

THE TRIUMPH OF ROCOCO: THE CHURCH OF THE GESUATI

Three great Venetian artists have contributed to making the large church of Santa Maria del Rosario which stands on the Fondamenta delle Zattere and is popularly known as the Gesuati, into a temple of the Rococo: the architect Antonio Massari, the painter Giambattista Tiepolo and the sculptor Gian Maria Morlaiter.

In the construction of this church, erected between 1726 and 1735, the predominant role was played by the architect, who designed not only its structure but also its rich internal fittings. Thus the building has a totally unitary character, into which the pictorial and sculptural

decoration fit perfectly, since they were part of the original project. In its design Massari used the suggestions made to him by the Dominican iconographers of the monastery, who wanted to exalt devotion to the Rosary and celebrate the glories and merits of their order.

It is from this viewpoint that we should interpret the frescoes of Giambattista Tiepolo that decorate the ceilings of the church's nave, presbytery and choir, executed between May 1737 and October 1739. On the ceiling of the nave Tiepolo painted three main scenes representing the *Appearance of the Virgin to St. Dominic*

(towards the high altar), the *Institution of the Rosary* (in the large central compartment) and the *Glory of St. Dominic* (towards the entrance), along with many other monochrome scenes depicting *Mysteries of the Passion*. The frescoes in the dome of the presbytery represent the *Papal and Cardinal Privileges* granted to the confraternities of the Rosary, while the choir of the friars has the emblematic image of *David Playing the Harp* at the center of the ceiling, ringed by figures of the *Major Prophets*. The picture on the first altar on the left is also intended to be an exaltation of the order. Representing *The Virgin with*

Three Female Saints of the Order (Catherine, Rose of Lima and Agnes of Montepulciano) to whom the Virgin appears, it was painted by Tiepolo in 1748 and added to the ones already present by Giambattista Piazzetta and Sebastiano Ricci, also depicting saints of the order.

Equally exceptional are the eight sculptures and six reliefs carved by Gian Maria Morlaiter, representing figures of saints and scenes from the life of Christ respectively and used to decorate the church's single nave and elegant Rococo high altar, finished in 1742, with its precious polychrome marble.

Enlightenment of the encyclopedists that paved the way for the triumph of the new middle class.

Tiepolo's first teacher was an eclectic artist, Gregorio Lazzarini, much celebrated in his own day. But only rarely does the memory of his clear and subdued colors reemerge in Giambattista's early pictures, painted around the age of twenty. The influence of the eclectic Lazzarini can be discerned, however, in the young Giambattista's astonishing capacity to pick out lexical and compositional elements from the works of other painters, whether his contemporaries or from previous centuries, and rework them to suit his own taste and sensibility. With the result that the initial period of Tiepolo's career is peppered with works of different stylistic and coloristic intonation. The first five panels he painted to be set above the arches in the Venetian church of the Ospedaletto (1715-1716) are characterized by a stream of glittering light and convulsed forms, a powerful and massive plasticism and a dramatic and fiery coloring. The evident baroque influence stems from the Emilian tendency that Crespi had revived in Bologna in the early eighteenth century and that Bencovich and Piazzetta had brought to Venice. But the contemporary portraits of *Doge Marco Corner* and *Doge Giovanni II Corner*, painted around 1716 for the family palace of Giovanni, the incumbent doge, have a lighter, sunnier coloring, clearly indebted to Sebastiano Ricci.

One of the most important models for the young Tiepolo, however, was Giambattista Piazzetta. It was from him that the artist took the solid plastic structure and articulated and forceful composition that we find in many of the early works, such as the *Sacrifice of Isaac* he painted in 1724 for the church of the Ospedaletto.

The insistence on a more refined coloring is also evident in some small canvases he executed for collectors. While these represent a somewhat minor activity, it is one that throws light on one of the more intimate aspects of the artist's personality, for he was to attain the most limpid

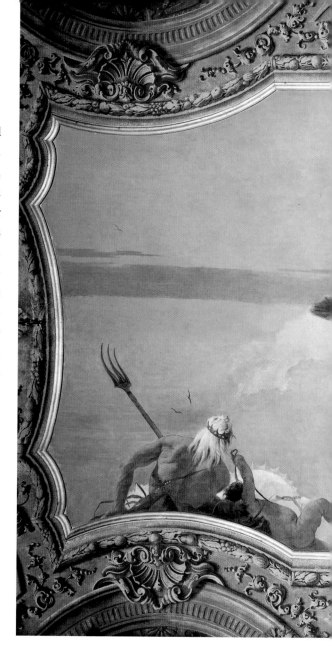

expressions of his poetics far more often in his sketches and in his drawings. Among these paintings, for example, are the four *Mythological Scenes* in the Gallerie dell'Accademia, in which the classical subjects are given a witty flavor of caricature and the grotesque by virtue of the light touch and brilliant color. Thus this wry episode saw him go beyond the baroque and offered the first languid hints of the rococo.

Around 1724 Tiepolo frescoed the ceiling of Palazzo Sandi with the *Triumph of Eloquence*. The colors now take on an ever paler tone and the composition is handled more freely. Here the baroque luminism and realism of Piazzetta have given way to a clear light that picks out and ignites the tapestry of colors. Tiepolo now owes a

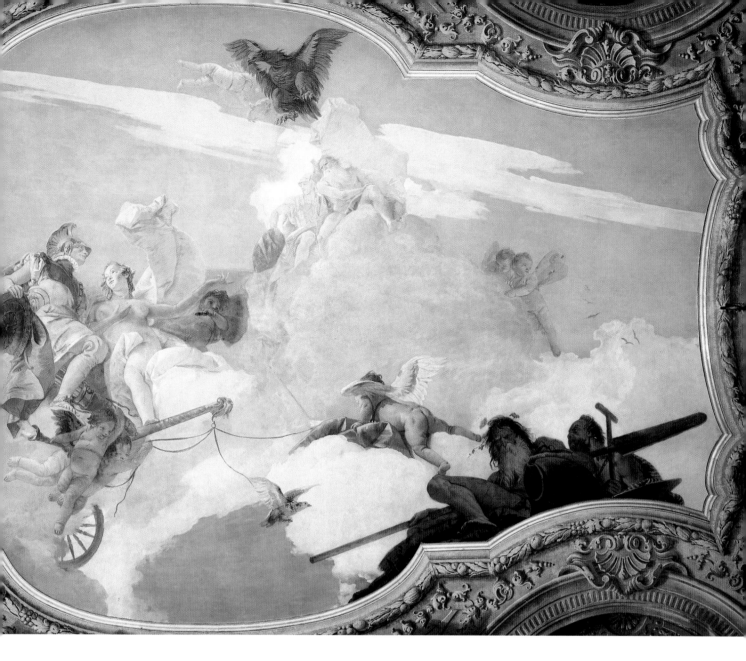

great deal to Ricci, who was at that time the main exponent of the decorative current in Venice. In the meantime the young painter was making a name for himself in the city and attracting a growing number of clients. In 1726 he entered the service of the Dolfin family and painted the *Roman Scenes* in their Venetian palace, and contemporaneously – to a commission from the patriarch of Aquileia, the Venetian Dionisio Dolfin – produced his finest work of this period, the *Scenes from the Bible* in the Palazzo Patriarcale in Udine (1726-1729). In these paintings the artist embarked on his conquest of light, which was going to be the protagonist of all his work in the future. In fact the fresco of *Rachel Hiding the Idols* is a feast of diaphanous and crystalline col-

ors, where the eye roams over melodies of pale greens, soft pinks, milky whites and ivories, while a silvery sky stretches above a landscape of glass. The nimble and lively drawing delineates figures that are almost set free of their outlines, so that they melt into a vibrant luminosity. Thus light becomes a decorative medium and takes on an ever purer quality, doing away with the limitations of a natural representation and creating instead the abstract means of expression with which he will find it easy to impart movement to his compositions and to seek out the most musical rhythms, the most exemplary beauty and the freest symphonies of color. Here we come at last to the mature Tiepolo, prone to hark back to the grand themes of sixteenth-century painting, and

page 159
GIAMBATTISTA TIEPOLO, Banquet of Antony and Cleopatra, Palazzo Labia, Venice.

page 158
GIAMBATTISTA TIEPOLO, The Marriage of Frederick Barbarossa and Beatrice of Burgundy, Kaisersaal, Residenz, Würzburg.

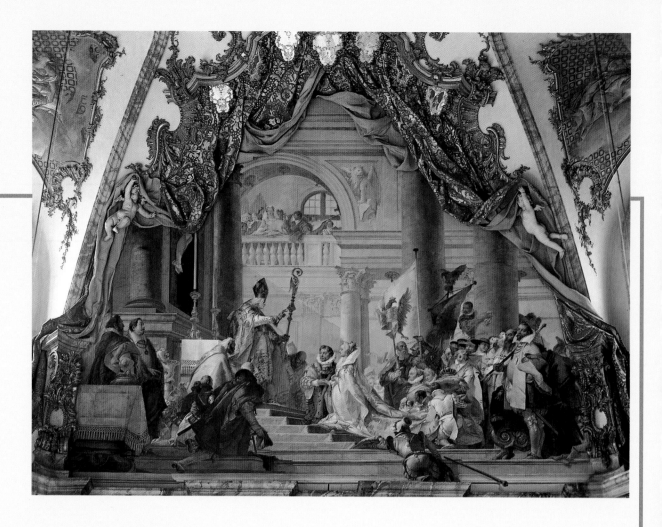

TIEPOLO AT WÜRZBURG

Giambattista Tiepolo worked outside the borders of the Venetian state on many occasions, going several times to Milan, where he frescoed numerous townhouses, and concluding his prolific career in 1770 at Madrid, where he had been summoned by Carlos III to decorate a number of rooms in the new royal palace. But by far his most celebrated decorative undertaking – for the quality of the painting as well as the scale of the work – is the one he carried out at Würzburg in Franconia, where Giambattista went in December 1750, accompanied by his sons Giandomenico and Lorenzo.

Prince Bishop Karl Philipp von Greiffenklau had entrusted him with the task of frescoing the large dining room of his residence, which only later would come to be called the Kaisersaal, the name by which it is universally known today. Within the fanciful decoration of white and gold stuccoes on the ceiling, Giambattista painted the large scene of *Apollo Leading Beatrice of Burgundy to the Genius of the German Nation* (Beatrice was soon to be married to Frederick Barbarossa). Immediately afterward he set to work on the walls, where he depicted *The Marriage of Barbarossa* and *The Investiture of Bishop*

Harold as Duke of Franconia, completing the work in October 1752. In these works Tiepolo was able to rise above the overly complex subjects, which were meant to bestow a historical legitimacy on the duchy of Franconia, and deploy all his astonishing skill with color and composition, the matchless elegance of his style, and his incredible ability to stage events with the true spirit of a theater director.

The client's satisfaction must have been truly great since he immediately entrusted Giambattista with the fresco decoration of the immense ceiling of the Residenz's grand staircase.

Here, over the summer of 1753, Tiepolo painted another splendid masterpiece at lightning speed, the scene of *Mount Olympus Surrounded by the Four Continents*.
The complex composition is given unity by the light that pervades it, radiating from the central figure of Apollo which stands out against the brilliant sky, and that renders the colors limpid and transparent.
The figures above the molding are a remarkable demonstration of Tiepolo's unrivaled imagination, capable of inventing poses, situations and images that flow seamlessly into one another.

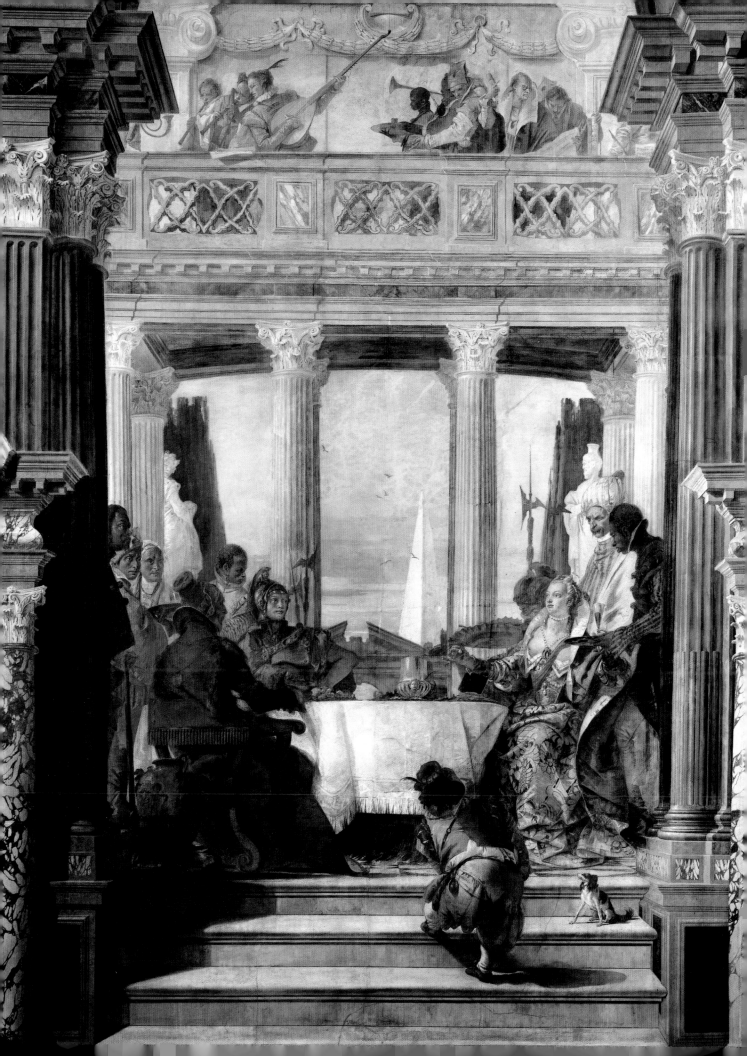

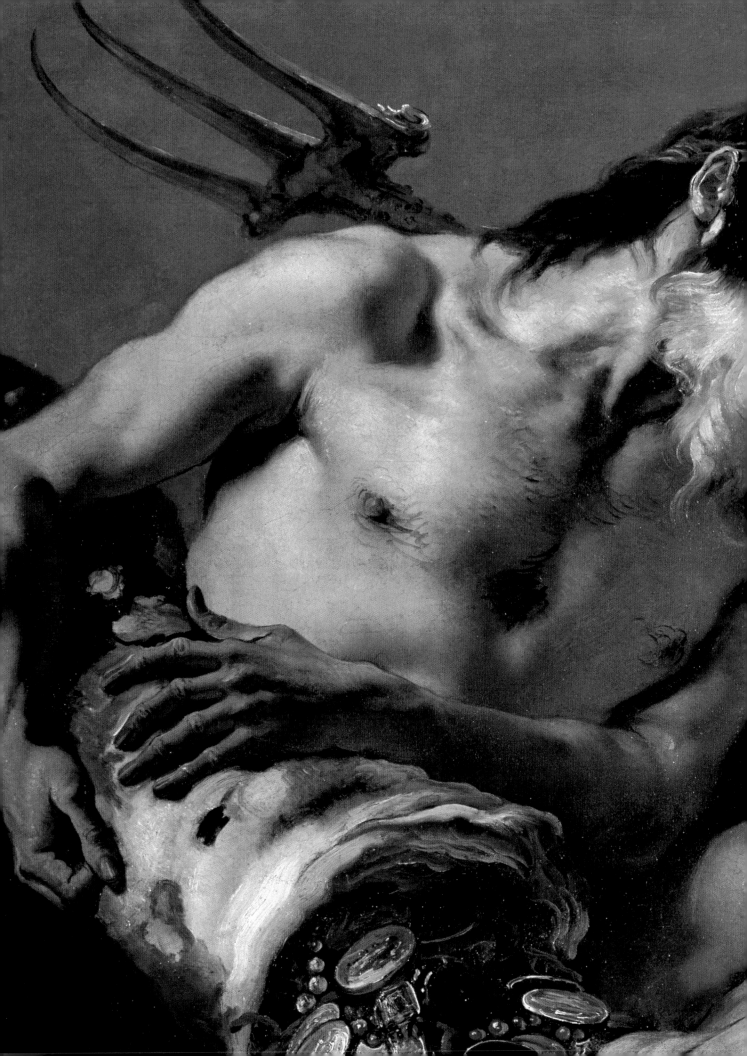

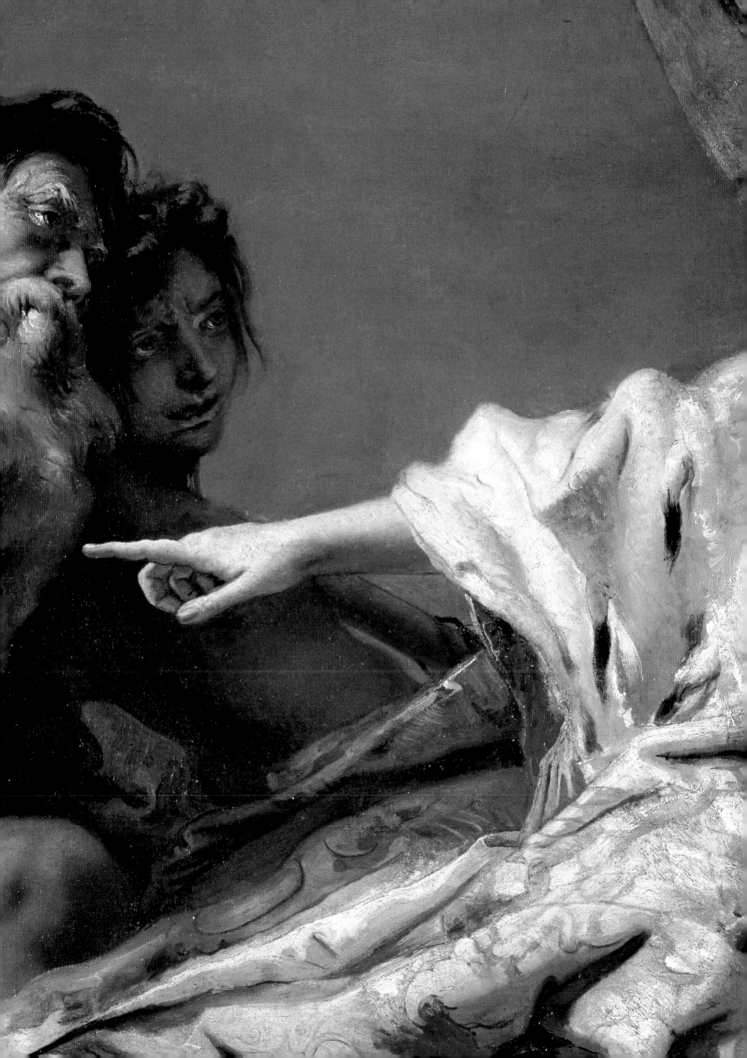

especially to Paolo Veronese. There is a self-portrait of him at this time in the *Apelles Painting Campaspe's Portrait*, now in the Montreal Museum of Fine Arts. Tiepolo is in modern dress, painting at the easel in his studio; in the background we can see canvases of large dimensions that can be identified as expressions of the decorative style in which he looked back to the sixteenth century. But Titian also appears among Tiepolo's "tutelary deities". In fact, the splendid *Danaë* in the National Museum of Stockholm constitutes a reworking – in a wholly eighteenth-century key, steeped in subtle irony – of a "mythological fable" painted many times by the great Titian.

Many of the works that Tiepolo executed outside Venice reflect the shift toward Veronese, in particular the frescoes of Palazzo Dugnani in Milan (1731), the Colleoni Chapel in Bergamo Cathedral (1733) and the Villa Loschi at Biron near Vicenza (1734). Here his allegories shake off all residues of naturalism and are set inside unreal and elegant works of architecture – often painted by the Ferrarese *quadraturista* Gerolamo Mengozzi, called Colonna – that are flooded with a musical light. The great masterpieces came at the end of the decade, and were the frescoes in the Venetian church of the Gesuati (1737-1739) and Palazzo Clerici in Milan (1740), and the canvases in the Scuola dei Carmini in Venice (1743-1748).

On the large ceiling of the same church, painted with the *Glory of St. Dominic*, the sacred figures, those of the saints of the Dominican order, the angels and the cherubim, hover amidst gaping skies that are streaked with clouds that gleam white in the sun and take on silvery and lilac, gray and rosy tones. But this is not a real and accurate light, like the one that could now be found in Canaletto's paintings, but an artificial light. It is an Apollonian splendor, carefully measured so as not to disturb the abstract order that was the only possible setting for his decorative inventions. And here we have a precise reference to the memory of Veronese, taking on that musi-

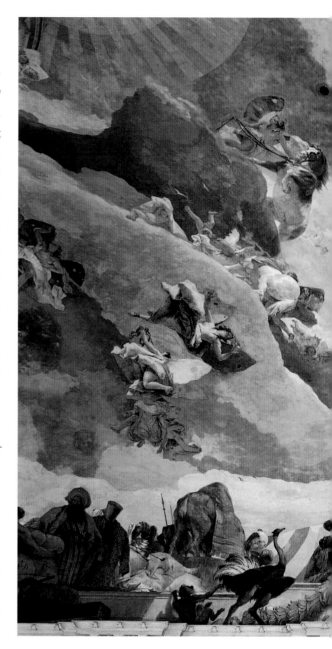

cal quality that was the great strength of the eighteenth-century decorators. A similar intensity of light is the central motif of Tiepolo's masterpiece in the Scuola dei Carmini, representing the *Virgin, Angels and the Christian Virtues*, where the artist achieved that physical ideal of beauty which was one of his formative themes.

In the years that followed, commissions came thick and fast, and Tiepolo worked unflaggingly on small easel paintings and large altarpieces, decorations in palaces and frescoes in churches. In 1743-1744 he painted the frescoes in Villa Cordellina at Montecchio Maggiore, the won-

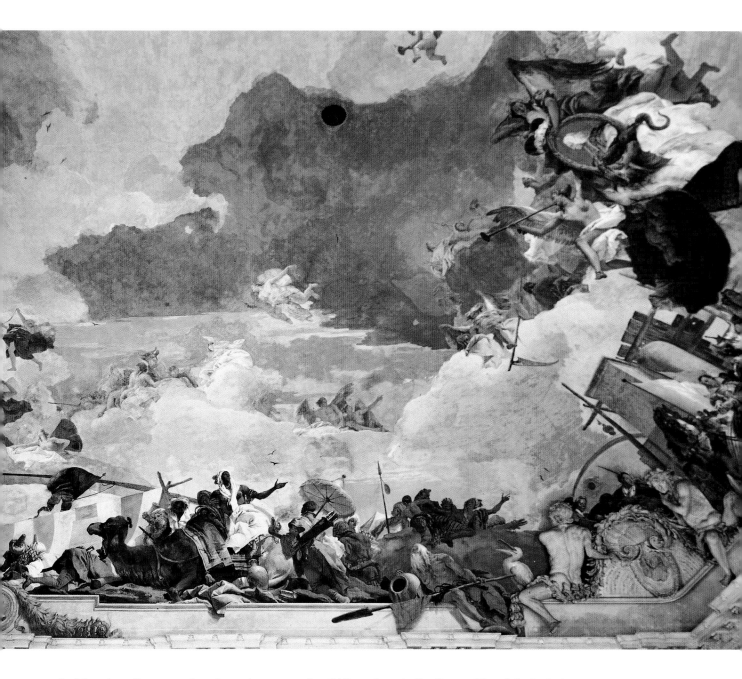

derful series of canvases based on the story of
Rinaldo and Armida, now in the Art Institute of
Chicago, and the ceiling with *The Apotheosis of
Admiral Vettor Pisani* for Palazzo Pisani Moretta.
In 1745 he painted the fresco of the *Holy House
of Loreto* in the church of the Scalzi, which was
destroyed in 1915. The sketches for some of
these works have been preserved, and at times
they appear superior to the full-scale versions in
their poetic unity, exquisite lightness of touch
and elegance of color.

In the frescoes in the ballroom of Palazzo
Labia (1746-1747), Colonna's scenographic scaf-
folding theatrically frames Tiepolo's depictions
of pagan deities and the meeting and banquet of
Antony and Cleopatra. A comparison of the
sketches with the frescoes again reveals how the
freshness of the invention was lost to some
extent in the more controlled execution of the
larger work. Nevertheless, these frescoes consti-
tute a resounding example of his approach to the
historico-decorative genre, in which the spectac-
ular scenery of the baroque is blended with the
lightness of the rococo. At the same time they
illustrate the final evolution in Tiepolo's color,
which tended increasingly toward a cold and

GIAMBATTISTA
TIEPOLO, Mount
Olympus
Surrounded by the
Four Continents
(Africa), Residenz,
Würzburg. Detail.

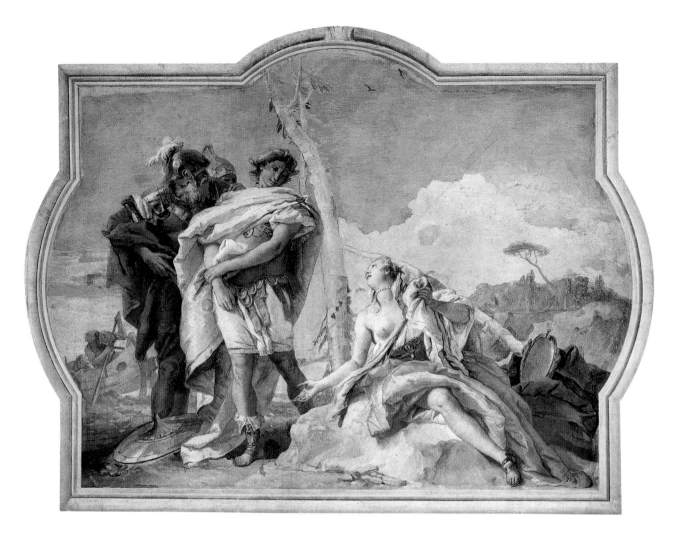

crystalline clarity, enriched by a varied play of light that freezes the reflections on the fluttering and sumptuous drapery, stiffening the forms within disjointed and jittery outlines.

Thus Tiepolo prepared the vocabulary for his greatest decorative venture: the frescoes in the residence of Prince Bishop Karl Philipp von Greiffenklau at Würzburg, painted with the help of his sons Domenico and Lorenzo (1750-1753). The Residenz's dining room, decorated with gilded stuccoes, and a majestic grand staircase offered spaces that Tiepolo's architectural inspiration was able to complete and re-create. In fact, the scenes of the *Investiture* and the *Marriage* of the client's ostensible ancestors are of extraordinary decorative effect, just as nothing can equal the symphonic sonority of the *Triumph of Apollo* on the vault of the staircase, where the real effigies of the protagonists are set amidst high-flown allegories of the four parts of the world.

Returning to Venice in the autumn of 1753, Tiepolo received more commissions of great importance: the frescoes in the Venetian church of the Pietà (1754), Palazzo Rezzonico (1757), Palazzo Canossa in Verona (1761) and Villa Pisani at Stra (1761-1762). These works would grow increasingly complex in their orchestration, relying on a clarified set of colors that are extremely intense in the foreground and then gradually fade into the diaphanous and luminous insubstantiality of the sky. Here too, the sketches keep the breath of creativity more alive. The distinction between Tiepolo's official style, placed at the service of his clients (as, for example, in the *Neptune Offering Gifts to Venice*, painted for the Doge's Palace), and his increasingly frequent escapes into the intimate and reflective world of small canvases, etchings and drawings grew even more marked toward the end of his career.

It is from this perspective that we should look at the frescoes in the Villa Valmarana at Vicenza (1757) with scenes from the *Iliad*, *Aeneid*, *Jerusalem Liberated* and *Orlando Furioso*. A more genuine mood emerges from the customary frills

of the Arcadian melodrama, offering a foretaste of Tiepolo's final style. The line is also new, tending to define the figures with a quavery sensitivity, breaking the planes into facets which reflect the light more precisely and creating an atmosphere of pensive intimacy.

In 1762, after finishing the fresco in the ballroom of the Villa Pisani at Stra, Tiepolo finally accepted an invitation to go to the Spanish court in Madrid to decorate the new royal palace. His contract with the king of Spain covered only the frescoes for the throne room ceiling, which he finished with his customary but now detached skill and with the assistance of his sons in 1764. Subsequently, he was commissioned to decorate the ceilings of the queen's antechamber and the Hall of the Halberdiers, completed in 1766. There is a more emotional character to the poetic motifs of his last works, including the sketches for the altarpieces in the royal church at Aranjuez (now at Prince's Gate in London), in which a realistic landscape is set between the quivering wings of the angels. But Tiepolo had begun to encounter hostility to his work as a result of the success achieved by the uncompromising neoclassicism of Mengs, who was now dominant in court circles. Out of fashion, the canvases at Aranjuez were in fact taken down and put in storage, ending up for the most part in the Prado. But the message of Tiepolo's color was not lost, for a great Spanish artist, Francisco de Goya, was to take it up in his own paintings and engravings, and draw on it, at the outset, to develop a style that was to become one of the emblems of the new century.

From the Arcadian Landscape to the Painting of the Enlightenment.

In 1740 the Venetian publisher Giambattista Albrizzi brought out a splendid folio edition of Tasso's *Jerusalem Liberated* with engravings made after drawings by Piazzetta. The passionate love affair and melancholic farewells of Rinaldo and

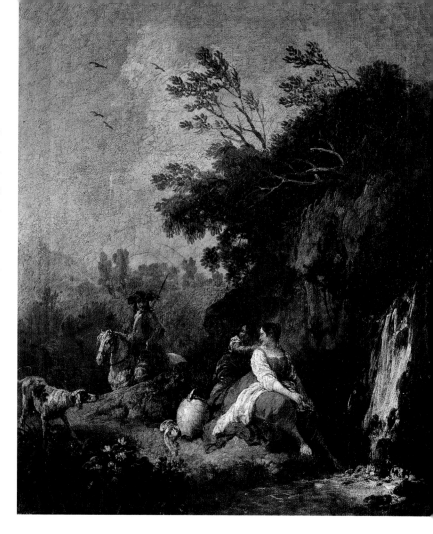

Armida were brought back into vogue through the republication of the great sixteenth-century poem. Besides, the return to nature was not just an invention of painters and poets. It was also proposed by the Enlightenment philosopher Jean-Jacques Rousseau in his *Emile* (1740), a work that addressed a long series of naturalistic concerns, closely bound up with the development of the sciences, that had found their most fertile terrain in France. Slowly but surely the culture of the Enlightenment was to push aside the frivolous fables, theatricality and mythological rhetoric of the Rococo, substituting a new and more objective view of the natural world. In the figurative field this was reflected in the emergence of the school of "Painters of Reality" over the course of the eighteenth century.

The first Venetian painter to tackle the new theme of the landscape was Marco Ricci (Belluno, 1676 - Venice, 1730), nephew of the celebrated Sebastiano. Marco went to Rome at the beginning of the century, expelled from his

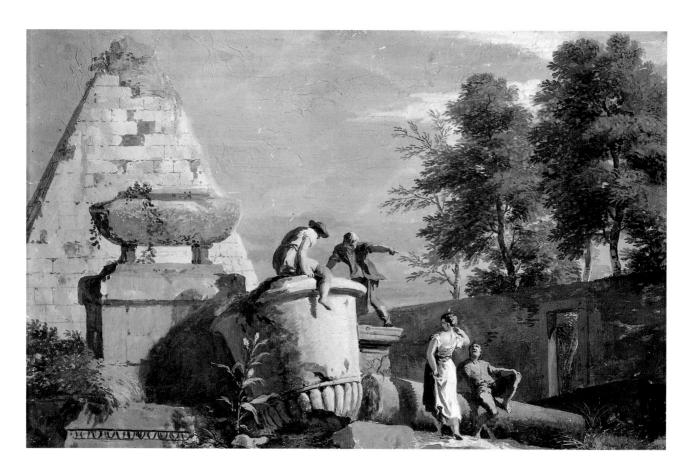

native city after a bloody brawl in a tavern, and was certainly impressed by the pre-Romantic poetics of Salvator Rosa, who continued the classicist tradition of Domenichino, Poussin and Claude Lorrain but with the introduction of a whimsical spirit. At the same time, however, he preserved, from his roots in the Veneto, the memory of the landscapes present in the paintings of Titian, who was also his model in the fields of drawing and engraving. He soon started to work with his uncle, joining him in England, where he had gone with Pellegrini in 1708 to paint scenery for the King's Theater. After 1716 he returned to Venice, where he stayed until his death, alternating the activity of painter with that of scenographer.

The typical subjects of Marco Ricci's pictures – broad and shady valleys, gigantic oaks, fast-flowing torrents under great and luminous skies, parks and gardens, classical ruins reconstructed with the fantasy of a scenographer in a manner that anticipates Romanticism – create an unrivalled model of eighteenth-century Venetian

landscape painting (*Storm in the Valley of the Piave*, in the Fondazione Querini Stampalia, Venice). A particularly interesting aspect of his activity, carried out chiefly in the last years of his life, is that of the landscapes he painted in tempera on kid-skin, producing effects of exceptional luminosity (*Landscape with Ruins*, in the Belluno Museum).

Thus Ricci exercised an influence on the greatest landscape artists working in the second half of the century, Zuccarelli and Zais, along with such painters of views as Canaletto and Marieschi, who occasionally ventured into the field of landscape painting.

Francesco Zuccarelli (Pitigliano, Grosseto, 1702 - Florence, 1778), trained in Tuscany and Rome, arrived in Venice in the fourth decade of the century, but then went to work in Bergamo and for long periods in England (1752-1762 and 1765-1768). He was undoubtedly the most international of the landscape painters operating in Venice and had a Europe-wide reputation, something in which he was favored by a suave and artificial style, rich in precious vibrations of

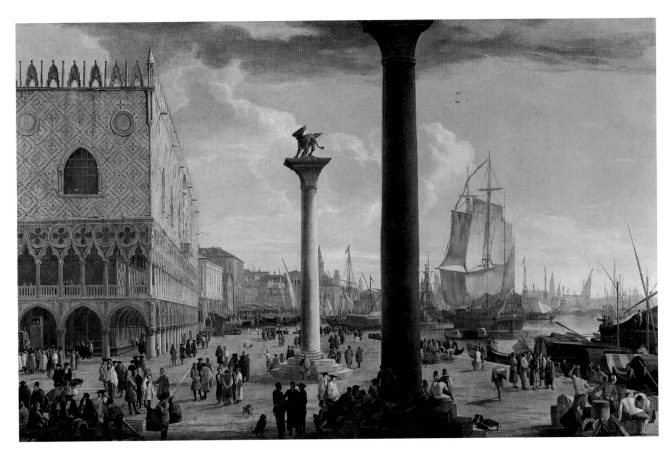

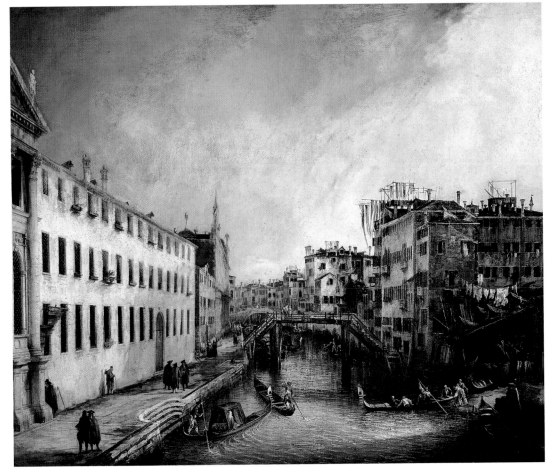

above
LUCA CARLEVARIJS,
View of the Wharf
with the Doge's
Palace, Galleria
Nazionale d'Arte
Antica in Palazzo
Corsini, Rome.

left
CANALETTO,
Rio dei Mendicanti,
Ca' Rezzonico,
Venice.

following pages
LUCA CARLEVARIJS,
View of the Wharf
with the Doge's
Palace, Galleria
Nazionale d'Arte
Antica in Palazzo
Corsini, Rome.
Detail.

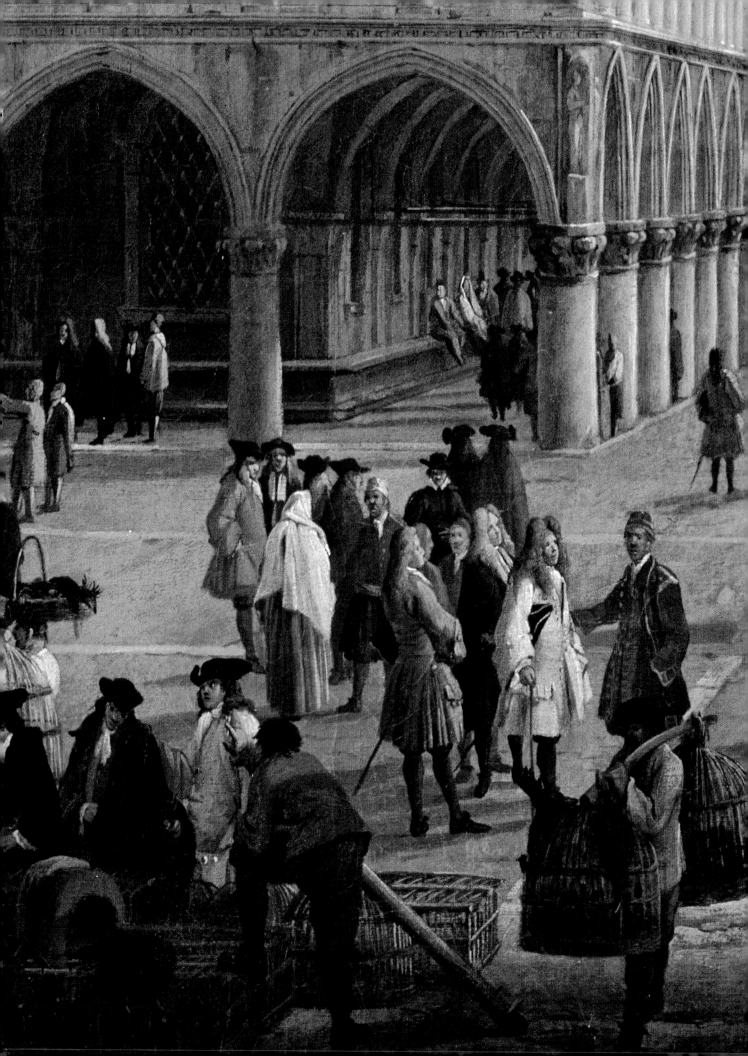

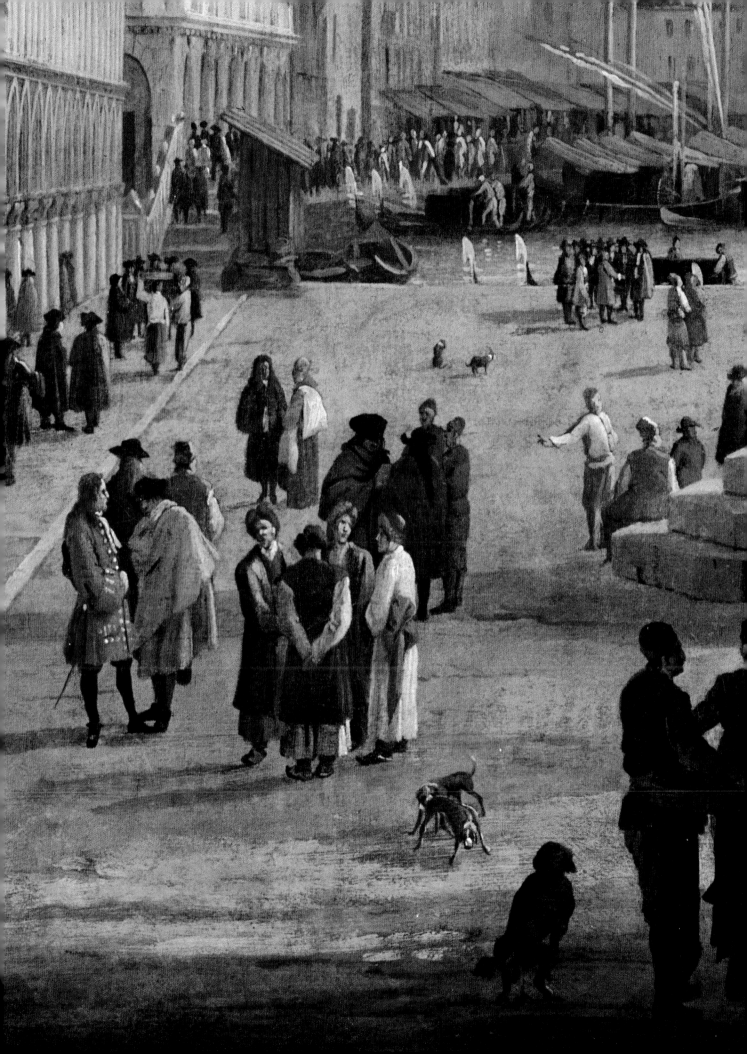

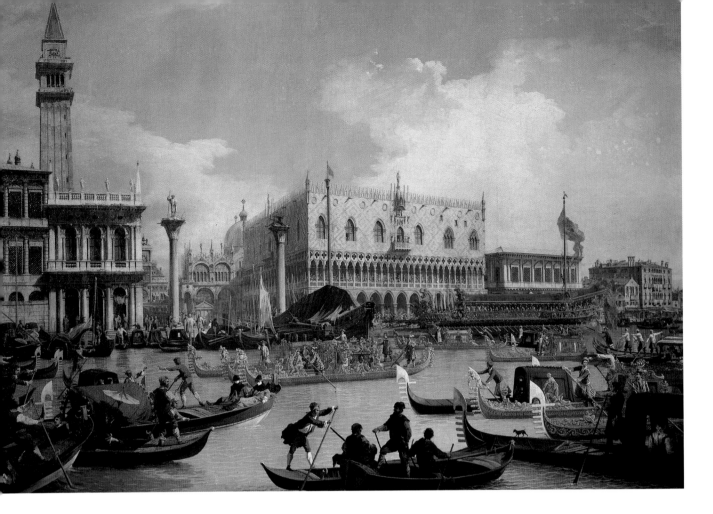

CANALETTO,
The Bucintoro
Returning to the
Molo on Ascension
Day, Pushkin
Museum, Moscow.

the surface that suited the taste of the day (*Landscape with Waterfall and Shepherds* in the Carrara Academy, Bergamo).

Giuseppe Zais (Forno di Canale, Belluno, 1709 - Treviso, 1784), on the other hand, seems closer to Marco Ricci, combining his robust vein with an extremely spontaneous and vivid approach to painting. In his old age he adopted some of Zuccarelli's affectations, but still clung to a more realistic image of nature, even though viewed through Arcadian eyes.

"Vedutismo". Up to now we have steered clear of the specific subject of the painting of *vedute* or "views", where what is meant by this term are topographically accurate – or at least apparently so – images of the city's monumental scenery. It is clear that such a genre was rooted in a vision that was no longer whimsical or romantic, but shaped by the aesthetics of the Enlightenment, with its stricter adherence to scientific principles. In fact many of the "painters of views" – as they called themselves from the eigh-

teenth century onward in order to distinguish themselves from practitioners of all the other genres, from the landscape to the caprice – made use of optical instruments (the "camera obscura") to reproduce what they saw with the greatest fidelity possible, before going on to modify it to suit their own requirements.

In the already rich milieu of eighteenth-century Venetian painting, the *vedutisti* constituted a group of great importance. Their precursors were artists of Northern European origin such as Joseph Heintz the Younger (Augsburg, *c.* 1600 - Venice, 1678), the author of kaleidoscopic images of the city's squares and canals in which the typically Northern taste for the precise representation of reality is united with a liveliness of coloring and effects close to that of Venetian painting. Yet his example does not seem to have made any significant impression on the city. Even the highly skilled Gaspar van Wittel (Amersfoort, 1652/53 - Rome, 1736), who was in Venice between the end of 1694 and 1695, does not seem to have attracted much attention among

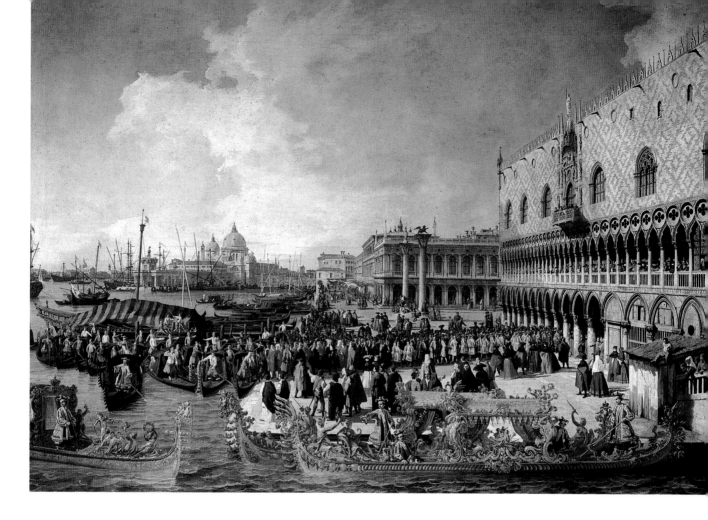

collectors or local artists with his views that only rarely captured the unique colors of the lagoon landscape, as the painter showed more interest in its scenographic possibilities, explored with the proficiency of an expert illustrator.

It is only with Luca Carlevarijs (Udine, 1663 - Venice, 1730), present in the city from 1679, that Venetian *vedutismo* can be said to have found the key to a felicitous interpretation of the surroundings: the fusion, that is, between the architectural theme and its free reworking by the painter. His copious production was almost entirely a response to the demand for a documentation of public events and monumental scenes that was typical of the first two decades of the eighteenth century. Certainly he earned fame with his brilliant palette, especially in the groups of small figures (known as *macchiette*) reproduced from life with meticulous drawings in pencil and ink, many of which can now be seen in the Victoria and Albert Museum in London and the Museo Correr in Venice. But his success also stemmed in part from his ability to

depict Venice's buildings with great precision, even if they are often shrouded in a rosy haze that softens their details, especially in the background (*The Regatta in Honor of Frederick IV of Denmark* in Frederiksborg Castle, 1709). The same realistic vision is also to be found in his later works, notable for their pictorial harmony (*Piazzetta San Marco*, Oxford, Ashmolean Museum; *View of the Wharf with the Zecca*, Rome, Galleria Corsini).

In the last decade of his life Carlevarijs found himself vying with the rising star of Venetian *vedutismo*, Antonio Canal, called Canaletto (Venice, 1697-1768). Canaletto began his career working with his father, a painter of theatrical scenery, and we know that he contributed between 1716 and 1719 to the staging of various operas in Venice and Rome. Shortly afterward, however, Canaletto broke his ties with the world of the theater and returned to Venice. That this was the consequence of a genuine crisis of artistic conscience we are told by Anton Maria Zanetti: tired of inventing theatrical scenes, the

CANALETTO,
The Reception of the Ambassador in the Doge's Palace, Crespi Collection, Milan.

following pages
CANALETTO,
Campo Santa Maria Formosa, Woburn Abbey.

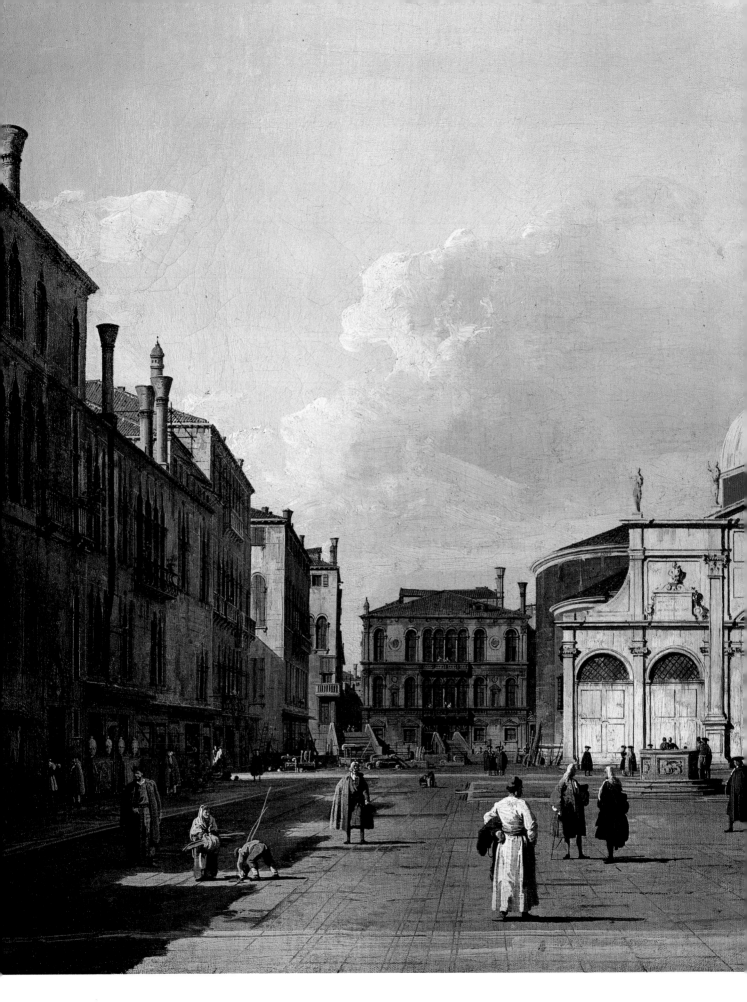

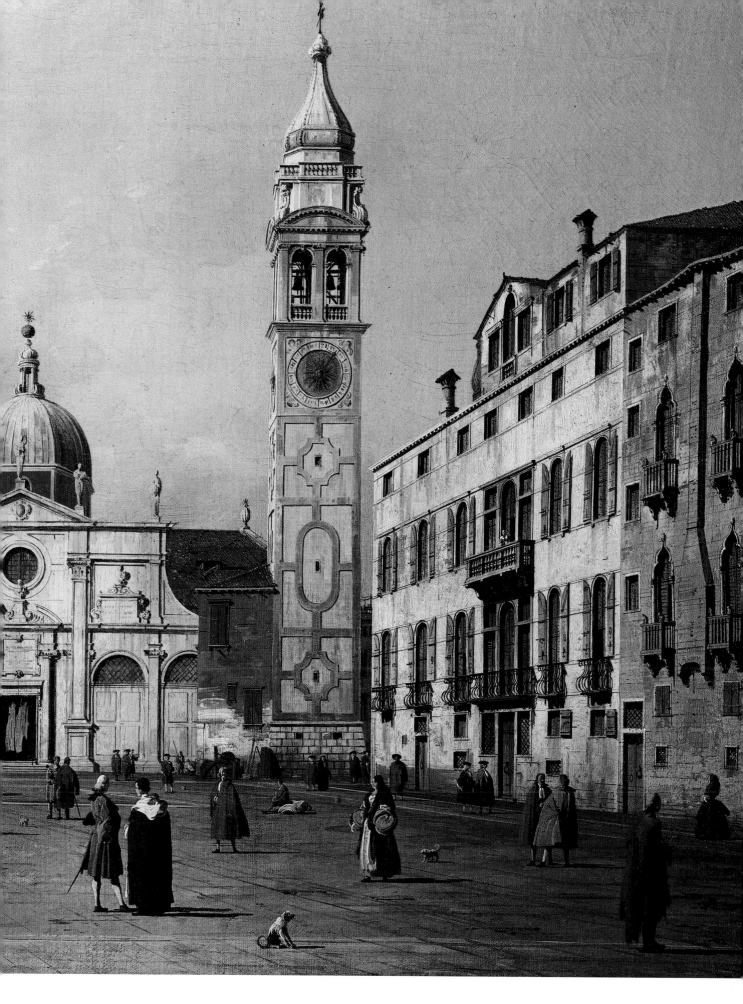

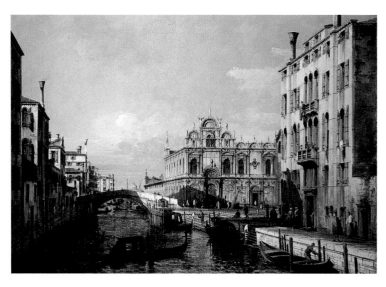

BERNARDO BELLOTTO, View of the Rio dei Mendicanti and the Scuola Grande di San Marco, Gallerie dell'Accademia, Venice.

painter turned to nature, inserting into the virtuoso framework of his scenographer's perspective the landscapes and views that the city presented directly to him. In this phase it was above all Marco Ricci who inspired him, with his *capricci* of ruins, and his influence is still clearly apparent in the four views that were probably painted for the prince of Liechtenstein between 1720 and 1724 (two of which are now in Ca' Rezzonico and two in the Thyssen Collection in Madrid), in which Canaletto presents a romantically suggestive image of Venice. In the *Rio dei Mendicanti*, for example, the painter explores with great realism the life of "minor" Venice, represented with great luminosity.

With works like these, Canaletto's prestige soon surpassed that of all his fellow *vedutisti*, owing to his ability to apply his skill with perspective to an imaginative evocation of the real world, with means and results that at first resembled the pictorialism of Marco Ricci and then moved toward a rational sensibility more in tune with the ideas of the Enlightenment.

The interest that Canaletto aroused and the idea that his painting was revolutionizing the tradition of the perspective view are documented in an exchange of letters in 1725-1726 between the Veronese painter Alessandro Marchesini and a merchant and collector from Lucca, Stefano Conti, who wanted two views of Venice to go with the three by Carlevarijs already in his pos-

session. In them Marchesini describes Canaletto as the only painter then present in Venice capable of painting views from life. He also states that Canaletto always used the camera obscura to make drawings of the places that he intended to reproduce and then worked from these (similar to the ones in the "Quaderno Cagnola", now in the Gallerie dell'Accademia) in the peace and quiet of his studio.

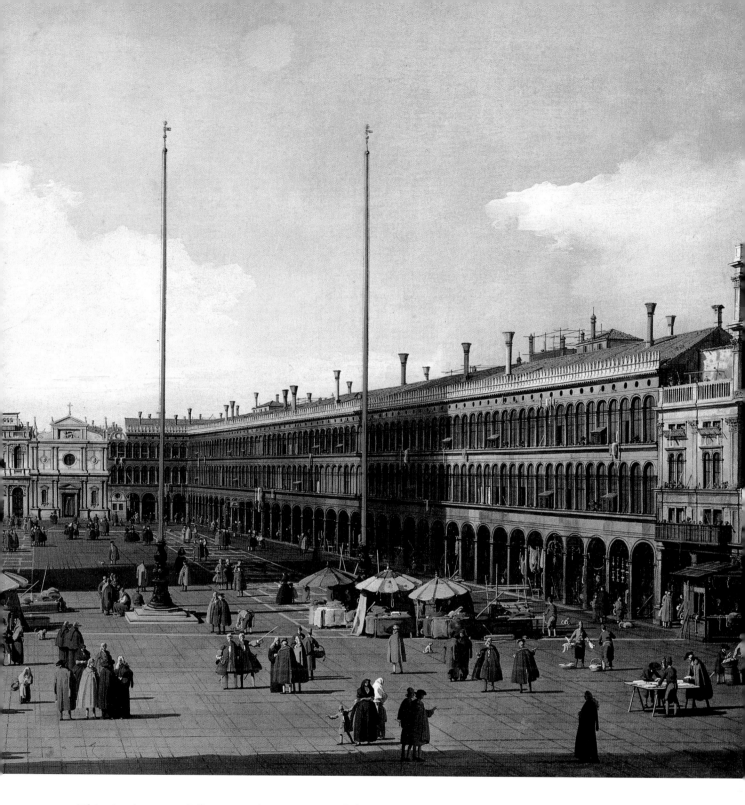

This is the essentially new element in Canaletto's approach, and the one that renders so unique some of his evocations of typically Venetian festivals (*The Bucintoro Returning to the Molo on Ascension Day* in Moscow, and *The Reception of the Ambassador in the Doge's Palace* in Milan). It is also present in paintings such as *The Stonemason's Yard* in the National Gallery of London, in which stone-cutters dress the marble with blows of their mallets under a scorching sun. In this way traditional views of Venice are used to translate "effects of perspective" into the most movingly lyric panoramas. They evoke a real setting in which the vibrating light descends like a luminescent dust on the white and pink plaster and the brick-colored roofs, while the reflections on the water undulate slowly, breaking up the images and putting them back together again.

CANALETTO,
View of Piazza San
Marco, Galleria
Nazionale d'Arte
Antica in Palazzo
Corsini, Rome.

The decade from 1730 to 1740 brought an uninterrupted series of commissions: thirty-eight views for the British consul Joseph Smith, his patron; twenty-four for the duke of Bedford (*Campo Santa Maria Formosa*, Woburn Abbey); more than twenty for the duke of Buckingham; fifteen for the earl of Carlisle (*View of the Bacino di San Marco*, now in Boston, 1739); and dozens of others, mostly for British clients, who became the main buyers of pictures of Venice in the eighteenth century. And yet the painter's creative inspiration was so great that it is not possible to detect any sign of weariness. The only difference was that his technique grew more supple and precise, entailing the use of many small strokes with the tip of the brush to depict the crowds of people, the bustle of the gondolas, the sparkling of light on the roofs. There is an excellent example of this in the collection at Windsor, the view of the *Grand Canal at Ca' Balbi* (c. 1735), thronged with people on the day of the regatta. This is Canaletto at the height of his powers, but also a moment when he verged on the almost "automatic" preciosity of the Rococo style and even ran the risk of settling into a manner that, however pleasant and joyful, would have led him away from the enlightened manifestation of his most effective style (*View of Piazza San Marco*, Galleria Corsini, Rome).

In 1746, yielding to pressure from Smith, Canaletto set off for London, where he stayed with brief interruptions until 1755. He was in his element painting the broad and watery expanse of the Thames and the stately homes in the charming countryside. He stretched his views out horizontally to take in ever larger expanses of space, a tendency that was already visible in the last canvases he had painted before leaving Venice.

It is often claimed that the period he spent in England had a negative effect on the artist, rendering his palette colder and his drawing stiffer and more incised, and some of the responsibility for this has been attributed to his contact with Dutch painters. At bottom, however, Canaletto did nothing but continue along the path he had marked out for himself at the beginning, taking his lucid analysis of the landscape to its logical conclusion and gauging the values of color and light with great accuracy (*Walton Bridge* in the Dulwich Gallery, c. 1750). Thus, in some of the last pictures he painted after returning to Venice for good, such as the *Portico of a Palace* offered to the Accademia in 1765, or the *Staircase of the Giants* in Mexico City, we find him even more lucid and meticulous. The patient search for the right light, the astounding perspective, the way that each of the shadows is given its correct value: in short the "reason" that always governed his pictorial language had certainly not displaced the authentic painter, capable of capturing the kaleidoscopic variety of Venice with undimmed vivacity.

If Canaletto proposed a rational and in a certain way lyrically abstract interpretation of Venice, his nephew Bernardo Bellotto (Venice, 1722 - Warsaw, 1780) seems almost from the start to have sought a more realistic vision, often touching on an authentic naturalism. According to contemporary sources, Bernardo began to collaborate with his uncle at a very early age, in 1735. His name appears on the list of members of the Venetian guild of painters in 1738, and this indicates that he was already pursuing an independent career. At least at the beginning, this career must have consisted chiefly of the execution of copies of his uncle's paintings and drawings. In fact, Guarienti wrote at the time that he "took to imitating him with much study and application". Guarienti also states that from the early years of the 1740's onward Bernardo made many journeys to Rome and to the principal cities of Northern Italy, where he painted numerous views (*The Old Bridge over the Po*, Pinacoteca Sabauda, Turin; *Views of the Gazzada*, Pinacoteca di Brera, Milan) that were characterized by their incisive realism and cold range of

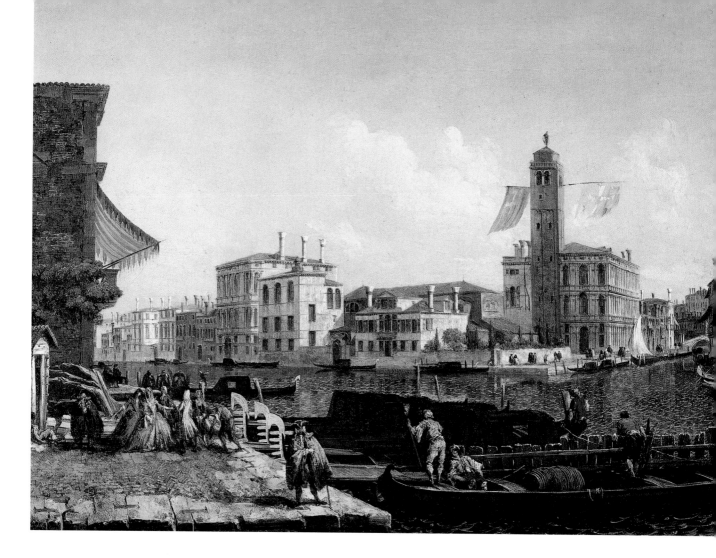

colors. The same stylistic elements appear in his views of Venice, which differ from those of Canaletto in the marked contrast between light and shadow, and in the thicker paint that is laid on in parallel brushstrokes (*View of the Rio dei Mendicanti and the Scuola Grande di San Marco*, Gallerie dell'Accademia).

In 1747 Bellotto left Venice forever, going to Dresden, where he settled at the court of August III, Elector of Saxony and King of Poland, remaining there for over ten years. Although his work was still based on Canaletto's, by now he began to show his independence: he probed ever deeper into the real qualities of the landscape, capturing the cold light streaked with iridescent reflections that is typical of northern panoramas. After wandering for a long time in the German-speaking countries, Bellotto arrived in Warsaw in 1766 and was soon appointed court painter by King Stanislaw Poniatowski. In his works for the Polish court – including the celebrated series of

canvases that decorate the so-called "Canaletto Room" of the royal castle – he carried on with his quest for more subtle chromatic values, producing limpid views of the city and its environs that are characterized by great topographical precision and animated by numerous figures.

Some ten years older than Bellotto, Michele Marieschi (Venice, 1710-1743) was an interesting *vedutista* whose complex personality is only now being rediscovered. Active as a theatrical scene painter in his youth, Marieschi – probably from 1735 onward – produced over the brief span of his career many views of Venice characterized by a fondness for broad expanses, superimposed brushwork, and thick paint laid on in lumps (*Rialto Bridge* in the Hermitage, *c.* 1737; *View of the Grand Canal at San Geremia* in the Buccleuch Collection at Malmesbury, 1742). His numerous imaginary views are of considerable interest for the extremely free and personal quality of the invention. Mostly of small format, they already

MICHELE MARIESCHI, View of the Grand Canal at San Geremia, Buccleuch Collection, Malmesbury.

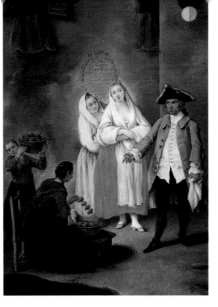

prefigure the pre-Romantic world of Francesco Guardi's late work (*Capricci* in the National Gallery of London, *c.* 1740). A characteristic of Marieschi – who spent much of his career working in the "picture studio" of his father-in-law Angelo Fontana – is the fact that he almost never painted the figures that appear in his works. In fact, the *macchiette* were entrusted to one of the specialists in Fontana's studio, usually Francesco Antonio Simonini, Antonio Guardi or Gaspare Diziani. But on a few occasions even as famous an artist as Giambattista Tiepolo lent a hand (*Courtyard with Stairs* in the Saint Louis Museum).

The Painting of Everyday Life.

In the second half of the eighteenth century attention turned decisively toward a consideration of the realities of human society and the natural world. This ideological orientation, which first emerged in France during the Enlightenment, found a favorable climate in Venice, where the ideas were imported through books or visits by distinguished personages, such as the one paid by Rousseau in 1742-1743.

Yet Venice never became a revolutionary city, for the liberals always remained an elite minority with no interest in subversive activities. Nor was this an exclusively Venetian phenomenon: a wind of change was blowing throughout the continent in those years. And this is why its reflection is to be found in the figurative arts everywhere, especially in Paris, London and Venice, which remained the three main centers of art. Watteau, the *petits-maîtres* and Chardin in France, William Hogarth in England, and Pietro Longhi and Giandomenico Tiepolo in Venice, were all representatives of a new culture in painting and the graphic arts, one that was grafted onto the old trunk of history paint-

ing with the force of a revolutionary idea: the representation of truth.

While the *vedutisti* made the monuments and scenery of the city the subject of their canvases, other Venetian artists turned their attention directly to human society through the portrait or the genre scene. Among the many painters of pompous official portraits and second-rate chroniclers of daily life, the one who undoubtedly presented a true picture of Venice and its people was Pietro Longhi (Venice, 1701-1785). His ideal format was the small genre scene, almost always thronged with figures and concerned with capturing not only individual faces but also the setting and atmosphere of society. From his early works with scenes of *Peasants* to the famous canvases of the *Sacraments* and the *Hunt in the Valley* (Fondazione Querini Stampalia, Venice), his paintings were produced in series, like the "Progresses" painted over the same period by Hogarth. In fact, Longhi's references to the European tradition of the family scene, portrait or record of an occasion, the so-called "conversation piece", are explicit. This came about not just through the influence of Hogarth's prints, but also through direct contact with French culture. The prime intermediary for this was Rosalba Carriera, who returned from Paris in 1722, where she had not only formed a friendship with Watteau but probably also came into contact with authentic examples – paintings, pastels, drawings and prints – of French portraits and genre paintings.

As a result of these links with European culture, Longhi was able to free himself from the provincialism of the Venetian portraiture of the early 1700's and pursue a more refined and international style, adapting himself to the aesthetics of the Enlightenment. In fact, he observed the

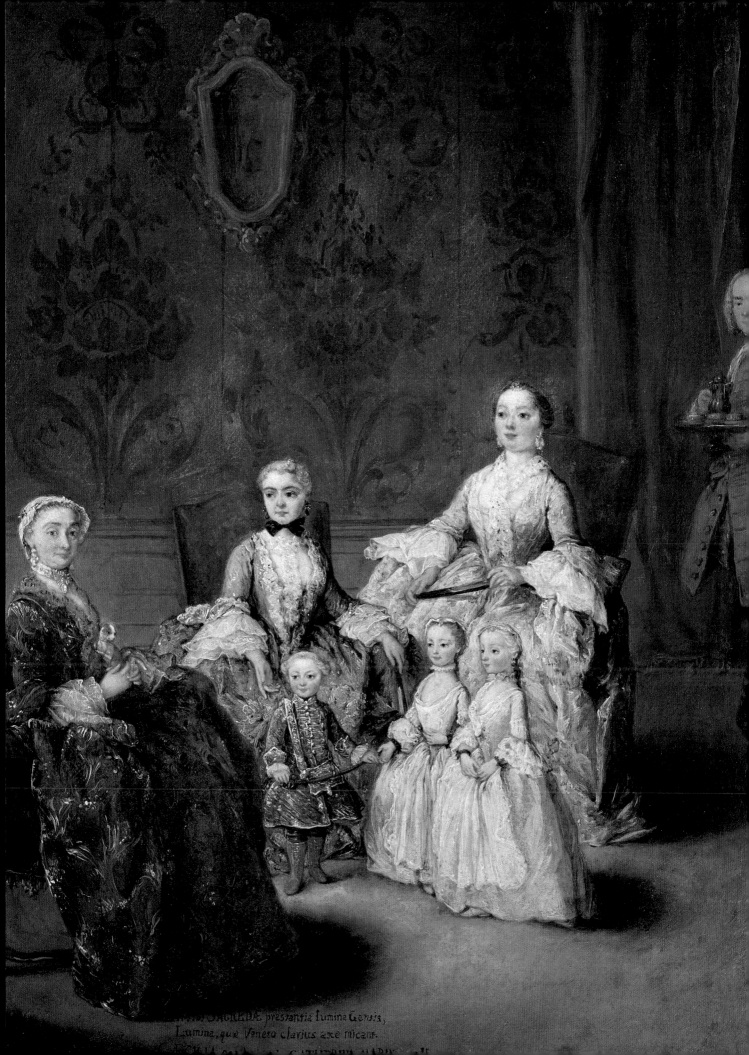

ORGREDAE prestantia lumina Gentis,
Lumina, quæ Veneto clarius æce nicant.

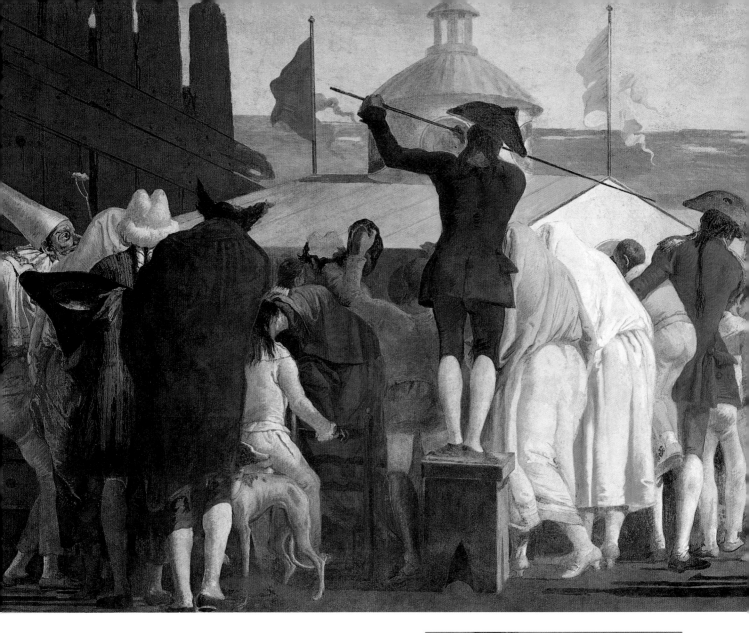

society of his time under the lens of reality. In the relatively uniform style of his brushwork, as delicate and painstaking as a miniature, the figures have an uncommon force and realism that goes beyond the apparent playfulness and superficial charm to enter into the truth of things. In this sense Longhi is a modern painter, who was active in the most advanced cultural circles of his day, assuming a unique position in late eighteenth century Venice.

Also fundamental in Longhi's development was a period of study in Bologna, where he certainly came into contact with the works of Crespi. In fact, his stay in the city proved crucial, as is evident from the robust and lively scenes of ordinary life he painted prior to 1740 (*The Polenta* in Ca' Rezzonico, Venice). With life in

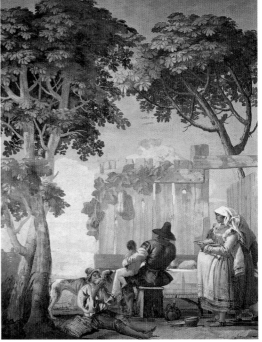

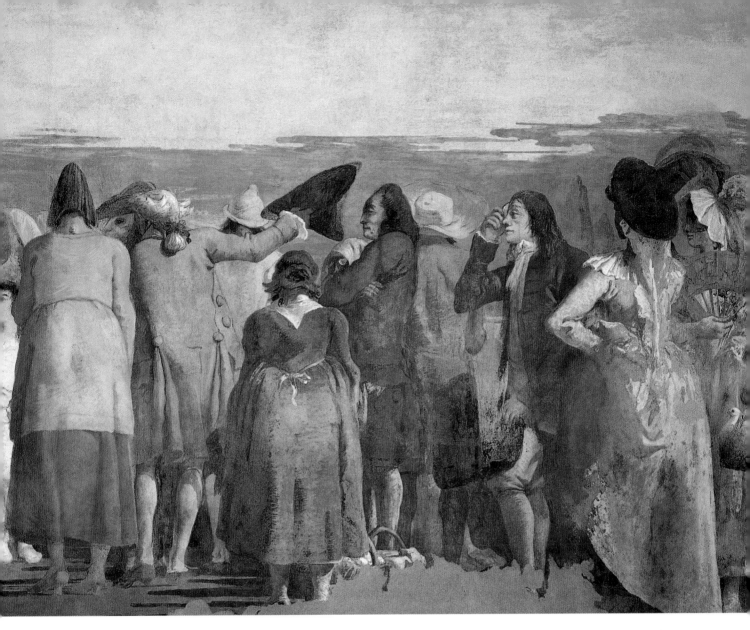

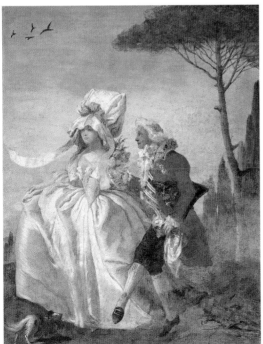

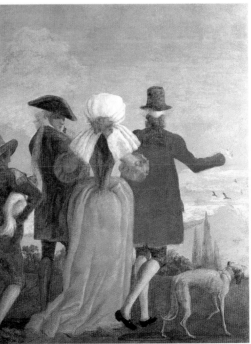

Venice as his sole subject, Longhi became the pictorial chronicler of the society of his time, demonstrating great sensitivity. His delicate but pungent palette, in which veils of colors laid on with the brushwork of a miniature painter enhance the most meticulous drawing, proved particularly well suited to such themes.

His first masterpieces are to be found in the early series now in the Gallerie dell'Accademia, dated around 1741. It includes the *Concert*, which is perhaps the one with the greatest vitality, due to the light which creates a tremulous atmosphere in the dimly-lit drawing-room. Extraordinary records of everyday life, Longhi's pictures were able to capture slices of real life with an inimitable pictorial freshness: note the lively descriptions in the *Vendor of Fritters* and in the *Rhinoceros* in Ca' Rezzonico (1751).

But Longhi was known to his contemporaries chiefly as a portraitist, and such he was without doubt, although in an affably decorative style. We see this in the small and rather glassy-eyed figures of his numerous paintings with the title *Patrician Family*, such as the one in Ca' Rezzonico, in the famous painting of the *Sagredo Family* that is in the Querini, dating from around 1752, and also in his life-size figures such as the *Portrait of Francesco Guardi* in Ca' Rezzonico (1764). In his role as "painter of the Venetian nobility" Longhi has historical importance as the only person to provide a true pictorial record of mid-eighteenth-century Venetian society.

His son Alessandro Longhi (Venice, 1733-1813) was a figure of minor importance, at times capable of painting psychologically penetrating portraits, in a gaudy and vibrant color that was suited to his sitters (*Portrait of the Pisani Family* in the Gallerie dell'Accademia), or sometimes in color that was delicately veiled with the refined tones of pastel (*Portrait of Giulio Contarini da Mula* in the Accademia dei Concordi at Rovigo, 1759).

Another genre painter who portrayed Venetian social life was Giandomenico Tiepolo (Venice, 1727-1804), son of the great Giambattista. He was obliged to express his personality on two different levels, resulting in a highly unusual process of stylistic development. Long subservient to his father, as the most faithful and attentive assistant on his large-scale decorative projects, it was not until much later that he found a vein of his own in grotesque subjects and caricatures. He created scenes of punchinellos, masquerades and gypsies, painted on canvas and in fresco, or in drawings. After early work for the Venetian church of San Polo (1748-1749) and in the guest quarters of the Villa Valmarana at Vicenza (1757), where he frescoed pungent scenes of *Peasant Life* – which are a marked contrast to the idealized mythologies and "poems" painted by Giambattista in the main part of the villa – Giandomenico accompanied his father on all his artistic wanderings, from Würzburg to Spain. Returning to Venice at the end of 1770, he devoted himself in particular to the graphic arts, drawing subjects, many of them caricatures, on a long series of large sheets that constitute an irreplaceable documentation of Venetian life in the latter part of the century. In this phase Giandomenico produced his own masterpiece in the frescoes with which he decorated his summer

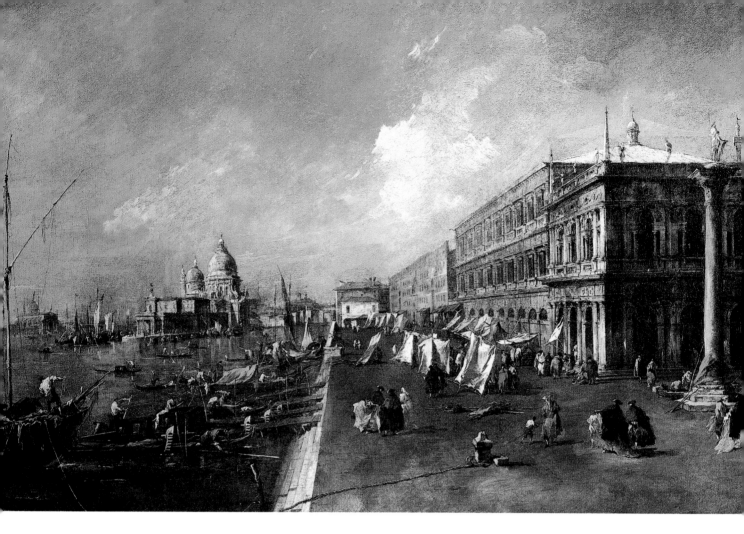

FRANCESCO GUARDI,
The Wharf and
St. Mark's Library,
Galleria Franchetti,
Ca' d'Oro, Venice.

residence at a small villa at Zianigo near Mirano (1759-1797, now in Ca' Rezzonico, Venice). In the later ones he seems to mock the more reactionary modes of behavior of his time: the scenes of the *Minuet* and the *Passeggiata* are in fact based on Giuseppe Parini's satirical poem *Il Giorno*, from which according to some he took the episode of "the maiden Cuccia", the little dog taken for a walk by a servant and fondled like a human being. The frescoes of the Sala dei Pulcinella – the popular Neapolitan character from the *commedia dell'arte* – have the same grotesque quality, one that has much in common with the satire of the British journal *Punch*. The artist also devoted a famous series of 104 large pen-and-watercolor drawings to the same character, a series that he entitled, ironically, "Amusements for Children" (now dispersed amongst various collections).

Giambattista Tiepolo's younger son, Lorenzo (Venice, 1736 - Madrid, 1776) was less gifted: a fine engraver of his father's works and painter of pastel portraits (*Portrait of the Artist's Mother Cecilia Guardi Tiepolo* in Ca' Rezzonico, Venice), he was also the author, during the last phase of his life in Madrid, of numerous pastels with realistic subjects, characterized by colors in pale tones, most of which are now in the Prado.

Toward Romanticism: Francesco Guardi. A tradition dating from the late eighteenth century presents Francesco Guardi, last representative of the *vedutismo* current, as "a good follower of Canaletto". Modern studies have demonstrated the falsity of this definition, which has only a smattering of truth in so far as Guardi – like many other painters – used the urban scenes drawn or painted by Canaletto as a model for the perspective of his own canvases. On the contrary, if we look at the relationship between the two – who were unquestionably the greatest Venetian *vedutisti* of the Settecento – we have to conclude that there has never been such a marked divergence between painters of the same

subjects: in the conditions under which they operated, in their temperament and in the language of their art.

Younger by almost a generation, Francesco Guardi (Venice, 1712-1793) found himself by force of circumstances acting as Canaletto's substitute when the latter went to England for about ten years, and then again after his death. In 1743 Marieschi died as well and Venice found itself short of painters of views. This is probably why Guardi decided to devote himself to *vedutismo*, a genre that had certainly not come to the end of its popularity at that point.

Yet Francesco's origins were very different. In fact he belonged to a family from the Val di Sole near Trent that had moved to Vienna. His father Domenico and brother Antonio were painters of "figures", i.e. subjects taken from poetry, history or religion.

The scarcity of documented works in the early period of Francesco's activity has made it difficult to define his own catalogue of figure paintings, leading to considerable confusion with the pictures of his elder brother. He was certainly the author of works such as the *Saint in Ecstasy* in the Trent Museum, the *Pietà* in the Pinakothek in Munich and the *Madonna* formerly in the Tecchio Collection in Milan, all signed. These are canvases of small size, executed with a heavy, dense brushwork that constructs the image out of characteristic contrasts of light and shade. Rather than following in the tracks of Rococo *chiarismo*, the style adopted by his brother Antonio, they seem to draw on the expressionistic manner of seventeenth-century painters and are even reminiscent of a certain "Gothicizing" harshness in the late-baroque style of Northern Europe.

In any case, Francesco must have embarked on his career under difficult circumstances that offered him little satisfaction. So it was necessary for him to find his own way, something that Francesco did a little at a time, trying out a vari-

ety of directions. One attempt that led nowhere was his venture into the production of genre paintings, an area that Pietro Longhi had dominated since the 1740's. In fact, Longhian motifs can be discerned in the two pictures representing *The Foyer* and *The Locutory of the Nuns of San Zaccaria* from just before 1750 (Ca' Rezzonico, Venice). The most successful aspect of the accurate depiction of these two celebrated rooms of

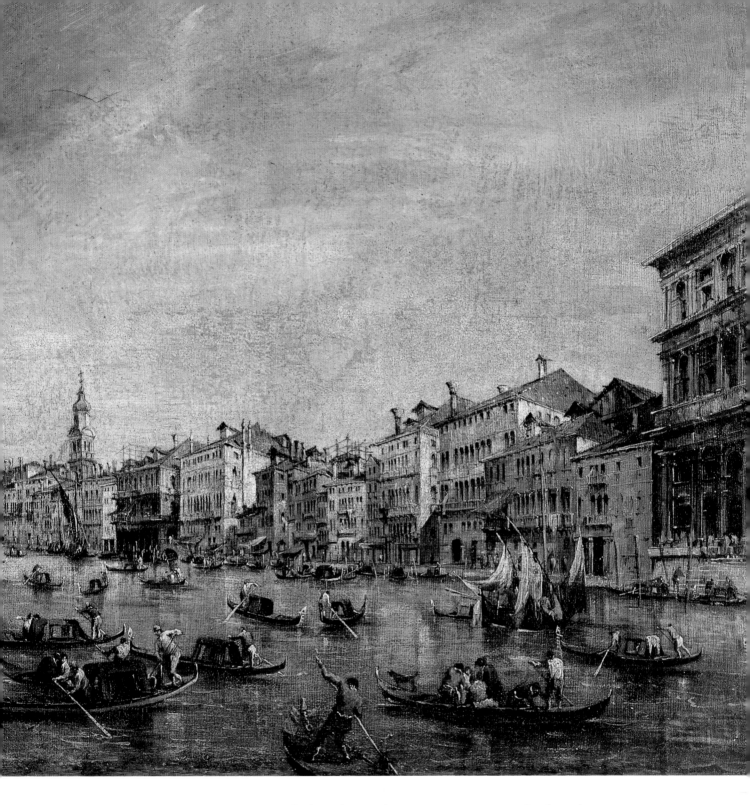

eighteenth-century Venice was the palette of colors he used. And for the first time we find an interest in the faithful representation of indoor settings in real light, as if they were landscapes. However, the effort cannot have proved very successful since, after a few more paintings of similar subjects, Francesco Guardi abandoned the theme.

And so we come at last to the period when he devoted himself to actual *vedute,* at the end of the 1740's. It is interesting to note that from the outset Francesco looked to Marieschi rather than to Canaletto for ideas and, above all, for stylistic suggestions. It is evident in fact that the *View of the Grand Canal at San Geremia* in the Baltimore Museum of Art does not just derive from a similar view by Marieschi in its perspective and in its figures, but also in its free and spontaneous brushwork, almost that of a *capriccio.* In this way

Guardi was able to make the most of the vibrant atmosphere, fantastic in its tone, that differentiates his style from Canaletto's and prepares the way for the extraordinary production of Venetian views and *capricci* in the years of his maturity.

In comparison with the works of Canaletto, the novelty of Guardi's language lies in his handling of light. In views such as that of the *Grand Canal Looking Toward the Rialto Bridge* that is in the Brera (*c.* 1760-1770) the luminosity takes on a wholly fantastic quality, conjuring up a vibrant and hazy atmosphere with a lyric tone that transcends Canaletto's realism, in a world of fleeting suggestions, luminous impressions and colors that are laden with feeling. This attitude of Guardi's has already moved a long way toward the modern vision of the landscape as an "emotional impression", and constitutes the foundation of his style in a long series of pictures on the single theme of eighteenth-century Venice, capturing an image that already foreshadows the city's decline. We see old plaster facings baked by the sun, canals crowded with boats, gondolas with sagging cabins and their iron fittings almost falling off, gloomy conversations between patricians dressed in cloaks and cocked hats standing in *campi* cut in half by shadow. Sometimes, especially toward the end of his life, the painter went from views of Venice to out-and-out *capricci*, and thus we find classical columns, arches and ruins transplanted into open seascapes, where the arid and scintillating color still smacks of brine under skies filled with wind-torn clouds.

Guardi's most successful period was probably the 1760's and 1770's. In 1764 a contemporary recorded, in fact, that he received an order for two large views of *Piazza San Marco*, which he executed with the aid of a camera obscura for an English visitor. Shortly afterward came the twelve large canvases representing the *Festivals of the Doges*, which were commissioned in connection with Doge Alvise Mocenigo IV (1763-1778). This series of public ceremonies, visits and festiv-

ities in which the doge took part had already provided the subject for a series of large drawings by Canaletto, engraved by Giambattista Brustolon from 1766 onward: it is one of the finest series of etchings produced in Venice in the eighteenth century. It was from these engravings that Guardi took the models for his paintings, now in the Louvre. The result is truly surprising. While we have no means of comparing them with paintings of these festivals by Canaletto, since he never made any, a comparison with the original drawings and with Brustolon's engravings provides a clear demonstration of Francesco's transfiguring and imaginative power. A good example

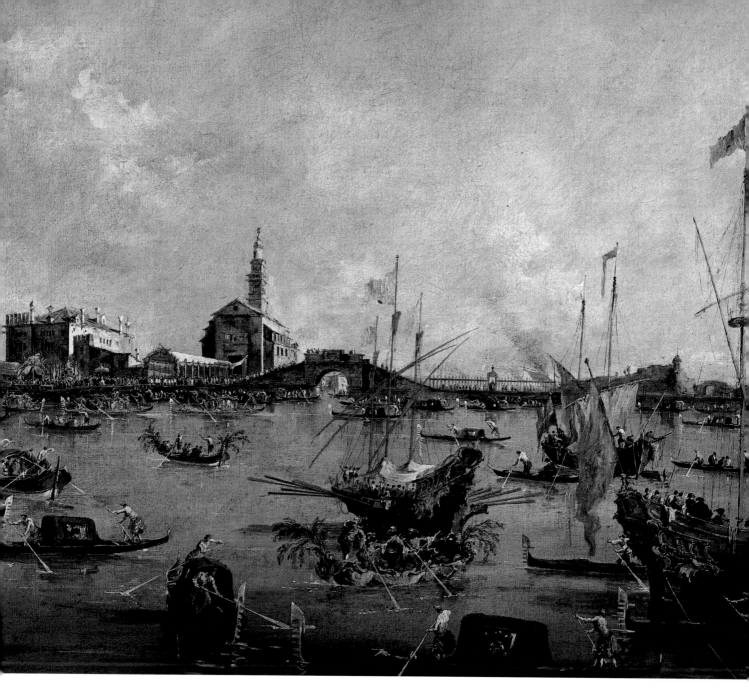

is *The Bucintoro at San Nicolò on the Lido*: while remaining extremely faithful to the original subject, Guardi transforms it into a completely independent work from the pictorial point of view.

Another official commission led to the series of paintings executed in 1782 on behalf of the Signoria to commemorate the *Visit of Pius VI* (museums in Oxford and Cleveland), along with the one devoted to the visit of the archduke and archduchess of Russia, Tsarevich Pavel and his wife Maria Feodorowna. During the same period he painted other views of great fascination, such as the one in the Ca' d'Oro with *The Wharf and St. Mark's Library*.

These last works seem to enter a new realm of poetics, one that clearly presages Romanticism. They are the enervated elegy of a world that has now gone forever, of which all that remains is a yearning: this is what we see in the *Return of the Bucintoro*, in a private collection in Milan, one of his masterpieces of the 1790's. Here everything, even the buildings and the boats, looks quivering and unsteady, and the Repubblica Serenissima, over a thousand years old and shortly to fall to Napoleon's troops, without a blow being struck, seems to be dissolving, with its ancient rituals, into passing shadows.

following pages
FRANCESCO GUARDI, Return of the Bucintoro, Private Collection, Milan.

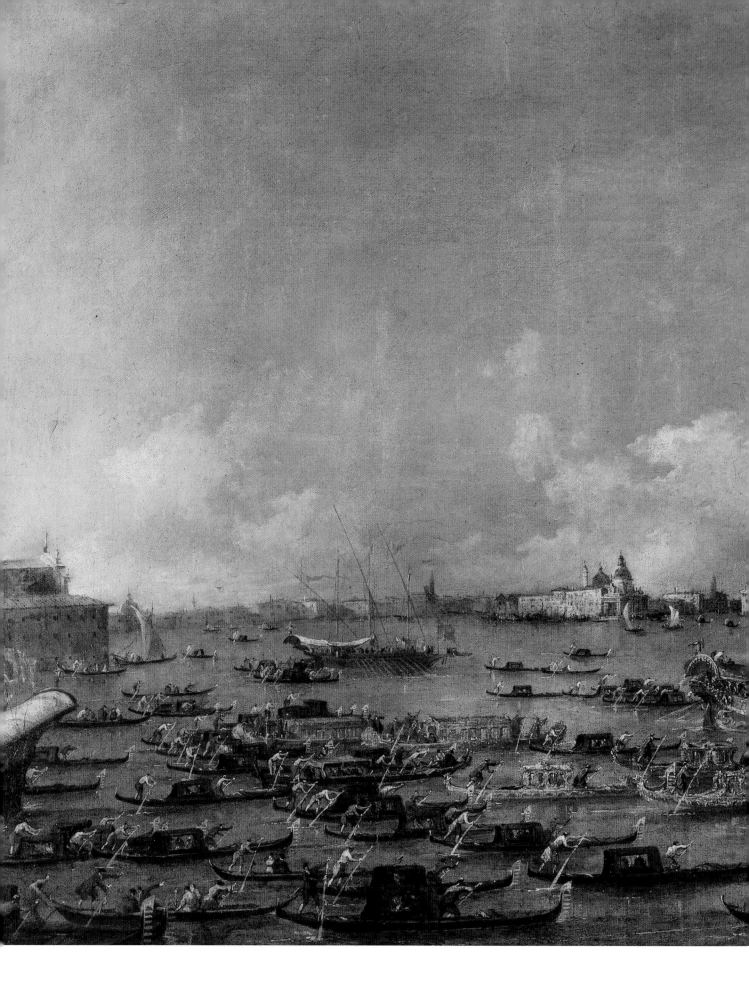

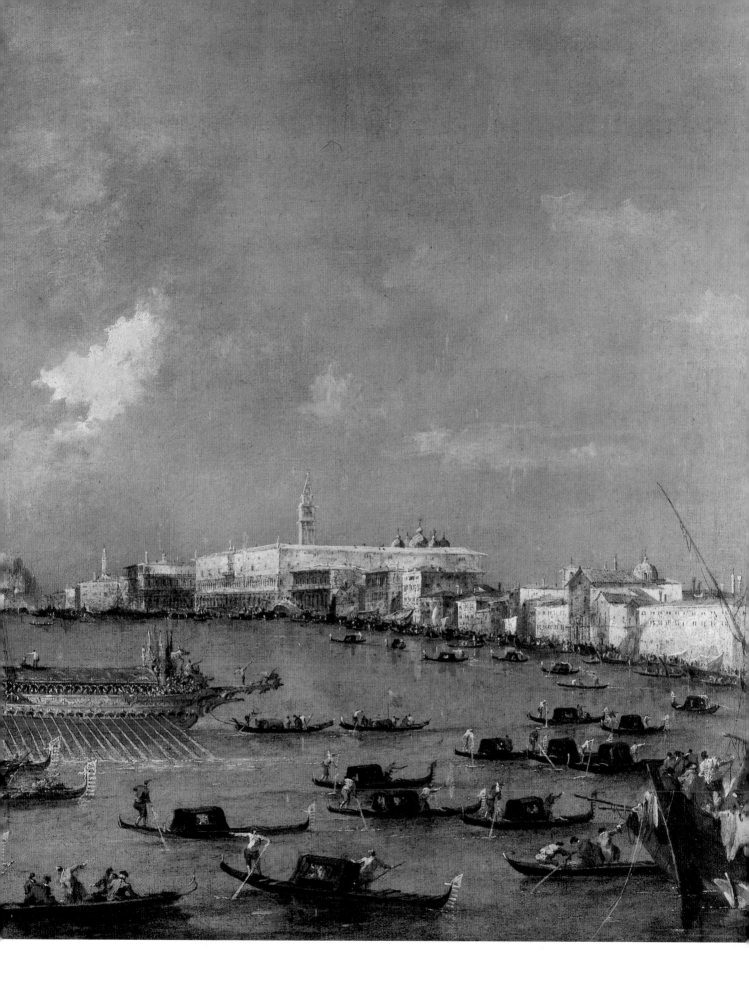

Index of Names

Recommended Reading

Brown, P.F., *Art and Life in Renaissance Venice,* New York, 1997.

Goy, R., *Venice: The City and Its Architecture,* London, 1997.

Norwich, J.J., *A History of Venice,* New York, 1982.

Olivari, M., *Giovanni Bellini,* New York, 1990.

Pedrocco, F., *Canaletto and the Venetian Vedutisti,* New York, 1995.

Pedrocco, F., *Titian,* New York, 1993.

Valcanover, F., *Carpaccio,* New York, 1989.

Vio, E., *The Basilica of St. Mark in Venice,*
New York, 2000.

Vio, E., *St. Mark's: The Golden Basilica,*
New York, 2002 (forthcoming).